PAINTED PONIES

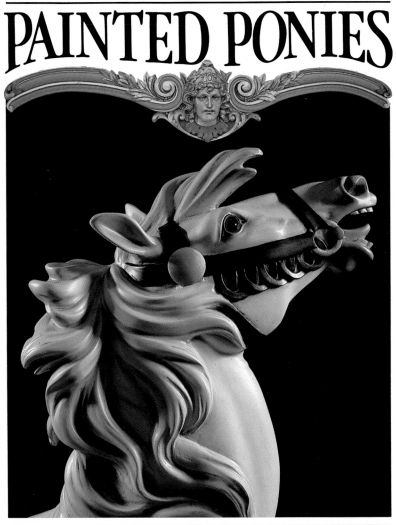

AMERICAN CAROUSEL ART

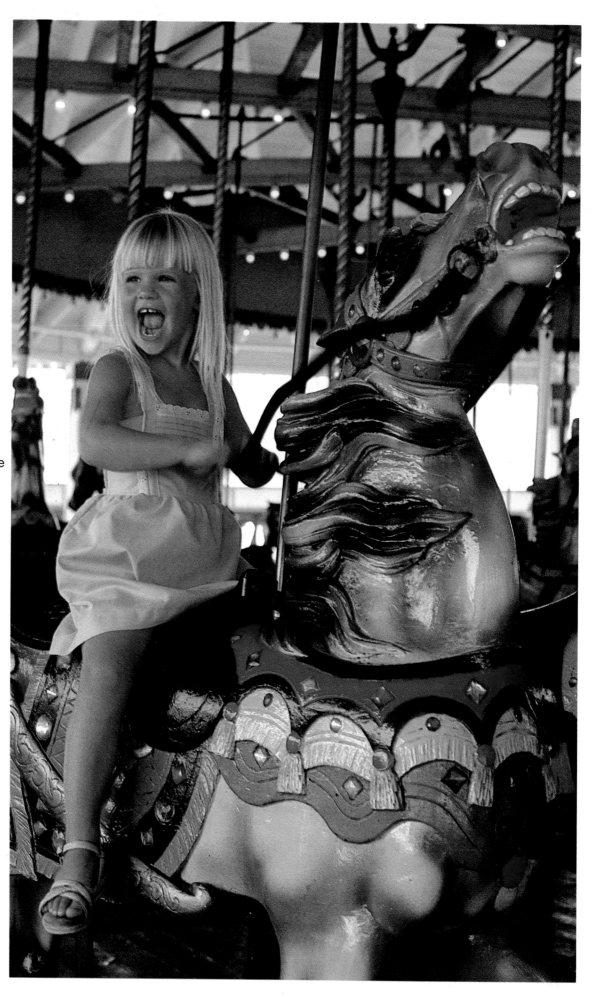

DEDICATION

This book is dedicated to the memory of **BARNEY ILLIONS,** America's last artist from The Golden Age of the Carousel.

Library of Congress Catalogue Card Number 86-51050

ISBN 0-939549-01-8

1992 printing

Copyright © 1986 ZON INTERNATIONAL DESIGN, INC.

PAINTED PONIES is a trademark of Zon International Design Inc.

Published by ZON INTERNATIONAL PUBLISHING COMPANY P.O. BOX 47 Millwood, New York 10546 Tel: (914) 245-2926

Art Direction and Design by William Manns

Color separations by Scantrans Ltd. Printed and bound by Khai Wah-Ferco (PTE) Limited, Singapore

PAINTED PONIES

BY WILLIAM MANNS
MARIANNE STEVENS
TEXT BY PEGGY SHANK

TEXT EDITED BY DRU RILEY PH.D.

AMERICAN CAROUSEL ART
ZON INTERNATIONAL PUBLISHING

ACKNOWLEDGMENTS

To present this book about the glory of the American carousel, we have ourselves worked as hard as a County Fair merry-go-round. On our journey we have criss-crossed the country many times and met many new faces — sometimes moving on after only one day. But the people and their knowledge, assistance or special gifts turned the work involved into a labor of love.

We owe the collectors of the beautiful figures and artifacts that fill the book a special thanks for their cooperation and time and for giving our photographers free rein. Without the extraordinary examples of carousel art from their private collections, this book would be incomplete.

Jon & Barbara Abbott
Gayle & Jim Aten
Dennis Berman
John & Cathy Daniel
Alice & Marc Davis
Leah & Peter Farnsworth
Gail Hall
Russell A. Hehr
Steve Hill
Edo McCullough
Sue & David McEachern
Rita & Allen Orre
Carol & Duane Perron
Frank Ryan
Judy & Carlos Sardina
Dagne & Al Schoenbach
Peggy Sue Seehafer
Barbara & Dick Shilvock
Joy & Larry Smith
Jo & Rol Summit
Tina & Bob Veder
Bebe Ventura
Mary & Walt Youree

We thank the many people who made this book possible especially JUDY BENSON, because of their tireless enthusiasm, expertise, unending support, wealth of information, ideas and criticism. Without them to help us over stumbling blocks, applaud each minor success or provide the missing link, this book would be a lesser work.

Richard Ahlborne
George Barta
Bryan & Brett Benson
Robert Bishop
Judy Brewton
Caitlin Calcagnini
Peggy Cardillo
David Chew
Maryjo Downey
Chatty Collier Eliason
John Emery
Helaine Fendelman
Tobin Fraley
Joanna Jacobson Hayes
Rebecca V. Hays
Gladys Hopkins
Cindy Issitt
Gary Jameson
Charlotte Lazenberry
Bob McCullough
Annabelle & Chris Miller
Lynda Miller
Wanda Miglus
Will Morton
Rachel Newman
Tony Orlando
Susan & Merrick B. Price
Rae Proefrock
Dru Riley
Bobby & Luz Scaggs
Betty & Raymond Shank
Lee Shank
Sharon Slusher
Jim Smock
Marge Swenson
Art Swords
Paul Tan

Judy & Gray Tuttle
Carl Ulanowicz
Richard Wickens
Eric Wolf

Carousel art is a fantasy land of visual delights. To capture the incredible variety created by the carving masters, our photographers visited almost every major operating carousel in North America and many private collections throughout the United States. Their excellent photographs are the foundation of PAINTED PONIES and we heartily thank each one.

Harry Bartlett
Richard Blair
Kevin D. Breighner
Peter Clark
Susan Foley
John Goldy
Sara & Jim Hennessey
Dave Hulbert
Susan & John Hultman
Tim Hunter
Cliff Kargus
David Manns
Dennis Manns
Robert Manns
Dianna Owens
Jeff Saeger
Richard Speers
Richard Szczepanski
Ron Tatariw
Pete Tekippe
Dana Tucker
Randy West

We also want to acknowledge the numerous parks and museums that permitted us to photograph their operating carousels and displays. A special "thank you" is in order to the following for their extra courtesy and helpfulness.

American History Museum, Smithsonian Institution
AstroWorld
Carousel Society of the Niagara Frontier
Kit Carson County Fairgrounds
Cedar Point
The Children's Museum, of Indianapolis
Crescent Park
Dickenson County Historical Society
Disneyland
Glen Echo Park
Henry Ford Museum
HersheyPark
Historical Crossroads Village
Kings Island
National Cathedral
Portland Carousel Museum
Rye Playland Park
Sands Point Preserve
Seabreeze Park
Six Flags Over Georgia
Spring River Park
Story City Park
Watkins Regional Park

And last, but not least, we are indebted to the relatives of the unique carvers and manufacturers that created the American carousel world. The memories of these descendants are a priceless heritage and welcome addition to the history of carousels. We are especially grateful to BERNARD ILLIONS and his wife BETTE for true inspiration.

Marguerite Cerney
Allan Herschell
Sam High III
William F. Mangels
Charles Rutter
Wilda Looff Taucher
Mr. & Mrs. John Zalar

CONTENTS

INTRODUCTION

Bernard Illions, youngest of carver Marcus Illions' four sons, began painting in his father's shop under the supervision of their cousin, Jack Illions, who was a talented artist in charge of the carousel painting. By 1920, when Barney was 19 years old he was painting entire carousels, including the extremely ornate Supreme models. In subsequent years he studied art formally and worked in Vaudeville and eventually as art director for National Screen's Hollywood Studio.

I would like to take you back to Coney Island, New York, where I was born and thoroughly indoctrinated in the world of carousel manufacturing. Apprenticed at 10 years of age as a painter, I was able to watch first-hand the carvers at work.

My father's carving studio was in back of our home. There was always an abundance of visitors in the shop, and they marveled at the carvings that would emerge from the blocks of wood. When the horses or other carvings were finished, they were sanded smooth. I preferred the patina the horses had prior to sandpapering, but of course, they had to be prepared for the public.

All of the patterns were sketched by Dad. My brother Phillip would transfer them to the raw wood. He carefully noted the grain of the wood to ensure the least amount of breakage, even though many parts were doweled later to give them more strength. I would collect the shavings from the carving benches and put them in the large pot-belly stove in the center of the studio. That was our heating system during the winter, and it did get cold in Coney Island.

One winter snow prevented the trains from running and my brother Rudy hitched one of our horses, Bob, to a sleigh that Dad had designed — a seashell-shaped sleigh with a lion's head and wings in front. The body of the sleigh was held up by carved filligree cast in bronze. Several carvers lived in Brooklyn and New York and Rudy gave them a ride to King's Highway, where some trains were running. On the way back, Bob, a very spirited horse, forced the sleigh against some trees and smashed it to pieces. Dad sent Rudy back to pick up every splinter. It was reglued and now rests in a museum in Florida.

Wintertime was our busiest season; sometimes we worked till 9 or 10 at night. Summertime was relaxing; very little work was in the shop. My brother Harry was operating Feltman's carousel, and brother Phillip operated Stubbman's carousel.

Many of the creative carvers were foreign-born and were the true artists of the merry-go-round.

In studying the different styles of carvings, one is amazed at the proficiency of those who are now recognized as masters of their art. Because of their pride in inventing their own styles, one can tell exactly the differences in their work. Some carvers kept improving, while others were content to stay with a primitive approach. It's easy to see the forerunners, the heights of art they attained. The "Old Gent," as my brother Phillip called my dad, admired the work of D.C. Muller and would often state this to his associates in the carousel world. He also had great respect for all carvers. Many people have their favorites, which is as it should be. In all phases of artistic endeavor, the artist endows a personal feeling to his art which lasts forever.

At the turn of the century the amusement business exploded. Baseball fields, bathing pavilions and amusement parks were everywhere. Carousels and all types of amusement rides were the form of entertainment for the whole family. Radio and television did not exist and the automotive industry was in its infancy. The nation accepted the carousel with open arms.

Initially, resorts such as Coney Island, New York, popped up to give wealthy people a place to swim in the ocean and be entertained. Hotels sprang up to accommodate them, and band concerts, led by such notable conductors as Sousa, Pryor and Creatore, were common. But this quiet resort soon burst into a mecca of the amusement world and carousels and other devices soon covered nearly 15 blocks of Surf Avenue. Carousels were located within two blocks of one another. My dad's carousels and the carousels he made horses for totaled 11. All Coney Island was amazed and hailed M.C. Illions as a master woodcarver. His versatility was unparalleled.

But times changed. Electronic progress and shifting public interest stole some of the magic from the amusement industry. Kiddie rides, the facsimilies of the larger devices, became more in demand. Then the crash of 1929 forced many carousel manufacturers out of business. It was a time when money was short and bread lines were long. Through it all, the remaining carousel carvers were optimistic that the future would again create a demand for their art. They had witnessed times of depression before and kept their hopes ever high.

I don't know how the other carvers would have felt about their work's selling for so much money in later years. Most old-time carvers would be astonished that their handwork was considered valuable in the art world. But the Old Gent would be happy that his art was recognized. One incident proves that point. An advertising agency latched onto one of his carousels and photographed a movie star astride a horse. It was for a beer ad. When my wife Bette and I brought this to my dad's attention, he was pleased to no end. There was no thought of being reimbursed, only that the horse showed up great.

My dad would have been happy with the carousel organizations trying to keep merry-go-rounds intact. But I feel the carousel figures, which have been mutilated by unruly members of the public, have a better chance of survival with collectors. Surely people who have a wooden horse that they admire in their home would care for and preserve it.

What the future holds for these carved masterpieces is hard to guess. Carousels still exist, but they are now made of fiberglass. The many carousel organizations are to be commended for their sincere regard for the carvers and carousels and for bringing the merry-go-rounds of yesteryear to the public's attention. I am also thankful for this excellent book, which artistically presents many superb woodcarvers of the past and the heritage of a time when life was not so hectic. It was a time when you could easily slip into the mood of an old 1928 song that said, "I love to catch brass rings on a merry-go-round as I ride and ride and ride around."

Bernard "Barney" Illions

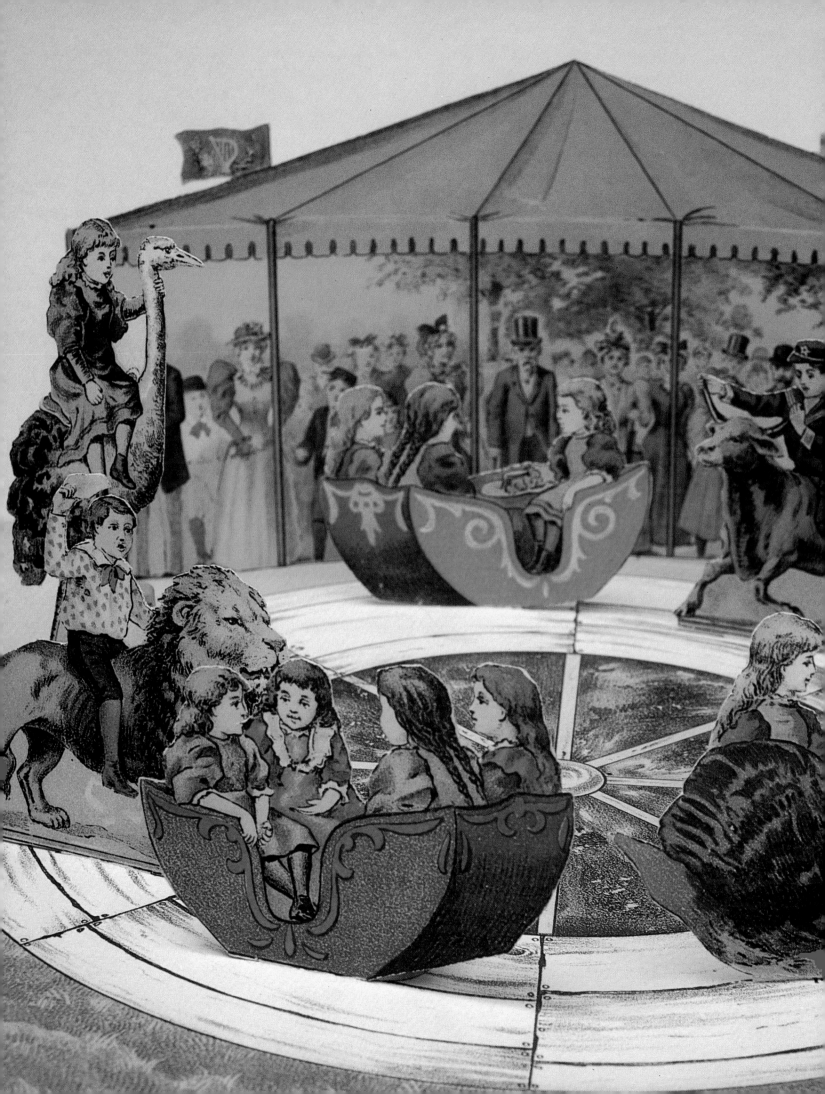

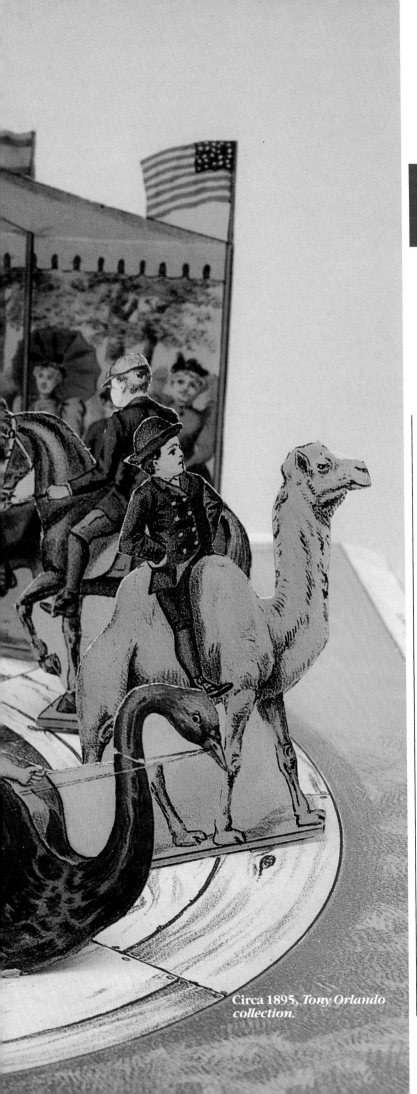

Circa 1895, *Tony Orlando collection.*

America's
CAROUSEL HERITAGE

Rollicking music pumped into the air by a carousel organ tempted everyone within earshot to join the circular parade. Glass jewels and sparkling mirrors scattered inviting beams of light into the eyes of the passing throng.

The whirling machines drew spectators closer and closer with an open invitation to excitement. Once astride the galloping horses, riders clutched richly carved manes covered with a slick coat of paint and felt the carousel wind blow across their cheeks. With their senses tingling and imaginations running wild, people returned again and again to climb aboard the carousel. Five cents bought a ticket to fantasyland.

Carousels found a warm welcome in America, but they were not invented there. The earliest mention of rides similar to carousels has been found around 500 A.D. The ancestor of today's machines probably was an Arabian game adopted by Spanish crusaders and carried throughout Europe. 'Carosello' was a 17th century Italian word meaning "little war." It described a contest among horsemen who tried to catch clay balls filled with scented oil. If the riders were unsuccessful, the "smell of defeat" enveloped them.

In the royal courts of France the game changed. Here the horsemen tried to spear gold rings with their lances while riding at full speed. This variation no doubt led to "catching the brass ring" on later carousels. To practice for the important exhibition, knights would mount crude wooden horses attached by beams to a central pole and turned by servants or real horses. The limited source of power kept the size of carousels small until after the Civil War, when the steam engine became popular.

'Carrousel' in French referred to an "entertainment by knights involving chariot races, pageants and exercises." These contests replaced former tournaments that involved serious martial confrontations among mounted soldiers. As armored knights who participated in these often-deadly tournaments were shoved aside with advancement in warfare, they turned to the less dangerous, but still thrilling carrousel. The spirit of the competition was similar to American rodeos, which celebrate the activities of the Old West.

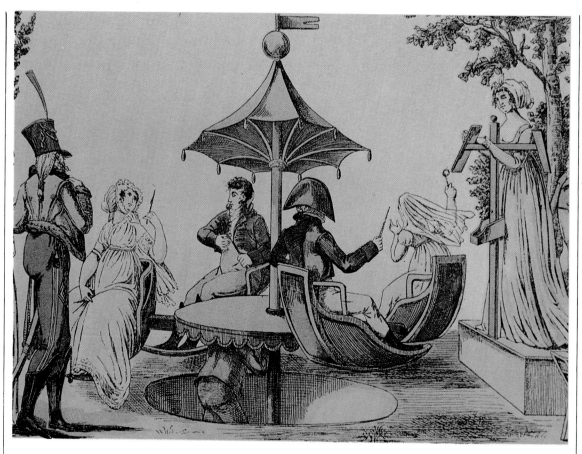

The French aristocracy developed many variations of the carousel, like this one in which riders, rotated by a man in the pit, try to spear metal rings, circa 1800. *New York Public Library.*

Grand tournaments were held in France in the mid-16th century. For these occasions, saddle makers, tailors, wig makers and jewelers concocted extravagant creations for both horse and rider participating in an event that resembled a midday gala rather than a "little war" on horseback. The horse trappings were apparently the inspiration for carousel carvers in Germany and the United States more than 200 years later.

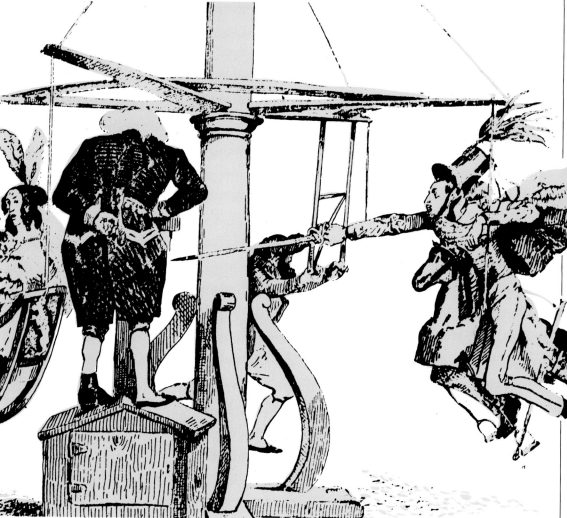

Spearing a ring has been part of the carousel tradition since its earliest appearance. Competing Arabian and Turkish riders trying to catch perfume-filled clay balls eventually inspired the French to catch gold rings with their lances. This sport was, in turn, adapted to amusement devices that became popular in Europe by the late 1700s. *New York Public Library.*

Before the 1860s, carousels had to be small enough to be turned by a horse or human being. Then Frederick Savage in King's Lynn, England, incorporated the steam engine with the carousel. Gustav Dentzel and other American carousel makers quickly adopted this new power source and began touring the countryside with portable machines. At the turn of the century, a home-town band in Iowa provides musical accompaniment for a portable Carry-Us-All built by C.W. Parker Amusement Company of Abilene, Kansas, circa 1900. *Gail Hall photo.*

Frederick Savage adapted the steam engine and its newly harnessed power to machinery that rotated the carousel platform. His invention heralded the beginning of the modern merry-go-round. Within a few years the improved amusement ride started to appear all over Europe. The first carousels had carts, gondolas, menagerie animals and horses. Savage, an engineer-machinist, followed his innovative use of power with a patent that added a galloping motion to the horses. His system of overhead gears gave the animals a familiar up and down motion still found on carousels today.

Wheelwrights, blacksmiths, carpenters and farmers in America built primitive carousels during their off-seasons in the early part of the 19th century. Their unskilled, part-time efforts and limited power source kept the machines small and rustic.

Late in the 19th century, the tide of immigrants washing onto America's eastern shores included skilled Europeans who were familiar with carousels produced in their native countries. By then the setting was right for the introduction of a new amusement. People across the United States had a little extra money in their pockets and they eagerly spent it for an exciting carousel ride. The Industrial Age supplied the power to turn the machines of the world, including the carousel, and it gave workers the freedom to pursue leisure pastimes.

Another modern development helped carousels secure a strong foothold in America. Trolley and railroad lines installed throughout growing cities gave the general population an inexpensive form of travel. To encourage use and increase profits, transportation owners often included amusement centers or parks at the end of their lines. They found that a carousel located in these strategically placed parks was a popular attraction.

The golden age of carousels, so called because of the large number of machines that were built then, lasted two decades-—from 1905 to 1925. But the recognized era of handcarved carousels in the United States began in the late 1860s when Gustav Dentzel constructed a simple bench-seat, horse-powered machine. His carved horses were a vast improvement over the rude efforts of the first unskilled carousel makers. The end of the carousel era in the early 1930s was directly linked to the financially crippling Depression.

During the heyday of carousels, patriotism throughout America , fueled by World War I and the Spanish American War, was rife in America. Wallpaper, dinnerware, door knockers, furniture and architecture liberally borrowed patriotic symbols. Stars and stripes, eagles and Uncle Sam were popular motifs.

Immigrants who had left family and friends in search of the independence, freedom and unlimited opportunities promised by America were more openly patriotic than many who were native-born. Carousel makers, most of whom came from other countries, often followed this trend and liberally used patriotic symbols and the portraits of favorite presidents on the carousel figures and rounding boards they produced. Carousel operators draped American flags and bunting across their machines for decoration. The Statue of Liberty, dedicated in 1886 with fireworks, speeches and much fanfare, was a beacon of freedom to those arriving from other countries. Understandably, the statue also became a popular figure on carousels.

In spirit and design, the people who chiseled, painted and delivered carousels sired a special American breed. Their satis-

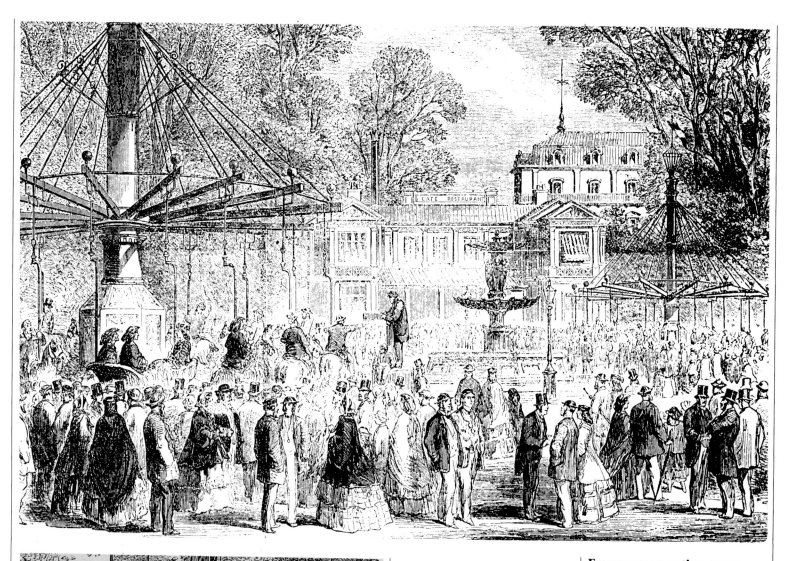

France was a nation populated by farmers who loved the barnyard animals of the carousel. In 1861 two enormous machines operated in a park in Paris. *New York Public Library.*

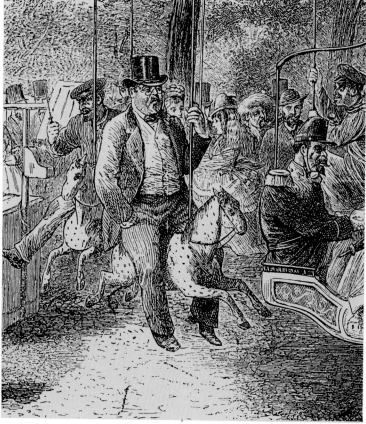

By the late 1800s many French cafés had started to set up portable carousels adjacent to their businesses. Here a British tourist on the Champs Elysées takes a ride on a swinging pony, circa 1874. *New York Public Library.*

The carousel inspired several types of amusement devices, including scenic railways, fancy gondolas, rolling ships and the "Un Manage Electric." The latter was a French invention that gave each rider an individually controlled, electric-powered horse. Patrons in the overhead gallery could sip champagne and place wagers on their favorite team. It would seem that the inside rider had a definite advantage, circa 1890.

Queen Victoria expanded the British Empire by spreading the English language, religion and culture to all parts of the world. Apparently England also took the "roundabout" or "tilt" to North Africa in the 1870s. This primitive device was constructed by local crafts-

men. The neck of each horse was hinged and attached to the rump of the horse in front of it by a metal rod. The heads bounced up and down as the carousel was tugged around by donkey power. *New York Public Library.*

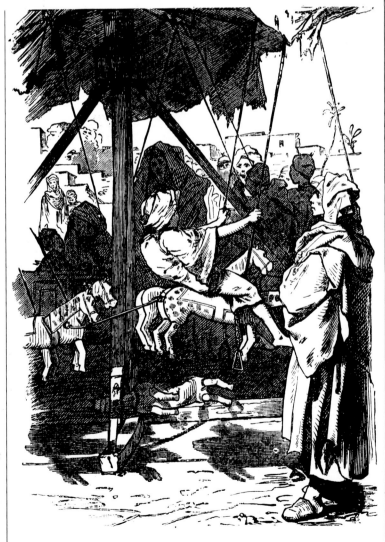

faction with the life they found in America inspired them to add purely American themes to the carousel figures. Cowboys and Indians were well represented, as was the cavalry. Theodore Roosevelt's forays with the Rough Riders, the opening of the Panama Canal and the Indian wars, including Custer's last stand, were in newspaper headlines and provided a variety of subjects to the carvers. Figures from Mother Goose nursery rhymes were used on American carousels, but never any popular cartoon characters. Mickey Mouse, Donald Duck and Pluto appeared on carousels in Mexico and France, but were passed by in their own country.

Usually the side of the carousel animal facing the audience, the "Romance" side, was adorned with carved decorations. In America and most of Europe this was the right side because the carousels turned counterclockwise. English merry-go-rounds or round-abouts turned clockwise so their animals were heavily carved on the left. Since the side of the figure facing the center received little treatment by carvers or painters the view from there was rather plain.

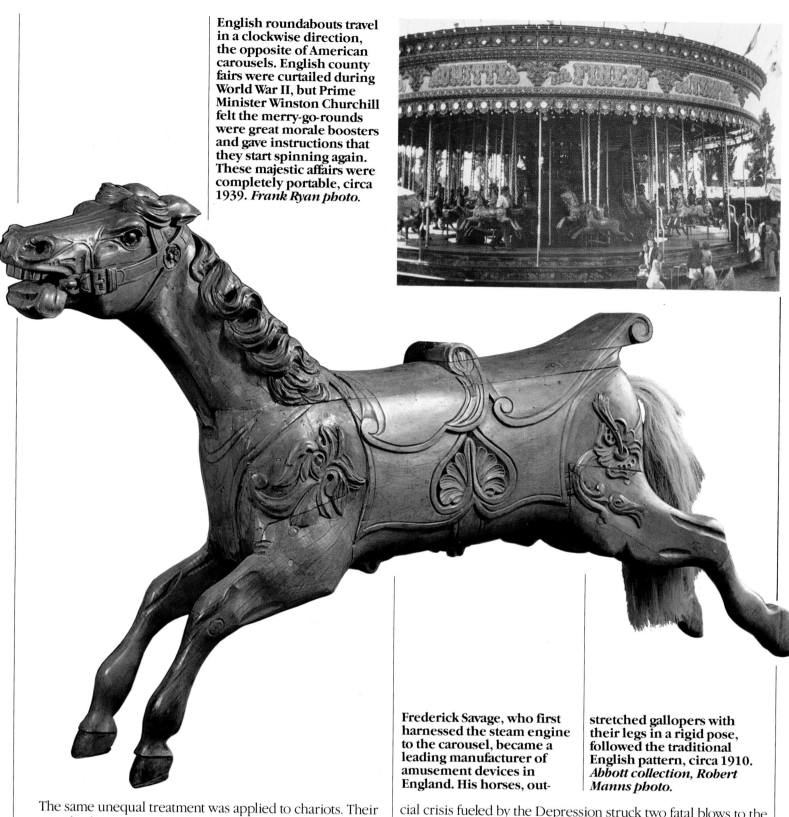

English roundabouts travel in a clockwise direction, the opposite of American carousels. English county fairs were curtailed during World War II, but Prime Minister Winston Churchill felt the merry-go-rounds were great morale boosters and gave instructions that they start spinning again. These majestic affairs were completely portable, circa 1939. *Frank Ryan photo.*

Frederick Savage, who first harnessed the steam engine to the carousel, became a leading manufacturer of amusement devices in England. His horses, out- stretched gallopers with their legs in a rigid pose, followed the traditional English pattern, circa 1910. *Abbott collection, Robert Manns photo.*

The same unequal treatment was applied to chariots. Their exposed sides were made from matching silhouettes, but the outside panel was laminated with extra wood for bas-relief carvings. Daniel Muller, who carved both sides of the chariot panels, was the exception to this practice. Sometimes the inner panel was intricately painted to look as though it was carved like the outside wall. Chariots carried the faint of heart, small children and women too modest to straddle a horse. On the early carousels, especially, movements were jerky and the speeds were relatively fast.

A shortage of supplies caused by World War I and the finan- cial crisis fueled by the Depression struck two fatal blows to the carousel industry in America. Both of these upheavals made carousel construction a less profitable business. Companies that switched to carving machines to mass-produce carousel horses in the 1920s or that abandoned wood figures for a cheaper, maintenance-free aluminum variety in the 1930s were the only ones to survive. Companies that converted to methods of production requiring fewer laborers captured the market. This combined with the passing of many master carvers reduced the excellence that once prevailed in the industry and left the work to less dedicated trades people.

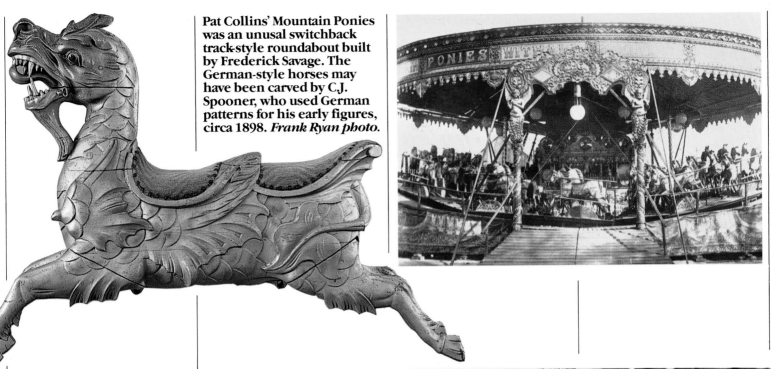

Pat Collins' Mountain Ponies was an unusual switchback track-style roundabout built by Frederick Savage. The German-style horses may have been carved by C.J. Spooner, who used German patterns for his early figures, circa 1898. *Frank Ryan photo.*

C.J. Spooner created a limited number of these unusual two-seated dragons to accompany his gallopers. This richly carved figure maintains the same parallel leg pose that was used on all other Spooner carvings, circa 1905. *Farnsworth collection.*

Frederick Savage, J.R. Anderson and C.J. Spooner were the three major manufacturers of English roundabouts. They all produced machines in various sizes and with similar stylized carvings. The horses often had two seats and were heavily decorated with ornate carvings over the body. Ornamental painting usually extended down the legs and up the neck of the horse. This Spooner roundabout was restored by Carol and Duane Perron of Portland, Oregon, circa 1905. *Susan Foley photo.*

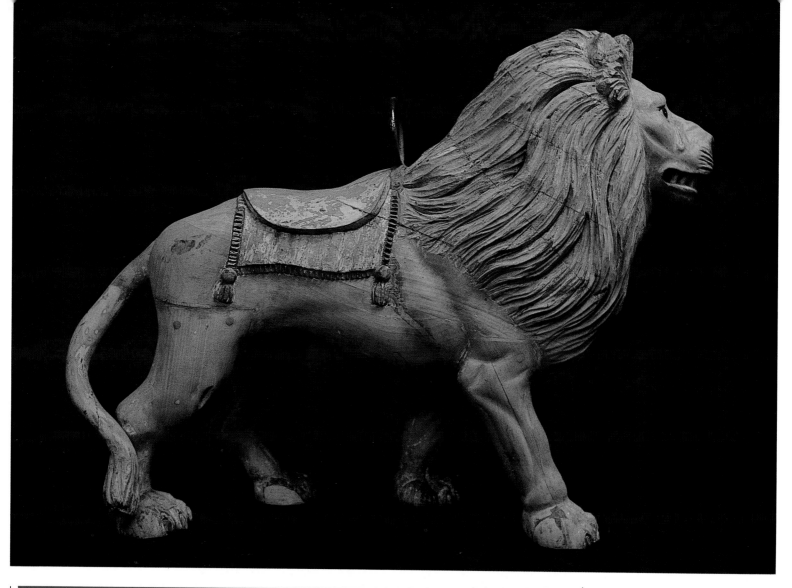

This small French lion was part of a portable Bayol street carousel, circa 1905. *Dave Stevens collection, Harry Bartlett photo.*

Gustave Bayol, the noted French carver, primarily produced playful barnyard figures, including pigs, roosters, rabbits, cats and cows complete with udders. His carousels sometimes carried only one type of animal, so a machine occasionally was populated entirely with rabbits, circa 1905. *Ventura collection.*

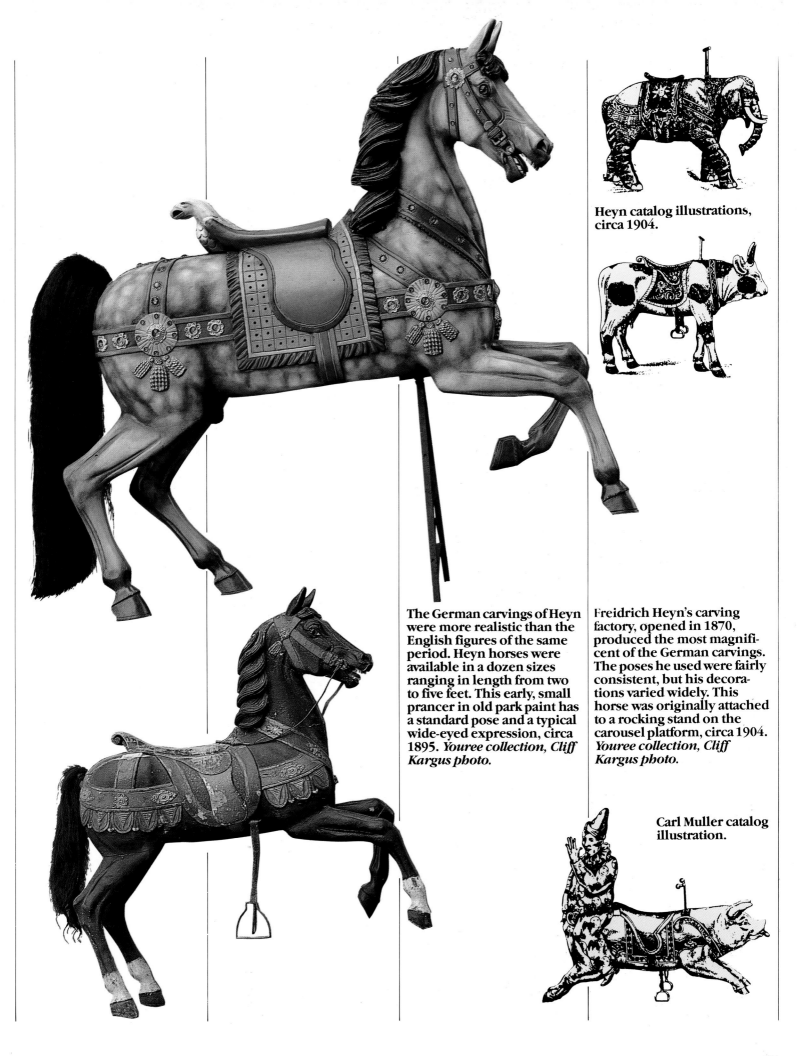

Heyn catalog illustrations, circa 1904.

The German carvings of Heyn were more realistic than the English figures of the same period. Heyn horses were available in a dozen sizes ranging in length from two to five feet. This early, small prancer in old park paint has a standard pose and a typical wide-eyed expression, circa 1895. *Youree collection, Cliff Kargus photo.*

Freidrich Heyn's carving factory, opened in 1870, produced the most magnificent of the German carvings. The poses he used were fairly consistent, but his decorations varied widely. This horse was originally attached to a rocking stand on the carousel platform, circa 1904. *Youree collection, Cliff Kargus photo.*

Carl Muller catalog illustration.

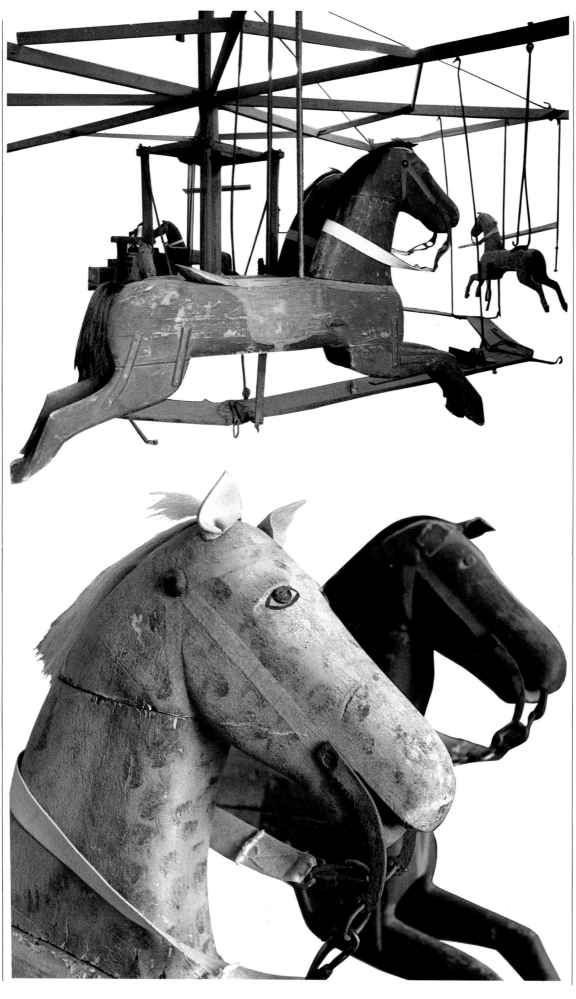

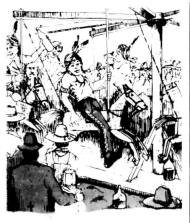

Traveling carnivals crossed the Allegheny Mountains as early as 1828, but when the first one visited rural America is no longer known. Historians usually ignore such non-political details as merry-go-rounds, but this particular one was commemorated because its installation in 1831 coincided with the arrival of several hundred Seneca Indians at Dayton, Ohio. The Indians, who were being sent to a western reservation, camped near the city. They were enthralled, not by Dayton or its ill-mannered, suspicious residents, but by the "flying horses" in a traveling show. Within a day or two, a combination of the Indians' excessive intake of liquor and high spirits aroused open antagonism in their rivals for the carousel, the people of Dayton. The ensuing brawl between the two groups of fans led to the destruction of the merry-go-round. *Montgomery County Historical Society, Don Moruzzi illustration.*

Hand-cranked "flying horses," handmade by woodworkers and wheelwrights with little experience carving large carousel figures, were typically primitive. This one was built on Maryland's eastern shore, circa 1860-1870. *Nassau County Museum, New York.*

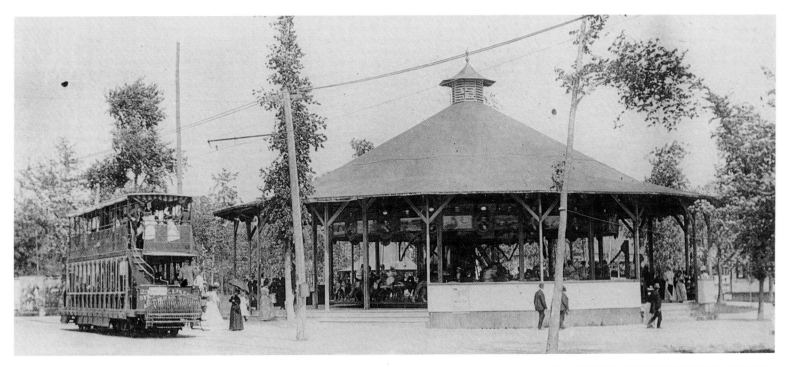

The American carousel industry developed slowly until the advent of the electric trolley. In cities all over the country, trolley lines took families with newly found leisure time to seaside destinations and amusement centers that began to appear. The Looff carousel above was photographed in 1900 at Syracuse. *Wilda Taucher photo.*

Americans at the turn of the century were eager for entertainment. They quickly turned beachfront resorts into wildy successful ventures. Looff, an early carousel builder and amusement park entrepreneur, owned several amusement centers, including this pier at Ocean Park, California, circa 1910. *Wilda Taucher photo.*

This postcard shows the popularity of New York's Coney Island. The center of the amusement industry, Coney Island boasted more than 20 carousels at one time.

Tastes in leisure pursuits were changing, too. People exposed to the horrible reality of the Great War may have demanded amusement rides with more death-defying thrills than the carousels of a simpler age could provide. When television became available to the general population in the 1950s, amusement parks themselves began to close from neglect. Americans began to seek their entertainment in the home.

A revival of interest in carousels in the early 1970s, partly inspired by a single book, *Pictorial History of the Carousel* by folk art historian Frederick Fried, ferreted out abandoned machines stored in barns and warehouses. Around this time the National Carousel Association and American Carousel Society formed. Many carousel figures have been reclaimed and restored to their former beauty since that time. With more value placed on the few remaining carousels in existence, a whole new generation has the opportunity to ride a colorful wooden horse and feel the carousel magic.

High-quality carvings popular with collectors today were produced by relatively few artists. During the six or seven decades that American carousels were being built, the men who are now listed in the carousel unofficial Hall of Fame created three general styles that embody the American effort.

Coney Island carousels were the flamboyant, stylized ones. Philadelphia style was fanciful but realistic. County Fair, the country cousins, traded cumbersome adornment for simplicity and greater mobility.

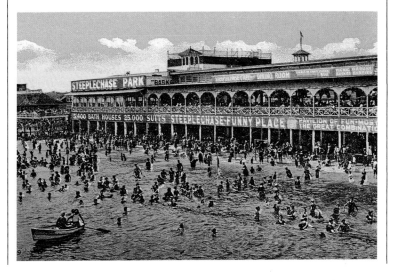

Remember Your First Thrill of
AMERICAN LIBERTY

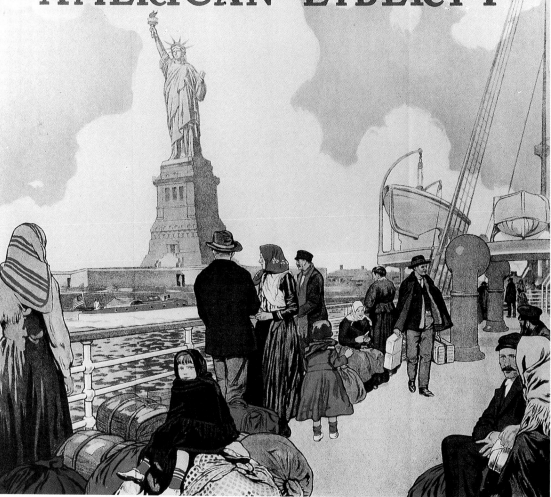

A wave of immigrants from 1870 to 1910 brought skilled craftsmen from all over Europe to America's shores. Unable to find employment in their traditional fields of furniture carving, cabinet making and architectural woodworking, many sought employment in New York's booming amusement industry, which flourished in the Coney Island neighborhoods. *New York Historical Society.*

Immigrant carvers immediately adopted patriotic themes, such as the flag-draped saddle on this early Dentzel lead horse from Watkins Regional Park in Largo, Maryland, circa 1905. *Gary Jameson photo.*

Many carving companies produced not only carousels, but also show fronts and ornate circus wagons. The calliope was made by Bode Wagon Works, circa 1917. *Collection of Henry Ford Museum and Greenfield Village.*

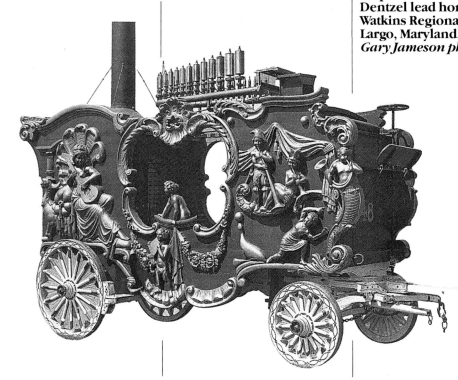

20

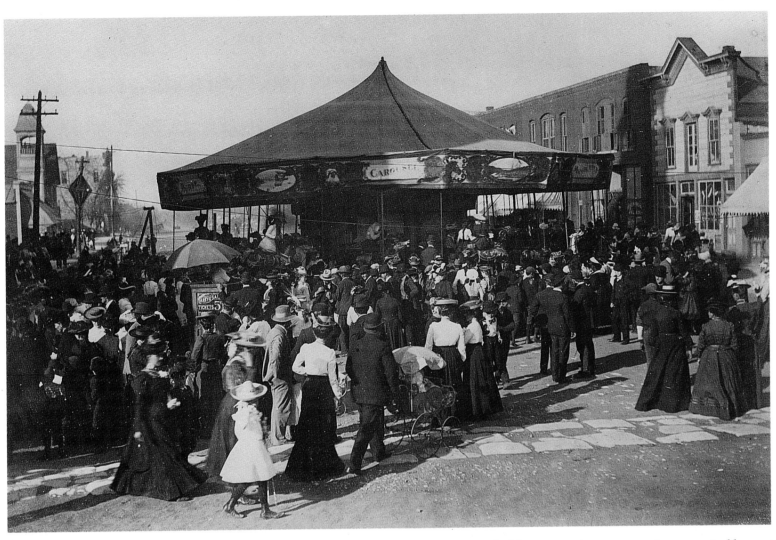

These three categories make up a convenient way to group carousels and the people who made them. As guidelines for tracing the development of American carousels, they are always colorful, though often useless. Carousel builders were not concerned with categories, but with creating functional devices of beauty.

Carvers followed basic patterns when making the figures commissioned for each carousel. The heads were reserved for the most talented carver and from this practice the expression "head man" was coined to refer to the person in charge. Otherwise, the artists were encouraged to decorate saddles and trappings as they pleased—providing the customer's wishes were carried out. This freedom produced some amazingly creative carousel treasures. Such independence within the factories contributed to the rich variety in styles and carving characteristics but it also has made identification of existing carousel figures difficult.

Artists occasionally carved their signatures on the lead horse, but other identification was rarely added to the figures. Most carousels displayed a name panel, but a sale or the effects of weather and time eventually caused it to be replaced or painted over.

Rural America, lacking waterfront resorts and transportation, was hungry for entertainment. Traveling carnivals that roamed the back roads of the Midwest were eagerly supported by the people of less-populated areas, circa 1902. *Dickenson County Historical Society, Kansas.*

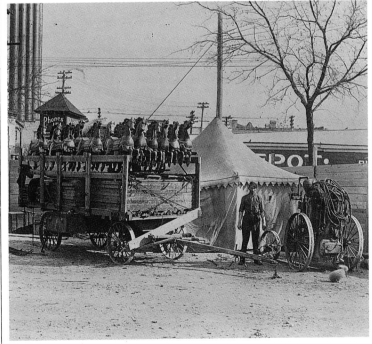

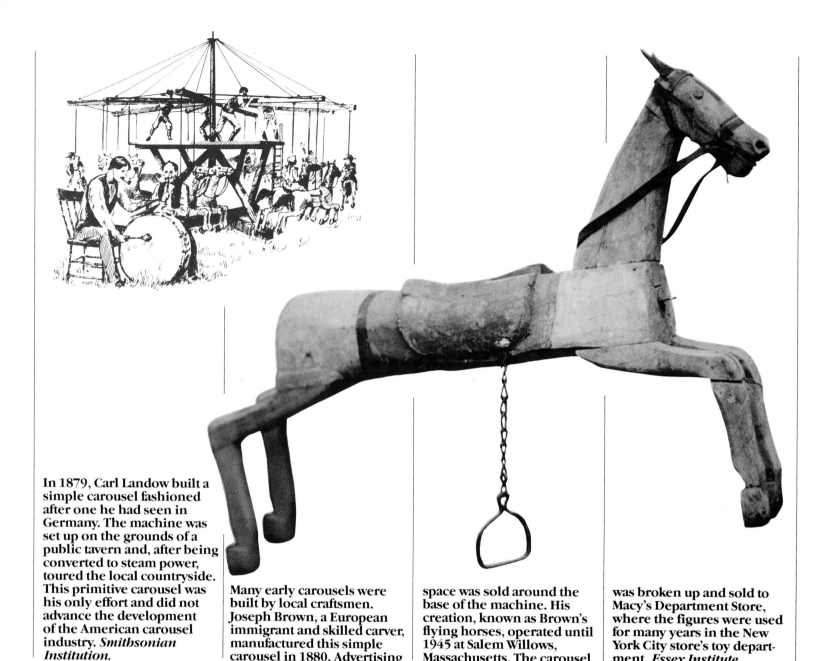

In 1879, Carl Landow built a simple carousel fashioned after one he had seen in Germany. The machine was set up on the grounds of a public tavern and, after being converted to steam power, toured the local countryside. This primitive carousel was his only effort and did not advance the development of the American carousel industry. *Smithsonian Institution.*

Many early carousels were built by local craftsmen. Joseph Brown, a European immigrant and skilled carver, manufactured this simple carousel in 1880. Advertising space was sold around the base of the machine. His creation, known as Brown's flying horses, operated until 1945 at Salem Willows, Massachusetts. The carousel was broken up and sold to Macy's Department Store, where the figures were used for many years in the New York City store's toy department. *Essex Institute.*

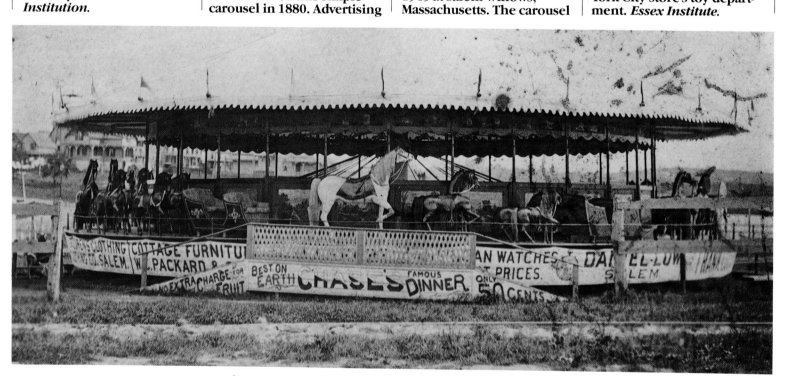

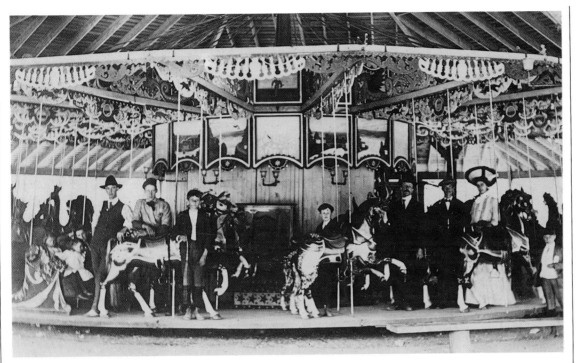

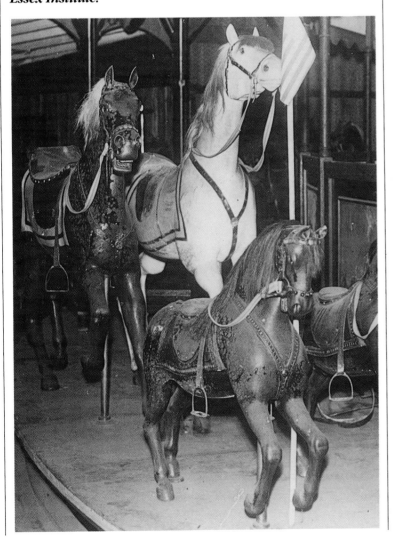

Established companies were not the only carousel builders. The Long family of Philadelphia constructed eight carousels in the early 1900s using figures supplied by carvers such as Charles Leopole, who later worked with D.C. Muller. Leopole had developed his carving style in the Dentzel factory where he had first worked. In 1904 this carousel, installed in Rochester, New York, was powered by a steam engine and illuminated by carbide gas lamps until electricity was added during the following season. It was moved to Seneca Zoo Park in 1915 and was lost to a fire in 1941. George Long Jr., standing behind the goat, later worked for Philadelphia Toboggan Company. *Merrick B. Price photo.*

Brown's primitively carved figures wore upholstered saddles and, unlike those produced by most other carvers, varied greatly in size. *Essex Institute.*

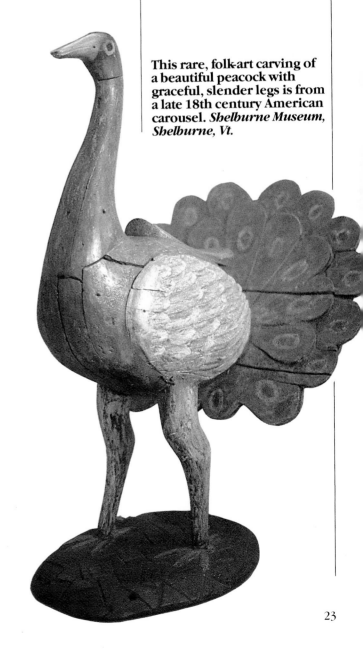

This rare, folk-art carving of a beautiful peacock with graceful, slender legs is from a late 18th century American carousel. *Shelburne Museum, Shelburne, Vt.*

The carousel companies brought together many creative craftsmen who were recent immigrants from all over Europe. Russia especially provided many of the finest carvers. Language differences, creative egos and strong personalities added to the excitement on the carousels and in the factories. Protesting shouts and raised voices often filled the air, but the arguments were never serious, according to Charles Rutter, a carousel painter. When he was a small boy, Rutter was at home in the Dentzel factory in Philadelphia. It was in that shop that he learned to paint carousels at the elbow of his grandfather, Angelo Calsamilia, a well-known and honored carousel painter. Rutter has memories of traveling with William Dentzel to amusement parks, where the factory owner would reach in his pocket and pick out the nickels—never any other coin—to keep the child busy while Dentzel tended to business.

Carvers often migrated from one company to another and back again for a variety of reasons. This mobility and the freedom to experiment and express individual talents in the factories trampled distinctive differences among the three major carving styles. In one shop four carvers might have produced four different styles of horses. This blending was especially prevalent in the Coney Island and Philadelphia-style factories that produced the large park machines.

Coney Island style emerged from the dazzling influence of the famous water-front amusement park in New York that bears the same name. Charles Looff pioneered the style and remained a competent carver and competitor in the carousel industry for 35 years.

Philadelphia style grew out of the imaginations of talented craftsmen who immigrated to the City of Brotherly Love. Gustav Dentzel, credited with installing the first stationary carousel, insisted on quality from his workers and produced what is considered the most well-proportioned horses. He, and his sons after his death, produced carousels until 1928, a span of 56 years.

Simple and hard-working, the County Fair-style carousels trace their history to Kansas and North Tonawanda in upstate New York. Charles Dare, the founder of the style, however, concentrated on building portable machines in New York City. Although his carousels never attained the sophistication of other builders, Dare was a pioneer and an inspiration to those who followed his lead.

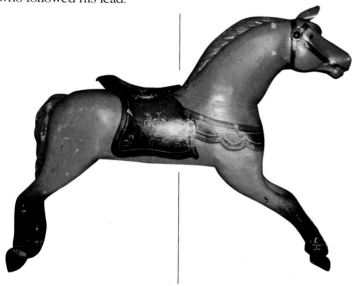

STEAM MERRY-GO-ROUND

A DELIGHTFUL EXERCISE FOR YOUNG AND OLD.

LATEST IMPROVED DESIGNS
STRONG AND ATTRACTIVE
SIMPLE IN OPERATION.

MANUFACTURED BY

NORMAN & EVANS

FOOT OF COMBINED LOCKS. LOCKPORT, N.Y., U.S.A.

COURIER LITHO CO. BUFFALO. N.Y.

A simple North Tonawanda style horse was produced by the Norman and Evans Company. This figure was originally on a carousel in San Francisco's Golden Gate Park, circa 1900. *Chatty Collier Eliason photo.*

Dozens of companies started producing steam riding galleries including Bungarz Steam Wagon and Carrousele Works. Owen and Margeson, among others, built machines on a small scale. Norman and Evans, boiler makers in Lockport, New York, began manufacturing carousels in the mid-1890s and continued for several years. Their machines were close copies of the ones made by Armitage Herschell Company. At the height of their success, Norman and Evans produced up to 75 carousels per year. Their 40-foot merry-go-round with 24 horses and four chariots could be powered for two weeks by one ton of soft coal. The company catalog claimed, "No fair, park, or pleasure resort is complete without a Merry-Go-Round. The receipts for a single day are sometimes as high as $300." The company closed following the death of William Norman in 1905. *Poster from Bob and Tina Veder.*

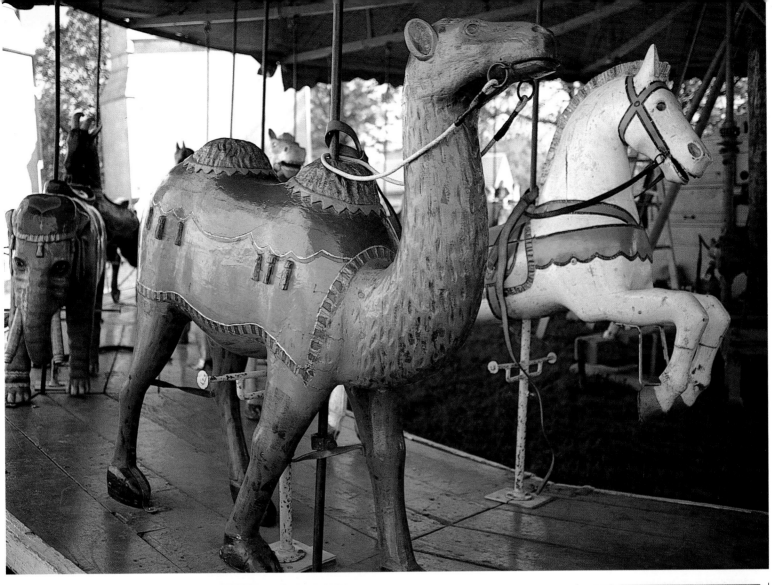

United States Merry-Go-Round Company produced naive but charming carvings of not only horses, but also menagerie figures, including goats, camels, elephants, giraffes and lions. One of their known surviving machines operates at the National Cathedral at Washington, D.C.

Cincinnati, Ohio, was home to several carousel makers, beginning in 1892 with the J.P. Marqua Company and the American Carouselle and Toy Company in 1893. Neither company produced carousels that have survived. In 1909, Gem Novelty Company changed its name to United States Merry-Go-Round Company. It built simple portable carousels ranging in price from $400 for a simple hand-powered machine with eight horses and two chariots to a $2,500 machine with a 36-foot diameter carrying 36 horses and four chariots. The company ceased production in 1917 when the factory began making war materials.

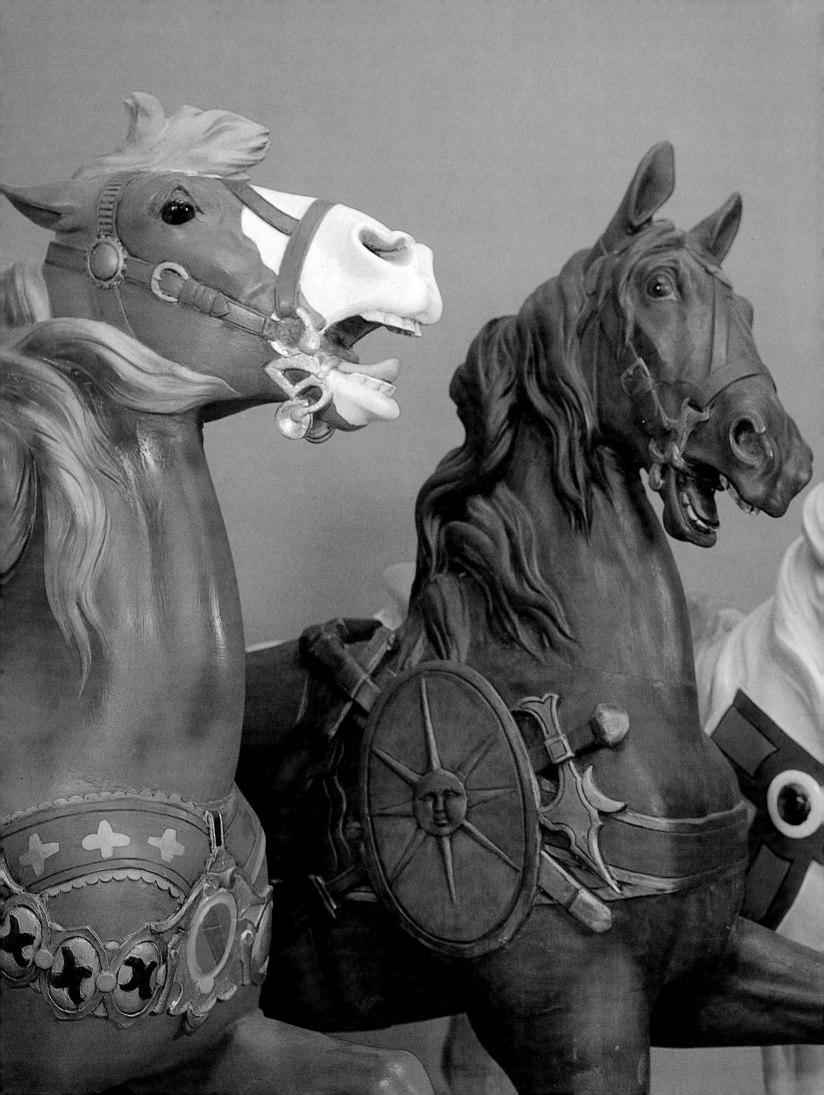

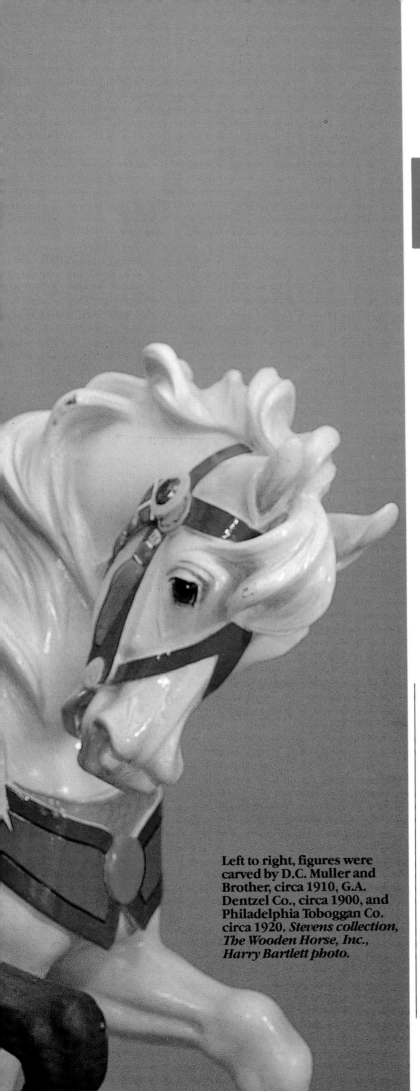

Left to right, figures were carved by D.C. Muller and Brother, circa 1910, G.A. Dentzel Co., circa 1900, and Philadelphia Toboggan Co. circa 1920. *Stevens collection, The Wooden Horse, Inc., Harry Bartlett photo.*

The
PHILADELPHIA
Style

Philadelphia-style horses were realistic. From the veins carved into perfectly shaped heads to the careful positioning of each well-formed leg, the wooden reproductions mimicked real animals. Natural poses captured the toss of a mane or a powerful gallop with the faithfulness of a stop-action camera. If it were possible, the carvers would have added the smell of the stable and a high-pitched whinny to their creations.

In the beginning American carvers imitated European designs. Carousels on both sides of the Atlantic carried mostly horses with a variety of menagerie animals, such as rabbits, chickens, tigers and giraffes, completing their herds. Medieval trappings were draped over horses that carried riders past the brass ring, a symbol of jousting expertise. As in the machines in Europe, animals were attached to a suspended platform. Carvers and entrepreneurs who introduced America to the carousel gained their experience from or were exposed to continental amusement rides, but they developed an all-American variety.

The Dentzel factory and Philadelphia Toboggan Company have been long remembered and highly praised in carousel history. These two Philadelphia-style factories employed many of the principal carvers who are still honored today.

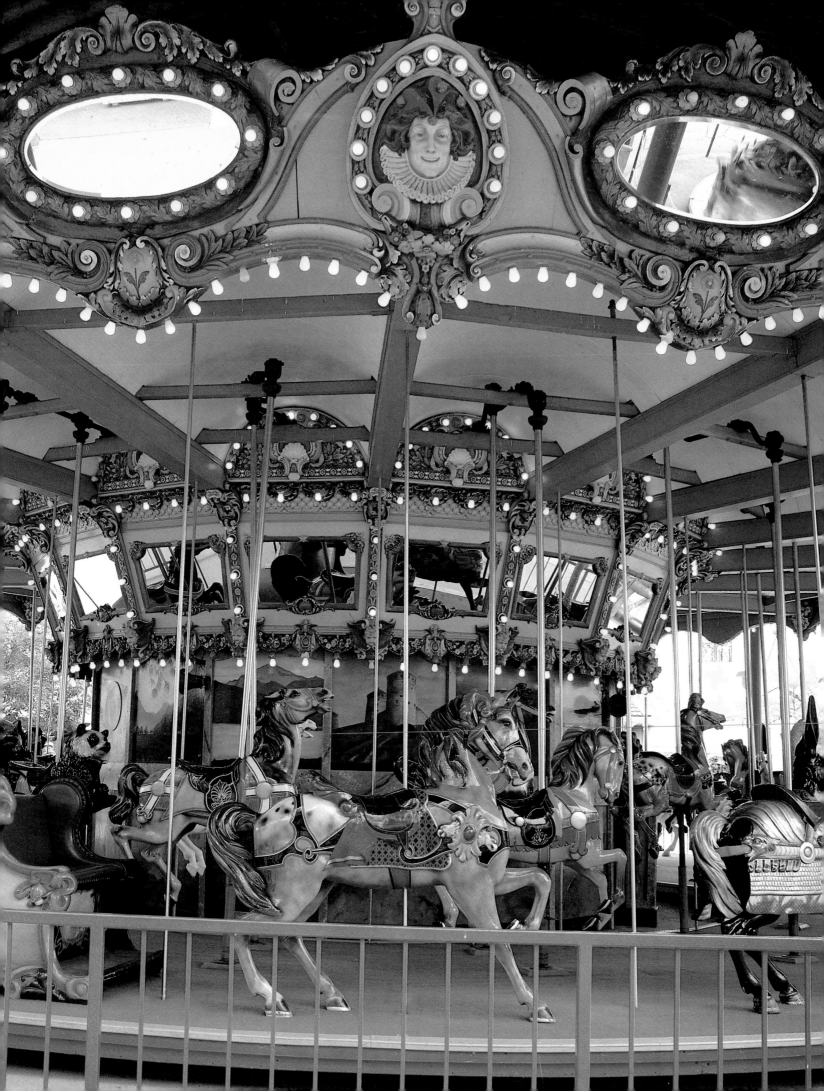

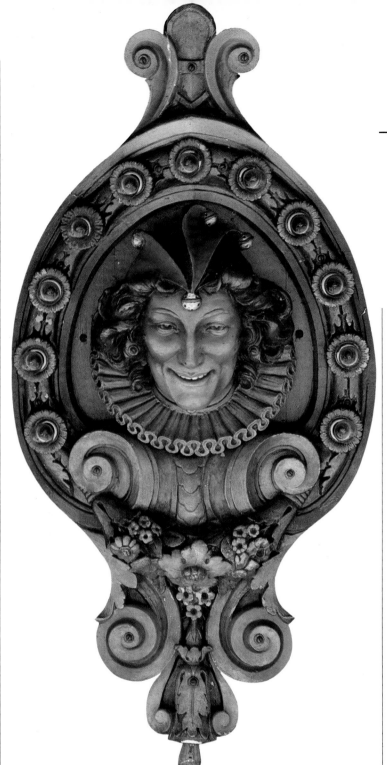

GUSTAV & WILLIAM DENTZEL

The patriarch of the Dentzel factory, Gustav A. Dentzel, immigrated to Philadelphia in 1860. The 20-year-old had carved carousels for his father in Germany and he soon began practicing that trade in America.

Seven years after landing in the new country, Dentzel changed the nameplate of the cabinet-making shop he started to G.A. Dentzel, Steam and Horsepower Caroussell Builder, and his lifelong dedication to carousels officially began.

Before embarking on his manufacturing venture, Dentzel toured the countryside with a small, portable carousel he had made. During his travels he discovered people were eager to ride his galloping wooden mounts.

Dentzel also learned a lesson about his adopted country. At Richmond, Virginia, the group of eager boys who ordinarily would have struggled to be first to ride the carousel threw stones at the machine instead. Eventually a spectator told Dentzel it was the music and not the carousel that irritated the crowd. In the South "Marching Through Georgia" was not a popular tune. From then on Dentzel was more careful about the music he selected for his band organs.

Dentzel continually experimented with variations on the standard carousel. He followed the development of energy sources, using horses at first and switching to the steam engine. He built a two-story ride, but soon tore it down and used the parts for other carousels. His double-decker machine created quite a sensation in 1890 when it first appeared in Atlantic City, New Jersey, but loading and unloading passengers took so long the contraption was unprofitable.

Jester-head shields created a crown for Dentzel's carousels. They were made of reinforced plaster and covered the overhead drive mechanisms, circa 1925. *John Goldy photo.*

One of the most magnificent of all American carousels, Kiddieland Carousel in Cedar Point, Ohio, was built by the Dentzel company, circa 1915. *John Goldy photo.*

Gold-leaf cherubs decorated the center pole housing of Dentzel's later carousels, circa 1920. *Susan Foley photo.*

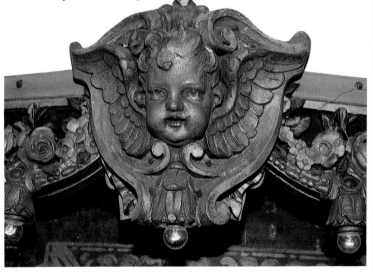

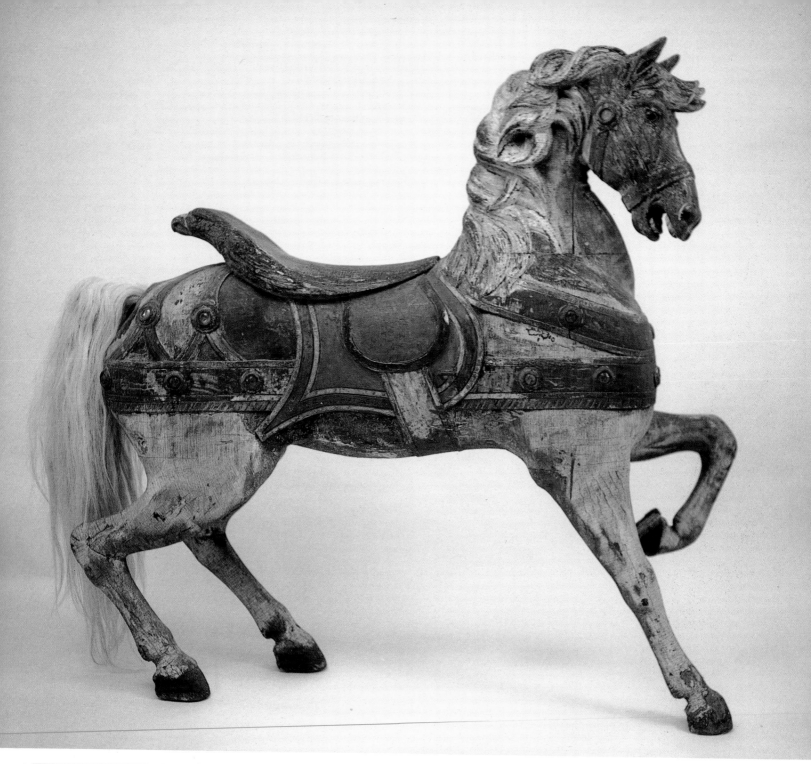

These outside row standers show characteristics of horses carved in the Dentzel factory beginning about 1890. This style, with its clumsy Roman nose, was abandoned when more proficient carvers joined the company. *Palace Amusements, Asbury Park, New Jersey.*

All early carousels had stationary figures firmly attached to the rotating platform. Dentzel adopted large standers in a static pose, which went through several evolutions. This beautiful horse, wearing old paint and a traditional eagle-back floating saddle, was given the unusual honor of carrying the company signature on the lower left portion of its saddle blanket, circa 1880. *Marianne Stevens collection, The Wooden Horse, Inc., Harry Bartlett photo.*

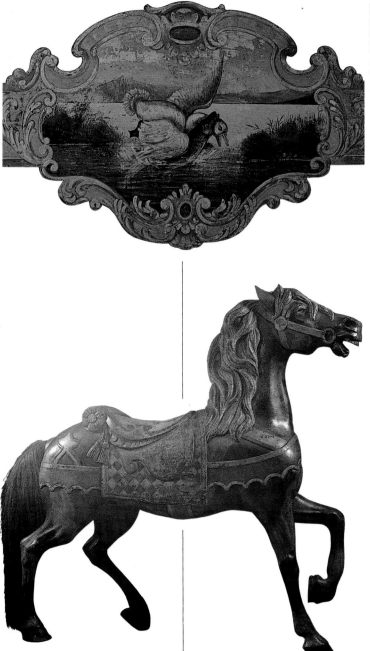

This 3-foot-high painting on wood, like most early scenery panels, depicted an animal scene. This type of panel was used from 1890 to 1910.

This beautiful stander in original factory paint has one ear forward and one backward. It is a transitional carving for the "flop-eared" style. The Dentzel machine, where this horse was found was last operated in Dover, Pennsylvania, circa 1890. *Daniel collection.*

Carved wooden shields about 2 feet high covered the joints of the carousel and hung between the scenery panels on early Dentzel carousels, circa 1890. *Veder collection.*

A carving attributed to Daniel Muller, this prancer in old paint was a popular figure on most Dentzel carousels from 1890 until the advent of the jumping mechanism, circa 1905. *Perron collection, Susan Foley photo.*

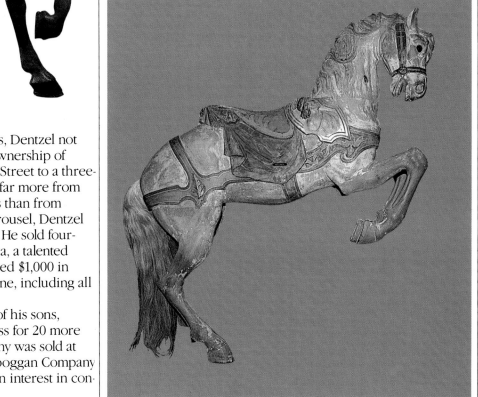

Like other successful carousel manufacturers, Dentzel not only produced the devices, but also retained ownership of some. When he moved his factory from Brown Street to a three-story building in Germantown, he was making far more from his operations in parks and amusement centers than from carousel manufacturing. For a three-abreast carousel, Dentzel received as much as $18,000 in the early 1920s. He sold four-abreast machines for $24,000. Angelo Calsamilia, a talented painter in the Dentzel factory for 20 years, earned $1,000 in 1927 for painting an entire three-abreast machine, including all the animals and the scenery panels.

The carousel pioneer died in 1909, but one of his sons, William, successfully steered the family business for 20 more years. After William's death in 1928, the company was sold at an auction to a competitor, the Philadelphia Toboggan Company. At that time, none of the family members had an interest in continuing the carousel tradition.

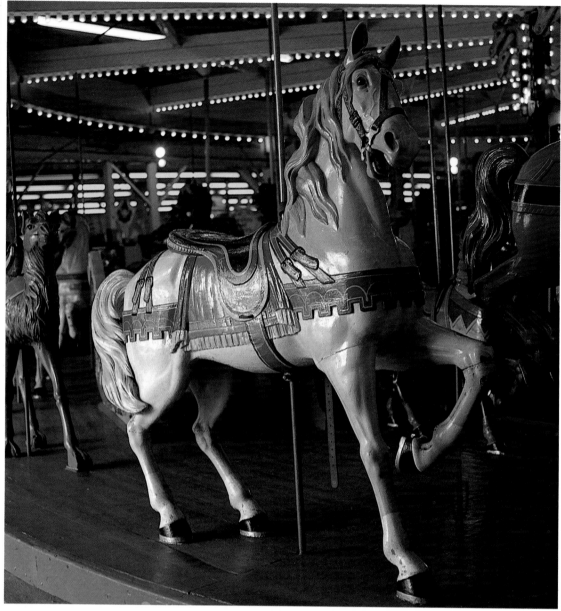

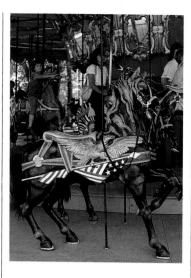

Dentzel usually had four to six thoroughbreds in the outside row. The American flag horse here was one of his most popular in this particular style. These noble figures were created by the Muller brothers, who began carving for Dentzel in the late 1890s. *Great Escape, Lake George, New York.*

This thoroughbred, a Muller creation, exhibits a startled but more realistic expression than is found on Dentzel's earlier outer-row horses. These horses were carved with many exciting mane positions and a wide variety of trappings, some very ornate. *Casino Pier, Seaside Heights, New Jersey.*

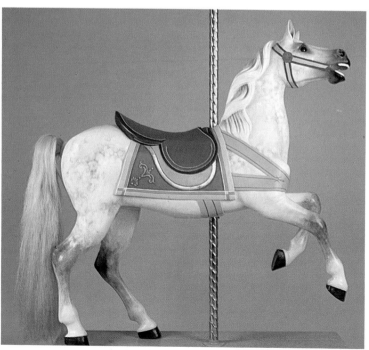

The *mare* was one of Dentzel's most popular inner-row figures. This beautifully proportioned prancer has a delicate grace and charm, circa 1900. *Restoration by Tony Orlando.*

The Dentzel *mare* was carved with simple trappings but with a variety of mane and facial expressions, undoubtedly depending on the skill and disposition of the carver. This lovely figure has a refined head and richly carved mane, circa 1900. *Children's Museum, Indianapolis, Indiana.*

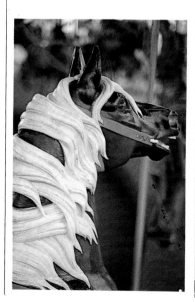

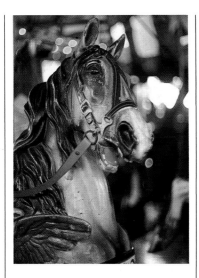

Daniel Muller had developed as a highly noted artist by 1900. His skill and sensitivity are clearly evident in the face of this noble carving.

This dark Dentzel creation wears imposing medieval gear — a sword and ax crossed under a shield — and thick ribbons. Like all of the stationary horses on Dentzel's early carousels, its tail is made from real horse hair to add motion and excitement. Dentzel placed several thoroughbreds, a popular class style, in his outside row of standers. This thoroughbred was last on a stationary machine in Johnstown, Pennsylvania, circa 1900. *Stevens collections, Harry Bartlett photo.*

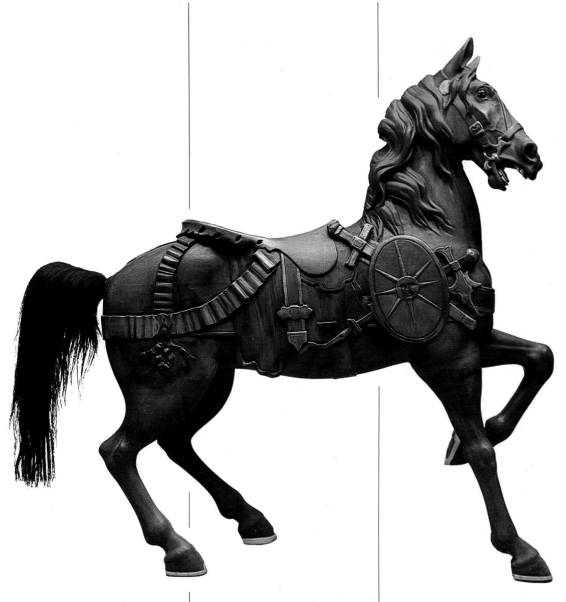

William Dentzel, or "Hobby-Horse Bill," was raised amid wood chips and the clamor of a band organ. In a 1938 bulletin called "National Association of Amusement Parks" Lamarcus A. Thompson, the man who built the "Switchback"—the first American roller coaster—wrote about visiting the Dentzels at a carousel installed in Atlantic City, New Jersey, in 1876.

Down by the sands at Atlantic City, I found a baby in a soap box. The box was strapped on the side of a horse next to the center pole of a Merry-Go-Round. The horse was pulling the Merry-Go-Round. In the box was little Billy Dentzel. Bill's mother was selling tickets, his father was taking up the tickets, watering the horse and looking after the Merry-Go-Round. Not only the device but the real estate on which he was riding around in the soap box was purchased by his parents at $19,000 and cost them a great struggle in making the payments as they fell due.

The thoroughbred was never carved in the jumping position. This one was modified to fit a Mangels mechanism, circa 1900. *Indianapolis Children's Museum.*

As the eldest son, William was first in line to take over the family business. He learned to carve in the factory, but after assuming control of the company he laid down his chisel for good. His brother Edward Paul continued the carving tradition, and together the sons carried on their father's commitment to quality.

William, who enjoyed life to its fullest, favored large ornate carousels. He frequently traveled to Europe for health and business and was well-liked among his associates. When he died, the Philadelphia Inquirer printed a respectful eulogy of the "Merry-Go-Round King."

A king is dead—is the author, painter, sculptor or orator who has given pleasure to millions of adult minds any more entitled to homage than he who has brought delight to millions of children's minds? Does it matter, after all, that the medium he employed was nothing more than a ring of painted hobby horses, to which a lot of laughing, shouting youngsters clung madly as they swung around a pole in dizzy circles? Merry-Go-Round King is no slight sobriquet to be remembered by.

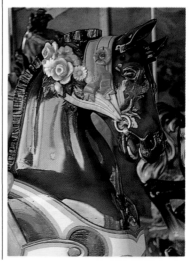

These roached-mane horses from the Kiddieland Carousel at Cedar Point, Ohio, were recarved with more elaborate embellishment of roses, eagles and tassels by Daniel and Alfred Muller in 1917. The owner, who wanted fancier figures, requested these additional touches, but they were not usually used on Dentzel figures, circa 1905. *John Goldy photo.*

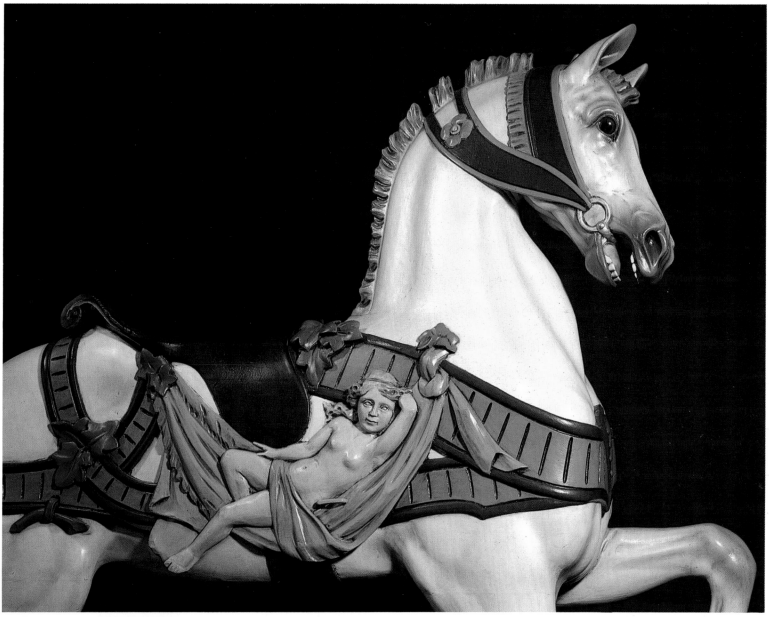

This horse is part of a carousel at Fleischaker Zoo, San Francisco, California, circa 1921.

Two to four of the popular roached-mane standers were usually placed on the outside row of late Dentzel carousels. They were made in two sizes, with the smaller figures placed in the second row. Though the pose was always the same, the embellishments and secondary carvings, including this sweet reclining nude by Cernigliaro, varied greatly, circa 1920. *Abbott collection, Robert Manns photo.*

Outside-row figures were the largest and most elaborately carved. Bell-laden harness straps decorate this horse. Its original colorful paint has been muted by layers of yellowing varnish, circa 1921. *Glen Echo Park, Maryland.*

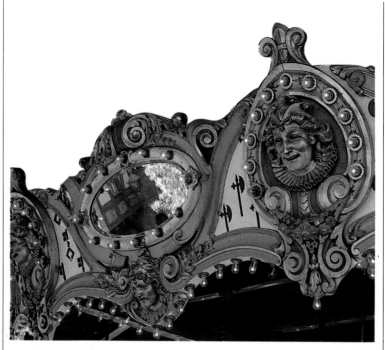
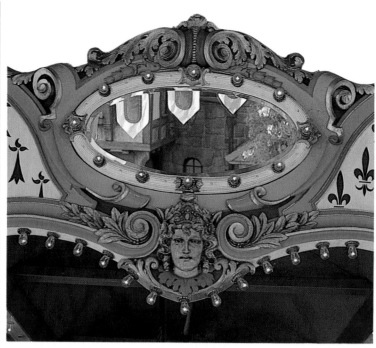
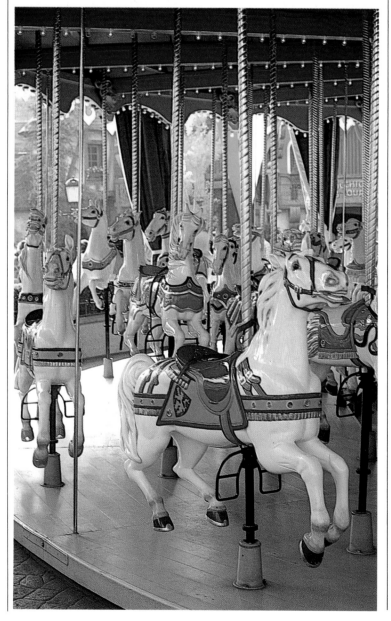
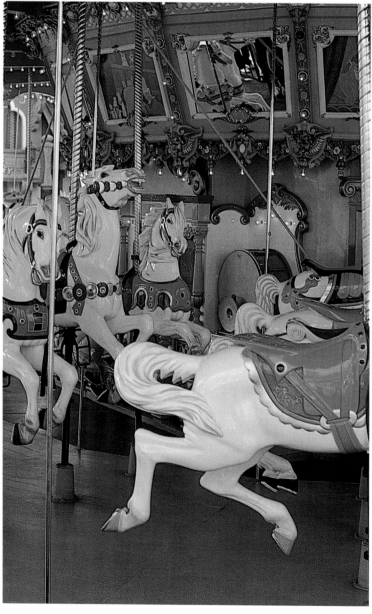

Disneyland's grand Dentzel machine has been modified to include figures carved by Carmel, Stein & Goldstein, and Philadelphia Toboggan Company. The outside-row standers were converted to jumpers. The center figure in the horse panorama is a beautiful carving by Daniel Muller. The wild-maned jumper is one of only five known to exist. Originally it was a second-row horse, since all Dentzel carousels had stationary figures on the outside row. Popular jester shields and mirrored panels crowned Dentzel's carousels. The painted, molded-plaster segments camouflaged drive mechanisms and steel rods and created a massive, ornate architectural structure for the machines.

At the turn of the century, Dentzel's carousels were in full bloom. The figures were large, handsome reproductions of their natural models. An impressive list of menagerie animals included cats, dogs, roosters, goats, mules, pigs, rabbits, bears, deer, tigers, zebra, giraffes, lions, kangaroos and ostriches.

Shields used to cover joints and the carousel's machinery were elaborately carved. Rounding boards provided large flat areas that were painted with idyllic landscapes, seascapes and human and animal portraits. Usually these panels were made with lightweight wood, but on permanent machines they were usually made from a combination of wood and molded plaster reinforced with burlap.

Development of the electric overhead drive freed the horses from their fixed stance on the carousel platform. Dentzel and many other builders, however, continued to place the immobile standers on the outside row and gave the jumpers free rein in the inner circles. Chariots, such as one seemingly scooped out of an elegant swan, were sprinkled among the zoo of animals on parade.

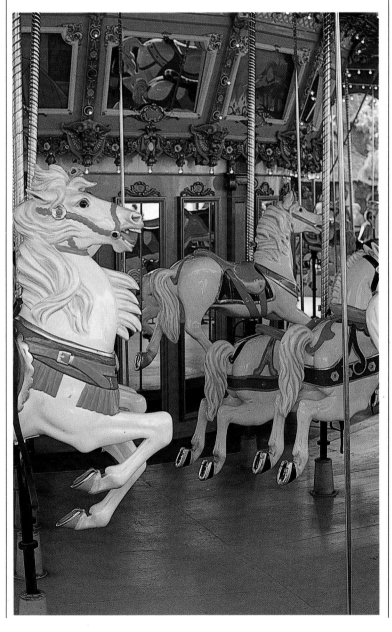

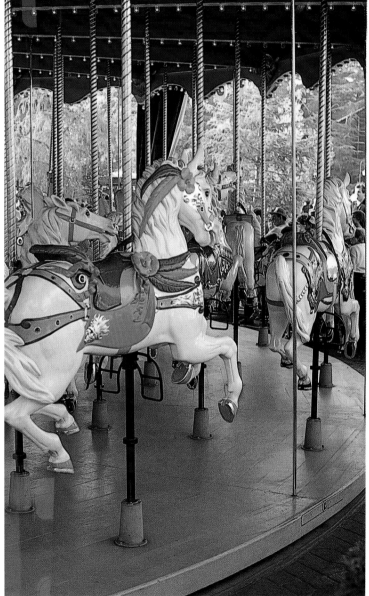

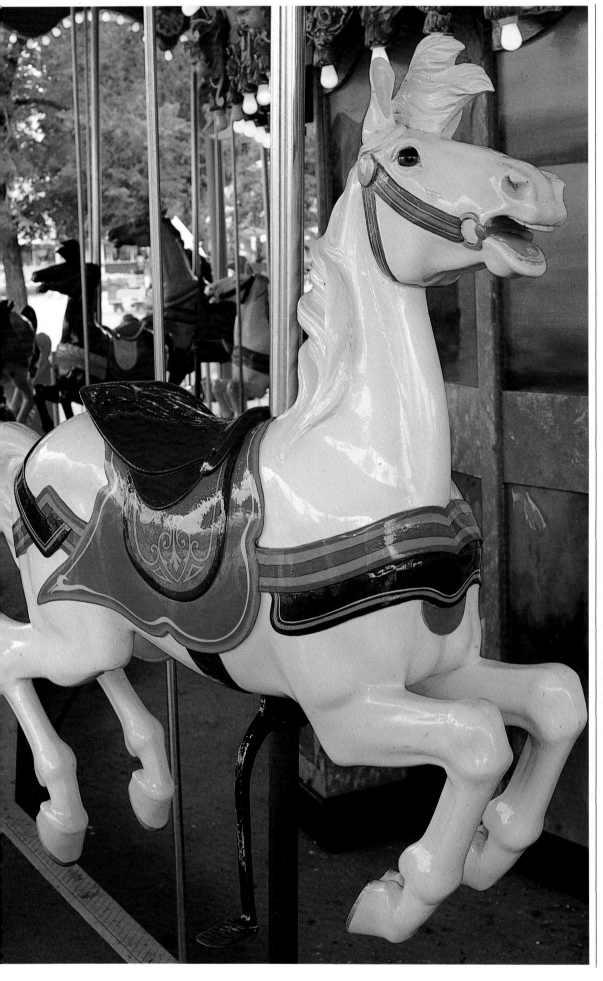

One of Dentzel's most popular, later, inner-row figures was the "top-knot" pony, the name coming from the wind-blown forelock. Trappings varied little on this figure, and they usually had interlocking detail in the flank strap, circa 1920. *John Goldy photo.*

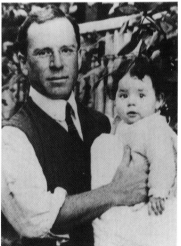

One of Dentzel's most talented carvers, Salvatore Cernigliaro, or "Cherni" as he was known, pictured here with his daughter, Marguerite in 1917. He was responsible for many of the marvelous menagerie figures and ornately decorated horses including the Arabian on the opposite page. *Marguerite Cherny photo.*

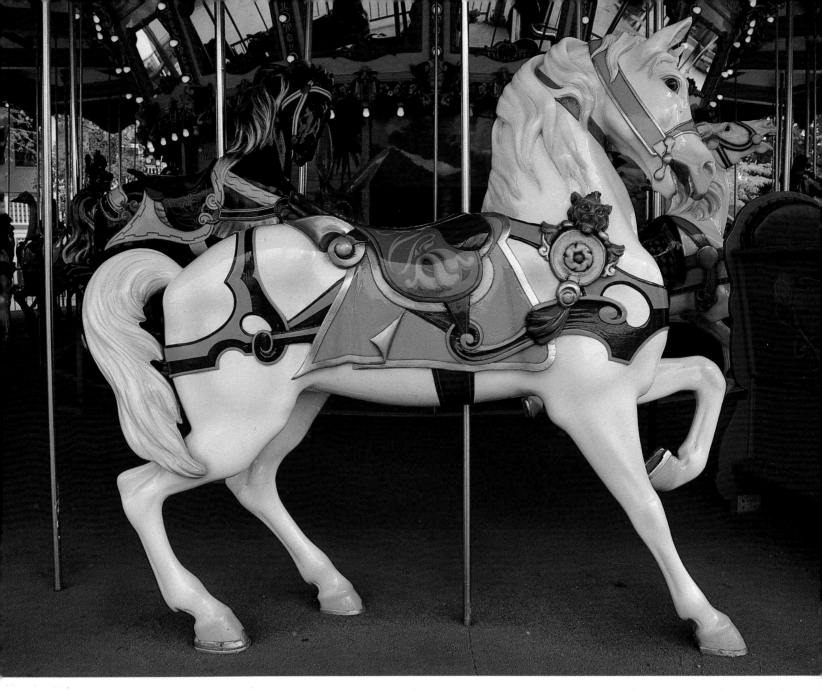

Salvatore Cernigliaro, a cabinet maker from Italy, joined the Dentzel factory in 1903 after immigrating to America. He adapted his natural skill for wood carving to carousel figures and soon earned the position as one of Dentzel's master carvers. He introduced an elegance to the Dentzel figures. "Cherni's" style is evident in this noble, aristocratic head that came to be known as the "sweet faced" or "Arabian" horse. Known for his exceptional decorative carving on the saddles and trappings, Cherni sometimes used playful subjects. He also introduced many of Dentzel's most popular menagerie figures, including bears, cats and rabbits, circa 1920.

Salvatore Cernigliaro, a 23-year-old woodcarver from Sicily, made an impact on the Dentzel horses soon after he was hired in 1903. "Cherni" reorganized the factory's method of carving pre-set patterns. But his biggest contribution was to introduce a series of menagerie animals, notably the Dentzel cat, pig and rabbit.

Cernigliaro's playful animals are still highly regarded today. These friendly creatures assume many different poses. The rabbit sometimes waves, the cat jumps and carries newly caught birds or fish in its mouth. The addition of these animals opened the door for more experimentation and variety of fresh subjects for the artists in the Dentzel factory.

Under the Sicilian immigrant's hand, the Dentzel horse gained more elaborate embellishments. Cernigliaro had worked with one of Italy's foremost craftsmen for about 10 years from the age of 13. During that time he helped decorate palaces, villas and businesses. Fancy harnesses, garlands and drapery appeared on the horses he carved and they became part of the Dentzel heritage.

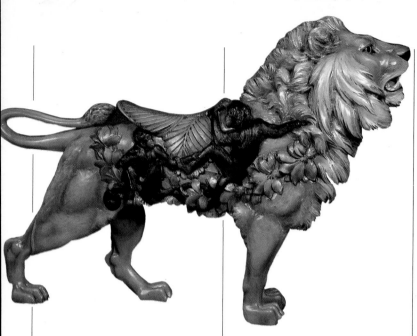

Cernigliaro's playful nature is evident in this wonderful one-of-a-kind carving of two monkeys clutching an unusual palm-leaf saddle. The beautifully restored golden lion comes from Sterling Forest, Tuxedo, New York, circa 1910. *Aten collection.*

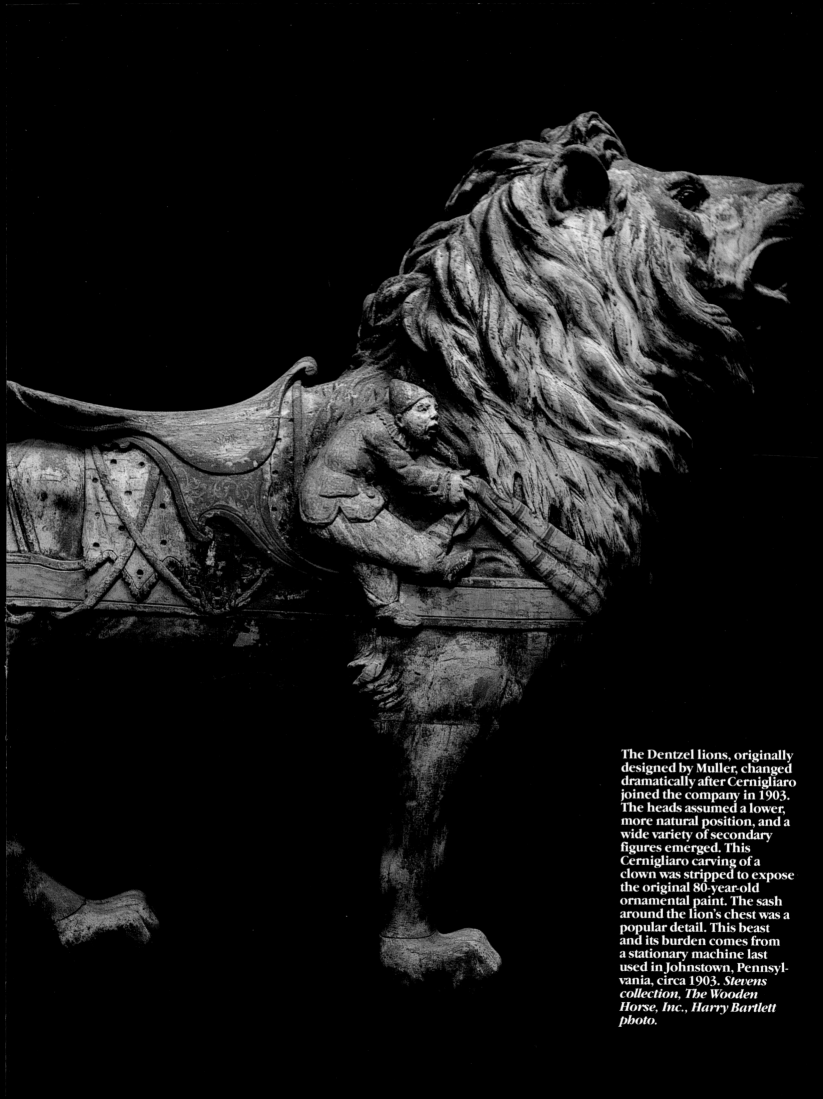

The Dentzel lions, originally designed by Muller, changed dramatically after Cernigliaro joined the company in 1903. The heads assumed a lower, more natural position, and a wide variety of secondary figures emerged. This Cernigliaro carving of a clown was stripped to expose the original 80-year-old ornamental paint. The sash around the lion's chest was a popular detail. This beast and its burden comes from a stationary machine last used in Johnstown, Pennsylvania, circa 1903. *Stevens collection, The Wooden Horse, Inc., Harry Bartlett photo.*

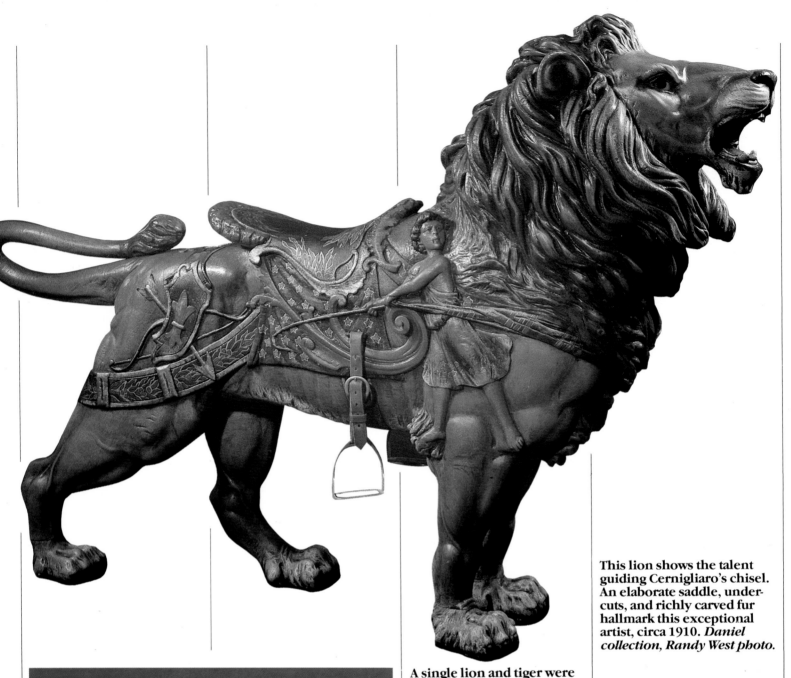

This lion shows the talent guiding Cernigliaro's chisel. An elaborate saddle, undercuts, and richly carved fur hallmark this exceptional artist, circa 1910. *Daniel collection, Randy West photo.*

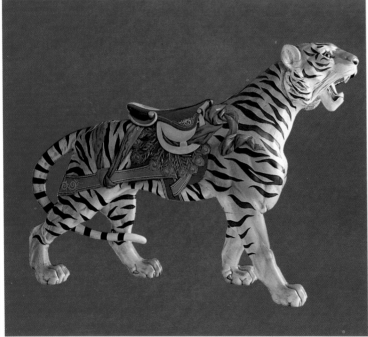

A single lion and tiger were usually on board Dentzel's menagerie machines. There were two tiger poses, the animal with parallel legs, not pictured, was the more rare. *Summit collection.*

Early Dentzel lions had an erect, menacing pose adopted from early German carvings. These lions possibly originated with John Henry Muller, father of Daniel and Alfred, circa 1897.

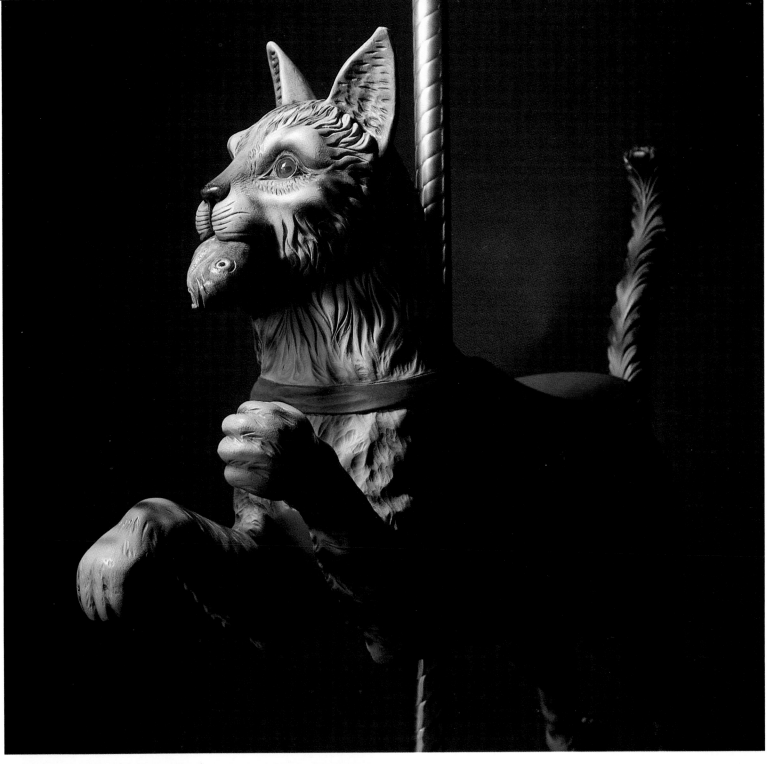

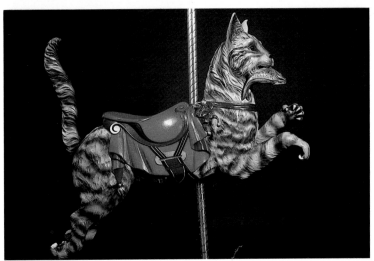

The cat, another Cernigliaro creation, was usually found in pairs on later Dentzel menagerie carousels. Facial expressions on these cats showed a geat deal of variation. *Joy Smith restoration, Abbott collection, Robert Manns photo.*

Every Dentzel cat had something in its mouth — a bird, fish, frog, crab, even a squid. *Tony Orlando restoration, Tim Hunter photo.*

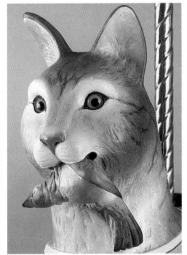

The pigs traveled in pairs, like most of Dentzel's jumping menagerie figures. Though this pig had tusks, it was given a smiling face so as not to scare children.

Most Dentzel carousels were built on special order to customers' specifications and included whatever assortment of figures they requested. The Dentzel pig was popular and was used on almost every menagerie machine. The pose rarely changed and the decorations were usually minimal, but facial expressions varied, circa 1921.

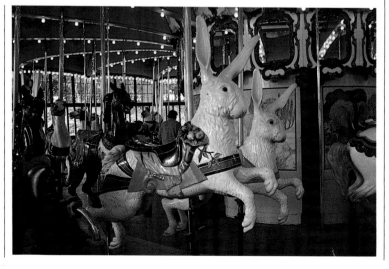

The rabbit was introduced by Salvatore Cernigliaro after the advent of the jumping mechanism in 1907, circa 1921. *Fleischaker Zoo, San Francisco, California.*

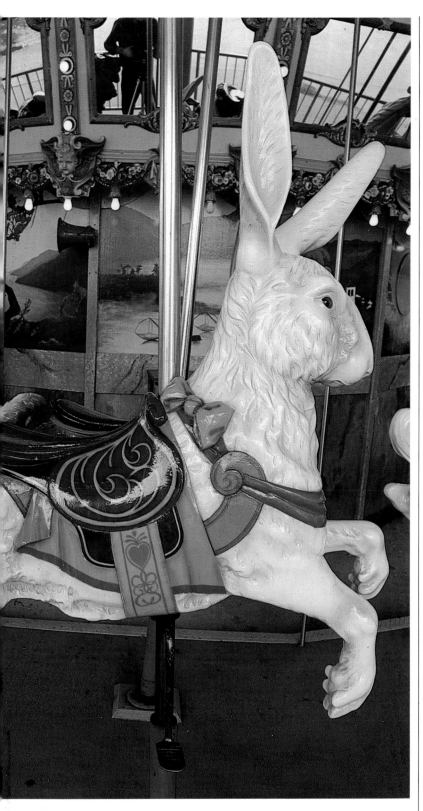

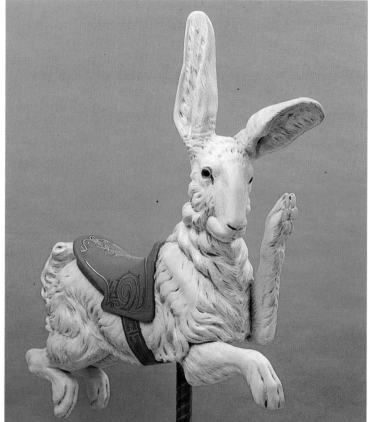

This rare "flirting rabbit," one of only three that exist, was a playful creation by Cernigliaro. When asked why he had the paw raised, he said, "It's the little boy rabbit waving at the little girl rabbit," circa 1915. *Patti Stevens collection, Harry Bartlett photo.*

Rabbits were carved in three different styles. The most common version was an English hare with a small face and the ears in an alert position, circa 1925. *Cedar Point, Ohio, John Goldy photo.*

One of Dentzel's rare canine carvings trots along on the platform at Lake Lansing Park, Michigan. This gun toting dog with a rabbit dangling from the saddle is one of only five of this style known to exist.

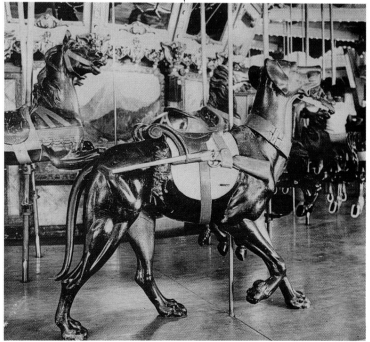

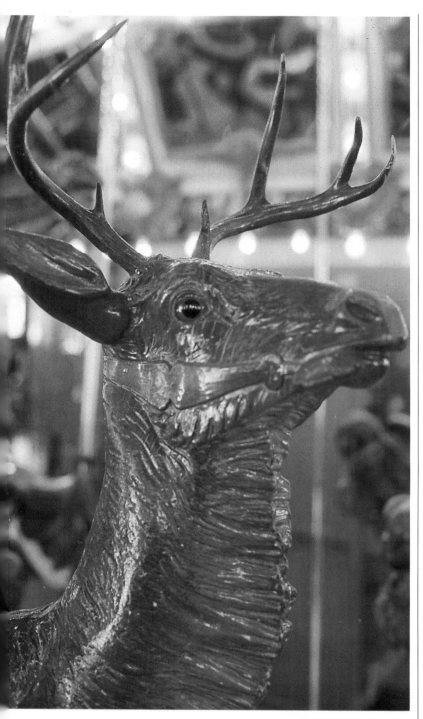

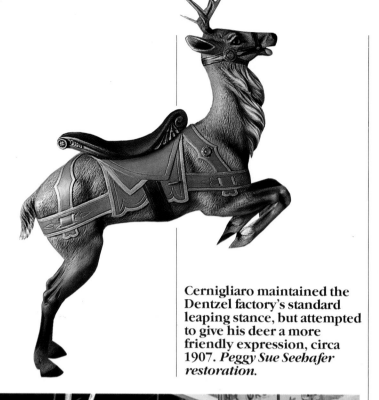

Cernigliaro maintained the Dentzel factory's standard leaping stance, but attempted to give his deer a more friendly expression, circa 1907. *Peggy Sue Seehafer restoration.*

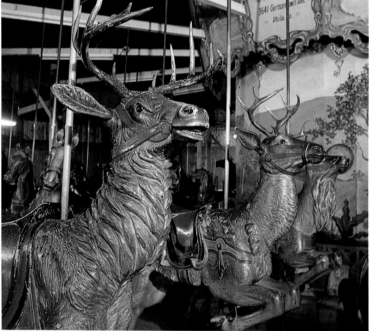

Deer were found on the earliest Gustav Dentzel carousels. Their evolution started with a walking pose, graduated to a leaping figure, as pictured, and were finally modified to jumping figures. The outside-row deer, according to tradition, were richly carved. The amount of fur on the throat gave some an elk-like appearance, circa 1921. *Glen Echo Park, Maryland.*

Above, right are a trio of Dentzel deer with three different expressions. The inner-row figure has a very square nose and mouth, found on early figures. The outer-row carving has a slightly open-mouthed grin and the second-row deer is carved with the traditional face, as seen on the left. This stationary carousel is in very rare, original factory paint and is located in the small town of Pen Argyl, Pennsylvania, circa 1905. *Carlton Strunk photo.*

Original paint on the carousel figures usually followed the laws of nature, but the colors could not be labeled subdued. Many of the horses leaving the Dentzel shop were painstakingly dappled and saddles were pin-striped and highly detailed. Some of the horses were stippled, a technique that makes flat paint look more like real hair. Menagerie characters may have received some unusual color combinations, but the overall theme was realism. Each row on the carousel was alternated by color, a line of dapple gray followed by a line of roan and line of palomino, so that the whirling motion transformed the machine into a panorama of shifting hues.

The mixture of artists dedicated to their craft and the Dentzels' business philosophy was a winning combination. For many years Dentzel animals and carousels have been most valued by collectors and park operators for their individual artistic beauty and the consistent quality of the carving.

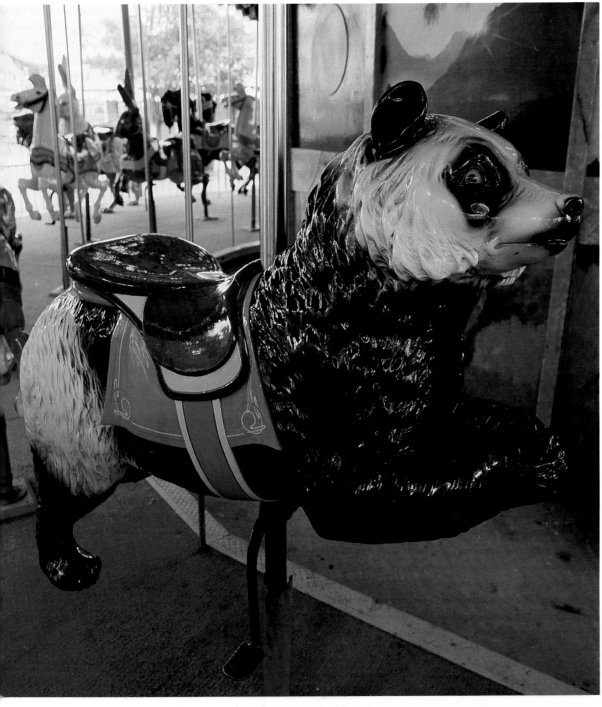

The ostrich was a rare bird in turn-of-the-century America. Its carver may have been inspired by a traveling circus that visited Philadelphia in 1899. Four ostriches were placed on a full menagerie carousel, two by two, on opposite sides of the platform. *Cedar Point, Ohio, John Goldy photo.*

The "honey bear" was a late addition to the Dentzel menagerie. It never became popular with the public compared to the other animals, but it was a charming addition to the carousel and highly prized by collectors. *Cedar Point, Ohio, John Goldy photo.*

"Smiley bear," with its tongue hanging out, was Cernigliaro's attempt to create a jovial figure. *Great Escape, Lake George, New York.*

47

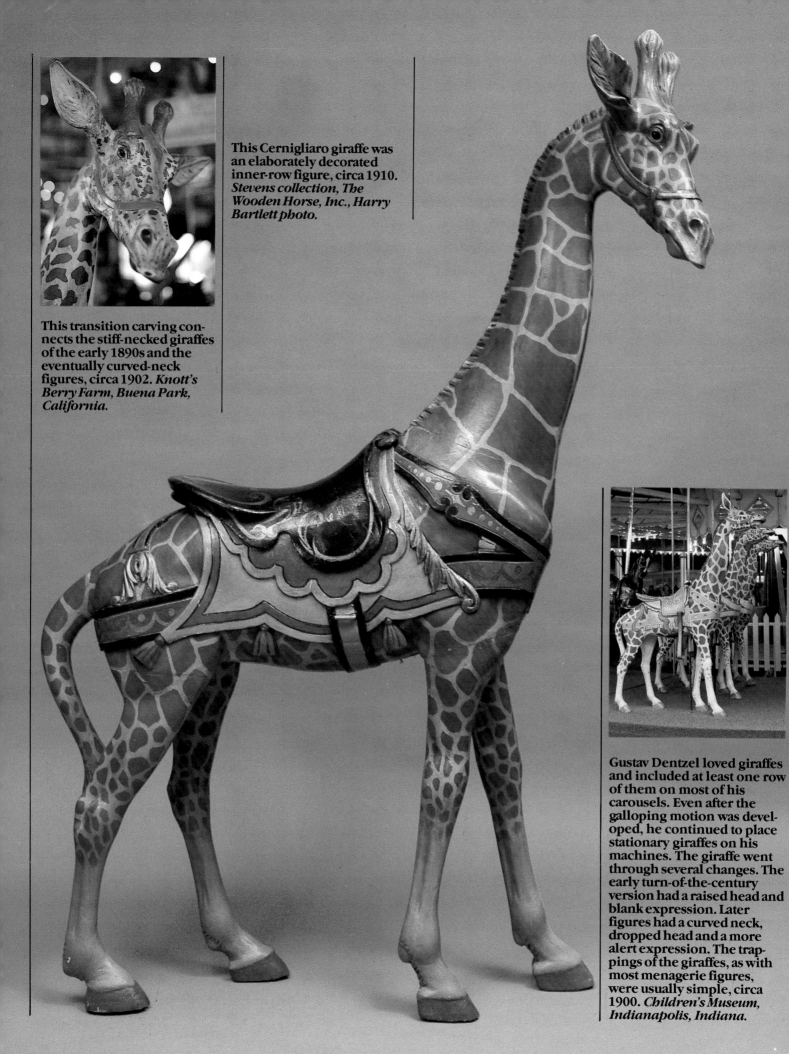

This Cernigliaro giraffe was an elaborately decorated inner-row figure, circa 1910. *Stevens collection, The Wooden Horse, Inc., Harry Bartlett photo.*

This transition carving connects the stiff-necked giraffes of the early 1890s and the eventually curved-neck figures, circa 1902. *Knott's Berry Farm, Buena Park, California.*

Gustav Dentzel loved giraffes and included at least one row of them on most of his carousels. Even after the galloping motion was developed, he continued to place stationary giraffes on his machines. The giraffe went through several changes. The early turn-of-the-century version had a raised head and blank expression. Later figures had a curved neck, dropped head and a more alert expression. The trappings of the giraffes, as with most menagerie figures, were usually simple, circa 1900. *Children's Museum, Indianapolis, Indiana.*

A Dentzel goat (right) in original factory paint shares the platform in Lake Lansing, Michigan with a distinguished group of friends. There are several rare figures on this carousel, including 2 dogs and a rooster, circa 1920. *Susan Foley photo.*

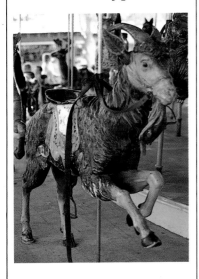

Before the jumping motion became popular all carousel figures were stationary. Dentzel and the other carousel makers experimented with many devices to add excitement to the unmoving figures. Real-hair tails and an assortment of menagerie figures were two methods they used. The prancing goat was on most early machines. Though the pose remained unchanged, facial expressions varied greatly. The goats were usually in rows of two or three and a few late machines had a rare jumping pose, circa 1902. *Knott's Berry Farm, Buena Park, California.*

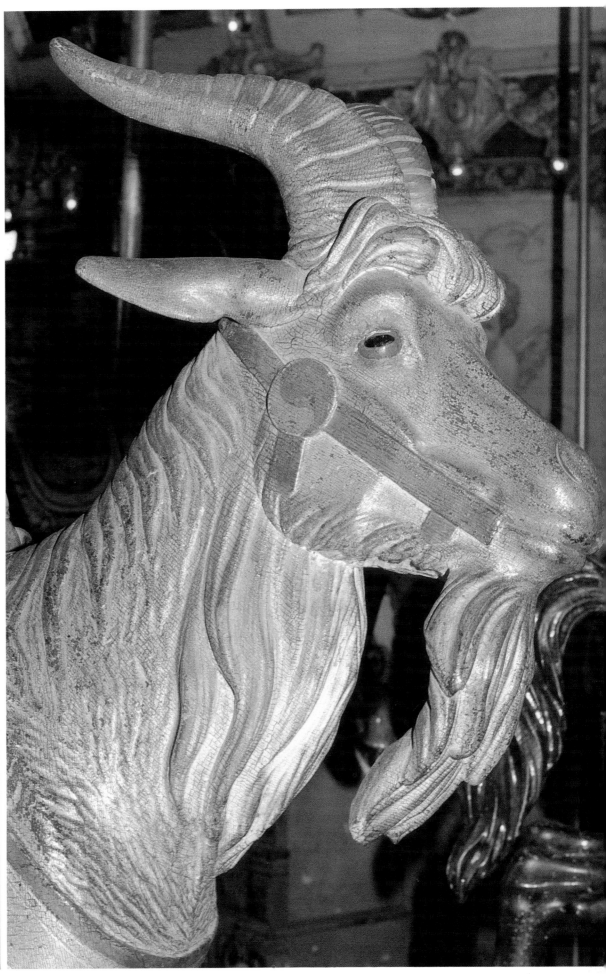

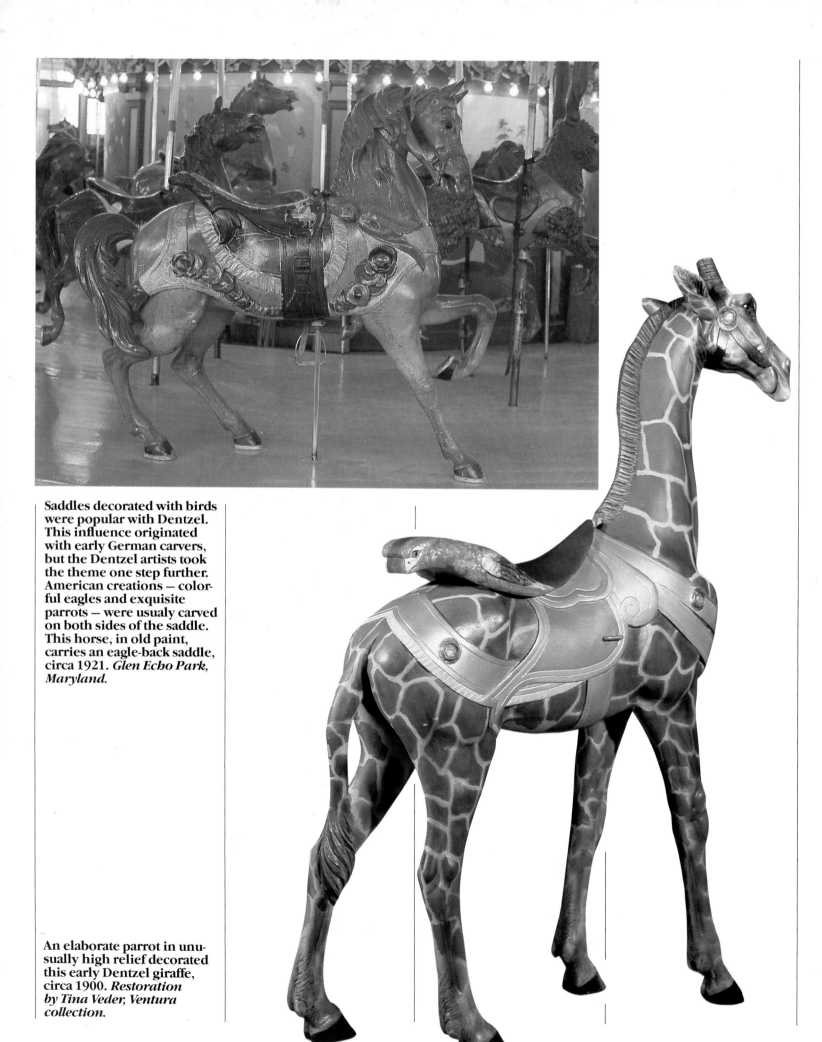

Saddles decorated with birds were popular with Dentzel. This influence originated with early German carvers, but the Dentzel artists took the theme one step further. American creations – colorful eagles and exquisite parrots – were usually carved on both sides of the saddle. This horse, in old paint, carries an eagle-back saddle, circa 1921. *Glen Echo Park, Maryland.*

An elaborate parrot in unusually high relief decorated this early Dentzel giraffe, circa 1900. *Restoration by Tina Veder, Ventura collection.*

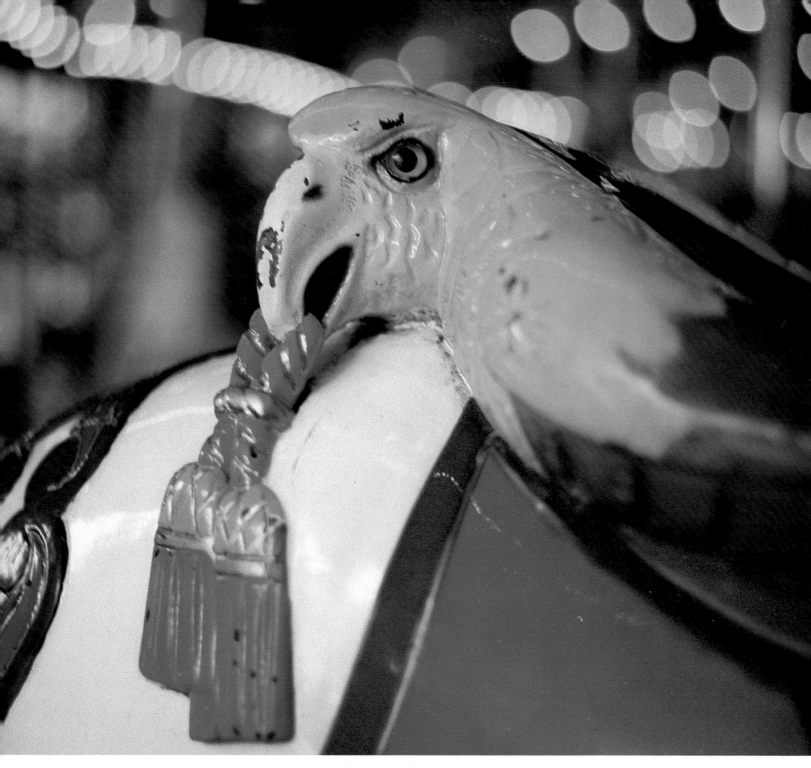

A tassle-toting parrot with a cocked head is one of the most skillfully carved bird decorations gracing American carousels, circa 1921. *Fleischaker Zoo, San Francisco, California.*

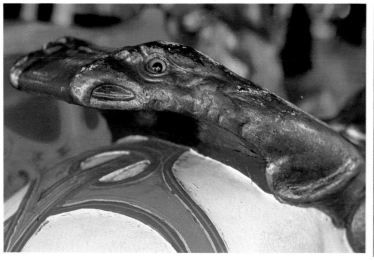

Eagles, a much more common saddle decoration, occasionally have been repainted as parrots. The hooked beak and sloping, rather than pronounced, forehead clearly identify them as eagles.

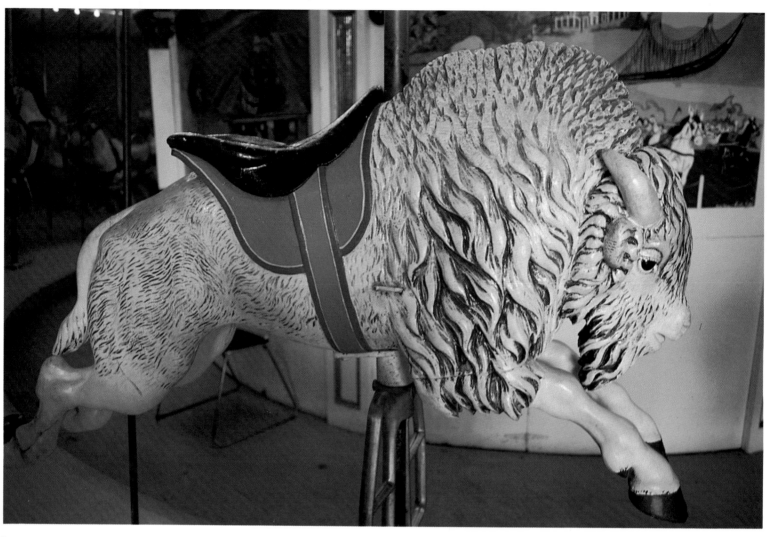

The bison, surprisingly, was a rare carousel figure. Only Looff is known to have carved a buffalo other than the two that are aboard this early machine in Largo, Maryland.

Other carvers produced donkeys and mules, but none was as skillfully carved as this Dentzel running burro.

Dentzel's carousel at Watkins Regional Park in Largo, Maryland, has a unique menagerie of many one-of-a-kind figures, including a hopping kangaroo. These fanciful carvings are attributed to Daniel Muller, circa 1900-1905.

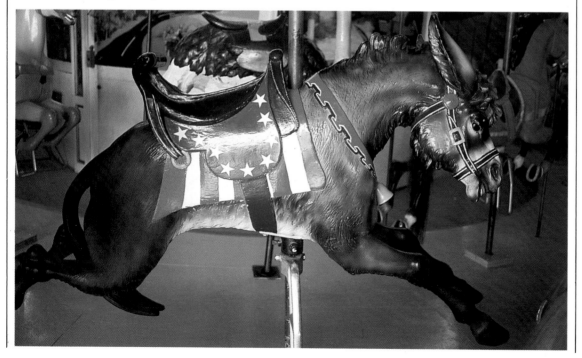

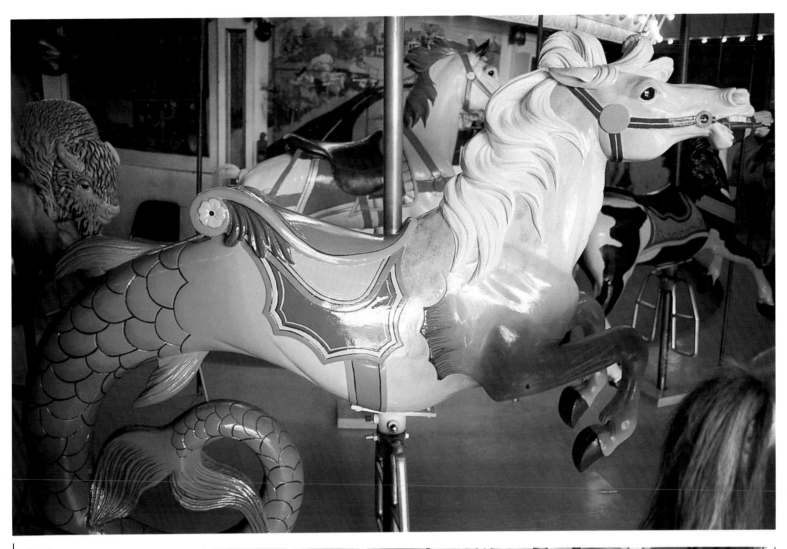

The hippocampus, a rare mythological sea horse having the forelegs of a horse and the tail of a fish, was a popular figure with most carvers, circa 1900-1905.

A pair of unusual cats of prey are on board this early carousel. These carvings are attributed to Daniel Muller, circa 1900-1905. *Largo, Maryland.*

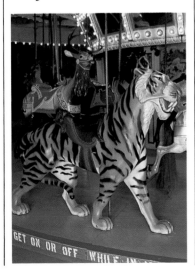

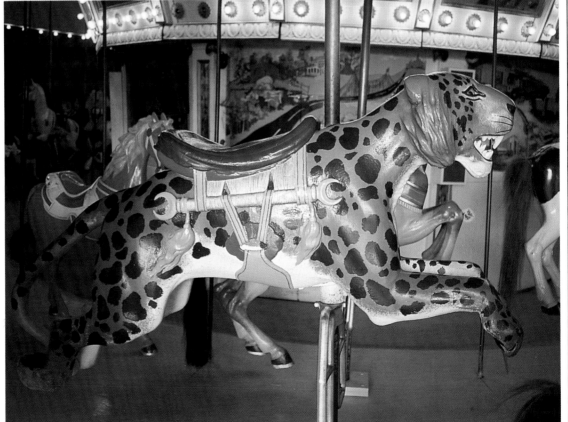

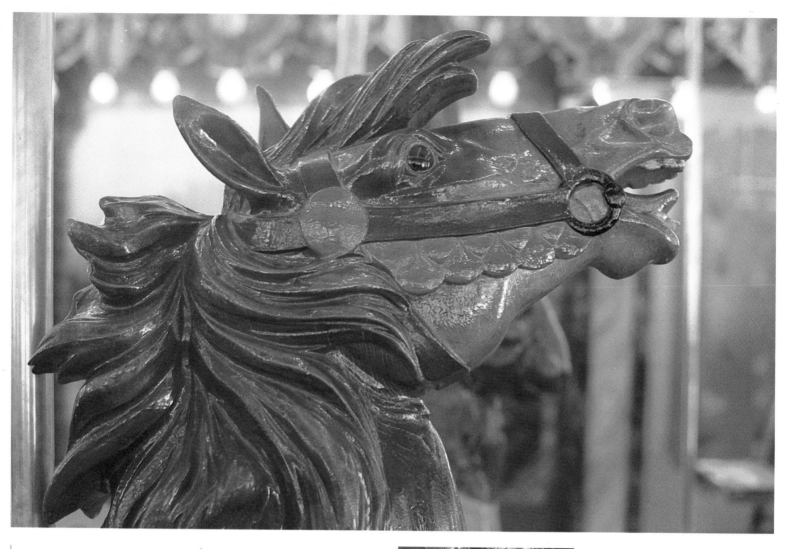

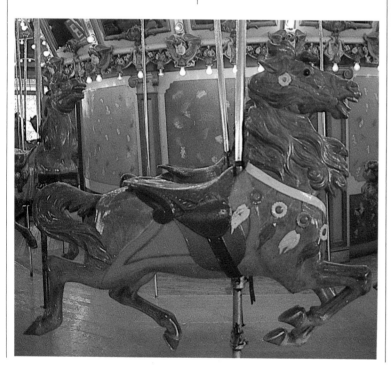

This Dentzel lead horse is the only example of its kind known to exist. The head is a scaled-up version of a rare second-row Muller jumper, pictured above, attached to the traditional American-flag, thoroughbred-style horse. It is one of the most exceptional of all Muller carvings. *Restoration by Tobin Fraley Studio, Daniel collection, Richard Blair photo.*

Daniel Muller worked in the Dentzel factory from 1888 to 1902 and again from 1917 to 1928. He was undoutedly the most gifted of all Dentzel's artists. He created these magnificent second-row jumpers around 1917. *Glen Echo Park, Maryland.*

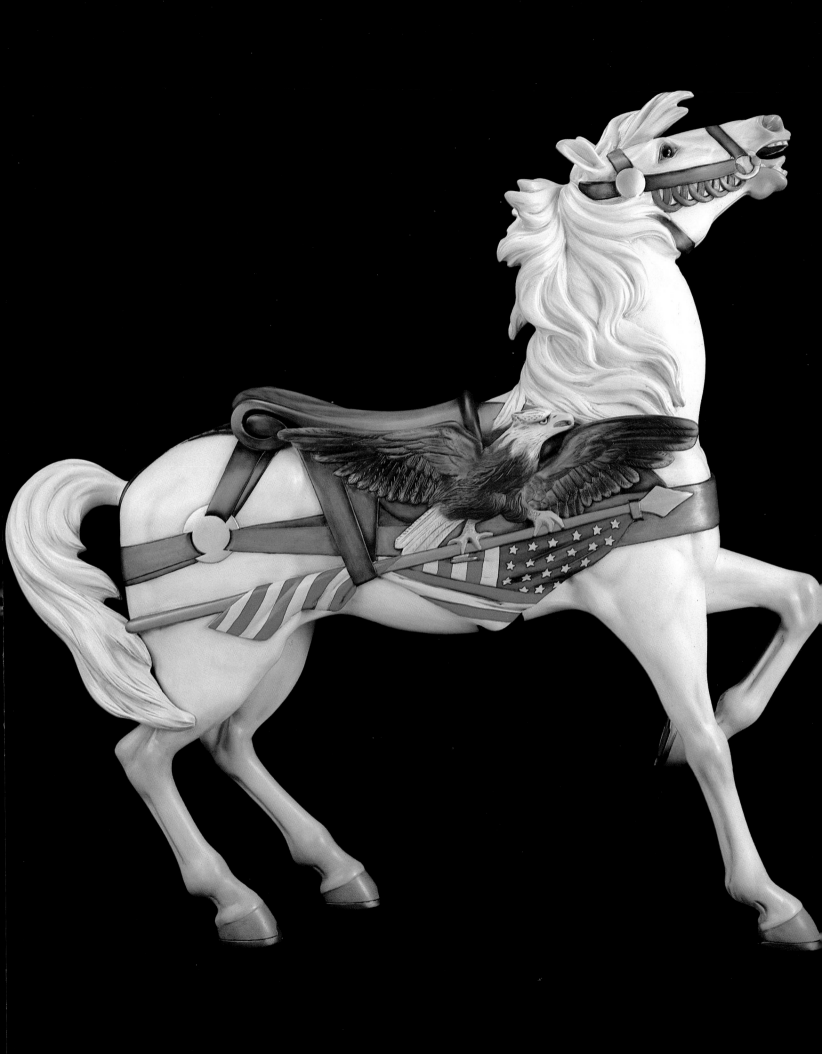

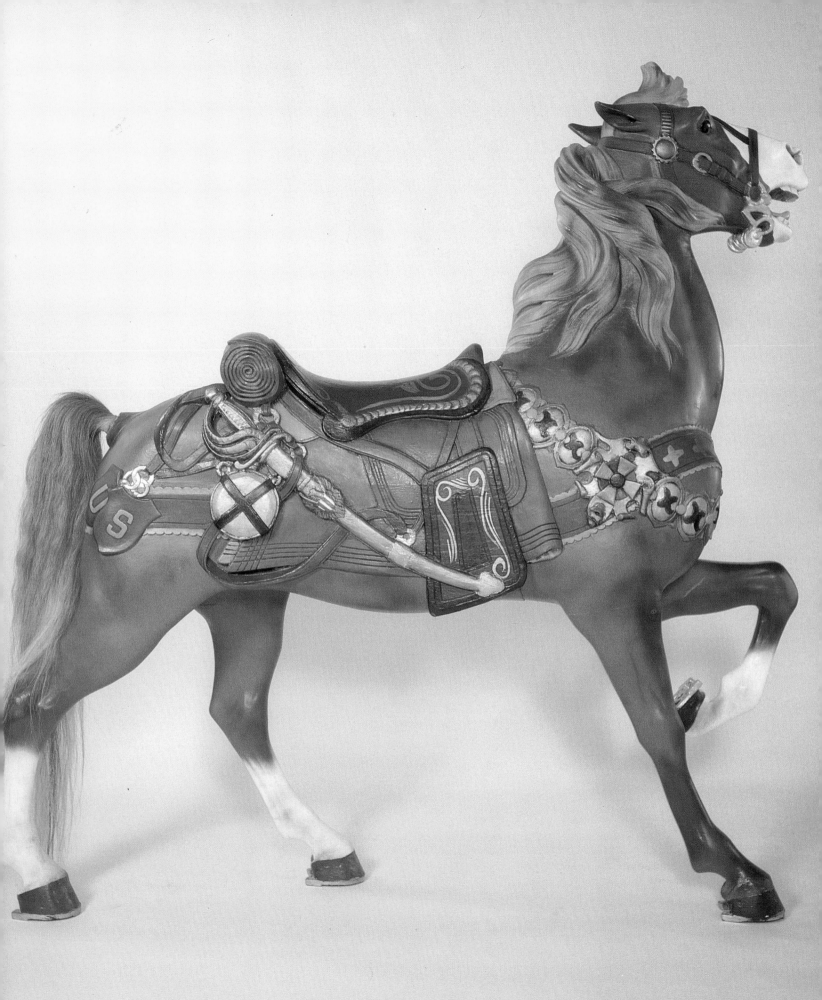

DANIEL MULLER

Daniel Muller was a trained sculptor and one of the most talented of all carousel carvers. His most renowned carvings are horses in military harness like this one bearing a military saddle, canteen and sword, circa 1910. *Stevens collection, The Wooden Horse, Inc., Harry Bartlett photo.*

This intricate carving is part of a chariot made by Muller. He was the only carver to detail both the outside and the seldom-seen inside section of the chariots. *Joe Leonard photo.*

Two brothers, Daniel and Alfred Muller, had close ties to the Dentzel factory. Their father, Johann Heinrich Muller, was a friend to and carver for Gustav Dentzel. After the early death of the elder Muller in 1890, the brothers were treated like part of the family in the Dentzel household. They left the factory to carve for others, in part to escape Dentzel's stern control. Their benefactor saw the brothers' departure as an act of treachery and never forgave their disloyalty. William Dentzel did not carry his father's grudge and rehired the two in later years when their own carousel company failed.

Of the brothers, Daniel Carl Muller was the more inspired artist. His exacting attention to detail, combined with formal training at Pennsylvania Academy of Fine Arts, enabled him to carve with a realism that was seldom duplicated. The classic equestrian sculptures of the pre-World War I period were an inspiration to the carver. Muller continued to study art, and sculpting in particular, throughout his life.

Daniel and Alfred formed their own carousel manufacturing firm, D.C. Muller & Brother Co., in 1903. The small factory turned out fine carousels, but could not compete with other, larger manufacturers. After producing 12 complete carousels plus supplying many figures to frame builders such as T.M. Harton, the factory closed in 1914, and the brothers turned to carving for Philadelphia Toboggan Company and other factories. Only three of the carousels produced in the Muller factory now survive and their horses and menagerie figures carved in the Muller factory are rare and highly desired by collectors. William Dentzel hired the brothers in 1918. They introduced many fresh and exciting designs in his factory and worked there until that business closed in 1928.

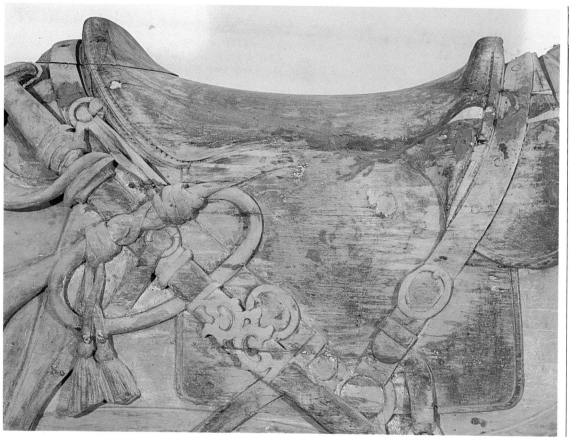

Muller's military-theme carvings copied authentic military accoutrements. He surpassed all other carvers in his attention to detail and in an attempt to recreate authentic trappings, he drilled a series of small holes, which were stuffed with strings, to represent hand-stitching on saddle seats, circa 1915. *Smith collection.*

Daniel won prizes in the early stages of his career for sensitive carvings of nude female figures. In his mature years his carousel horses took on a military theme, which was popular with classic sculptors of the time. The Lincoln Memorial in Washington, D.C., had just been completed and drew attention to the Civil War period. Across the country public statues commemorating Civil War cavalry heroes became popular. Although Muller mixed and matched military eras on a single horse, he adhered to correct style as closely as the limitations of the carousel would allow.

Muller recreated unbelievably accurate military trappings. He attached as many items as possible to the saddle and harness, but maintained an overall sense of realism, circa 1910. *Stevens collection, Harry Bartlett photo.*

Daniel Muller adopted many of the popular poses used in classic equestrian statuary. His lifelike figures seemed capable of walking off the carousel platform, circa 1915. *Smith collection.*

Muller's military carvings usually depicted mature, powerful horses in embattled-frenzy poses. He typically adorned these steeds with a modified version of a model 1859 McClelland saddle.

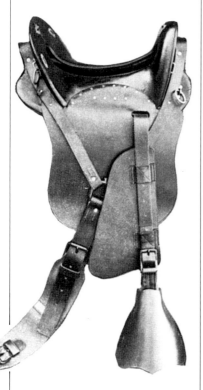

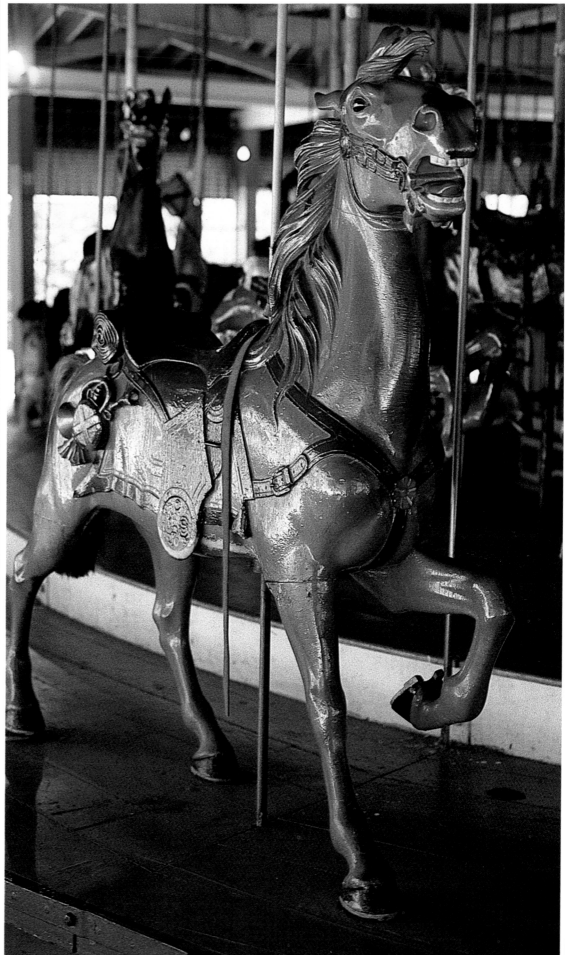

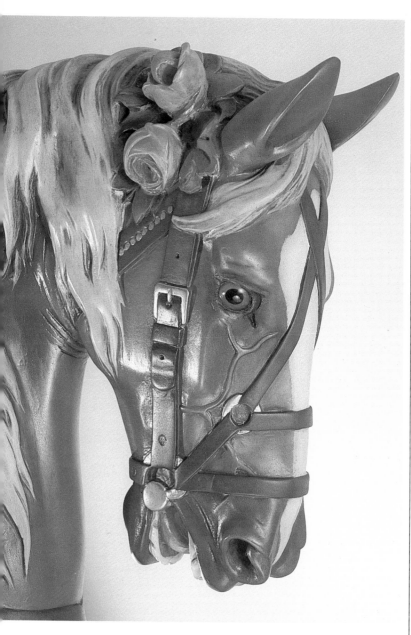

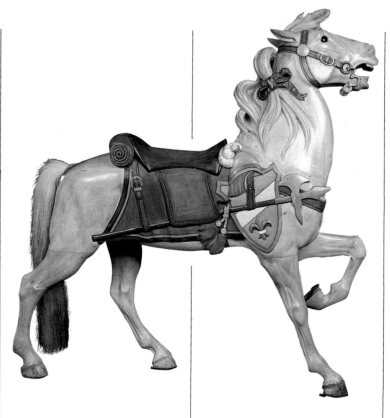

Muller created some of the most exquisite and artistic examples of carousel carvings. These majestic horses are representative of his later work. He tangled a ribbon and roses in the manes of many of his horses, as the "rose pony" shows. All of these figures may have been aboard the same carousel in Hanover, Pennsylvania, circa 1910. *Stevens collection, Harry Bartlett photo.*

This magnificent military horse has a British theme. Muller often used ribbons to decorate the manes of his more powerful carvings, circa 1910. *Aten collection.*

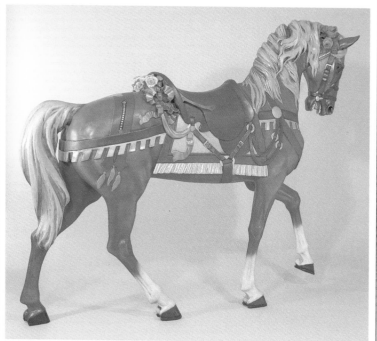

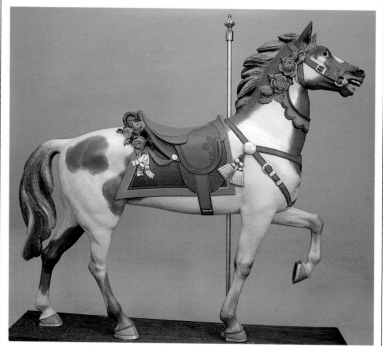

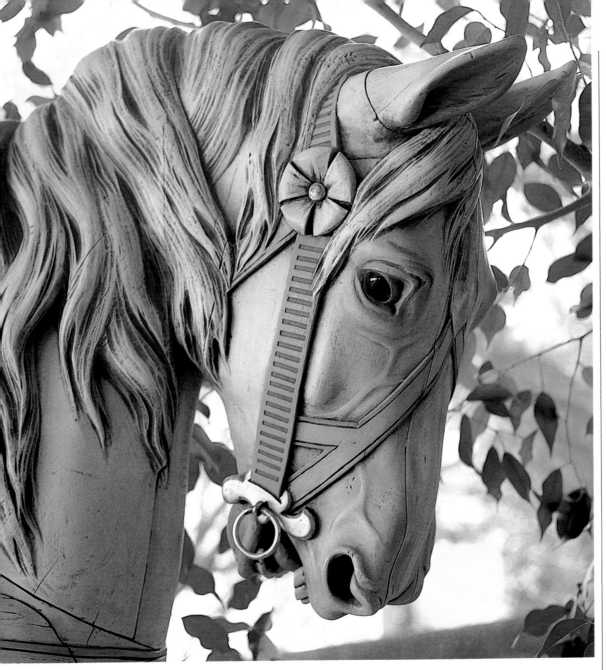

The sensitive, expressive eyes Muller bestowed on his figures are not usually found in the work of other carvers, circa 1910. *Summit collection.*

An aristocratic roach-maned charger, draped with an intricate overlay of Greco-Roman trappings, is one of Muller's unique carvings. The reins on this horse were incorporated into the carving rather than as attached leather straps, circa 1910. *Veder collection.*

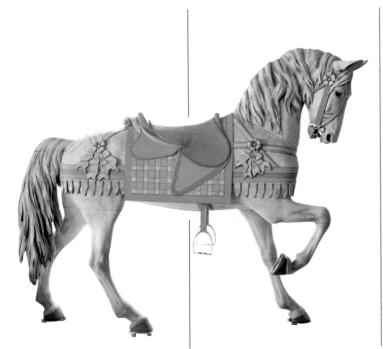

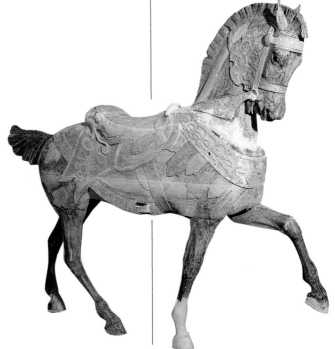

The magnificent Muller carvings of a wild-eyed cavalry mount, above, and a beautiful Indian pony, below, are found on Astroworld's carousel, Houston, Texas.

Muller's jumpers usually had long bodies, as seen on this pistol-packing western-style horse. The figure was part of the Muller carousel at Cedar Point, Ohio, circa 1905. Over the past 50 years the outer-row standers on this carousel have mysteriously disappeared.

This inner-row jumper displays an unusually graceful pose, circa 1910. *Forest Park, New York.*

D.C. Muller and Brother produced several machines for frame builder T.M. Harton, including these spirited inner-row jumpers which were sold for about $45 each in 1905. *Cedar Point, Ohio, John Goldy photo.*

Horses and their trappings reflected Muller's infatuation with the cavalry. Canteens, bugles and swords hung from military saddles and bedrolls were tucked under the cantles. Some military accoutrements were too plain for the lively visual needs of the carousel, so Daniel, wielding his chisel and artistic license, combined saddles, saddlecloths and military tack to create an exciting theme on the carousel.

In his dedication to reality, Muller would carve stitching holes in the saddles and insert heavy thread to give the illusion that real leather had been used. His Indian ponies were adorned with lifelike feathers and his saddles and bridles sometimes were carved to resemble tooled leather. Muller took carousel carving to its highest level of perfection and created some of the finest examples of the carvers' art.

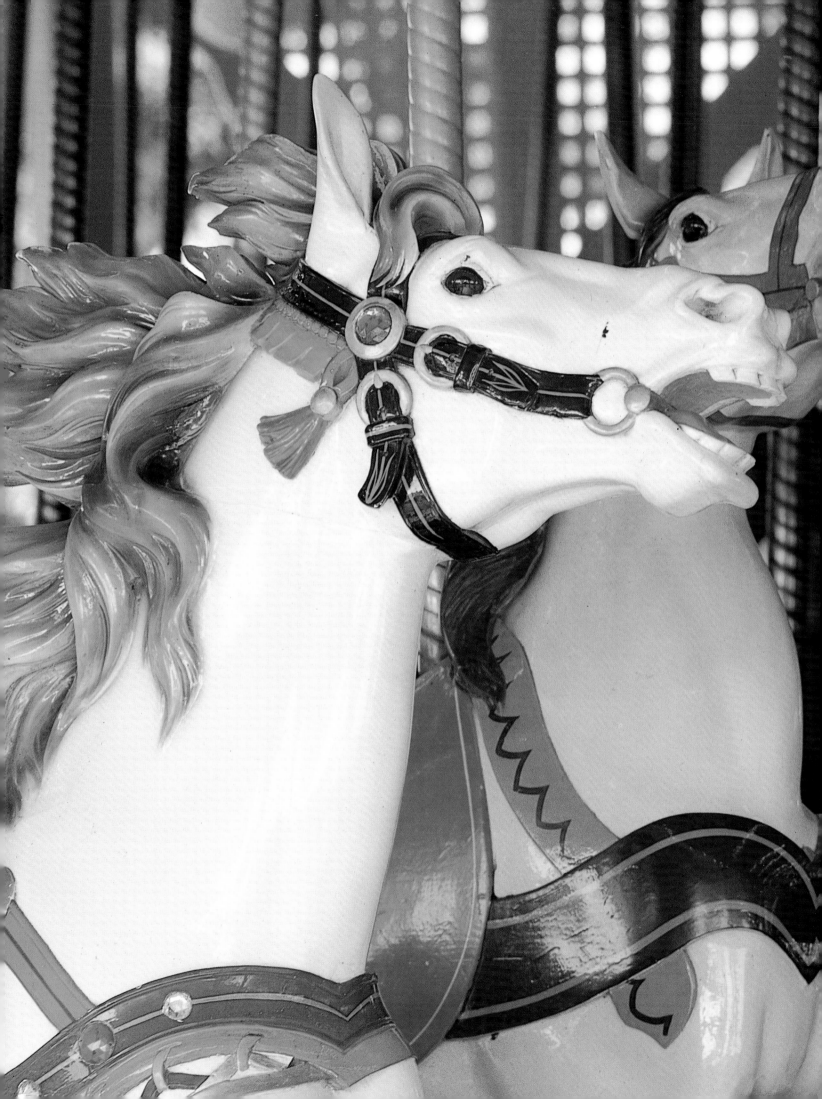

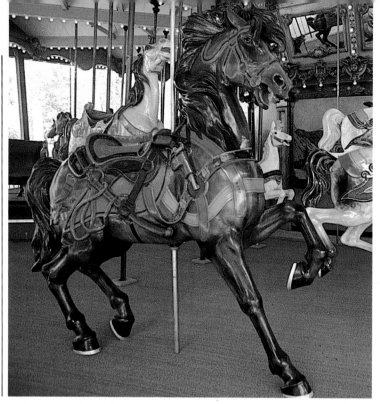

This flamboyant military steed carved by Muller may be the only haunted horse in existence. According to the legend, after the park closes, the ghost of a lone woman frequently climbs onto the extraordinary black steed, the extinguished lights begin to glow and the carousel slowly turns, circa 1917. *Cedar Point, Ohio.*

This exceptional armored lead horse, one of only five Muller carved, was added to the Dentzel Kiddieland carousel at Cedar Point, Ohio, about 1917 in an attempt to create a more exciting carousel. *John Goldy photo.*

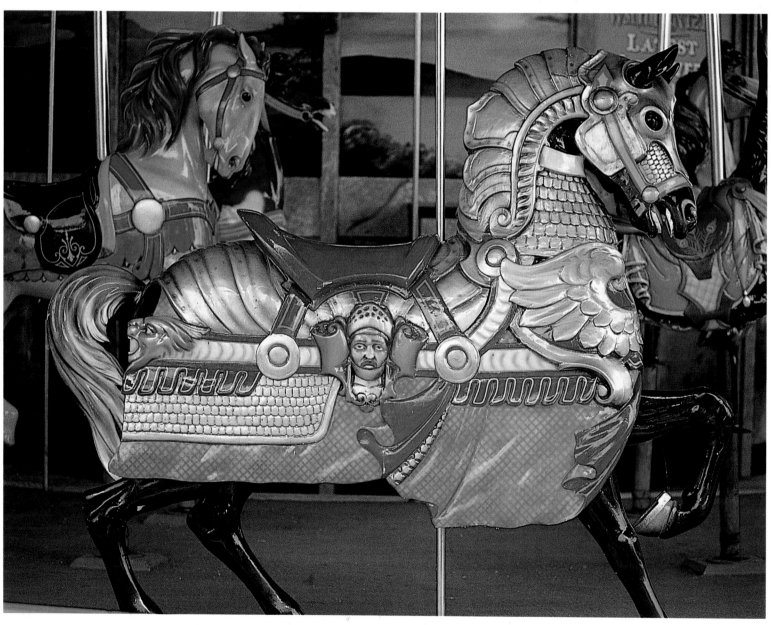

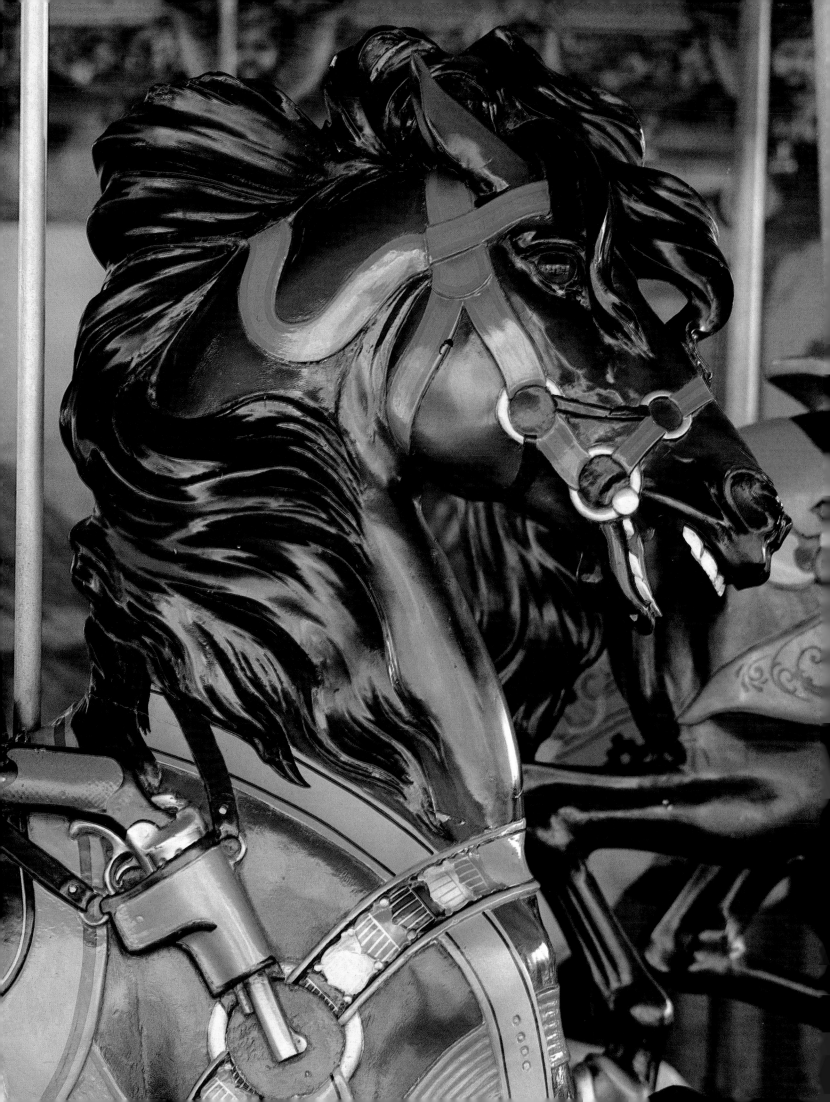

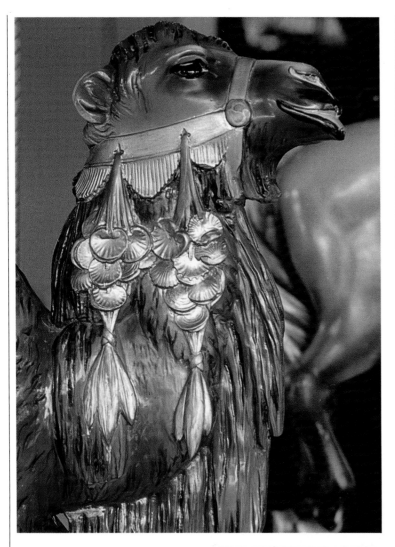

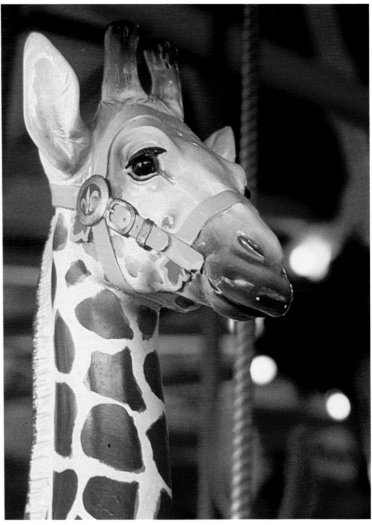

A Dentzel carousel at Astroworld, Houston, Texas, carries many of Daniel Muller's most magnificent menagerie animals. It is unusual to find these figures carved with such elaborate detail and exquisitely ornate trappings, circa 1915.

This solemn-faced Muller giraffe riding the Astroworld carousel platform sports an intricately carved saddle and a trio of unusual monkey faces tucked behind the cantle, circa 1915.

The saddle decorations of a Muller deer include a pair of dogs nestled within a hunter's horn, circa 1915. *Astroworld, Houston Texas.*

A jaunty monkey peeks out from behind the saddle of this outer-row zebra. Ornamental carvings under the cantles were not only decorative, but they also reinforced the high-backed saddles, circa 1915.

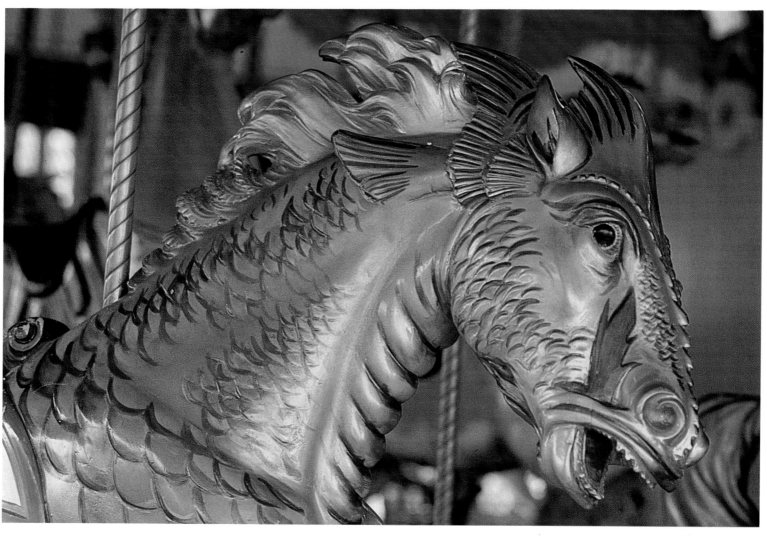

Muller's sea horses deviated from the typical pattern originated by Dare and followed by most subsequent carvers. The fierce creatures Muller created mixed horse and fish features in an innovative fashion, circa 1915. *Astroworld, Texas.*

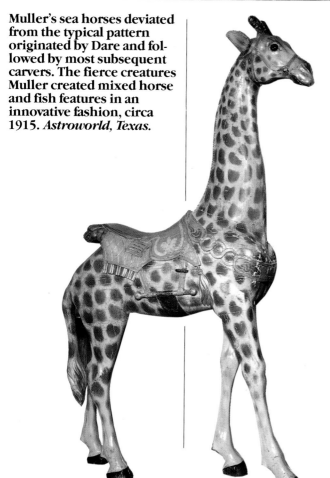

This second-row giraffe wears rare original paint, circa 1905. *Veder collection.*

The power and excitement embodied in Muller's sea horse carvings cannot be muted with layers of garish park paint, circa 1905. *Joe Leonard photo.*

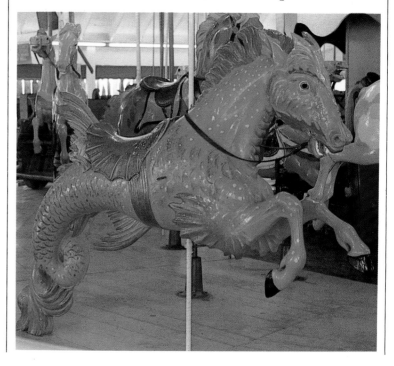

67

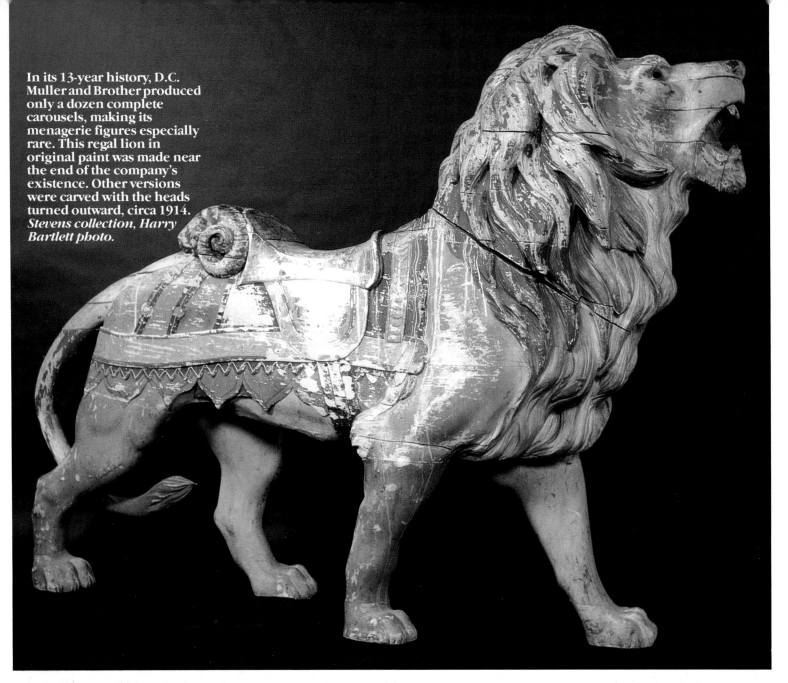

In its 13-year history, D.C. Muller and Brother produced only a dozen complete carousels, making its menagerie figures especially rare. This regal lion in original paint was made near the end of the company's existence. Other versions were carved with the heads turned outward, circa 1914. *Stevens collection, Harry Bartlett photo.*

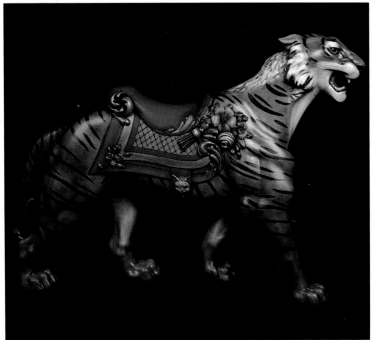

Daniel Muller used lavish ornamental carving on his outside-row menagerie figures. This fierce tiger, beautifully restored by Gayle Aten, seems tamer with a delicate floral bouquet clustered on its shoulder. *Aten collection.*

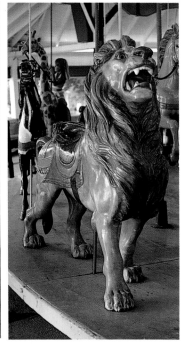

Muller and Brother's early lions were almost identical to those the two men had been carving in the Dentzel factory. The snarling lions assumed erect poses and wore simple trappings, circa 1905.

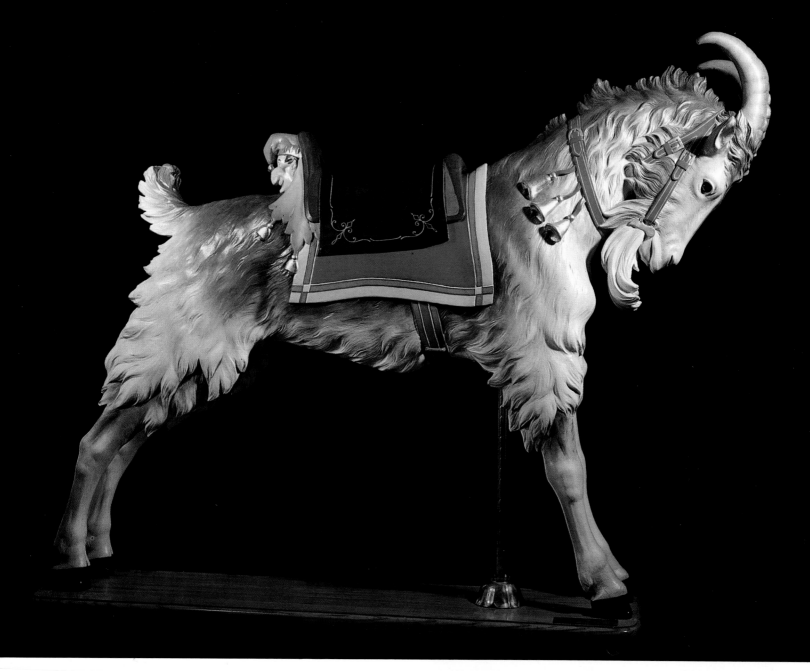

An early Muller goat with an eagle-back saddle and park paint pranced around the carousel in Westview Park, Pittsburgh, Pennsylvania. *Farnsworth collection.*

This extremely well-carved goat gives proof of Daniel Muller's exceptional artistic ability. With a simple chisel, he captured the spirit of a butting ram. Muller often placed richly carved bells as harness decorations on both his menagerie and horse figures. The symbolism of Punch, who appears on all three of the known Muller goats in this stationary pose, has been lost, circa 1907. *Tony Orlando restoration, Abbott collection, Robert Manns photo.*

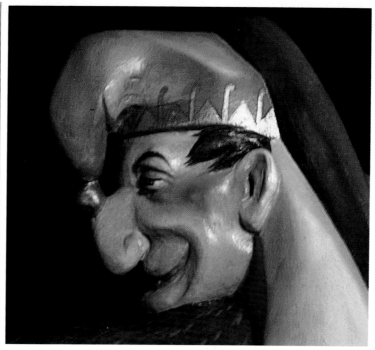

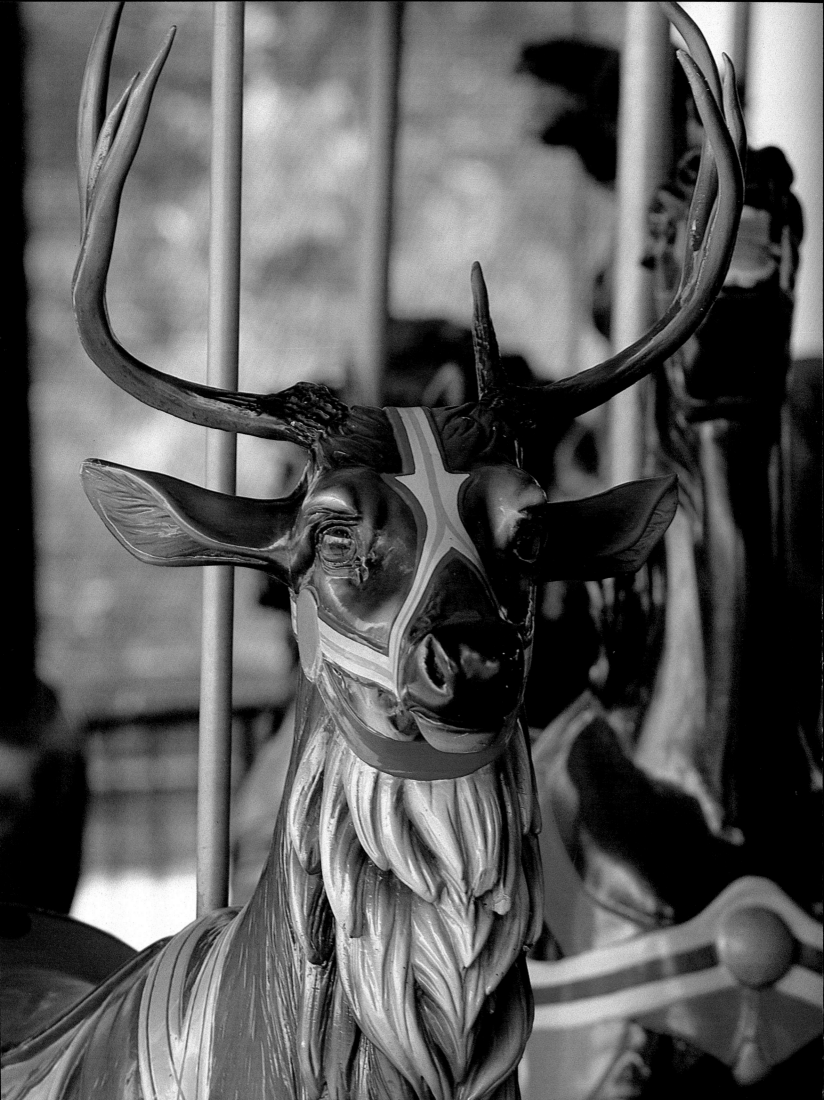

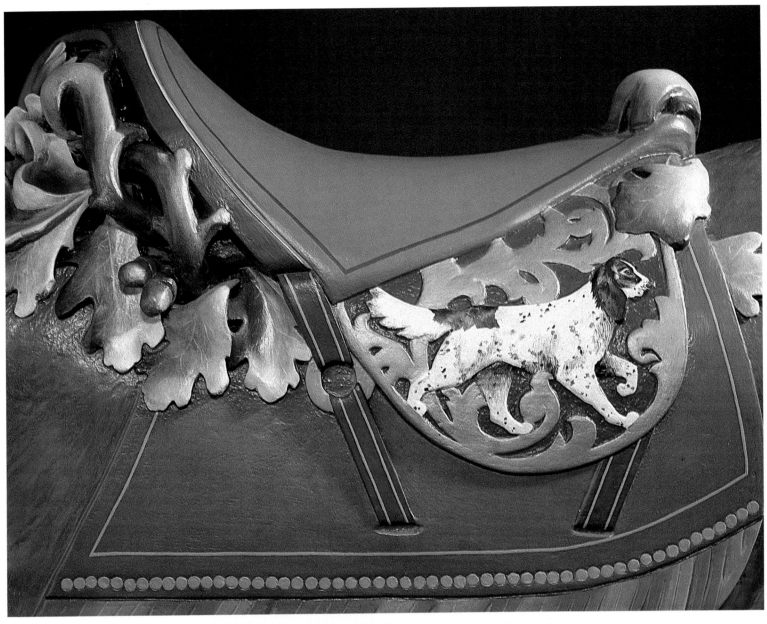

Daniel Muller's sensitive carving of a walking deer is festooned with a gorgeous bow and bell. He often encircled the necks of his outside-row menagerie figures with carved ribbons. This deer, circa 1907, was taken from a carousel that operated in Hanover, Pennsylvania. *Abbott collection, Robert Manns photo.*

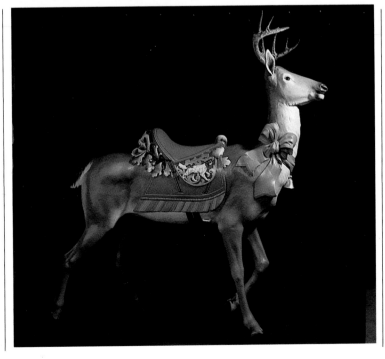

An alert buck with an elaborate star headstall makes the rounds on the Frontier Town carousel at Cedar Point, Ohio. This beautiful deer exhibits a rare walking pose. *John Goldy photo.*

Saddle decorations on Daniel Muller's menagerie figures were extraordinarily creative. Oak leaves and acorns build a lush support for this deer's saddle while a beautifully carved, English setter decorates the filigree saddle flap.

Carousel Manufacturer
THE PHILADEPHIA TOBOGGAN CO.

Philadelphia Toboggan Company, a late entry in the carousel lineup, is another name synonymous with longevity and quality. The entire theme of the large, elaborate carousels was an important consideration. Philadelphia Toboggan Company considered the overall scheme one of the main ingredients of the carousel. Many of its carousels were installed in buildings designed and erected by the company. Center panels that reached upward to the ceiling formed the backdrop, and heavily carved rounding boards studded with jewels, mirrors and light bulbs crowned the creation. The entire effect created a three-minute magical experience for the rider.

Businessmen, not carvers, ran the PTC, as it is often called. One of the co-founders, Henry B. Auchy, formed Gray Manufacturing Company to build and operate his first three-abreast carousel in 1899 for a large picnic area that he owned. Chestnut Hill Park in Philadelphia was the first business venture associated with the amusement industry for Auchy. At that time the native of Pennsylvania was already successful in the produce and liquor distribution businesses.

The sumptuous location of the carousel in a tree-rich park may have inspired the architectural excellence that Auchy strived to achieve. To meet that end, he usually hired skilled artists to work in his factories.

Auchy organized the Philadelphia Carrousel Company in 1900 with Louis Berni, an importer of band organs. Three years later Auchy and Chester E. Albright formed Philadelphia Toboggan Company to "build finer and better carousels and coasters."

Early PTC carousels carried animals with exotic saddlepacks. Eagles and parrots often perched on the backs and sides of the carousel animals. Saddles sometimes were made to resemble water lilies. The pommels in the front were sometimes carved to resemble frogs, and beneath the cantles in the back panthers lurked. Both major Philadelphia-style companies featured fantastic trappings and beautiful secondary figures on their carousel animals.

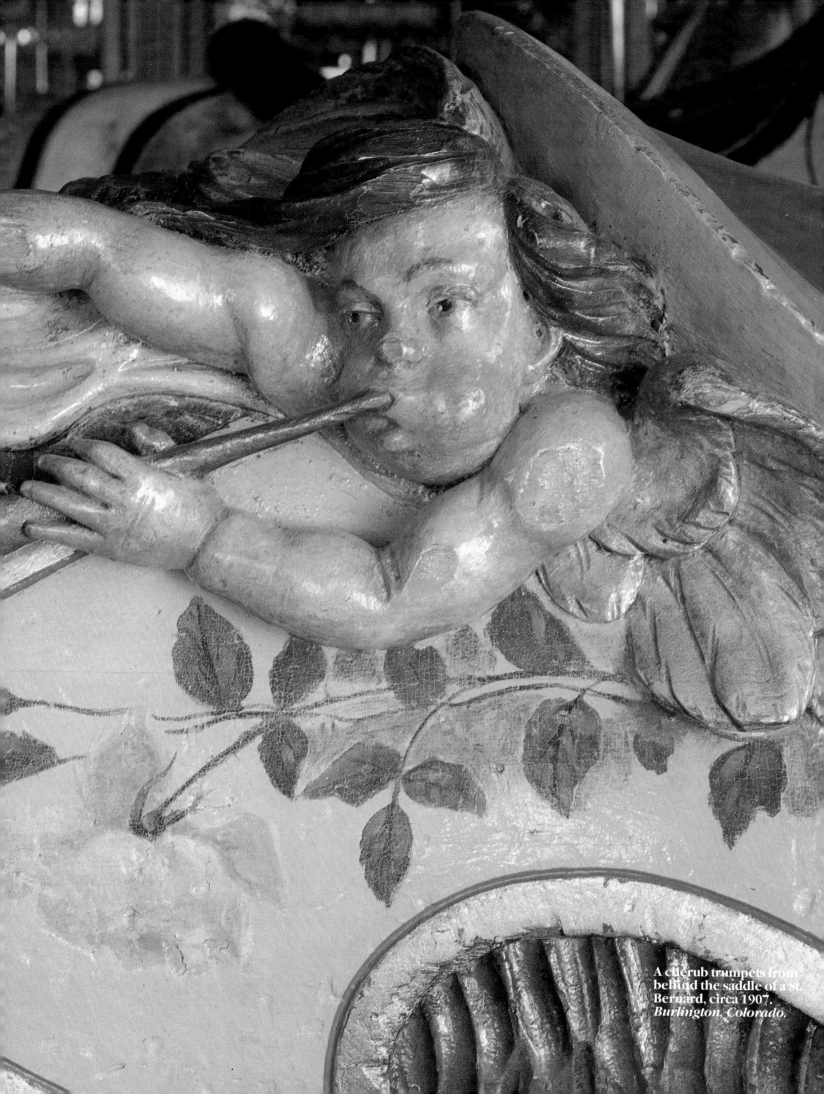

A cherub trumpets from behind the saddle of a St. Bernard, circa 1907. *Burlington, Colorado.*

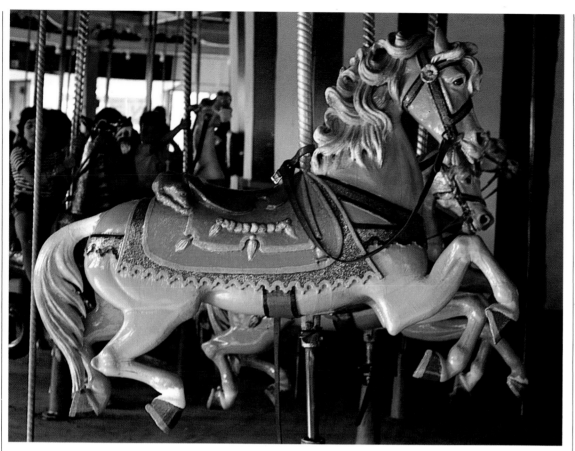

In the fall of 1902, twenty-three year old Salvatore "Cherni" Cernigliaro arrived in Philadelphia. He worked for several months carving his first carousel figures for Mr. E. Joy Morris. He picked up the work quickly, but when spring came and the carousel was installed, Cherni was out of work. He then went to work at the Dentzel carousel factory. This may be one of Cherni's first carousel carvings.

Long attributed to the Philadelphia Toboggan Company, the carousel at Lake Quassy in Middlebury, Connecticut is known to be the work of E. Joy Morris. He was a well-to-do Philadelphia entrepreneur who produced about two dozen carousels from 1896-1904. These early horses, with manes of flowing ringlets, have clever carvings behind almost every saddle, circa 1902.

A massive lion leads the menagerie on the E. Joy Morris carousel at Lake Quassey in Middlebury, Connecticut, circa 1902.

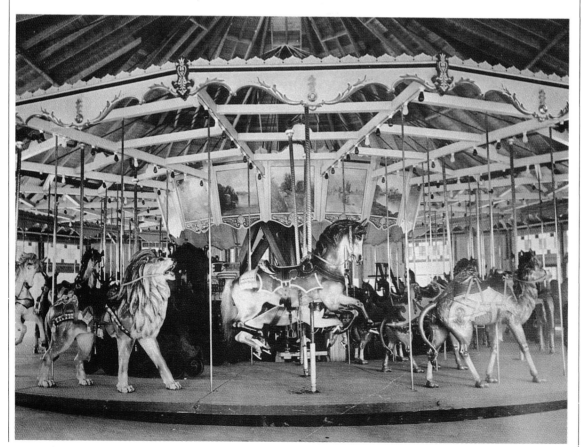

Late in 1903 E. Joy Morris sold his roller coaster patents and inventory of more than 200 carousel figures to Henry Auchy and Chester Albright. They used this instant inventory of figures to produce four complete machines in 1904, including the first PTC carousel pictured here. The machine was shipped to Norfolk, Virginia. Later, after the figures were converted to jumpers, it operated in Manchestr, New Hampshire until fire destoryed it in 1960.

The E. Joy Morris figures were carved by Charles Leopold who also worked as the head man at the Gustav Dentzel shop. For Morris, Leopold created a unique and well proportioned group of figures with intricate trappings. These were part of the 200 original figures used to establish the PTC in 1904.

Another carousel that was originally identified as being an early product of the P.T.C., this interesting E. Joy Morris machine last operated at the Skylon Tower in Niagara Falls, Canada. These early carousel carvings have a wide variety of clever secondary figures carved behind the saddle. These include caricatures of the carver's pets, such as this lovable bulldog and industrious cat. Many of these whimsical carvings added a touch of humor to the carousels, circa 1902.

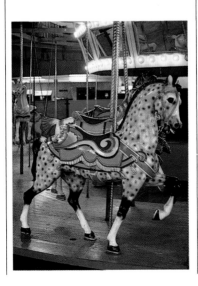

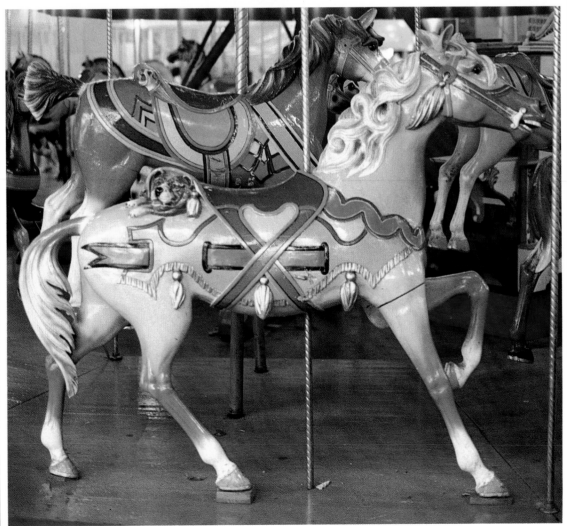

One of America's finest surviving carousels, Philadelphia Toboggan Company's No. 6 machine, operates in Burlington, Colorado. The three-abreast stationary machine originally was shipped to Elitch Gardens in Denver in 1905. When the Kit Carson County commissioners bought the carousel in 1928 for $1,250, they were severely criticized for extravagance during hard times and two of the officials never ran for public office again. The county fair, where the carousel was located, was shut down during the Depression and remained closed until 1937. The building housing the carousel during that time was used to store hay and grain, which attracted rats and snakes to live within the cozy carousel figures. Rather than set fire to the infested, decrepit machine, as many people suggested, county employees scrubbed the figures, applied some touch-up paint and coated them with several layers of varnish. The carousel rotated to the sound of tape recordings of country and western tunes until its band organ was restored for America's Bicentennial. Inspired by the success of that project, Kit Carson County Carousel Association hired Will Morton of Denver to strip away the layers of varnish and expose the paint originally applied in the factory to the figures, chariots and outer rim. This painstaking project was miraculously completed in 18 months. John Pogzeba restored the 45 oil paintings on the rounding boards in 1977.

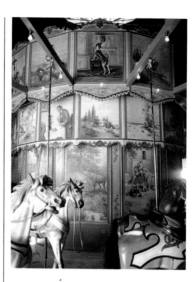

This magnificent lead horse has an authentic full-faced "chamfrom" and a suit of richly carved German armor over an intricate chain-mail blanket, circa 1905. *Burlington, Colorado, Ric Helstrom photo.*

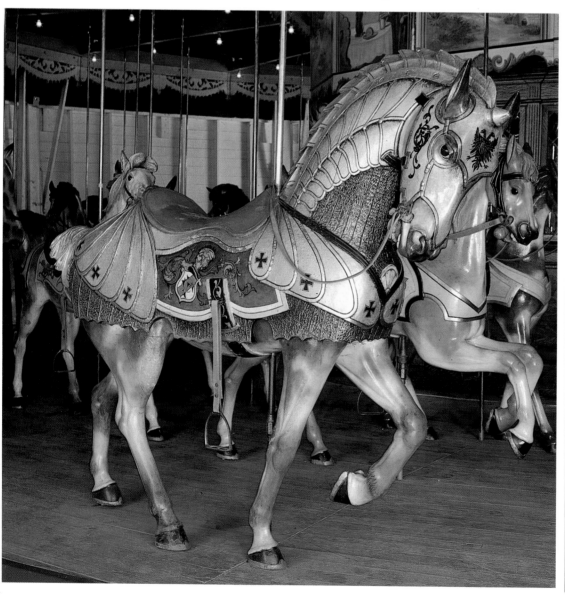

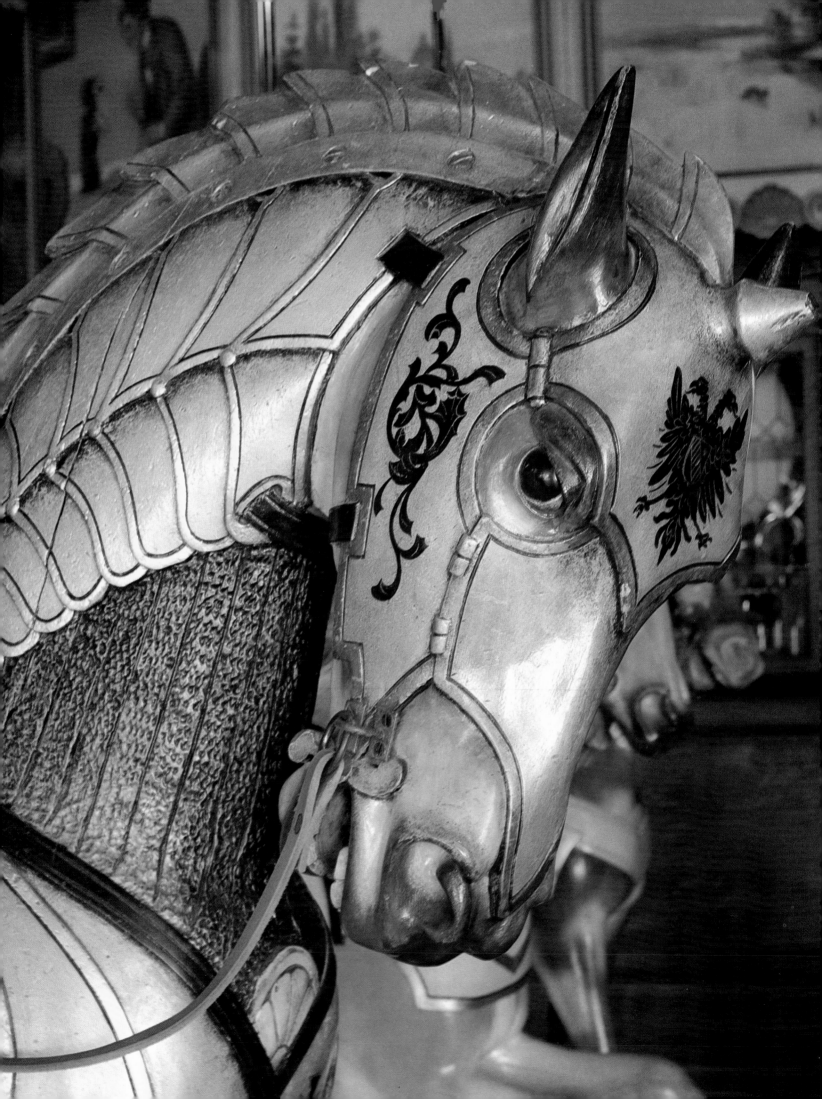

The exquisite, skillfully carved figures on the PTC, No. 6 carousel in Burlington, Colorado, are attributed to the artistic skills of Daniel Muller. Daniel and his brother, Alfred, worked for Philadelphia Toboggan Company as freelance carvers before forming their own firm. While building their own carousels, the brothers continued to supply Henry Auchy with figures for several years. *Ric Helstrom photo.*

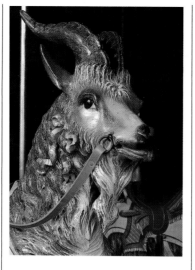

A fanciful ribbon adorns this richly carved, charming goat. *Ric Helstrom photo.*

A ram pokes its nose out from under the saddle of this outside-row goat. *Ric Helstrom photo.*

The menacing tiger on the Burlington, Colorado, carousel platform has a humorous touch added with a small face peeking out from the depths of a watermelon. Playful subjects were often used as saddle decorations on even the most ferocious beasts, circa 1905. *Ric Helstrom photo.*

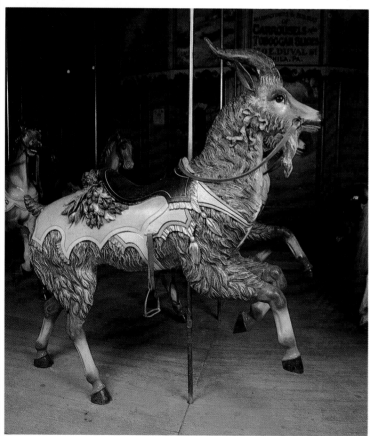

A fearsome, growling tiger has exceptionally well-carved features. *Philadelphia Toboggan Company, No. 6 carousel, Ric Helstrom photo.*

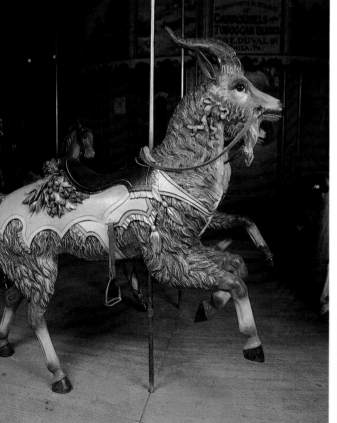

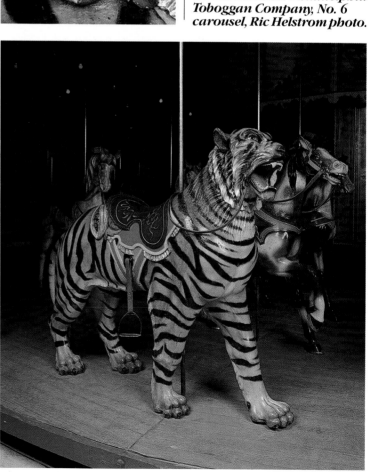

A trio of zebras populate the platform of PTC No. 6 carousel. The outer-row figure has an elaborately defined, curious elf behind the saddle. *Ric Helstrom photo.*

A group of menagerie figures await completion in the carving shop of Philadelphia Toboggan Company, circa 1905. *Smithsonian Institution.*

A ferocious king of beasts roars on board Burlington's stationary carousel. A decorative sash announcing the company's name and address is suspended between a pair of exquisite cherubs. These lovable imps were often used to soften the appearance of fierce menagerie figures to make them more inviting to young riders, circa 1905. *Ric Helstrom photo.*

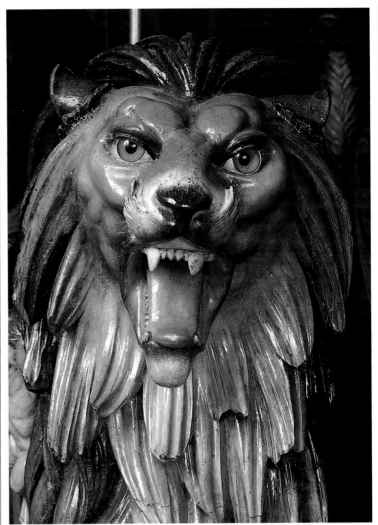

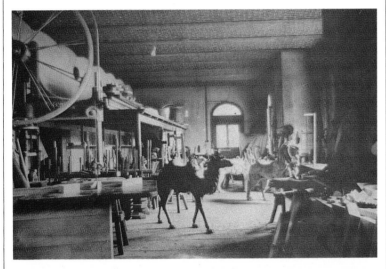

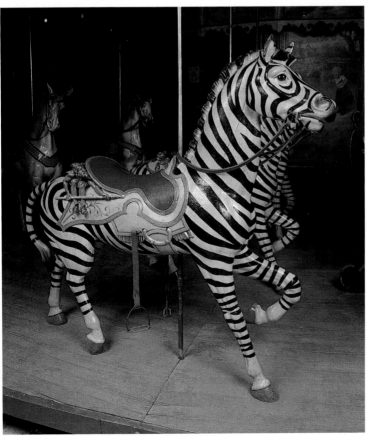

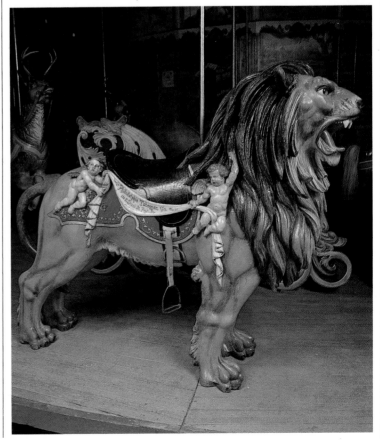

Outside-row figures, because they were the most visible to the passing crowds, were covered with fine details and myriad secondary subjects. This stately long-necked creature, leading two other less-decorated giraffes, has a slithering snake coiling around its neck and an alarmed monkey crouching behind the saddle.

Realistic and richly carved fur and trappings, combined with lifelike and well-proportioned animals characterized the carving skill of Daniel Muller. This highly detailed and lavishly embellished camel has all the hallmarks of Muller's mastery. *Ric Helstrom photo.*

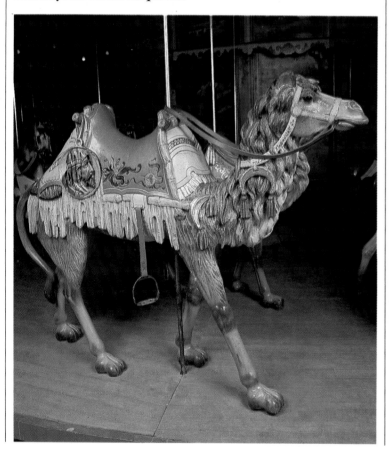

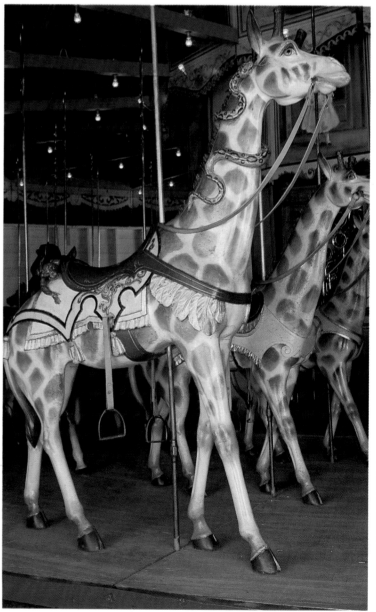

Bruno "the magnificent" is an extraordinary early carving from the PTC No. 13 carousel, which last operated in Fort Wayne, Indiana. This brandy-toting St. Bernard, purchased at auction in the early 1980s and sporting muted, but original factory paint, is one of five known to exist. The beauty of the dogs carved during the early period of the PTC is comparable only to the canines carved by Looff, circa 1906. *Aten collection.*

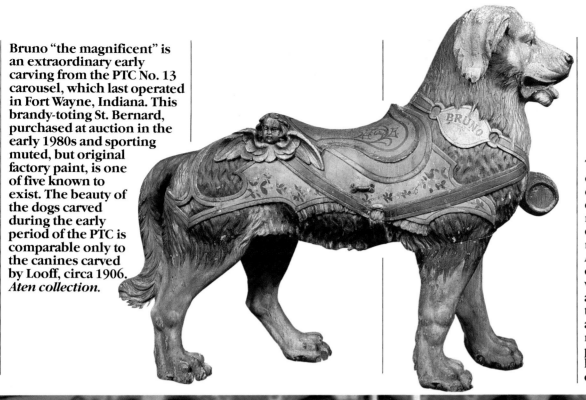

The hippocampus, which combines the head and forequarters of a horse and tail of a dolphin, was a popular mythical creature included on most of the PTC menagerie carousels. Henry Auchy began producing carousels populated entirely with horses in 1907, although catalogs advertised that menagerie figures were available until 1912. This may have reflected the popularity of horses or the lack of adequately talented carvers.

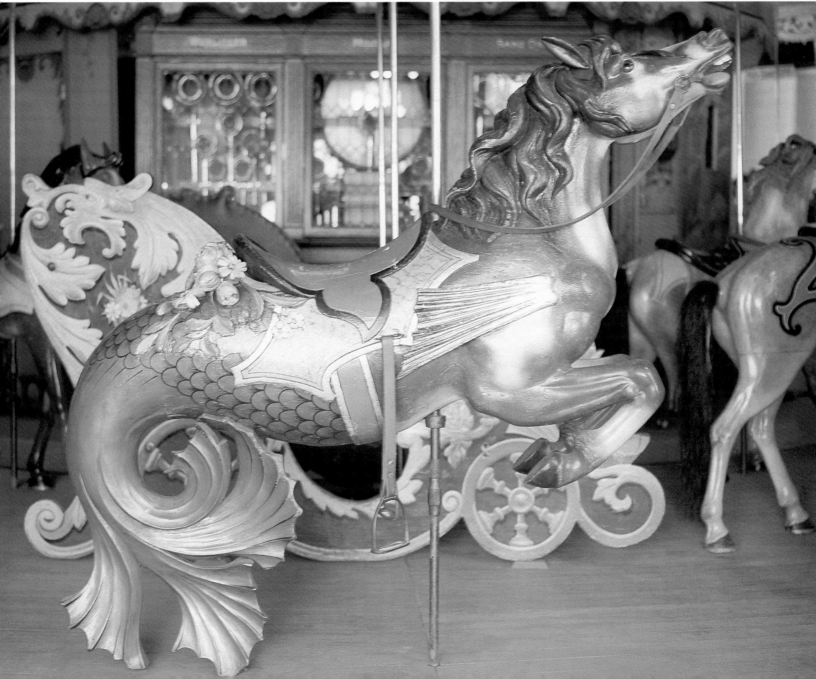

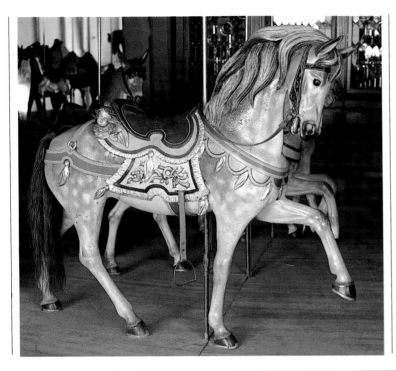

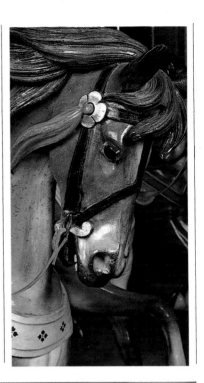

The beautifully restored horses on Philadelphia Toboggan Company's No. 6 carousel in Burlington, Colorado, have lifelike and well-proportioned bodies and slender legs. The figures, in elegant and classic poses, are consistent with the developing talent of Daniel Muller, circa 1905.

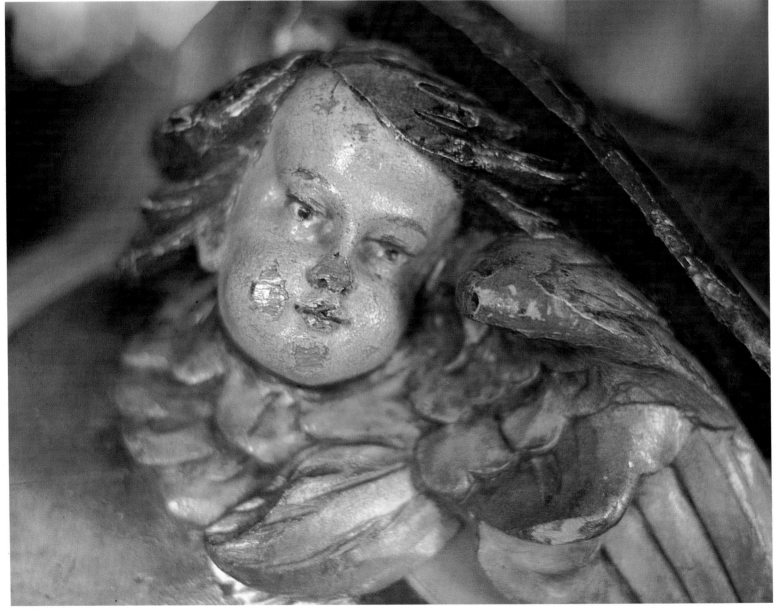

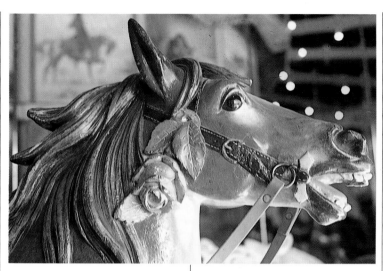

A single rose adorns the bridle of this stylish steed, circa 1905. *Burlington, Colorado.*

A high-pitched whinny is all that is missing from this pinto Indian pony. Daniel Muller's Indian ponies are among his best work. On this one a bearskin saddle blanket is attached with an intricately carved surcingle or girth, circa 1905.

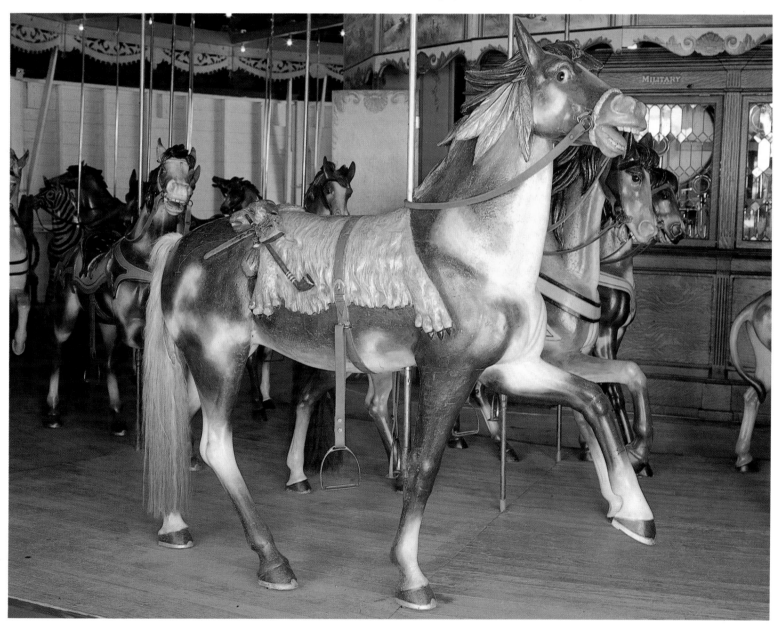

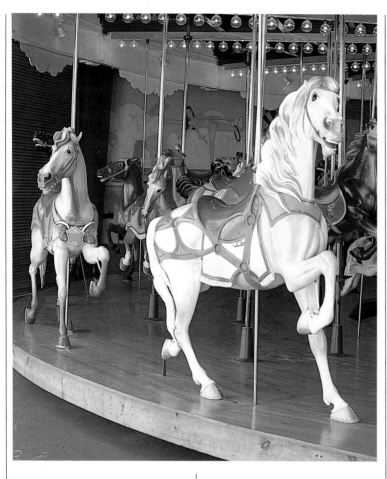

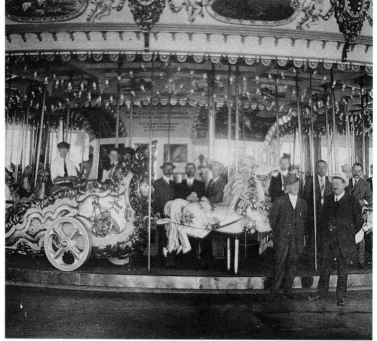

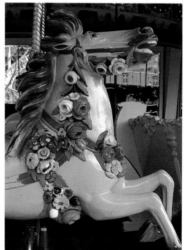

Disproportioned and awkward features characterized the carvings of the PTC after the Muller brothers decided to form their own company. At this time the number of orders drastically dropped, circa 1910. *PTC No. 9, Old Orchard Beach, Maine.*

Henry Auchy, wearing a white hat in the foreground, stands in front of the newly installed PTC No. 21 in West Haven, Connecticut, circa 1912. *Sam High III.*

High-set eyes and elongated heads were typical of the PTC horses during the period immediately before Frank Carretta joined the company in 1912. This horse is from PTC No. 21 carousel at Magic Mountain, Valencia, California.

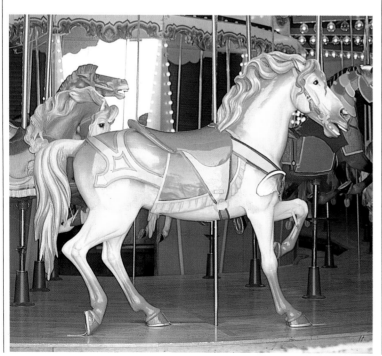

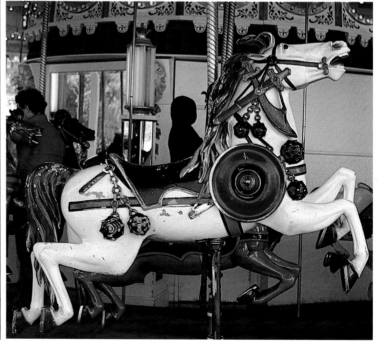

A carousel ride without music is certainly incomplete. Tunes for the earliest carousels were provided by two- or three-piece bands. The three-minute, magical experience was soon accompanied by the boisterous sound of a band organ, which cost between $2,000 and $3,000 at the turn of the century. High-quality carousel manufacturers, such as PTC, used the finest organs imported from Italy, Belgium and Germany. These wonderful instruments were enclosed within elaborate wooden cases and included carved human figures that were occasionally animated to bow and turn to the beat of the music. Gavioli was one of the finest band-organ suppliers to the carousel industry and one of his productions accompanies PTC No. 15, circa 1907. *Smithsonian Institution.*

An exquisite maiden wearing a cape, hat and original paint was part of a Gavioli band organ, circa 1910. *Stevens collection.*

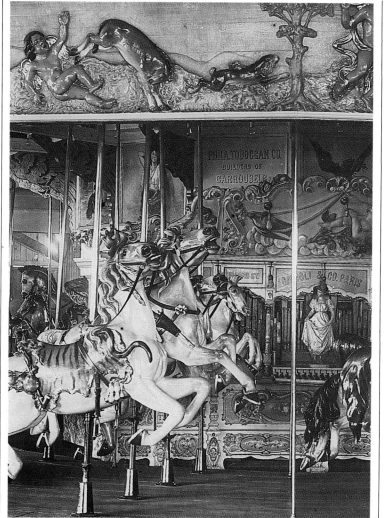

Philadelphia Toboggan Company produced elaborate machines of unparalleled architectural splendor, which sold for approximately $12,000. The four-abreast PTC No. 21 carousel pictured (below) here was installed in West Haven, Connecticut, circa 1912. *Smithsonian Institution.*

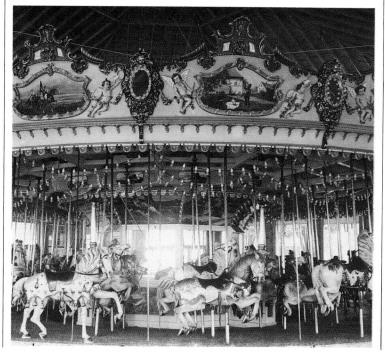

Despite the pledge for excellence, the Philadelphia Toboggan Company's style changed dramatically in 1907. The chief carver at this time is no longer known, but no more menagerie animals were produced and the style of the horses changed drastically. Inexperienced carvers were probably responsible for the alterations. Orders diminished when the horses evolved into disproportioned beasts with large heads and flimsy, weak legs. Eyes were placed high on the horses' foreheads and called attention to their too-long noses.

But during this time chariots in the PTC factory flourished. Painted with infinite care, they were extremely ornate. Shields on the armored horses during this period carried elaborate stenciled patterns and heraldic devices.

Carved figures at Philadelphia Toboggan Company leaped back into the circle of quality around 1912 when two expert carvers began working for the factory. Charles Carmel began carving figures for PTC in his own Coney Island shop. He contributed to the improved quality of carvings for PTC's carousels until 1921.

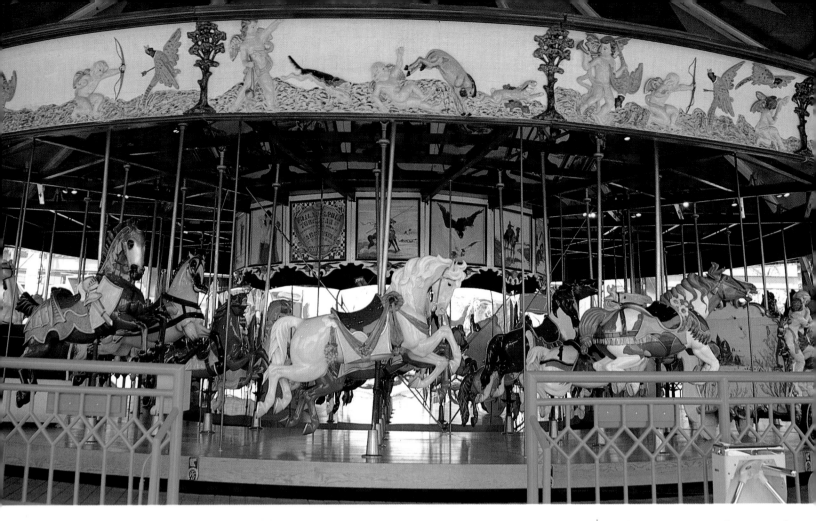

Magnificently restored by the Perrons, their friends and volunteers in Portland, Oregon, PTC No. 15 provided joy and wonderment to visitors of Expo '86 in Vancouver, B.C., Canada. *Susan Foley photo.*

PTC's No. 15 carousel is representative of the carving talent of Leo Zoller, the company's first master carver. This carousel received special attention in an effort to create highly animated, exciting carvings, especially on the outside row. This dapple gray, stretching horse with a winged cherub decorating the chest strap is an example of this change, circa 1907. *Susan Foley photo.*

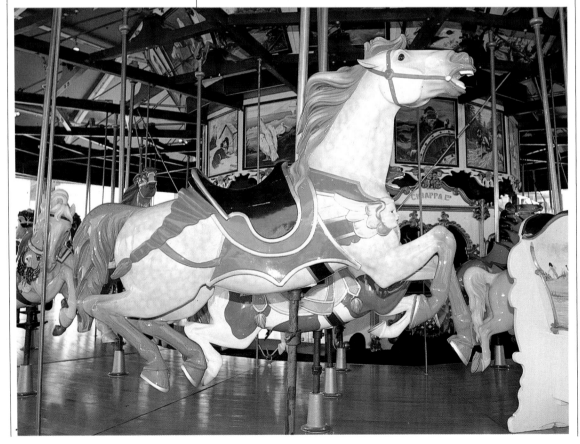

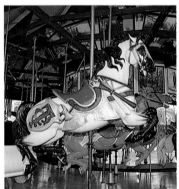

Philadelphia Toboggan Company did not permit its carvers to sign their work. But they did create many marvelous figures carrying the company's monogram, as is seen on this medieval jumper. *Susan Foley photo.*

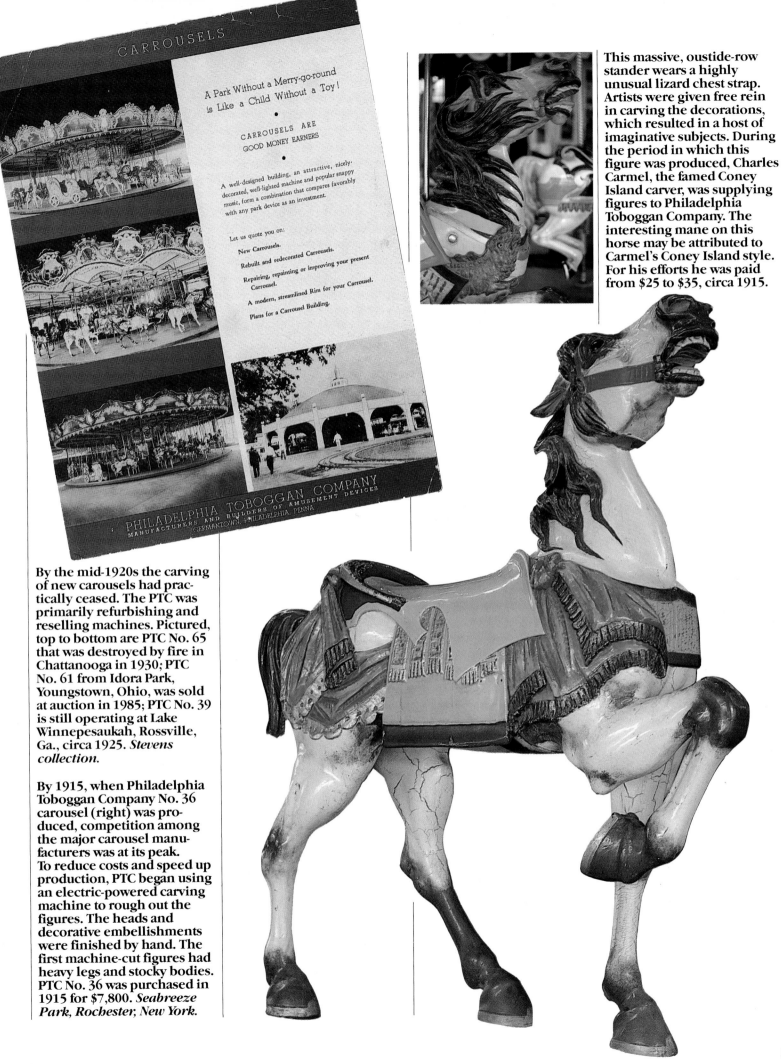

A Park Without a Merry-go-round is Like a Child Without a Toy!

• • •

CARROUSELS ARE GOOD MONEY EARNERS

• • •

A well-designed building, an attractive, nicely-decorated, well-lighted machine and popular snappy music, form a combination that compares favorably with any park device as an investment.

Let us quote you on:

New Carrousels.

Rebuilt and redecorated Carrousels.

Repairing, repainting or improving your present Carrousel.

A modern, streamlined Rim for your Carrousel.

Plans for a Carrousel Building.

PHILADELPHIA TOBOGGAN COMPANY
MANUFACTURERS AND BUILDERS OF AMUSEMENT DEVICES
GERMANTOWN, PHILADELPHIA, PENNA.

This massive, outside-row stander wears a highly unusual lizard chest strap. Artists were given free rein in carving the decorations, which resulted in a host of imaginative subjects. During the period in which this figure was produced, Charles Carmel, the famed Coney Island carver, was supplying figures to Philadelphia Toboggan Company. The interesting mane on this horse may be attributed to Carmel's Coney Island style. For his efforts he was paid from $25 to $35, circa 1915.

By the mid-1920s the carving of new carousels had practically ceased. The PTC was primarily refurbishing and reselling machines. Pictured, top to bottom are PTC No. 65 that was destroyed by fire in Chattanooga in 1930; PTC No. 61 from Idora Park, Youngstown, Ohio, was sold at auction in 1985; PTC No. 39 is still operating at Lake Winnepesaukah, Rossville, Ga., circa 1925. *Stevens collection.*

By 1915, when Philadelphia Toboggan Company No. 36 carousel (right) was produced, competition among the major carousel manufacturers was at its peak. To reduce costs and speed up production, PTC began using an electric-powered carving machine to rough out the figures. The heads and decorative embellishments were finished by hand. The first machine-cut figures had heavy legs and stocky bodies. PTC No. 36 was purchased in 1915 for $7,800. *Seabreeze Park, Rochester, New York.*

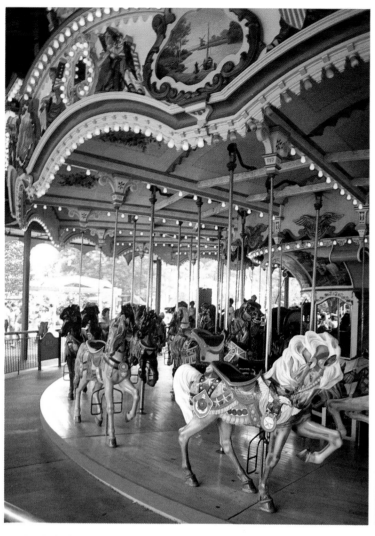

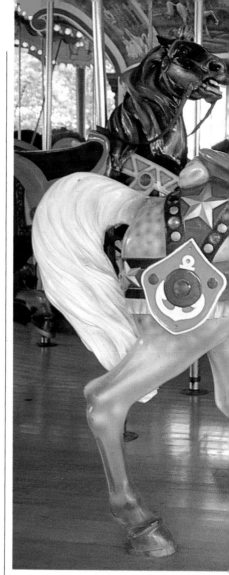

Though the carving machine was in wide use by 1919, when Philadelphia Toboggan Company's No. 47 was produced, the carousel has elaborately hand-carved figures, which indicates it may have been built on special order. These extraordinary horses were created by artist John Zalar. His expressive style was developed when he carved for Charles Looff in both Rhode Island and California. PTC so valued Zalar's carving talent that when ill health forced him to return to California in 1921, he continued to carve for the company and shipped completed horses via the Panama Canal to Philadelphia until 1923. *Hershey Park, Pennsylvania,*

John Zalar's one-of-a-kind military mount is decorated with a unique bandolier chest strap, circa 1919. *Judy Benson photo.*

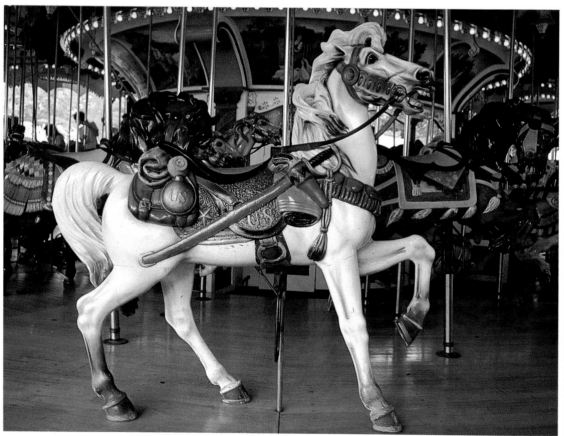

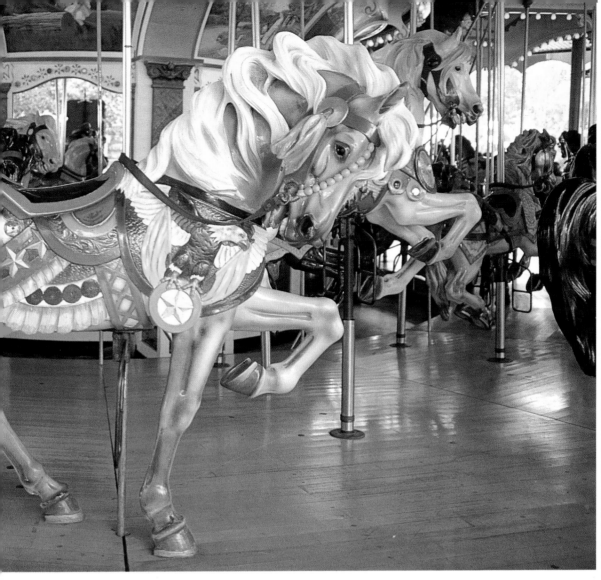

Skillfully carved hunter's kill including a fox, birds, and rabbits decorate the saddle backs of several horses on PTC No. 47. *Judy Benson photo.*

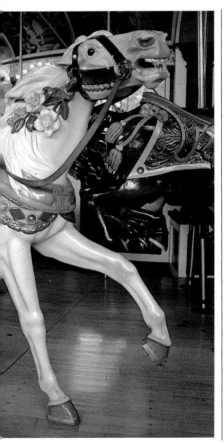

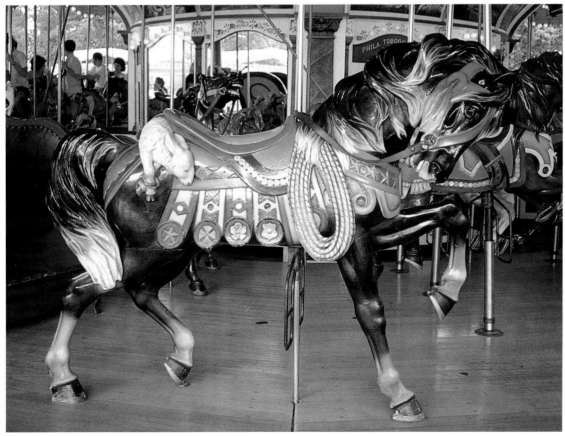

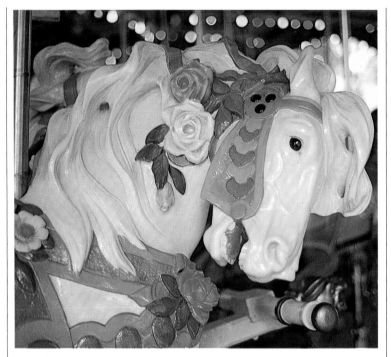

Philadelphia Toboggan Company was one of the few companies to produce a Roman-style chariot with a wrap-around front. Carousel No. 51 has two elaborate chariots with velvet upholstery and seating capacity for eight. This majestic Columbia-theme chariot is crowned with the bas-relief portrait of an Indian chief, circa 1921-28.

The most grandiose carvings on PTC's later machines were usually reserved for its armored lead horses. This elegant charger proudly carries the company's initials, circa 1921-28. *Elitch Gardens, Denver, Colorado.*

Elitch Gardens in Denver, Colorado, boasts two pairs of the most magnificent chariot horses ever carved. They may have been the work of John Zalar. PTC No. 51 carousel was ordered and begun in 1921, but was not delivered until 1928, three years after Zalar's death. *Art Swords photo.*

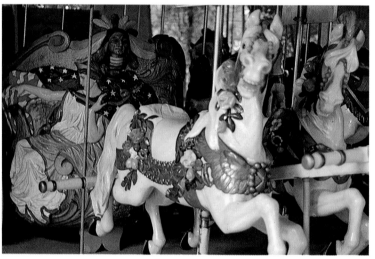

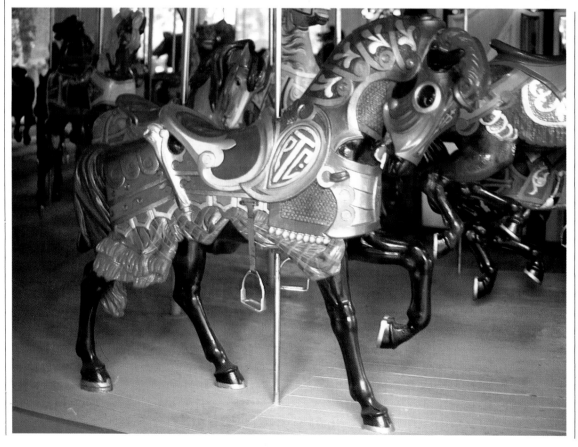

Many of the carvers developed their craft while producing religious carvings for church interiors. It is not surprising to find angels and cherubs, such as the plump character riding on the side of this chariot, as decorations, circa 1921-28. *Elitch Gardens, Denver, Colorado.*

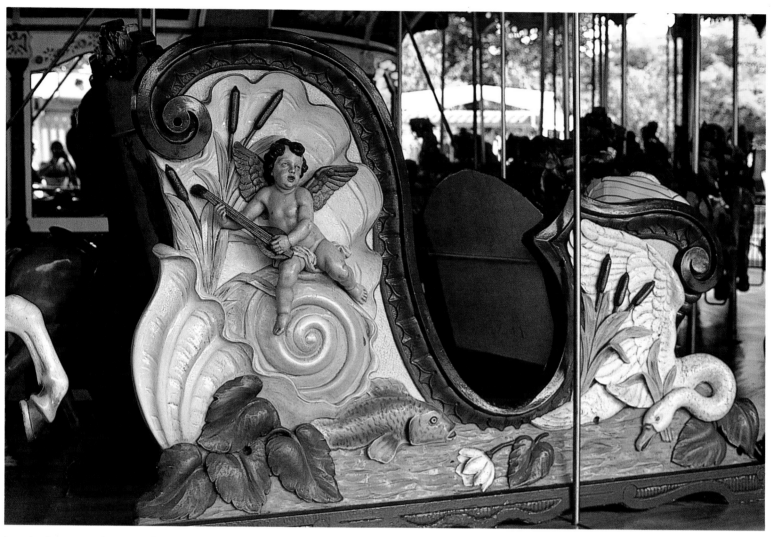

At the same time Frank Carretta from Milan, Italy, was hired at the factory. He was originally a furniture carver but did not like the business. A perfectionist, Carretta found his niche while carving carousels for the Philadelphia Toboggan Company. He not only reintroduced natural-looking horses, but he also added exciting embellishments to the entire carousel.

A catalog from 1913, approximately the time that Carretta was made foreman of the carving shop, describes the special features of the large carousels.

The pole, framework, rods and machinery are entirely hidden from view by elaborate decorations such as the dome ceiling, which is artistically painted and decorated. The eight large bevelled mirrors in panels around the machinery, with four pedestal extensions and topped off with eight fine oil paintings in concave shape. The rim on the outside of arms which is decorated with heavy carvings and mouldings, a fine oil painting in each of the eighteen sections, appropriately framed, and each joint of rim covered by bevelled oval mirror in heavy carved and gold-leafed frame.

Carretta twice won first prizes for carving at National Amusement Park conventions. In 1928 he won with a dappled charger crowned with a massive tossed mane. A medieval stallion with ornate trappings earned him another award in 1929.

Payroll books indicate that the company paid $1 to have a horse sanded in 1913 and the company's chief painter earned $95 to retouch and varnish an entire carousel. The price for carving 46 animals for one carousel in 1914 cost PTC $1,716.

Cherubs were always a popular theme. Seashells and cattails decorate a chariot on Hersheypark's PTC No. 47, which features a lute-playing angel serenading a swan, circa 1919. *Kevin Breighner photo.*

Chariots, or at least benches, appeared on the earliest carousels. They were provided for ladies and children, too timid or young to straddle the animals on the platform. Cherubs were among the most popular themes used by the chariot carvers. Puyallup, Washington is the home of this PTC portable carousel. *Jim and Sara Hennessey photo.*

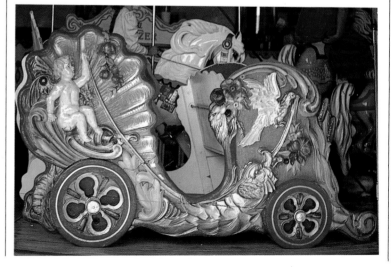

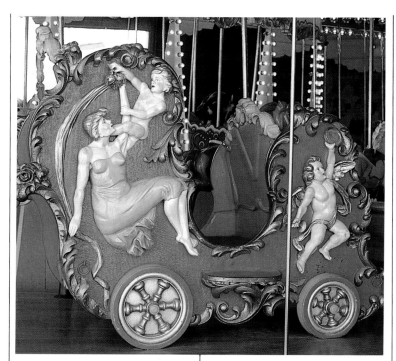

Women and cherubs were another popular combination among carousel carvers. This early chariot is on board Philadelphia Toboggan Company's No. 19 at Old Orchard Beach, Maine. Passengers had to use a step to enter this high-sided creation, circa 1910.

A later and more elaborately carved slab-sided chariot, depicting a woman-and-cherub scene, was last on board Philadelphia Toboggan Company No. 59 in Panama City, Florida, circa 1922.

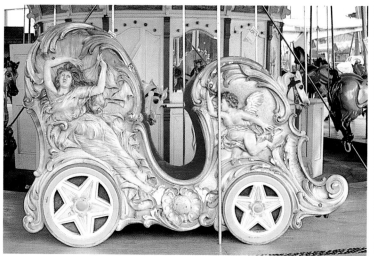

This grand chariot, with its beautiful Columbia-theme carvings and PTC monogram, was photographed in 1985 at Panama City, Florida, on the day of its final ride.

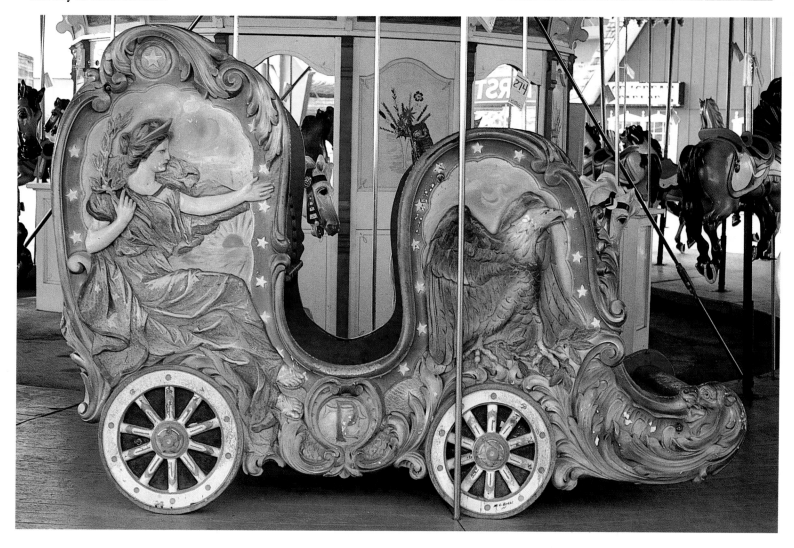

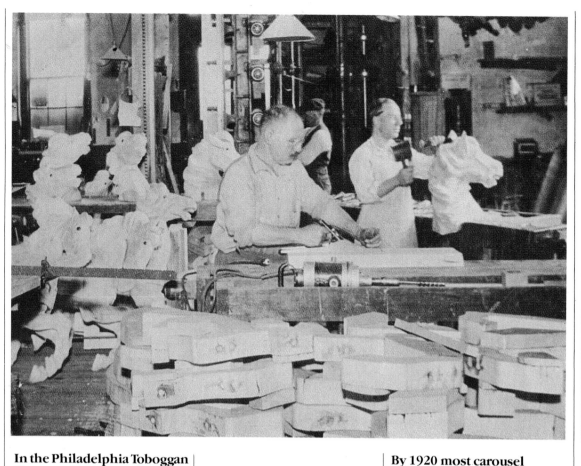

In the Philadelphia Toboggan Company's carving shop, carver Salvatore Cernigliaro, on the far right, applies finishing touches to a horse's head, circa 1922.

By 1920 most carousel manufacturers were using the carving machine. The device uses a finished head as a pattern and four grinders cut away excess wood to make duplicates. Bodies and legs were made in the same manner.

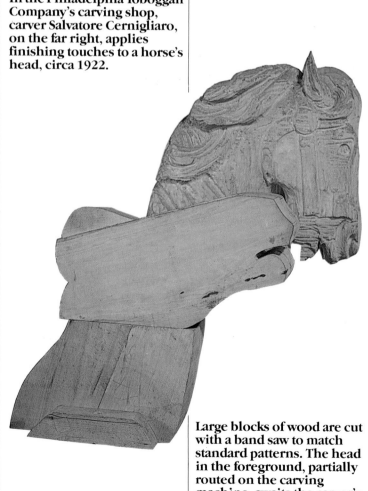

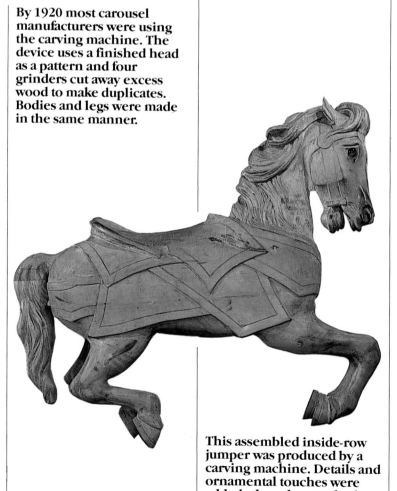

Large blocks of wood are cut with a band saw to match standard patterns. The head in the foreground, partially routed on the carving machine, awaits the carver's finishing touch.

This assembled inside-row jumper was produced by a carving machine. Details and ornamental touches were added when the roughed-out figures were finished by hand.

A skilled sculptor from Austria was hired in 1915. John Zalar spent five years with the Looff factory before a series of family problems led him to change employers. His successful crossover between the Coney Island and Philadelphia companies shows how easily the styles intermingled and blurred differences.

Before Zalar joined the great wave of European immigrants to America, he had done Austrian church sculptures in wood, marble and plaster. In New York, where he first settled, he sculpted a large crucifix for a church in Brooklyn and designed ornamental ironwork. Zalar's association with carousels began in 1911 when he moved his family to Rhode Island and began carving in the Looff factory.

Looff, the Coney Island pioneer, lured Zalar to the West Coast in 1914. But Zalar had worked at the new Looff factory only a year when his wife Johanna died suddenly, leaving him to care for six children. He returned to New York, remarried and was hired by Philadelphia Toboggan Company in 1915.

Zalar worked in the PTC factory for five years, adding the Coney Island penchant for elaborate decorations to the carousel figures he carved. In 1920 at the age of 46 Zalar was advised by his doctors to move to a warmer, drier climate to combat his worsening tuberculosis. A sick man, Zalar worked at home in California and sent completely hand-carved horses to Philadelphia Toboggan Company until 1923. Two years later the carver, highly valued by manufacturers of two different carousel styles, died.

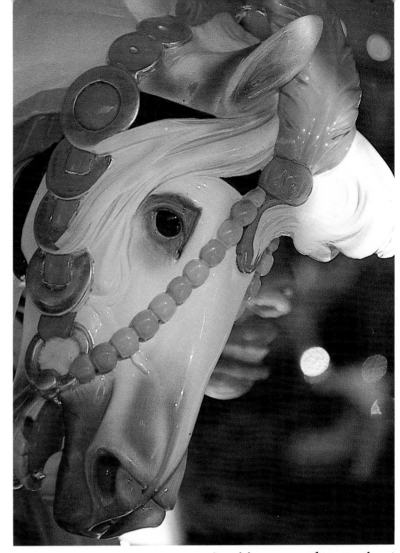

Though the simpler, less expensive figures produced with the carving machine were very popular, elaborate hand-carved creations were produced for special orders. These statuesque outside-row figures include a rare armored horse, with, surprisingly, a Texas longhorn decorating its hip. These carvings by John Zalar were on board PTC No. 65 at Riverview Park, Des Moines, Iowa. The carousel was later destroyed by fire in 1930 at Chattanooga, Tennessee, circa 1923. *Smithsonian Institution.*

Sensitive eyes and romantic decorations characterized the noble carvings by John Zalar. This exciting figure rides the Philadelphia Toboggan Company No. 46 carousel in Disneyworld, circa 1918. *Dianne Owens photo.*

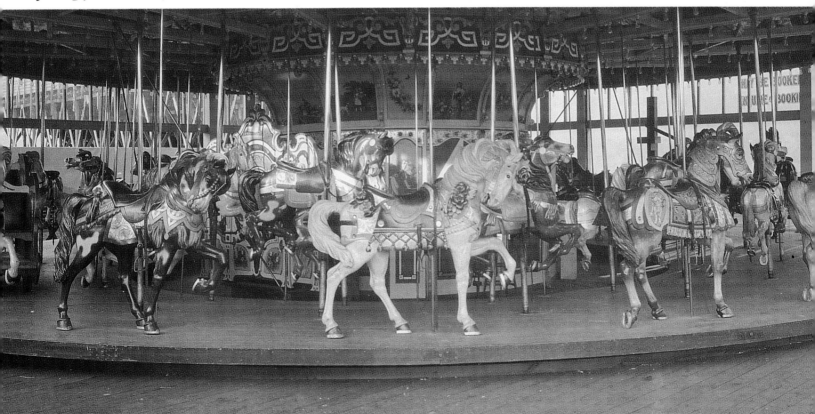

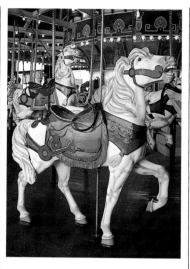

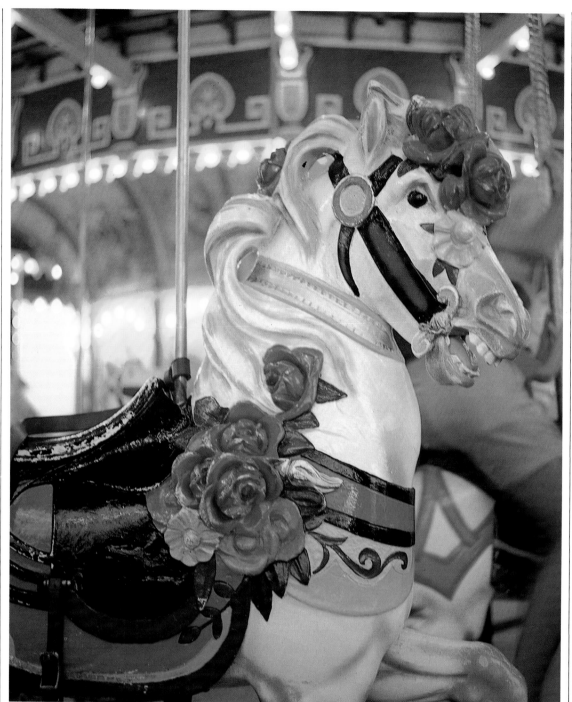

After 1925 Philadelphia Toboggan Company ceased carving new carousel figures. Only carver Frank Carretta and painter Gustav Weiss were left to create carousels by refurbishing and adding new decorations to old stock. PTC No. 75 may have been created in this fashion. An enormous floral bouquet decorates the forelock of the carousel's massive lead horse, circa 1926. *Ocean City, New Jersey.*

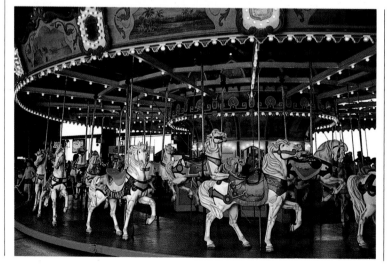

After 1925 Philadelphia Toboggan Company had only two full-time carousel employees on the payroll. Carretta, the carver, along with G. Weiss, a painter, created new machines from old stock, carving new decorations and refurbishing old machines. The company produced 10 such machines before halting carousel manufacturing in 1933.

When Philadelphia Toboggan Company bought the Dentzel factory in 1929, it hired many of the employees that had been working for its competitor. Ten years earlier Samuel H. High, in association with John R. Davies and Arnold Aiman, bought all of the PTC stock. The company is still in business today as a "ski-ball" game manufacturer under Samuel High III.

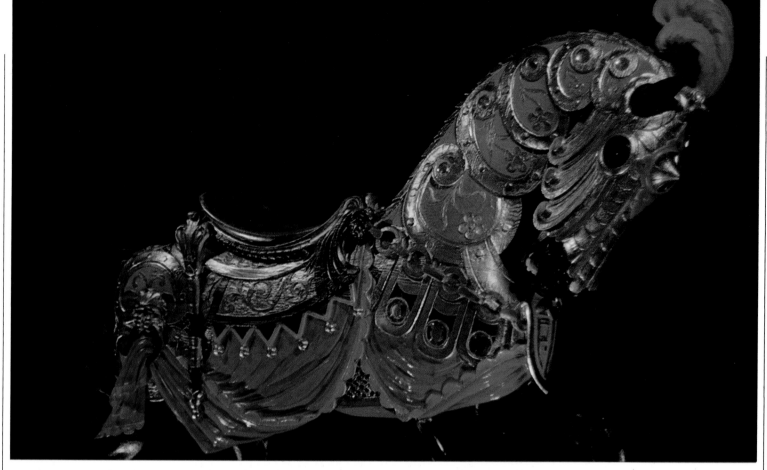

Fewer than 3 percent of the thousands of carousels that once populated American amusement centers have survived. Fire and neglect have destroyed the majority of these pleasure machines. Natural disasters — floods and storms — have also taken their toll. Many amusement parks, constructed on picturesque riverbanks, were at the mercy of devastating floods. An example is the carousel at Coney Island in Cincinnati, Ohio, which was submerged by the great flood of 1937. Various parts of the carousel horses came unglued during the submersion. Some of the animals and their parts escaped and floated down river. According to reports of the time, the park offered a reward for the return of the horses and some were recovered as far away as Memphis, Tennessee. Doubtless the scene of park employees sorting heads, tails and legs was a macabre sight. Ed Schott, then the park's general manager, often delighted in retelling the story of how the count of tails and heads came out uneven. The carousel (PTC No. 79) is now at King's Island Park in southwestern Ohio. *Steve Hill, Rivergate Productions photo.*

For PTC's 25th anniversary, Frank Carretta carved this dramatic display figure, which won a carving award at the 1929 convention of the National Association of Amusement Parks. *Tina Veder photo.*

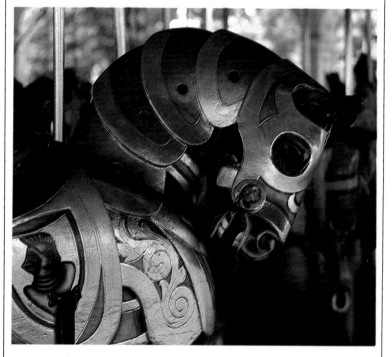

PTC's most splendid creations were its armored horses, circa 1926. *Kings Mill, Ohio, David Manns photo.*

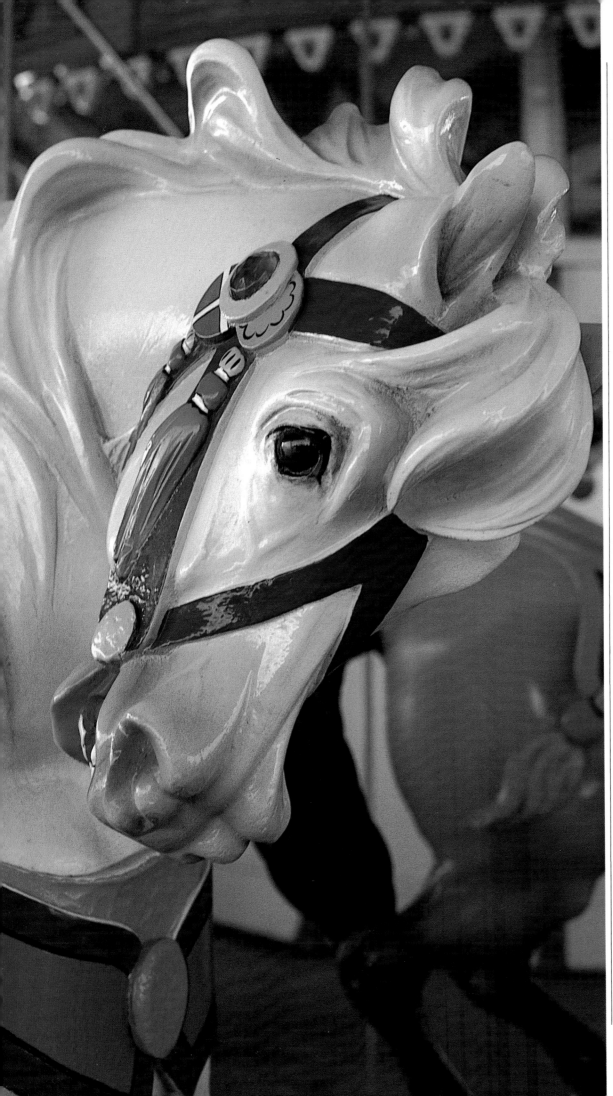

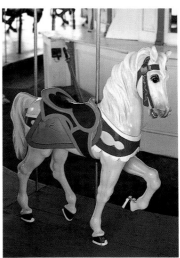

The carving machine created more sophisticated inner-row horses. This cute inside stationary pony was provided for small children, circa 1922.

The tucked head, stylish pose and romantic trappings characterize the fanciful work of carver John Zalar. He created the most memorable figures of Philadelphia Toboggan Company's later carousels. These gorgeous horses were last on board PTC No. 59 in Panama, City, Florida, circa 1922.

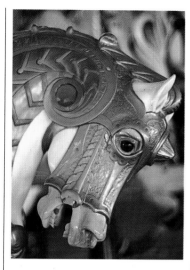

John Zalar gave his horses spirited animation by his sensitive attention to the eyes. The warm, appealing expressions he created could not be lost, even under elaborate facial armor, circa 1922. *Santa Monica Pier, California.*

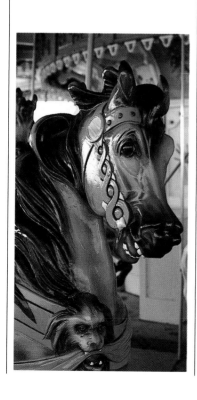

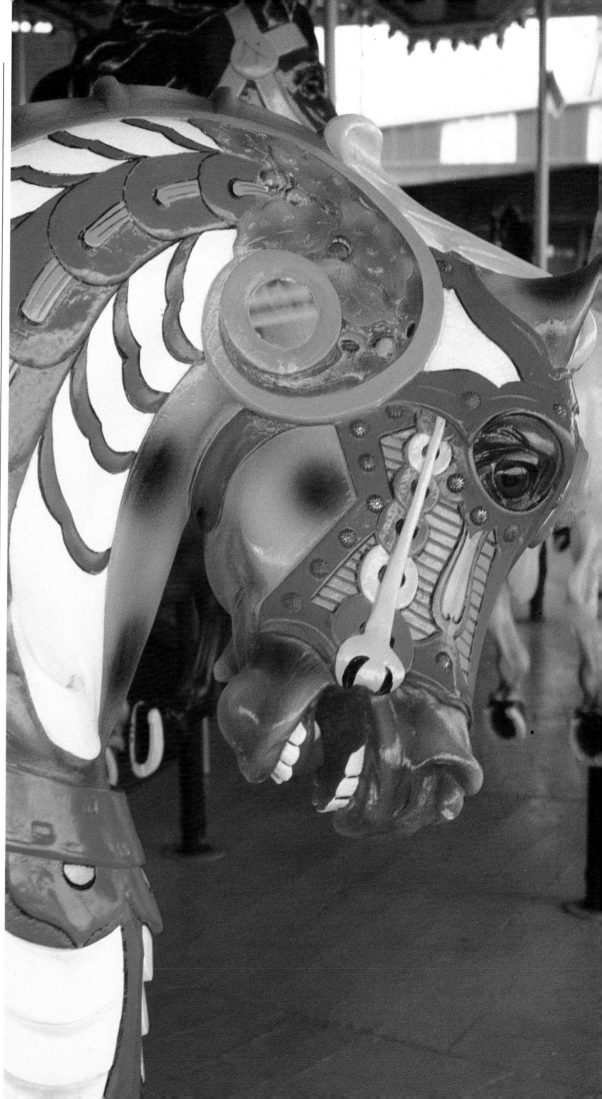

The
CONEY ISLAND
Style

Coney Island horses, with manes flying, charged through the imagination of eager riders, stirring up fond dreams and thrilling visions. The ocean-front amusement park in Brooklyn, New York, that gave this style of carousel its name set a pace of unprecedented delight—a pace the carvers adopted with their prancing animals.

Along Coney Island's two-mile beachfront, amusement rides, games, entertainment, bath houses and food stands selling popcorn, ice cream, hamburgers, hot dogs, beer and saltwater taffy competed for the attention of the pleasure-seeking crowd.

As time and money freed Americans to pursue leisure activities, more and more people swarmed to the entertainment center. Included in the wave of humanity that surged to the resort area was a steady stream of skilled immigrants ready to build spectacular attractions. From the onset, Coney Island was a land of enchantment with exotic shows providing entertainment and brightly lit towers, domes and minarets scrambling the skyline.

Tumbling gold-leaf manes crown typical Coney Island-style carousel horses. Menagerie animals, a part of the Coney Island carousel from the beginning, and horses were painted with realistic body paint. But unusual objects—cherubs, rose garlands, frogs and eagles—peeked from under saddles or arose from painted hides.

Generalizations rarely stick to descriptions of North American carousels, but Coney Island carvers often aimed for a flashy effect. Of the three carousel catagories, Coney Island animals exhibited the most fanciful or romantic ideals. Skilled craftsmen took ornamentation to the edge of reality, and they did not sacrifice quality in workmanship.

The benchmark for excellence in Coney Island carousels was the "Fabulous Feltman." Charles Feltman, originator of the famous American "hot dog," installed Looff's second carousel on the grounds of his restaurant complex around 1880. It was the largest restaurant in Coney Island and by 1920 could serve a thousand patrons a day. The carousel installed there proved to be wildly successful.

No one carousel builder can claim sole responsibility for the unparalleled beauty of this celebrated landmark. The original carousel, built by Looff, was partially burned at the turn of the century. The owner then commissioned two perfectionists—carver Marcus Charles Illions and amusement ride manufacturer William F. Mangels—to rebuild the damaged machine. Salvaged Looff animals were incorporated into the reconstructed carousel although Illions' replacements were more dramatic than the originals. Illions had worked for Looff when the carousel was first built, though, and very likely carved many of the original figures.

On the original carousel, Looff had buried light sockets within the outside horses' bodies. He bored holes into the sides of the animals and put a light bulb in the center. Multi-colored jewels covered the holes and were incorporated in the carved trappings. As these gems with their inner glow rotated with the carousel, they treated spectators to a sparkling parade.

Illions retained this feature on the outside horses that he added, but no other carousel adopted the unusual device. Like the ill-fated, two-tiered carousels built and abandoned by Philadelphia-style manufacturer Gustav Dentzel and Coney Island pioneer Looff, glowing, electrified jewels were creative but an impractical idea.

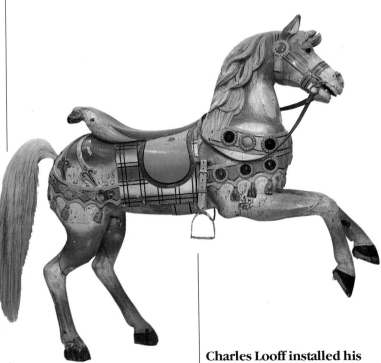

Charles Looff installed his first carousel at Coney Island in 1876, the year America celebrated its centennial and Custer was massacred. Because this amusement was so successful, Charles Feltman commissioned Looff to build a carousel for his Ocean Pavilion. This machine had the unique feature of electric lights embedded in the sides of the horses, circa 1880. *Summit collection.*

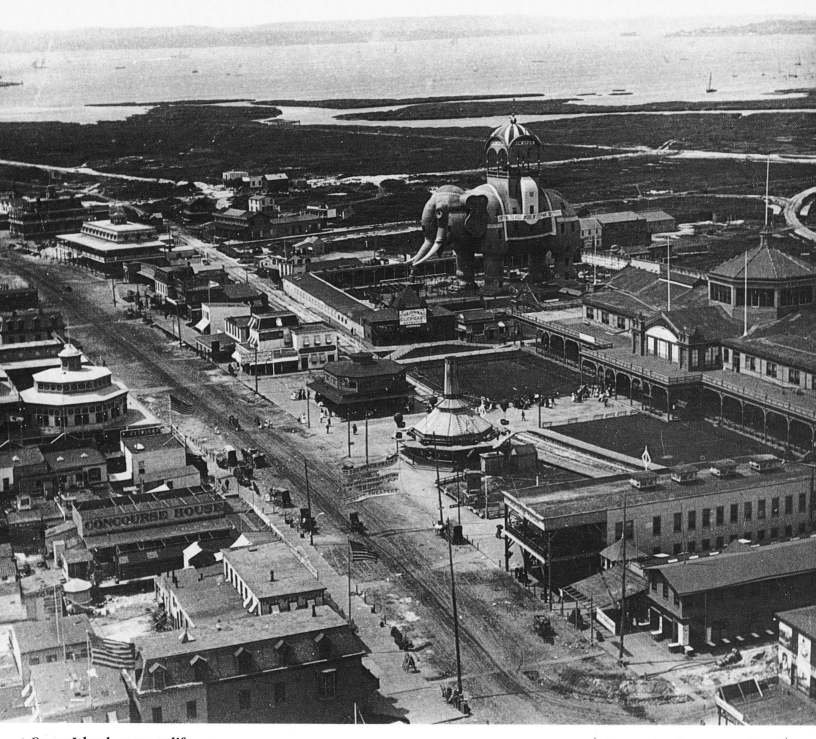

Coney Island sprang to life at the end of the Civil War, when George Tilyou built a hotel on the beach. Once the trolley lines were installed, making inexpensive travel available to New York's growing middle class, many restaurants and amusements sprang up. The tin-skinned Elephant was 122 feet high and contained shops and hotel rooms. The bizarre building was inspired by the success of P.T. Barnum's Jumbo. The 20-foot-diameter legs held a cigar store and spiral staircases. Four carousel buildings are shown in this photograph, circa 1897.

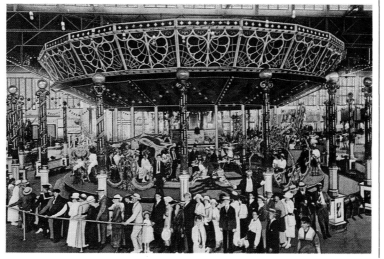

Devastating fires occured every few years, prompting the perpetual rebuilding of Coney Island which included many amusement areas, such as Dreamland, Steeplechase Park and Luna Park. After each fire, grander, construction arose, much like the mythical Phoenix. The El Dorado carousel, with handsomely carved horses, pigs, ducks and gondolas, had been imported from Germany, where it was originally built as an amusement for William II, Emperor of Germany. His royal seal adorned one of the chariots. *Stevens collection.*

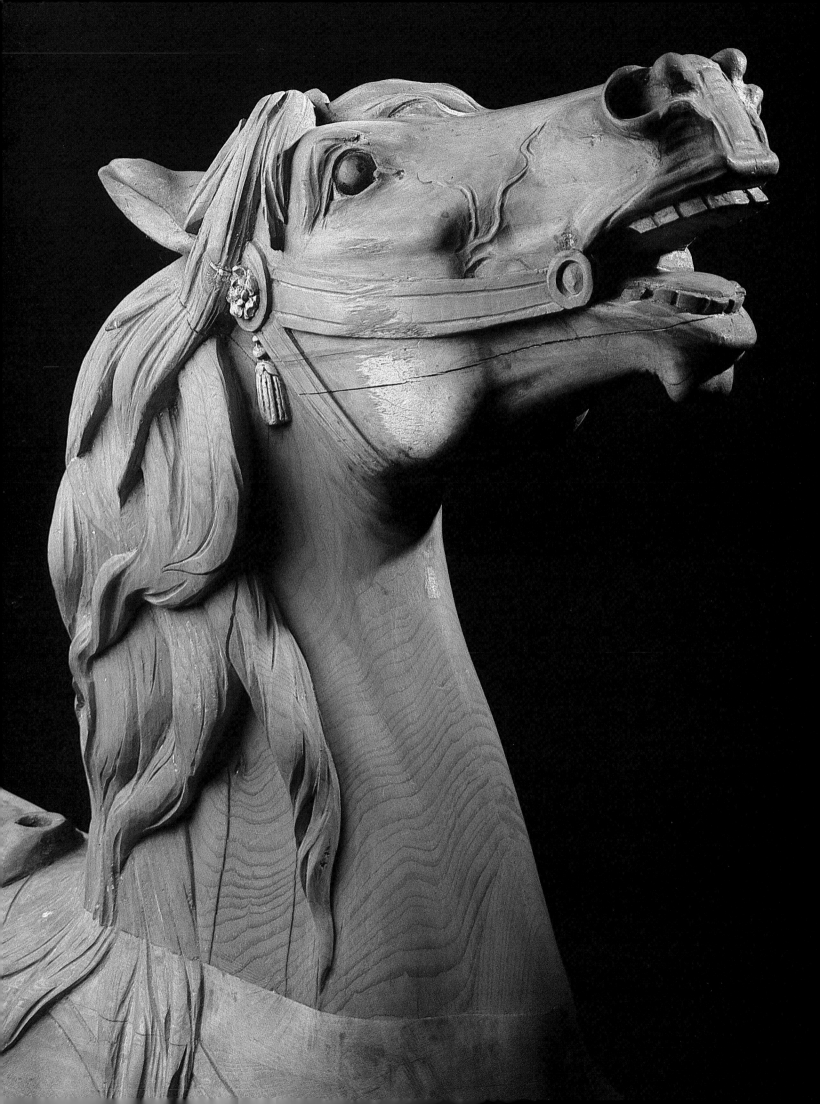

An exquisitely carved bird on the back of this expressive outside-row stander served not only as decoration, but also as support for the saddle back. The chest strap is festooned with a plaster composition of rosettes and tassels. Looff later discovered that these were easily broken off and he began carving them in wood. The horse was last on board a carousel in Salem Willows, Massachusetts, circa 1900. *Sardina collection.*

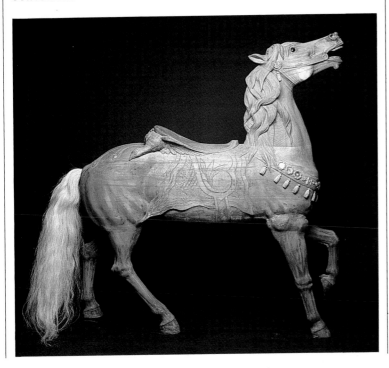

Charles I.D. Looff showed other carvers and manufacturers that Americans were ready to welcome carousels into their hearts. He is credited with installing the first carousel at Coney Island in 1876, the year of America's centennial celebration. This carousel, located on the grounds of Balmer's Bathing Pavilion at the intersection of West Sixth Street and Surf Avenue, offered camels, zebras and ostriches along with the standard horse figures.

Looff's second carousel, installed at Coney Island in the Feltman restaurant complex around 1880, became a landmark for the famous amusement park. A furniture carver from an area between Germany and Denmark called Schleswig-Holstein, Looff built his first three carousels entirely by himself. The third was erected at Young's Pier in Atlantic City, New Jersey.

Success with his first machines encouraged Looff to open a carousel factory. By 1890, he employed four carvers in the shop on Bedford Avenue in Brooklyn, New York. His oldest son, Charles Looff Jr., later worked designing chariots and saddle packs in the same factory.

Looff usually gave his horses pleasant, friendly faces, which often showed several teeth in a smile. He varied the color and ornamentation on saddles and trappings and made each horse different. He used a picture of George Washington astride a favorite horse as a model for the stances he gave his carvings. Like many of the new Americans arriving in the new land, Looff was extremely patriotic. Proof can be seen in his abundant use of a flag motif in the carvings and portraits of American heroes and statesmen gracing the rounding boards of his machines.

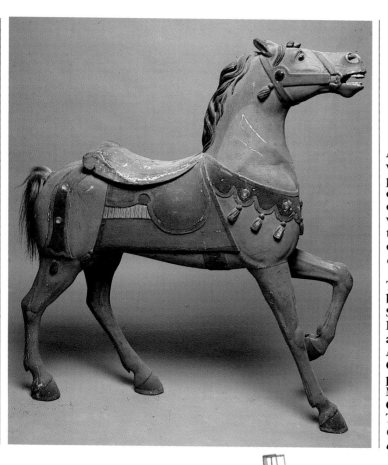

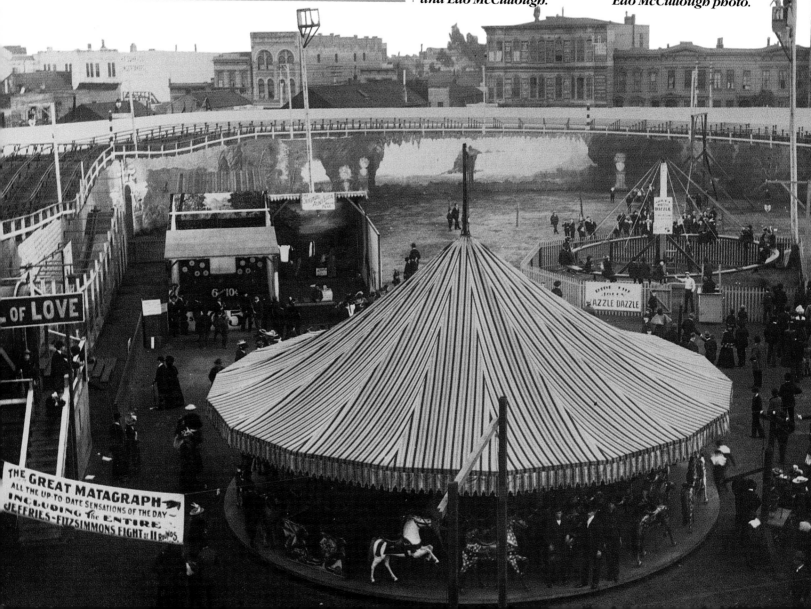

An outside-row stander, wearing a coat of old park paint, retains the folk-art charm found on Looff's early carousels. The trappings were very simple in the tradition of early German carvings, circa 1885. *Beerman collection, Jeff Saeger photo.*

This season pass was signed by George Tilyou for his Steeplechase Park in San Francisco, California. Tilyou also built a steeplechase at Atlantic City, New Jersey, and Coney Island, New York. The pass was presented to James McCullough, a well-known Coney Island showman and Tilyou's cousin, circa 1899. *Courtesy Marianne Stevens and Edo McCullough.*

One of Looff's early carousels operated at Steeplechase Park in San Francisco, California. The menagerie machine had horses on it similar to the one pictured above. All carousels at this time had stationary figures. In the background, the famed steeplechase track and a strange ride called the Razzle Dazzle, built by the McCulloughs of Coney Island, are visible. This park was destroyed during San Francisco's 1906 earthquake and the site is now part of the Moscone Convention Center, circa 1899. *Marianne Stevens, Edo McCullough photo.*

This early hippocampus is attributed to Charles Looff, who populated his second machine with these half-horse, half-fish creatures. The carving is almost identical to the pug-nosed pony, below, and may have been a horse that had its legs replaced by a set of fins.

The hippocampus, which is wearing a beautiful patina of old park paint, may also have been a prototype, circa 1880. *Summit collection.*

These petite inner-row figures were placed on Looff's early machines. Carved in a simple hobbyhorse style, both have beguiling, friendly faces. They were carved especially to attract children. Looff had begun to develop asymmetrical poses — one ear forward and one back or one hind hoof raised — to create animated stances for his stationary figures. They were part of a carousel that was moved around 1910 in Pennsylvania from Barnesville to Muncie, circa 1882. *Perron collection.*

The carousel builder put camels, deer, greyhounds, ostriches, storks and other animals on his machines. He also used pairs of panthers to pull small chariots. Many of the menagerie animals leaving the factory were carved by Looff and their proportions were pleasing and natural. Most of the carvers that Looff employed were also skilled craftsmen. The result was that realistic, finely carved pieces were consistently produced in the factory, no matter which group of employees was working on them.

In 1895, Looff set up his showcase carousel at Crescent Park in Rhode Island. Now, 90 years later, people are still scrambling atop the richly decorated horses that carried riders in days past. The restored carousel with 62 horses and four chariots is one of only 13 Looff carousels still in operation today.

Constant improvements changed the look of this machine from year to year, but it always displayed Looff's attraction to sparkling mirrors, glittering jewels, gold and silver leaf paint and lavish ornamentation. The four-abreast machine was housed in a domed building with stained glass windows that drenched the ride and riders with rainbows. Providing the necessary carousel sound was a magnificently carved band organ constructed by A. Ruth and Sohn in Germany. The gilded and white carousel was an exuberant exhibition of Looff's skills.

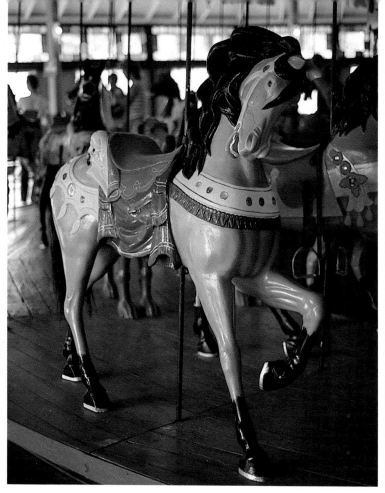

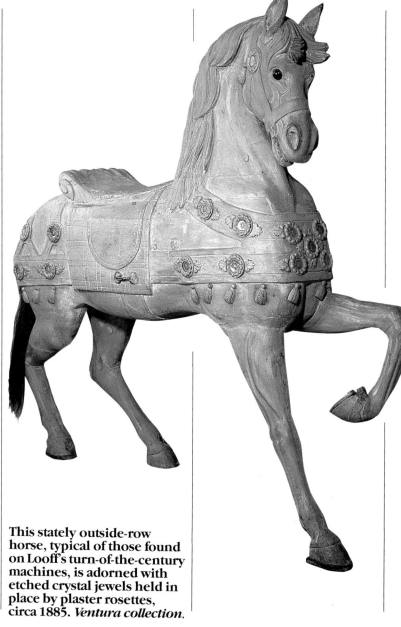

An exciting outside-row horse with a tossed head comes from Looff's Slater Park carousel in Pawtucket, Rhode Island. By the time this figure was carved, Charles Carmel and Marcus Illions had started working as freelance carvers in the Looff shop and the poses became more realistic and animated, circa 1895.

An early Looff stationary carousel with an ample supply of eager customers was photographed in Dallas, Texas, circa 1895. *Wilda Taucher photo.*

This stately outside-row horse, typical of those found on Looff's turn-of-the-century machines, is adorned with etched crystal jewels held in place by plaster rosettes, circa 1885. *Ventura collection.*

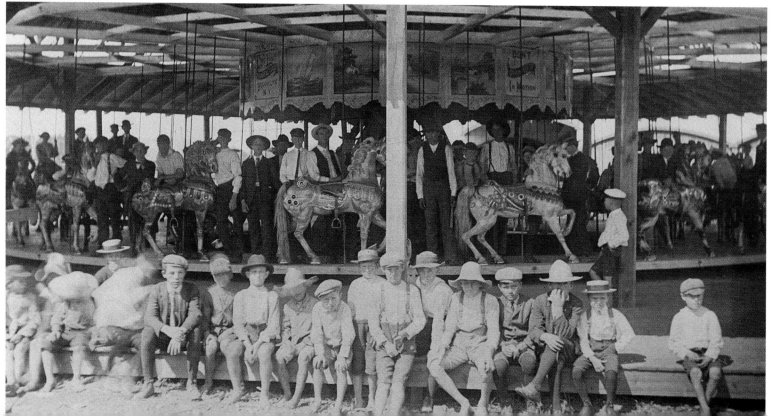

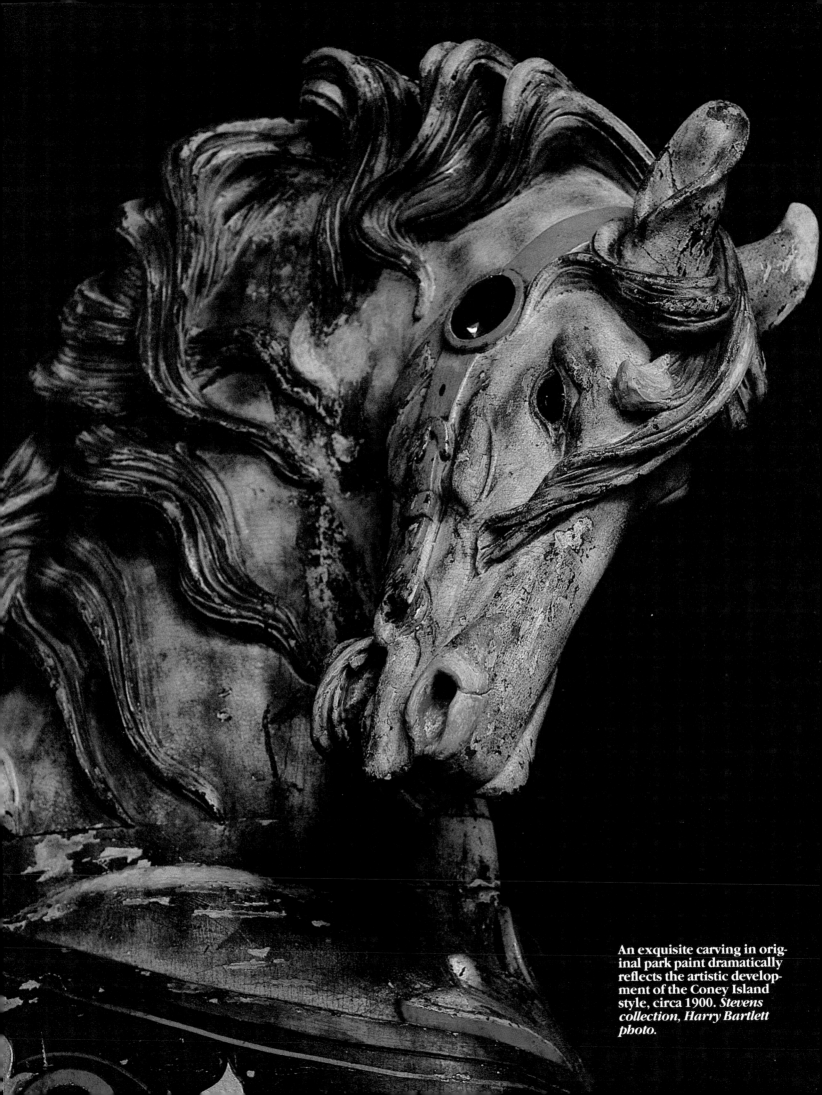

An exquisite carving in original park paint dramatically reflects the artistic development of the Coney Island style, circa 1900. *Stevens collection, Harry Bartlett photo.*

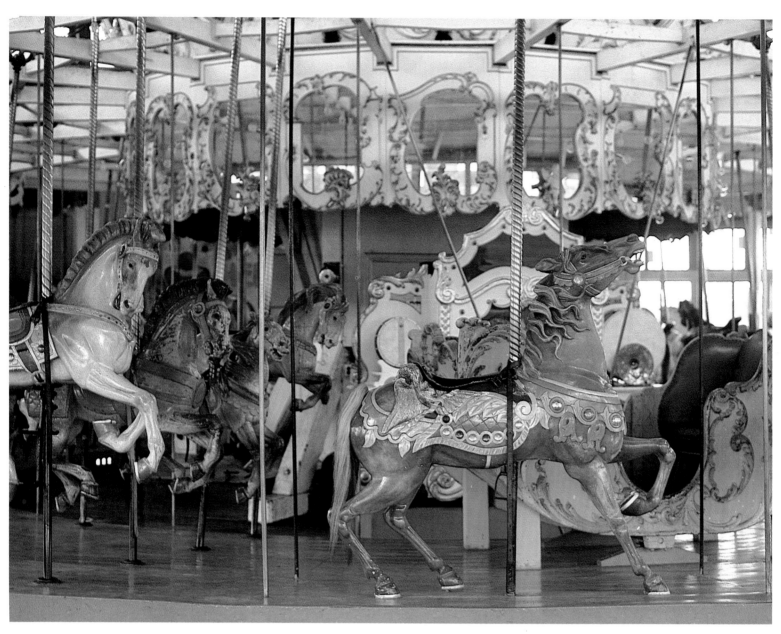

Crescent Park at Riverside, Rhode Island, became the site of Looff's showpiece carousel. The machine was constantly upgraded with new figures and mechanical improvements, including the overhead jumping mechanism added in 1905.

Looff used myriad secondary carvings under the saddle cantles. This regal lion carving rides on the back of one of his armored horses on the Crescent Park carousel, circa 1910.

The eagle saddle decoration, popular with many carvers, originated with Looff in the late 1890s.

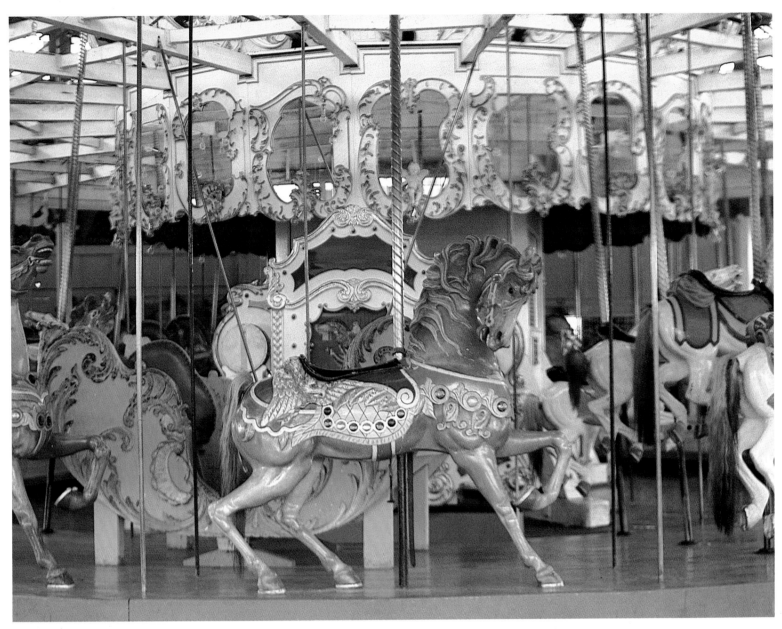

Crescent Park carousel at Riverside, Rhode Island, was used as an operating showroom, where prospective customers could select figures that they wanted included on their carousels. From 1876 to 1916 Looff built approximately 40 carousels and owned and operated several of them, circa 1900.

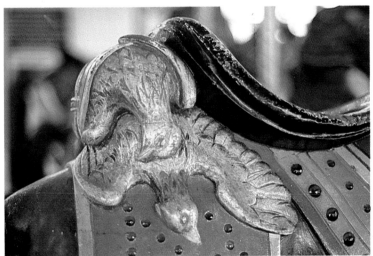

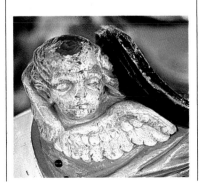

Looff's later carvings often carried cherubs on the trappings.

The hunter's kill, a popular decoration, often showed birds, foxes, rabbits, and even lambs hanging from the saddle.

BUY TICKETS
CASHIER BOOTH

109

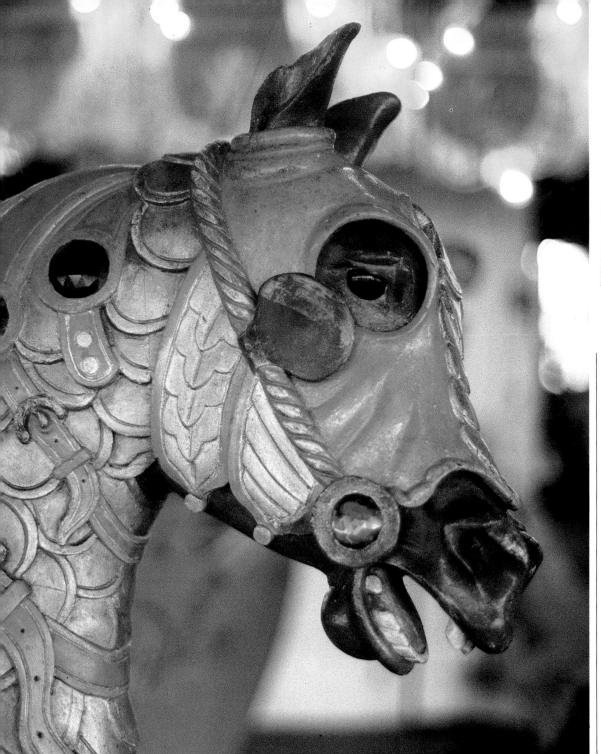

Several of Looff's early carousels had patriotic scenery panels and shields covered with the portraits of American presidents. This restored shield adorned with President Ulysses Grant was on a turn-of-the-century carousel. *Tony Orlando restoration, Tim Hunter photo.*

A unique armored stander from Looff's Crescent Park carousel at Riverside, Rhode Island, was carved with a cloth-like face mask and an unusual blinder attached to the bridle. It may have been carved as a prototype and abandoned for the more traditional and popular plated armor, circa 1895.

The origin of the armor-clad carousel horse is unknown, but it is likely that it originated in the Charles Looff shop. Early carousel manufacturers, in competition for the amusement ride nickel, added a wide assortment of menagerie figures to enhance the excitement on platforms that carried only stationary animals. This may have led to the creation of the armored steed. It has also been suggested that Looff's own children were thrilled by the knights of the King Arthur stories. This partially armored horse is one of the earliest known to exist. Originally it had a hair tail and its rear legs were in a stationary pose before it was adapted to the jumping mechanism, circa 1891. *Perron collection, Susan Foley photo.*

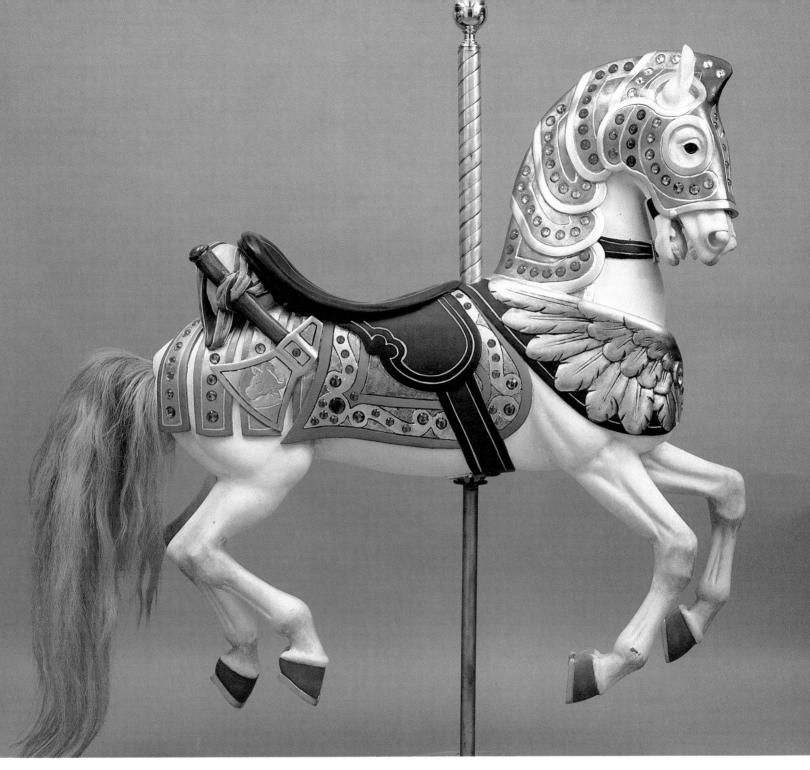

After the jumping mechanism was introduced, the proportions on Looff's figures changed, with the backs becoming shorter and the heads become more interesting and exciting. This armored horse was one of his most popular styles and was carved with a variety of head positions and secondary carvings, including a magnificent winged chest plate, circa 1910. The carousel it was on last operated at Ocean Beach Park, New London, Connecticut. *Stevens collection, Harry Bartlett photo.*

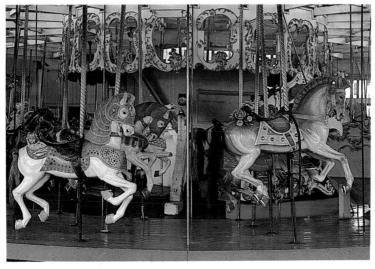

A pair of armored jumpers gallop around Looff's Crescent Park carousel at Riverside, Rhode Island.

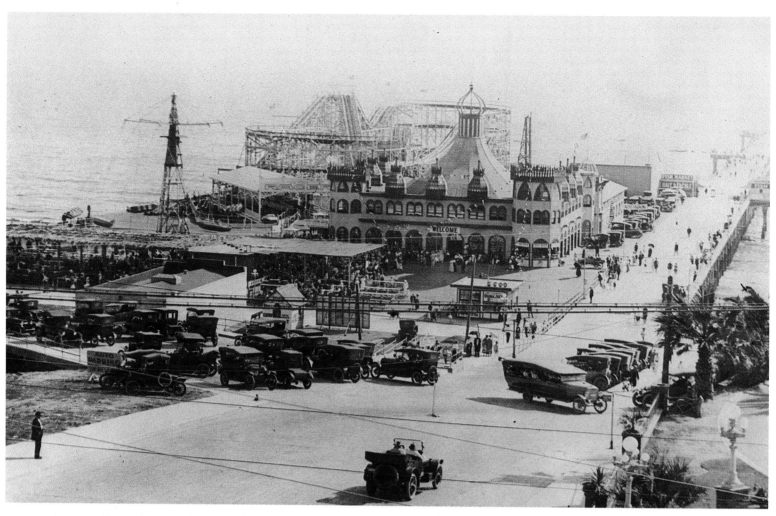

In 1905, Looff moved his entire business out of Brooklyn after a dispute with the city over his land. The City of New York condemned the property on which Looff's factory stood in order to build a park. He relocated near the Crescent Park carousel in Riverside, Rhode Island.

John Zalar, a talented sculptor had joined Looff's factory by this time and he accompanied Looff in the move. During this time business boomed as orders for carousels increased, and Looff expanded into the production of other amusement rides and fun houses. Catering to the comfort of the spectators, Looff usually lined the area around his carousels with rows of rocking chairs. By sharing the cool shade cast by the roofs over his carousels with hot, weary carnival goers, Looff had an appreciative audience to listen to the marvelous band organ music and admire his creations.

Although he was an excellent carver, Looff probably stopped working in the factory in 1909 and devoted most of his time to administrative duties. By now a self-made millionaire, he decided to expand his business by moving his operation and family to California in that same year. Near the harbor at Long Beach he set up his factory and installed a West Coast showpiece to rival the carousel in Crescent Park. He and his wife Anna Dolle, who raised the couple's six children, lived in apartments in the second story of the accompanying hippodrome on the Pike at Long Beach until their deaths in 1918 and 1930, respectively. From the new location, which was large enough to hold five completed carousels, Looff also built hippodromes to house his carousels and giant roller coasters that were installed all along the west coast of the United States.

After the turn of the century, Looff spent less time in the carving shop and more time managing his growing amusement park empire. In 1910 he moved his operation to Long Beach, California, and built a series of amusement centers along the West Coast, including locations in Seattle, Washington, and Santa Cruz, Long Beach and Santa Monica, in California. He chose the Santa Monica site, pictured above, because he wanted a place "with good transportation — a popular beach frequented by a high class people." This center turned out to be one of his most popular parks, circa 1915. Wilda Taucher photo.

Santa Monica Pier is still the home of a hand-carved carousel. Since 1947 it has housed Philadelphia Toboggan Company's No. 62 machine. The entire pier and carousel have been restored recently. Looff's original Santa Monica Pier carousel was later operated at Belmont Park, San Diego, California, and was sold piecemeal in the late 1970s.

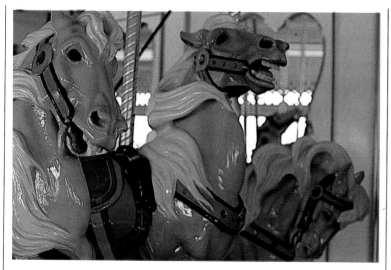

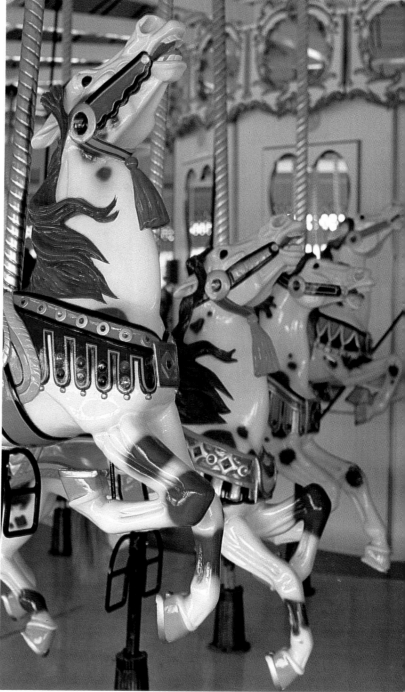

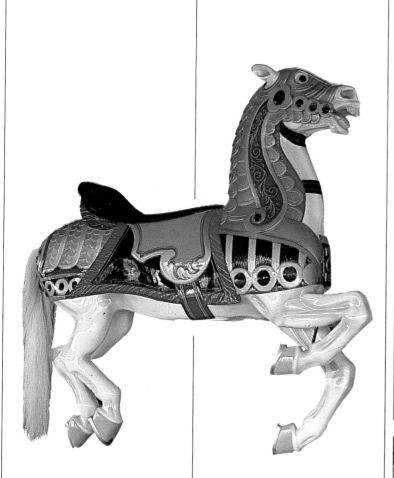

Looff set up his West Coast factory at Long Beach, California. A beautifully restored menagerie carousel, which previously operated at Whitney's Playland in San Francisco, California, has been installed there. This machine has a thrilling mixture of jumping giraffes, goats and camels and a magnificent assortment of horses that typify Looff's later style. Charles Carmel was working for Looff during the time this carousel was made and it carries carvings similar to that artist's works, circa 1905. *Shoreline Village, Peter Clark photo.*

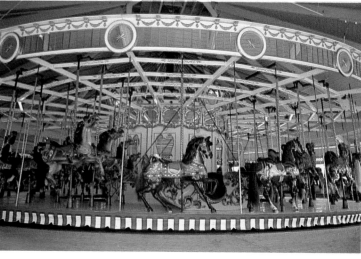

113

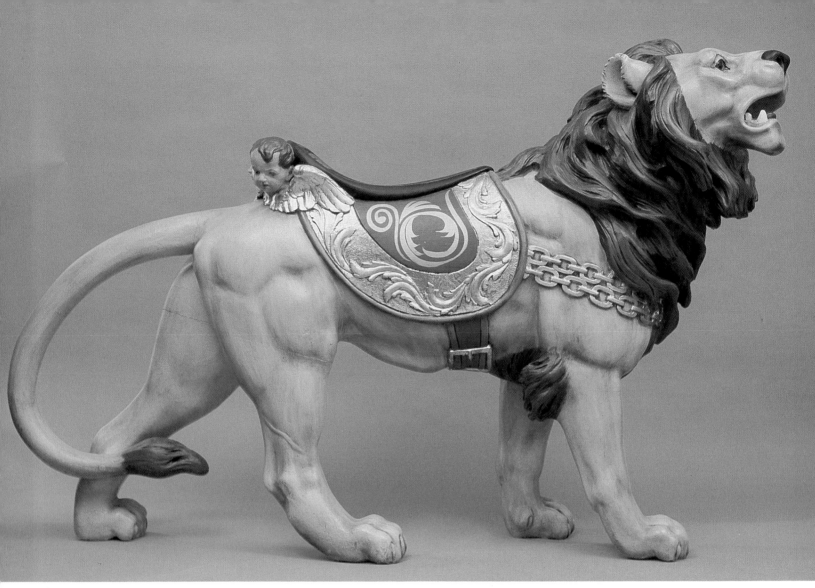

This small, but powerful Looff lion has exquisite cherubs decorating its saddle. It was last on board the Ramona Park carousel in Grand Rapids, Michigan, which was the only surviving Looff carousel that included this menagerie figure, circa 1905. *Stevens collection, Harry Bartlett photo.*

Few of the tigers carved by Looff have survived, but one of the rarest of all carousel carvings is his "sneaky tiger." It is one of only three of this style known to exist, circa 1905. The figure was taken from the Luna Park carousel, Seattle, Washington, *Stevens collection, Harry Bartlett photo.*

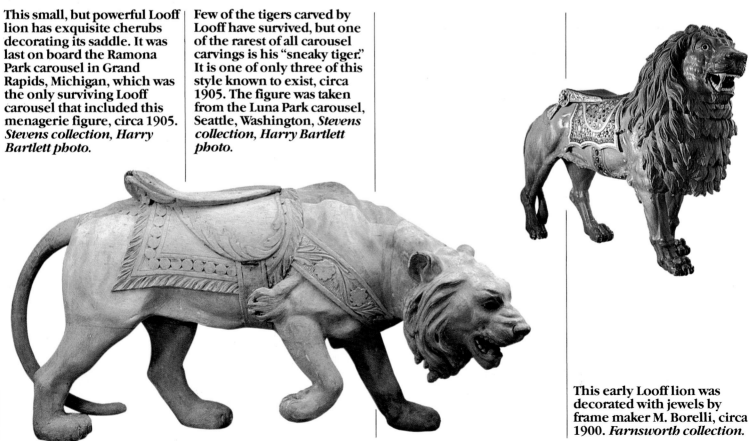

This early Looff lion was decorated with jewels by frame maker M. Borelli, circa 1900. *Farnsworth collection.*

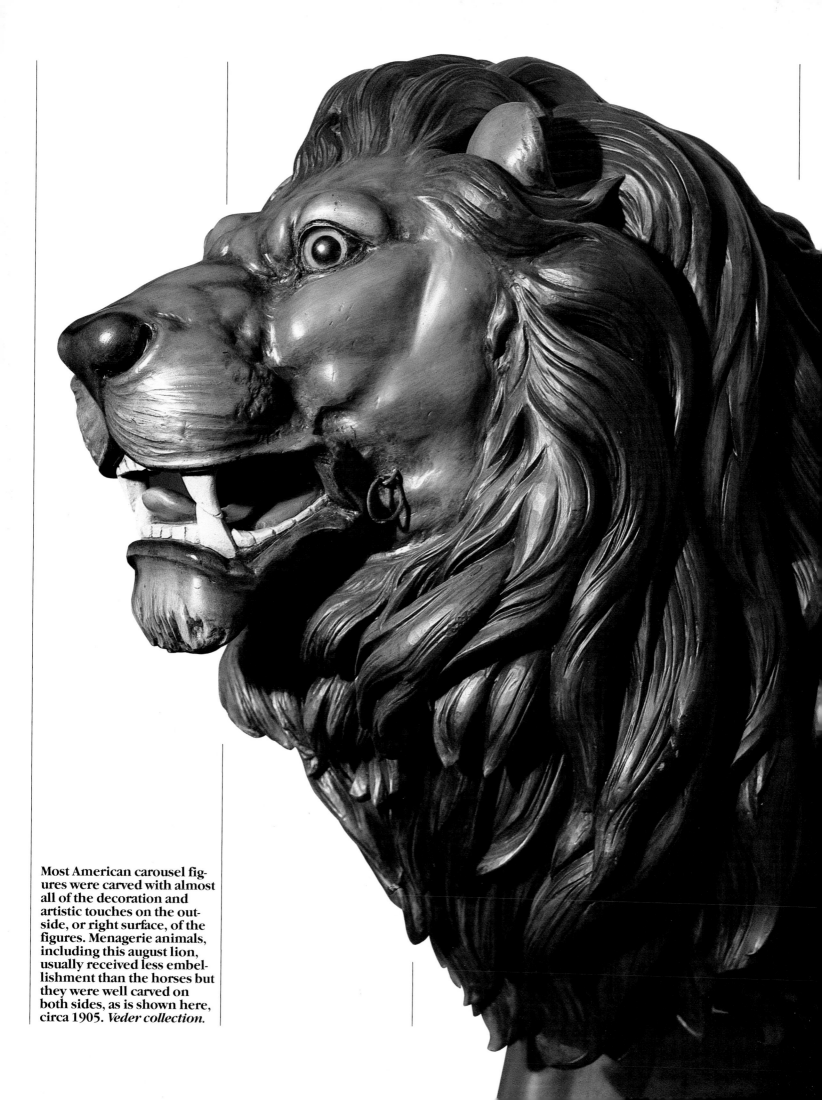

Most American carousel figures were carved with almost all of the decoration and artistic touches on the outside, or right surface, of the figures. Menagerie animals, including this august lion, usually received less embellishment than the horses but they were well carved on both sides, as is shown here, circa 1905. *Veder collection.*

Looff was very partial to dog carvings. This large, yet graceful, greyhound is representative of those found on his later machines, circa 1900. *Perron collection, Susan Foley photo.*

This stocky St. Bernard is typical of the dogs Looff placed on his stationary machines. The pleasant animal retains a bit of the folk-art charm found in his early carousel figures. This style of dog was abandoned when more proficient carvers, such as Illions and Carmel, joined the firm, circa 1895. *Berman collection.*

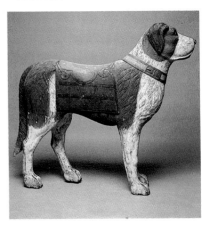

Elephants were never very popular carousel figures, possibly because Americans during this time were rather unfamiliar with them. A few companies carved the great beasts, but rarely were the creations as fine as Looff's. *Willamette Center, Portland, Oregon, Susan Foley photo.*

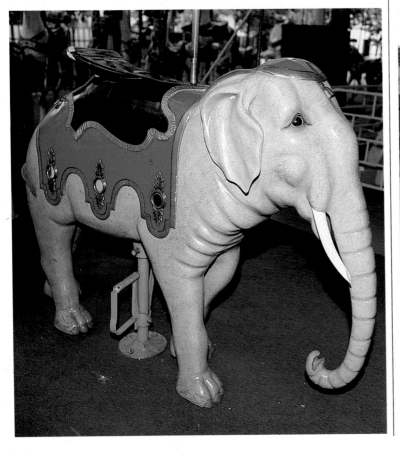

Bears were another one of Looff's favorite animals. He bought five of these unusual figures from a New York carving shop. The remarkable features about them are their movable heads and the absence of saddles, circa 1905. *Willamette Center, Portland, Oregon, Susan Foley photo.*

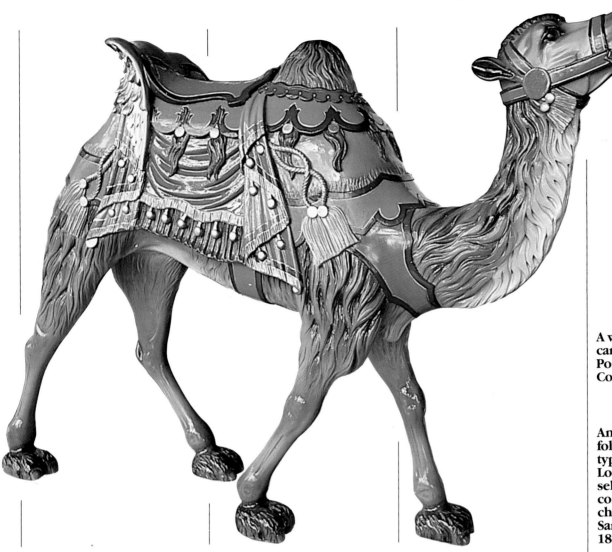

A well-restored ornate Looff camel rides the Lighthouse Point carousel in New Haven, Connecticut, circa 1900.

An early goat exhibits the folk-art carving style that was typical of those found on Looff's first stationary carousels. This one was part of a converted stationary machine at Seaport Village in San Diego, California, circa 1885.

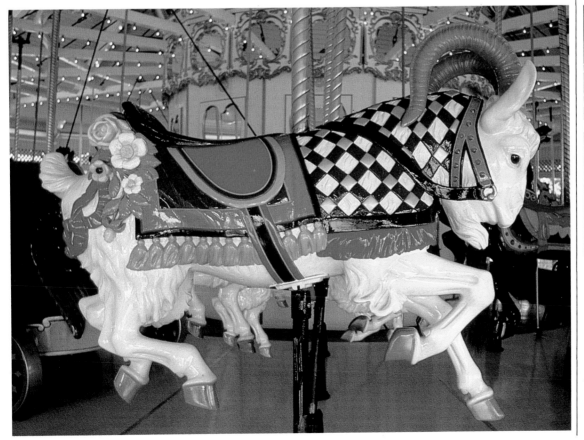

A superb jumping ram with fantastic decorations spins on the Shoreline carousel at Long Beach, California, circa 1905. *Peter Clark photo.*

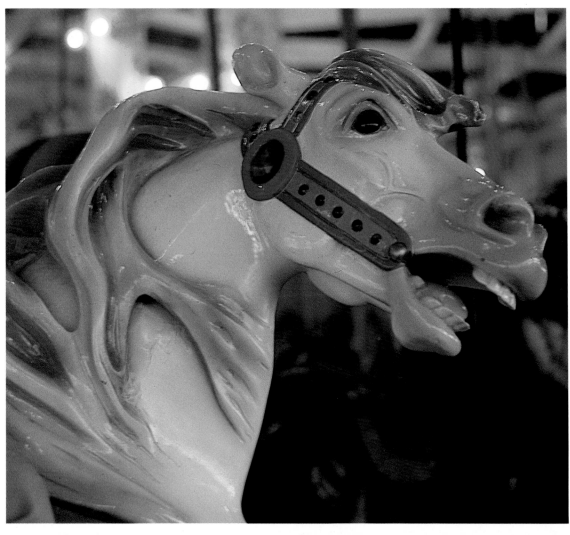

In 1911 John Zalar moved to Rhode Island, where he worked in the Looff carving shop. Up to that time, the Austrian immigrant had earned his living designing ornamental iron work. In his native country, Zalar sculpted religious figures in plaster, marble and wood. A highly valued carver, Zalar moved with Looff in his transcontinental relocation to California. Zalar's wife died a year after the move, so the artist moved his six motherless children back East, where he was hired by Philadelphia Toboggan Company. He was an exceptionally talented artist, who produced extremely stylized, exciting figures. His horses had tucked heads, expressive eyes and intricate, flowing manes. The figures he created for Looff and later Philadelphia Toboggan Company were very similar. Zalar is ranked with Muller and Illions for creative genius. Highly regarded by both Coney Island and Philadelphia companies, he was only 51 when he died in 1925. He is pictured here at Looff's factory at Long Beach, California. *S.J. Zalar photo.*

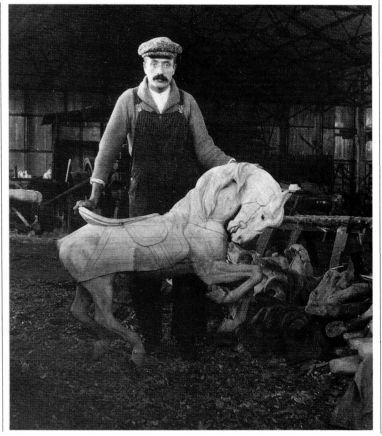

Looff's eldest son Charles carved most of the chariots, including this partially completed one. Looff used his Crescent Park building as a workshop during the busy winter months. The intricate interlocking dragons are still on board Looff's Crescent Park machine. *Wilda Taucher photo.*

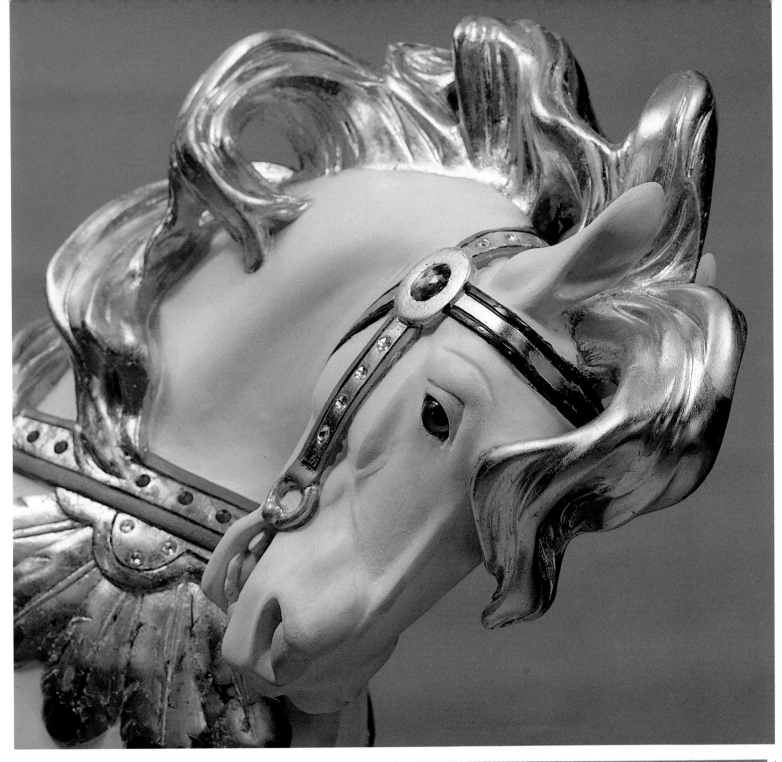

John Zalar's artistic talent is obvious in this sensitive carving, which exhibits his characteristic tucked head, windblown mane and dramatic oversized forelock. A pair of grouse seem to dangle from the saddle of this exemplary work of art. The fine restoration was made to match the flamboyant, glittering gold-leaf style of the turn-of-the century Coney Island carousels. Marcus Illions is credited with introducing the gold-leaf manes, but the practice was used by most other shops, circa 1914. The horse was part of a carousel that last operated at Ocean Beach Park at New London, Connecticut. Because the horses on this machine were unusually ornate for such a small carousel, experts speculate that these figures were part of the second Crescent Park merry-go-round. *Stevens collection, The Wooden Horse, Inc., Harry Bartlett photo.*

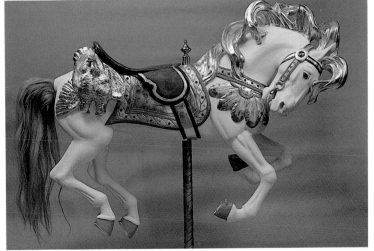

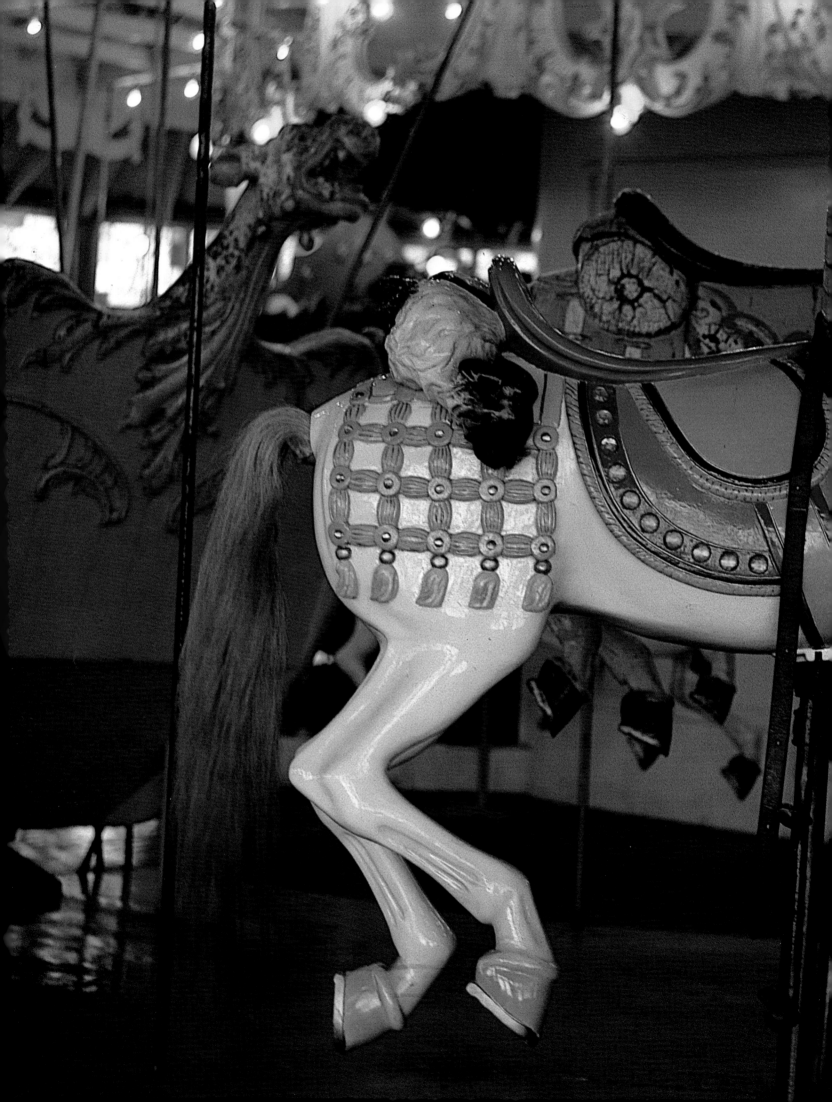

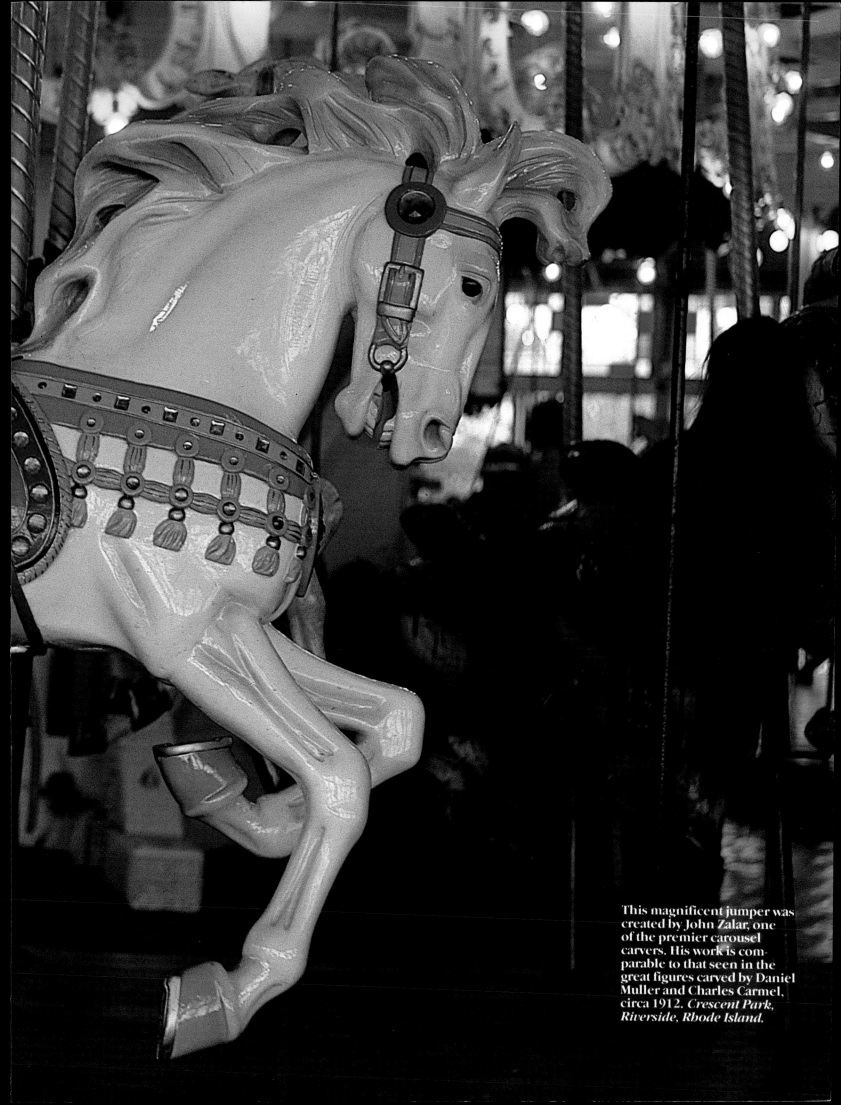

This magnificent jumper was created by John Zalar, one of the premier carousel carvers. His work is comparable to that seen in the great figures carved by Daniel Muller and Charles Carmel, circa 1912. *Crescent Park, Riverside, Rhode Island.*

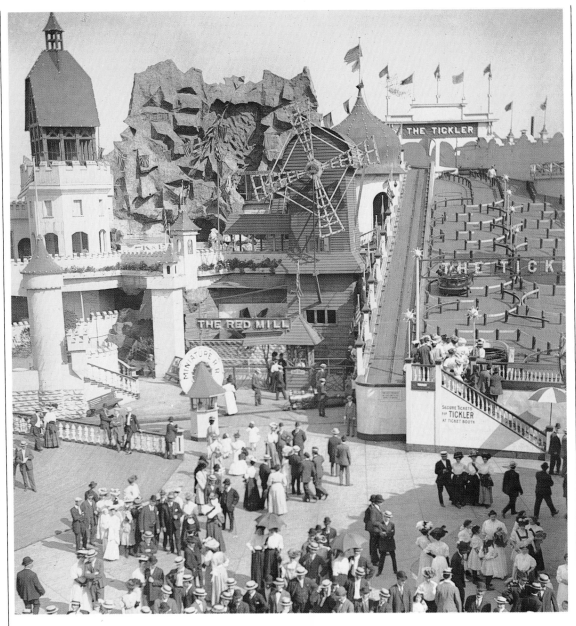

William Mangels combined his skills as an inventor and entrepeneur in the carousel industry. Besides using figures carved by Marcus Illions and Charles Carmel to build dozens of elaborate carousels, he designed many other popular amusement devices. The "Tickler," consisting of cars that would spin and change direction while descending an incline, was one of his early inventions and an immediate success at Coney Island. His most famous invention, the "Whip," has entertained generations of Americans. *New York Historical Society.*

The Stubbman carousel on Coney Island's Surf Avenue was a joint venture combining the carving talent of Marcus Illions, who produced horses, and William Mangels, who constructed the machinery. Between 1900 and 1909, they produced scores of machines. The highly inventive Mangels improved and patented an overhead jumping mechanism inspired by English carousel builder Frederick Savage. Mangels' 1907 patent was enormously successful and later was used by other frame and carousel builders, circa 1925. *William Mangels Jr. photo.*

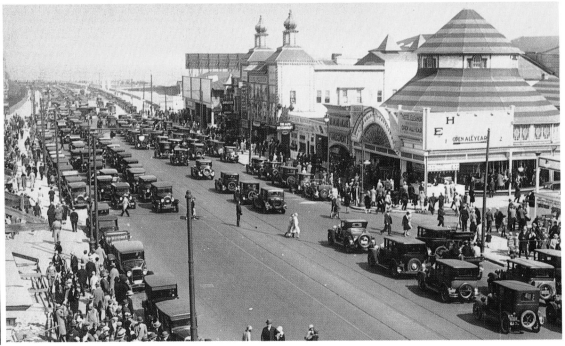

WILLIAM F. MANGELS

William F. Mangels

The Wm. F. Mangels Co. Carousel Works of Coney Island employed about two dozen machinists, mechanics and painters to produce the platforms, gears and cams used on carousels. The factory assembled scores of carousels with figures supplied by carvers M.C. Illions, Charles Carmel, Solomon Stein, Harry Goldstein and others. Pictured are his sons F.W. Mangels, front row right, and W.F. Mangels Jr., top row left. *F.W. Mangels photo.*

William Mangels was never a carver. He was a specialist in the engineering and fabrication aspects of producing carousels. He blended the carvers' imaginative creations with the hardware of motion and served America a fantasy machine.

Mangels arrived in America from Germany in 1886 and eventually established a machine shop in Coney Island. He was interested in and worked for amusemant parks from the beginning of his career. Mangels spent his spare time learning about local affairs, carousel history and inventions recorded in the United States Patent Office. These three interests served him well in his career. They were also a boon to the carousel industry.

Mangels made a careful study of the carousels imported to the United States from England and Germany. He and a man named William Johnson registered the first set of patents for an overhead crank that produced the familiar gate of carousel rides. Their design appears to be modeled after the Gallopers invented by Frederick Savage in England. In 1907, Mangels patented an improvement on the galloping action. His invention is still used by all modern machines. (The first patent for *Improvement in the Flying Horse,* No. 7419, was registered by Eliphalet S. Scripture of Green Point, New York, in 1850. His invention used an overhead suspension that produced a galloping motion.)

While he was busy running the Wm. F. Mangels Co. Carousal Works making carousels and thrill rides, he began preserving records, models and memorabilia about amusement devices. Mangels organized the American Museum of Public Recreation in 1927, but he received little help, financial or otherwise, from members of the association.

Almost single-handedly and relying on his own funds, Mangels erected a building and filled it with models, photos, tools and artifacts of the amusement industry. Before the Dentzel factory was sold in 1929, Mangels convinced the executors of the estate to donate historically valuable carved pieces, machines, photos, records, tools, and signs to his museum. His efforts prevented a great deal of knowledge about American carousels from slipping into obscurity.

When he was 82 years old, Mangels wrote *The Outdoor Amusement Industry,* a book sponsored by the National Association of Amusement Parks, Pools and Beaches. The narration offers a description of amusements during Mangels' time and noteworthy changes and improvements. In 1955, the carousel historian sold his private collection of carousel items to the Circus Hall of Fame and Horn's Cars of Yesterday. Both are now defunct and the exhibits sold piecemeal to various museums and collectors. In 1958, Mangels died at the age of 92.

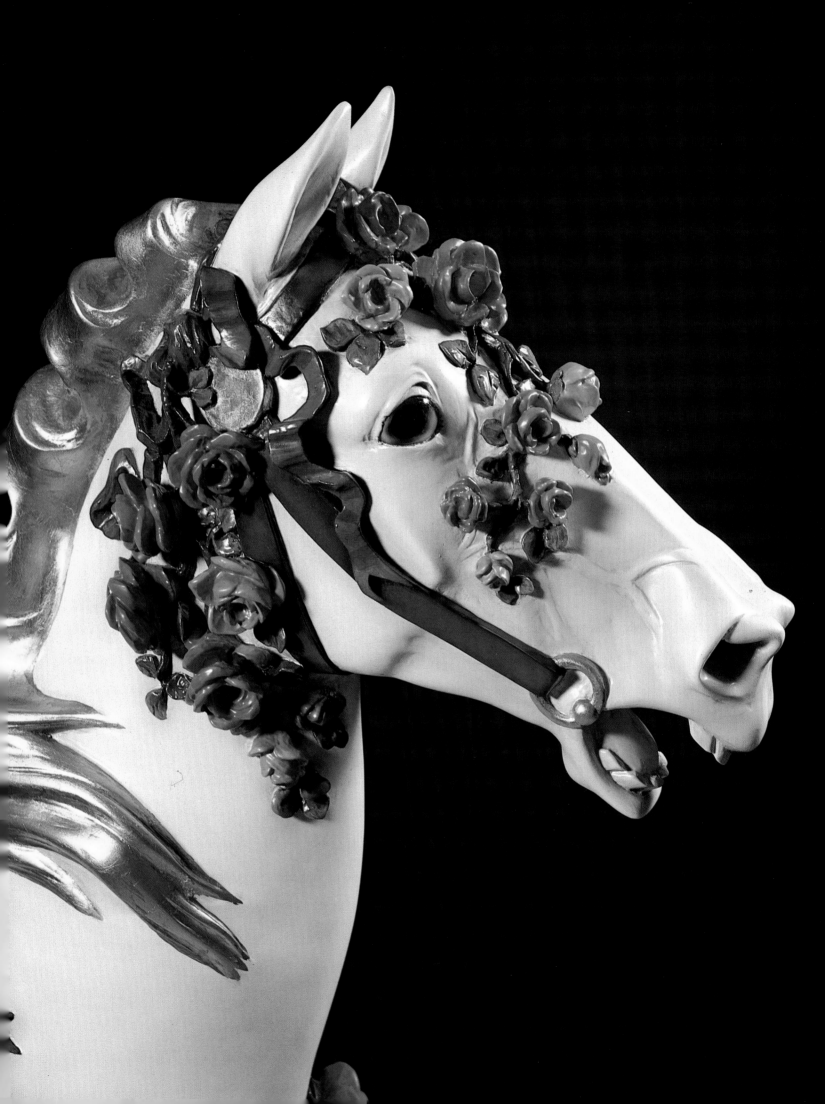

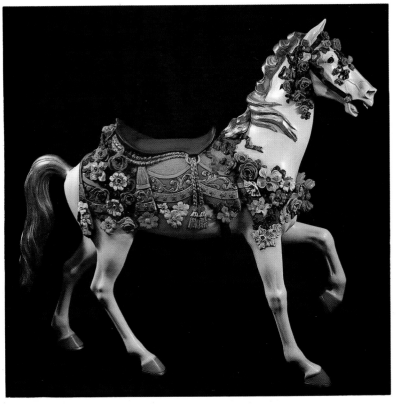

This American Beauty was the lead horse for M.C. Illions' last carousel, carved in 1927. His finest Supreme carousel, it was installed in the lobby of the Prospect Hotel at Coney Island, New York. Three of these completed carvings are known to exist, though each is slightly different from the others. *Daniel collection, Randy West photo.*

In 1980 a couple searching for a carousel figure to decorate their home discovered a rare and unfinished Illions American Beauty horse in an abandoned Pennsylvania barn. Among the forgotten treasures in the barn were unfinished horses, mirrored shields, tools and patterns from Illions' Coney Island shop, circa 1927. *McEachern collection.*

Marcus Illions carved for several carousel makers in the early part of his career and was most successful when he concentrated on the artistic side of the business. Born in 1866 in Vilna, Lithuania (now a part of the Soviet Union), he had roamed from his native land to Germany and later, England. He landed in the United States as a wagon carver for an English traveling circus. When Illions was a boy, his father, a horse trader, noticed his son's aptitude for wood carving and apprenticed him to a carving shop. Not much else is known about Illions' education, but his work reflects a knowledge of Greek and Roman sculpture.

Illions worked as a freelance carver in Brooklyn during the 1890s. He joined forces briefly with a blacksmith named Theodore Hunger in 1903. While Illions carved "Show Fronts," "Circus Wagons," "Hand Sculptured Horses" and "Highest Class Carousells," his partner made the mechanical parts. It was also in 1903 that he carved the famous Roman ticket booth for Luna Park in Coney Island and was recognized for his creative skills. The large entrance covered with crescent moons and flamboyant scroll work heightened Illions' reputation as a master carver. His versatility and skill are apparent from the variety of projects he was commissioned to carve. Ticket booths, scenic coasters, furniture models, organ fronts and church carvings are a sampling of his work.

A productive, though short-lived, partnership between Illions and Mangels resulted from their collaboration on the Feltman carousel restoration project. During their association, the basic design for jumping horses was developed. Mangels' overhead crank mechanism freed the horses from their fixed stance on the platform. Illions was able then to experiment with poses suitable for horses that could gallop with all four hoofs cutting the air. The two men produced some of the finest carousels, but their strong personalities clashed and the partnership was dissolved. They respected each other's abilities, however, and continued to do business together until 1909.

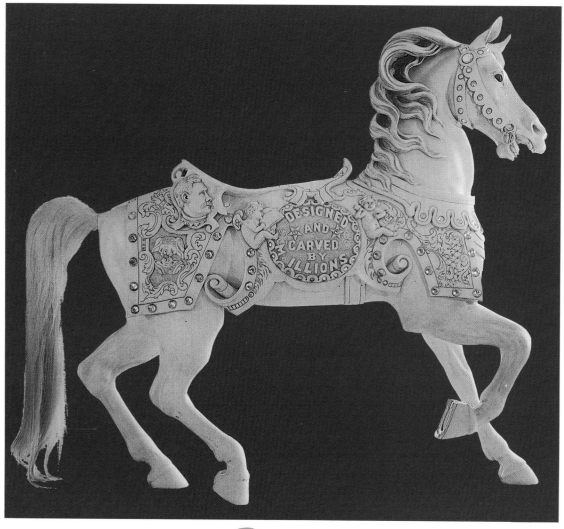

Illions worked for several years, beginning in 1890, in Looff's Coney Island carving shop. Illions introduced a new excitement to the Looff horses. This is a style he continued to carve while later working with Mangels. This Illions carving was last on board a carousel at Bopp's Hippodrome in Revere Beach, Massachusetts. 50 layers of old park paint were chipped away by artist Gladys Hopkins to reveal the original colors of this butterscotch pinto, circa 1891.

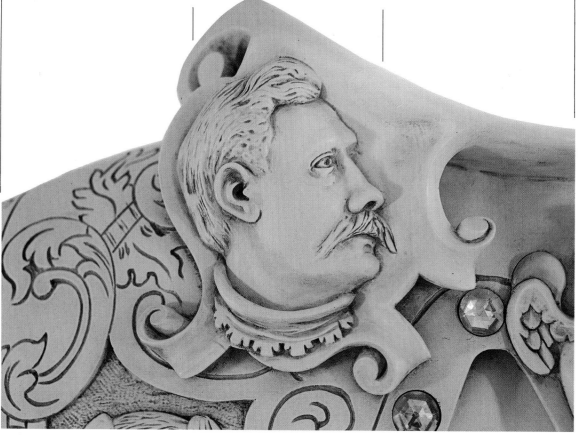

Few carousel artists signed their work, but M.C. Illions was the exception. An extremely proud man, he signed many of his creations that have survived today. This rare horse not only carries his signature, but also his portrait. Produced in 1910 as a shop display figure, it was later placed on a platform when Illions was behind schedule and needed to hastily complete an order. Originally shown in company photographs as a flashy pinto, the figure has been reconditioned and awaits a fresh coat of color. *Summit collection.*

This high-flying jumper was carved by M.C. Illions during the time he produced horses for William Mangels. This association began in 1900 with the refurbishing of the Feltman carousel, and lasted until 1909 when M.C. Illions and Sons was founded. During the time of the Illions-Mangels association, Illions carved hundreds of horses. The early horses were typified by proud strong poses, long thin heads, and round muscular bodies, circa 1905. *Youree collection, Cliff Kargus photo.*

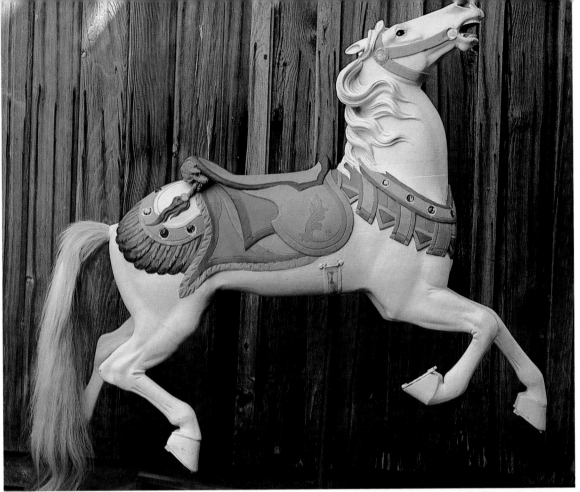

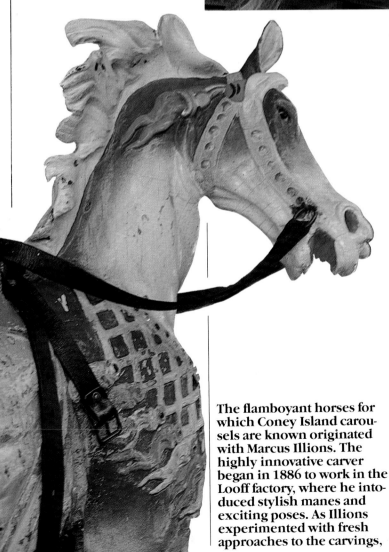

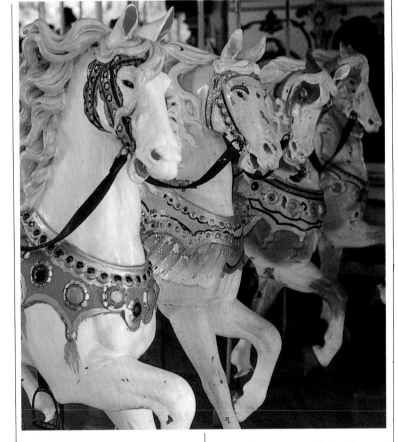

The flamboyant horses for which Coney Island carousels are known originated with Marcus Illions. The highly innovative carver began in 1886 to work in the Looff factory, where he introduced stylish manes and exciting poses. As Illions experimented with fresh approaches to the carvings, he developed extremely animated horses with manes blowing wildly in the wind or cascading in ringlets. In 1965 his horses from the Stubbman and Feltman carousels were combined on a single carousel, which debuted at the New York World's Fair. It now operates in Flushing Meadow, Queens, New York, circa 1900-1908.

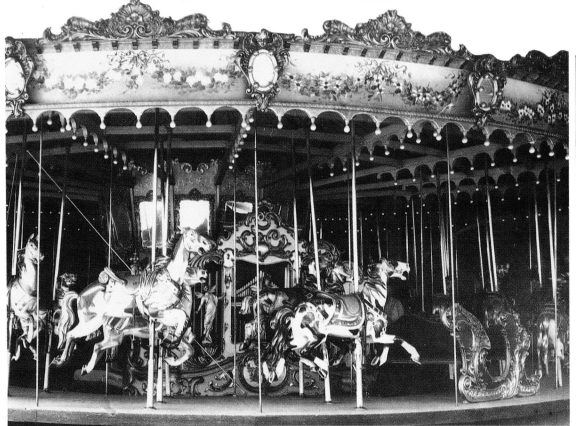

In 1917-18 Illions and his son Rudy took this elegant portable carousel on a tour of southern states in an effort to raise money. World War I caused shortages of material and soured the carousel business. The tour was plagued with bad weather and failed to raise the hoped-for cash. *Barney & Bette Illions photo.*

The claw and skin saddle is an unusual creation also known as a "bat-wing saddle." Illions eventually dropped the style for the more popular English-style saddle, circa 1909.

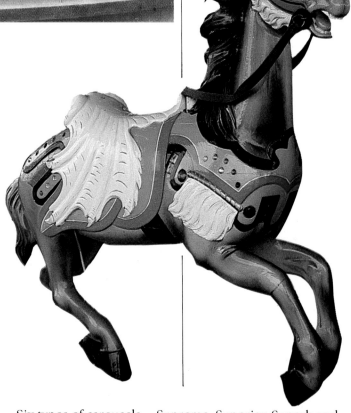

Illions' familiarity with horses is obvious on this figure. Carousel horses carved with a pacing gait, with which the legs moved in parallel on opposite sides of the body, were very unusual.

The Coney Island carver often raced his own horses in friendly competition with other sulky drivers in Brooklyn parks. Misquamicut, Rhode Island.

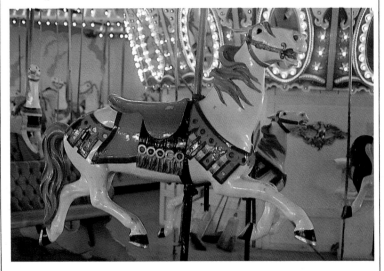

Illions worked on carousels in several capacities. Before opening his own factory, he formed partnerships with other carousel manufacturers. After 1909, M.C. Illions & Sons Inc. was solely a family affair with sons Phillip, Rudy, Harry and Barney assigned to all aspects of the business. For a while Harry carved, as did Phillip, who also acted as secretary and provided customers with cost estimates. Rudy specialized in the mechanical works and Barney, now an artist in California, painted all parts of the carousel from horses to picture panels. The factory on Ocean Parkway in Coney Island, produced carousels from 1909 and 1929 and repaired them until 1945. When orders flooded the small business, Illions pressed uncles, cousins and nephews into service as painters and sanders.

Six types of carousels—Supreme, Superior, Superb and Monarch I, II, III—were offered for sale. The Supreme carried 74 horses, four abreast, and two fancy chariots on a 54-foot platform. On one Superior machine, 66 horses and two dragon chariots could seat 74 passengers, but the carrying capacity for standing customers was even greater.

The factory supplied Allan Herschell with one set of horses, carved in the County Fair style, and several sets carved with double saddles to Prior and Church's race track ride. Small horses used by a company called Pinto Bros., which operated little carousels in the streets of Coney Island, were also made in the Illions factory.

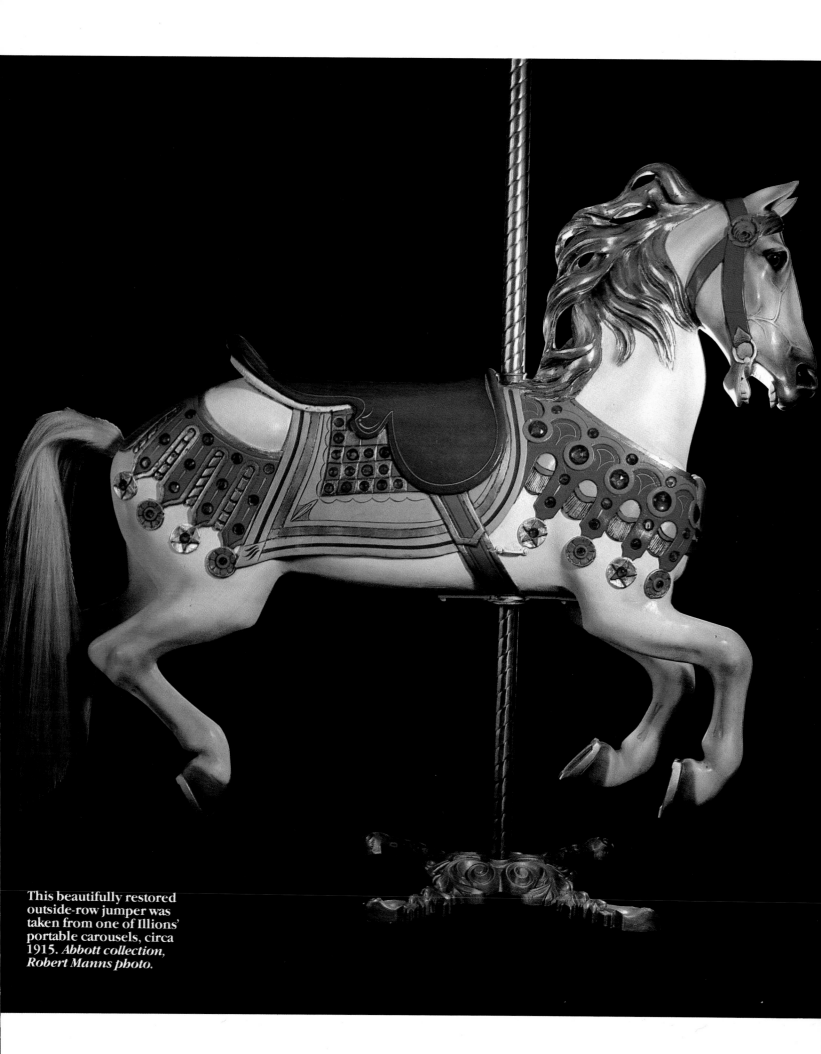

This beautifully restored outside-row jumper was taken from one of Illions' portable carousels, circa 1915. *Abbott collection, Robert Manns photo.*

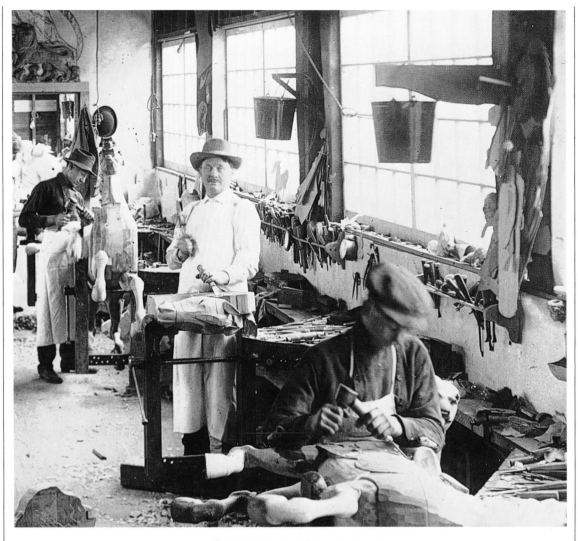

M.C. Illions & Sons Inc. rarely numbered more than five or six people. Marcus Illions appears in the center, with sons Phillip on the left and Rudy on the right. According to Illions' youngest son, Barney, his father could carve equally well with either hand. Guiding his chisel, he created flowing manes with precision and certainty of purpose. The action and subtle expressions Illions produced were part of his artistic gift. Sometimes, especially on the king horse, the master carver would personally create the entire body, legs, tail, head and trappings. He was patient and rarely temperamental, except when confronted with inferior work. The walls of the factory were covered with patterns and sketches. Illions would draw cardboard patterns, refine and cut them. His son Phillip would trace the patterns onto the basswood and cut them out on the band saw. A typical carousel horse required eight pieces of wood for each leg, 20 for the body, 16 for the head and two for the tail — a total of 70 pieces for each horse. After planing and gluing these pieces, the parts were in the make-ready stage. Using the band saw, Illions would rough out and remove unnecessary material, straining the endurance of the saw's blade. He is the only carver known to have sculpted free-hand with the band saw, circa 1912. *Bernard and Bette Illions photo.*

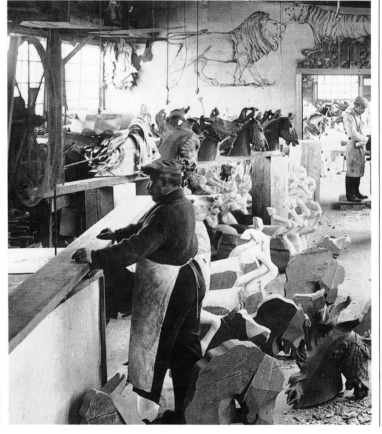

A Mr. Gudke, a carver and superb upholsterer, stands at the band saw while Louis Becker stands in the doorway of the crowded workshop. Horse heads in various stages of production are strewn around the machines. Orders for carousels were usually placed in the fall, with delivery scheduled for park openings in the spring. Because of Illions' uncompromising dedication to quality, the spring months were hectic as dozens of horses were being prepared for painting, crating and shipping. In the Coney Island shop, Illions also produced wooden patterns for all the machinery's iron castings, circa 1912. *Bernard and Bette Illions photo.*

Flamboyant manes and animated poses have always been synonymous with the carvings of M.C. Illions. Originally, almost all of the flying manes on the Illions figures were covered in 22-carat gold or silver leaf. Illions began using gold-leaf manes at least by 1900. He realized the gold brought out the highlights and details of his carvings and created a dramatic overall effect. Pictured right is a magnificent Illions carving, circa 1910. *Fun Forest Park, Seattle, Washington, Jim Hennessy photo.*

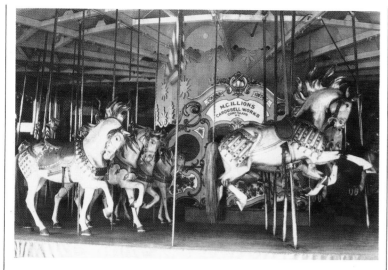

One carousel aficionado, Roland Summit, says Illions is one of his favorite carousel carvers because Illions' work reveals a continuous evolution of style. Early horses are identical to Looff's creations, but eventually Illions' own creative genius emerged. From conventional, tame horses came wilder steeds. Year after year Illions experimented with more straps and tassels or the effects of colored glass jewels. A medieval stage was part of the evolution process. Whenever Illions believed that other carvers were imitating his style, he changed directions. This also contributed to the transition of the carver's style.

Capturing motion was one of the last areas that Illions tackled. Through the lift of the head, position of the legs or toss of the mane and tail, Illions froze the essence of speed. His wooden horses were mirrors of the snorting, pawing, genuine animal. Illions' creations strained at their halters, muscles tense. Wild manes lashed the necks of his animated chargers and whipped upward in the carousel wind. Some of his manes had openings carved in the expanse of wood, a negative pattern effect that was later employed by sculptors in other mediums and styles.

Attention to detail, from the beginning life-size sketches to the final strokes of the chisel, characterized Illions' work. He actually kept a stable and rode his models nearly every day. Four racetracks within a short distance of the factory gave him the opportunity to study the movement and mannerisms of racing horses.

Illions was always an innovator. As soon as another carver adopted aspects of his style or designs, he would create new and more exciting ones. Fascinated by motion, Illions in his later carvings set out to create the most exciting, animated carousel horses ever to grace a platform. Illions wanted to establish his shop as the premier builder of firstclass carousels. The two horses in this photograph have reached opposite sides of the country. The one on the right is on board a working Illions carousel in Seaside Heights, New Jersey. The stander on the left is on a mixed carousel in Seattle, Washington.

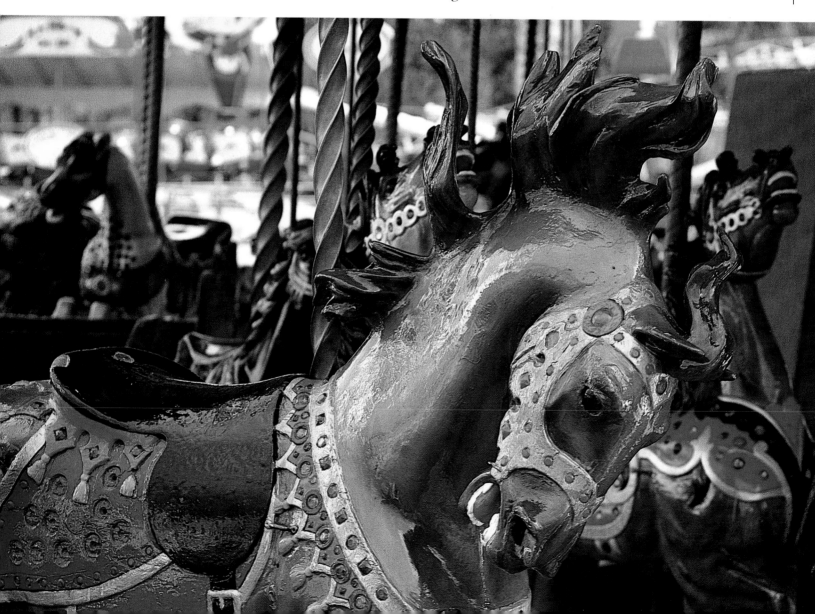

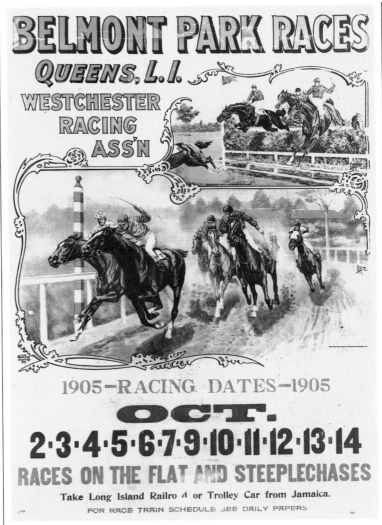

Four racetracks were located in the vicinity of Coney Island giving Illions an opportunity to study the thoroughbreds and their actions, attitudes and mannerisms both on the track and in the stable. Illions' carvings were greatly influenced by young race horses. Typically, 2- or 3-year-old thoroughbreds race and these spunky adolescents spring from the starting gates in a wild frenzy. Many of the poses Illions used were adopted from the antics of these frisky colts. These exciting figures gallop around the Dentzel carousel at Fleischaker Zoo at San Francisco, California. With a little imagination, you can picture them bursting from the starting gate, circa 1912.

Marcus Illions was an avid horseman who maintained a stable of three or four horses next to his Coney Island home and rode his fancy mount, Bob, daily. He loved horses and was constantly looking for new ways to capture their spirit in wood for his carousels.

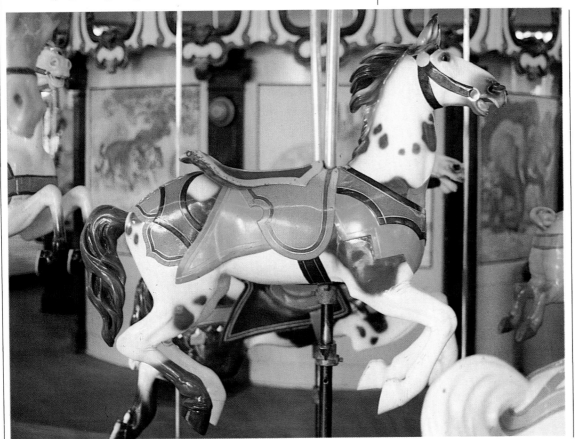

A beautiful jumper with a sleek body gallops around the platform with a group of Dentzel menagerie figures. A cherub saddle decoration and floral bridle arrangement adorns this exuberant carving. Originally, bridle straps were attached to the bit. Illions usually carved his horses with open mouths, as if they were straining at the reins, circa 1912. *Fleischaker Zoo, San Francisco, California.*

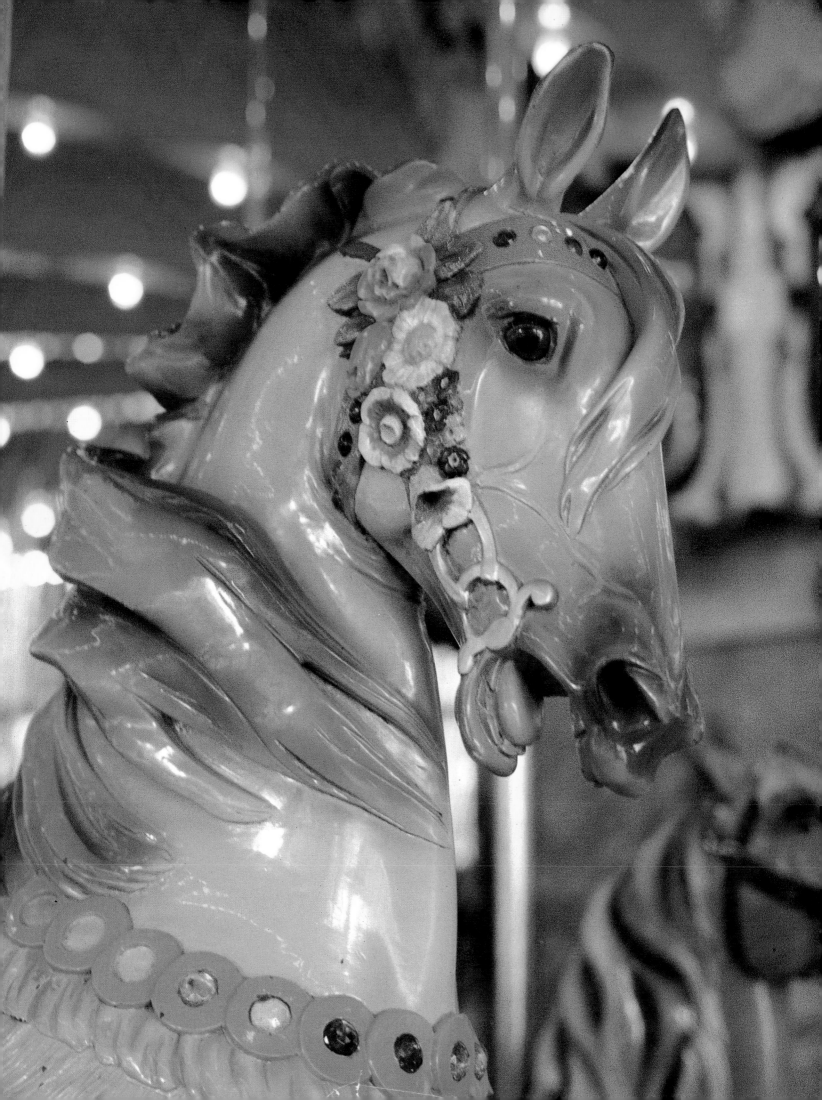

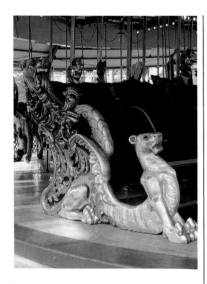

The dragon was a popular theme for chariots, probably stemming from the enormous interest in Oriental art that swept America and Europe shortly before World War I. Illions carved several variations and sizes while using the same basic design, circa 1909. *Riverside Park, Agawam, Massachusetts.*

Like most artists, Illions was proud of his work, but unlike other carvers, he often added his signature to his work, as he did on this spirited armored carving. Beautifully restored, complete with 22-carat gold leaf manes by Brian Frederick and Ellee Teree, circa 1909. *Riverside Park, Agawam, Massachusetts.*

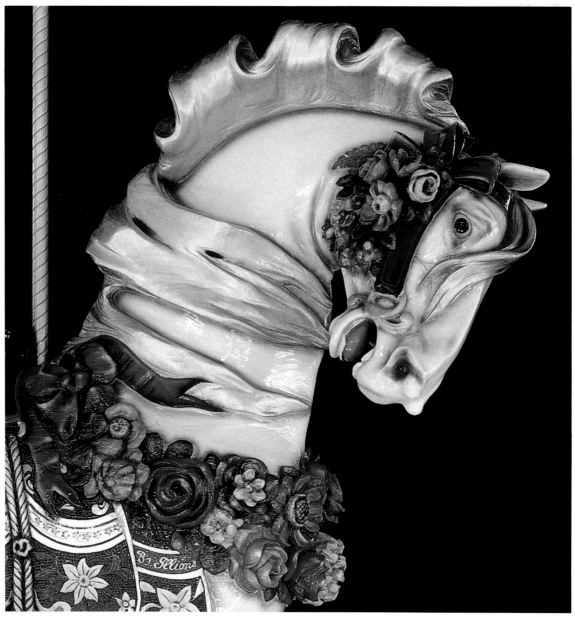

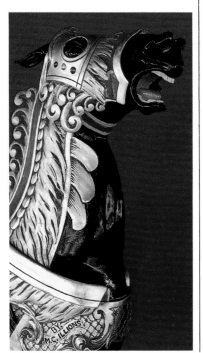

The lead horse on the Riverside Park carousel was Illions' first American Beauty or "flower horse," as he referred to it. This impressive stallion was the prototype for the lead horse pictured on page 124. The heads and poses are different, but the decorations are similar. This figure also has the distinction of having a determinable sex, rare in American carousel figures. Reportedly, Illions added this feature to the lead horses being shipped to customers he did not like, circa 1909. *Agawam, Massachusetts.*

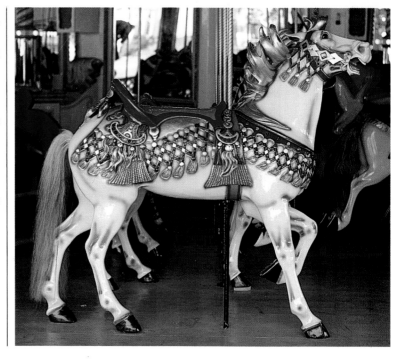

M.C. Illions & Son carved few menagerie figures. With the introduction of the jumping mechanism, horses became much more popular and menagerie figures were produced only on special order. Illions did carve stationary animals, including giraffes, goats and hippocampuses, which were half horse half fish. A half dozen Illions lions, including this stately beast beautifully restored by Mary Lawrence Youree, have survived, circa 1910. *Youree collection, Cliff Kargus photo.*

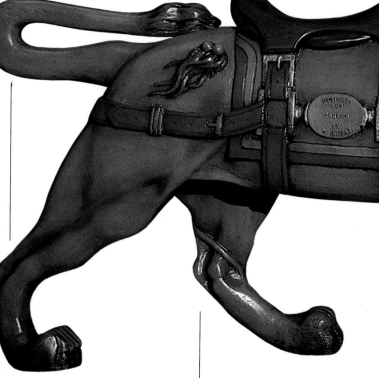

Illions carved beautiful deer with attentive poses and fur laden with heavy ringlets, circa 1909.

Illions' tiger had a lanky appearance and a broad head.

According to Bernard Illions, son of the famed carver, the family-owned business produced no menagerie figures after 1910. It is likely that Illions gladly stopped making the less popular animals in favor of all-horse carousels, with which he could create the motion and excitement that he loved, circa 1909. *Agawam, Massachusetts.*

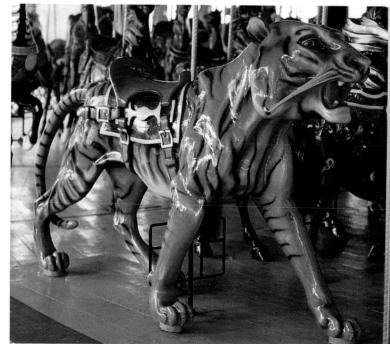

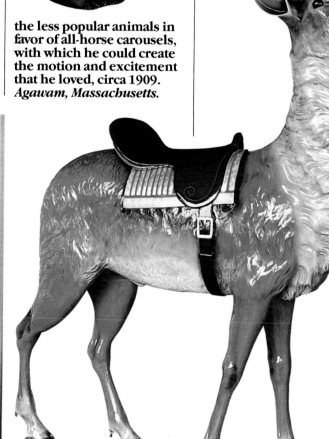

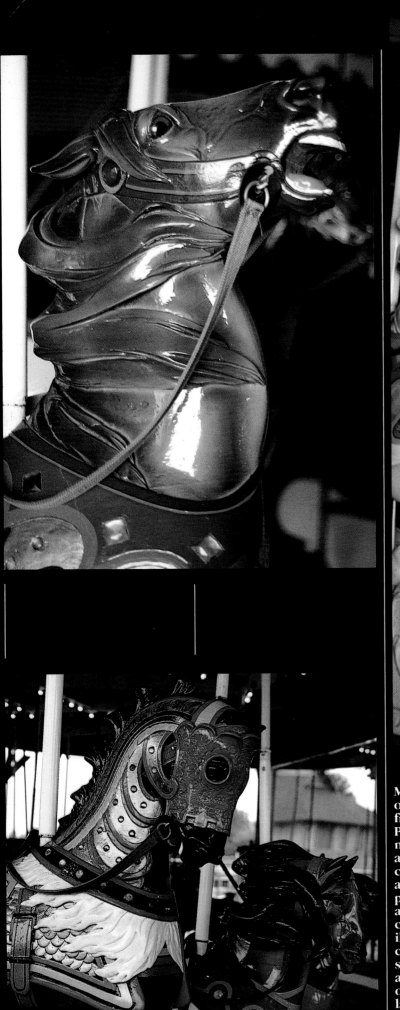

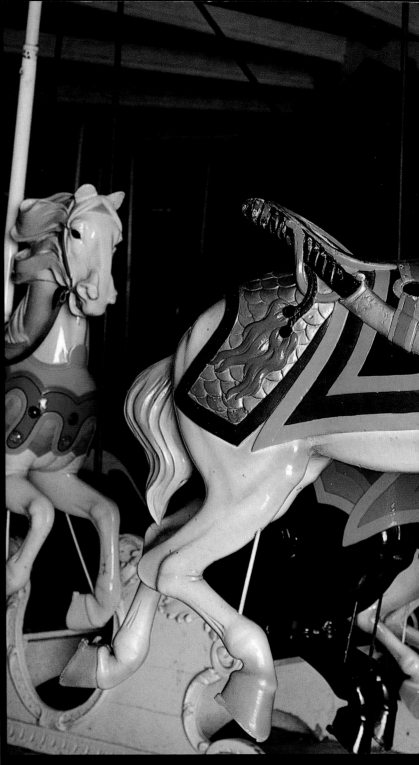

M.C. Illions & Sons produced only 15 park carousels and five or six portable ones. Pictured here is a portable machine from Wyandot Park at Columbus, Ohio. This carousel is owned by the city and leased to the park. Illions' portable carousels were large and elaborate, with richly carved horses. To create the illusion of speed, Illions carved spirited horses that strained at their bits. The aluminum tails, replacing the original hair ones, were a later addition.

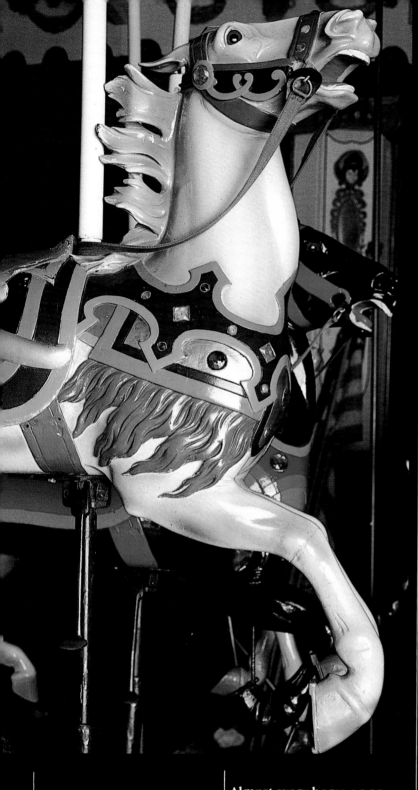

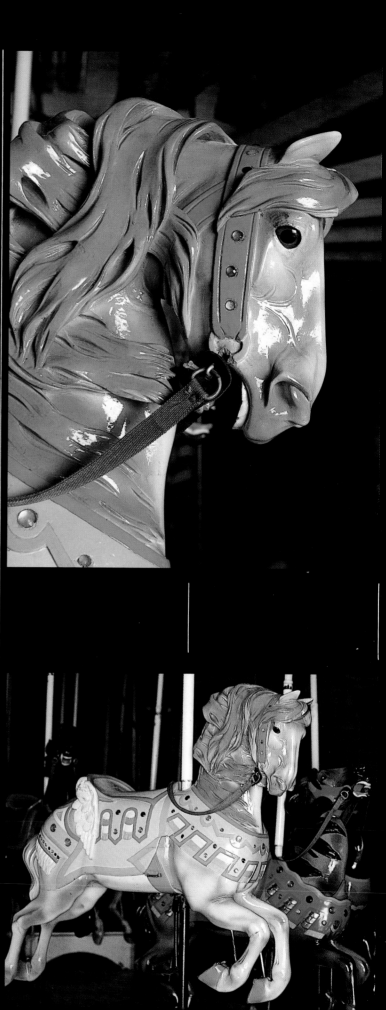

Almost every horse on an Illions carousel wore a gold-leaf mane. The manes on his earlier carvings fell in flowing ringlets and more naturally resembled hair. This carving style with its deep ridges made adding gold leaf a troublesome chore. The process involves laying extremely thin sheets of gold on a sticky, clear varnish spread over the wooden carving. To simplify the gold leafing, Illions began carving manes with flattened sections, as seen on these horses, circa 1909.

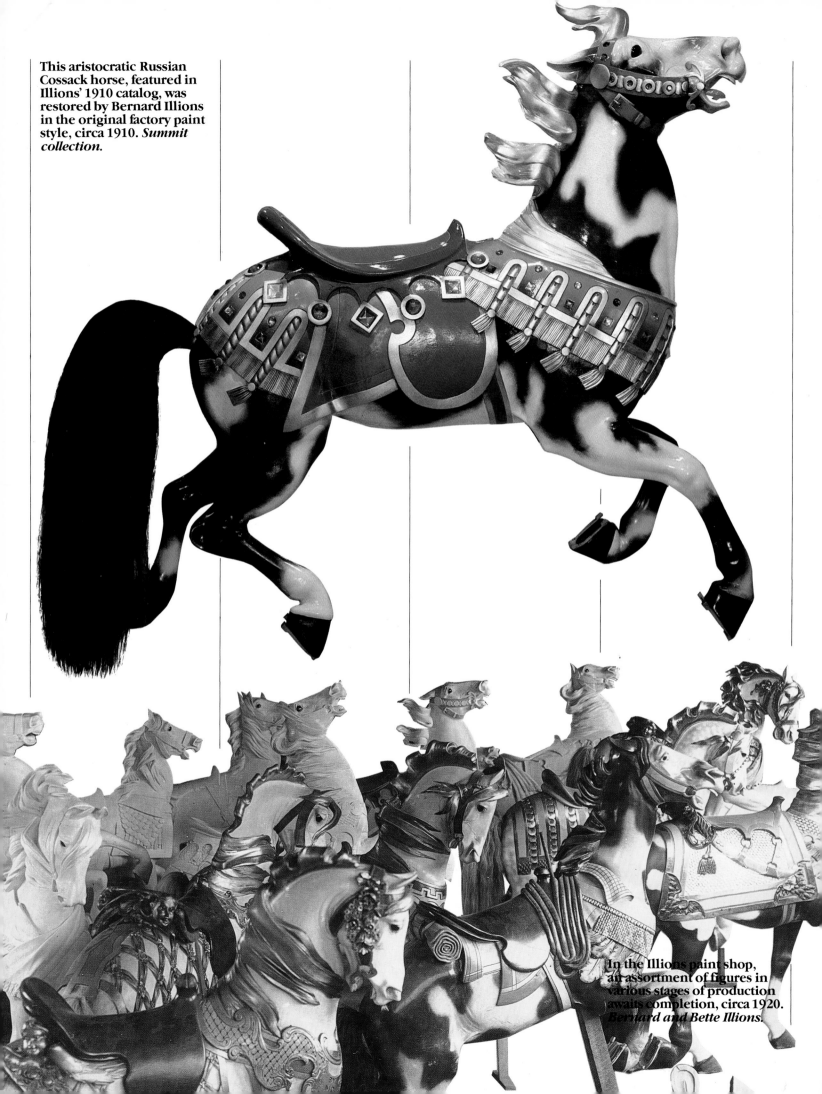

This aristocratic Russian Cossack horse, featured in Illions' 1910 catalog, was restored by Bernard Illions in the original factory paint style, circa 1910. *Summit collection.*

In the Illions paint shop, an assortment of figures in various stages of production awaits completion, circa 1920. *Bernard and Bette Illions.*

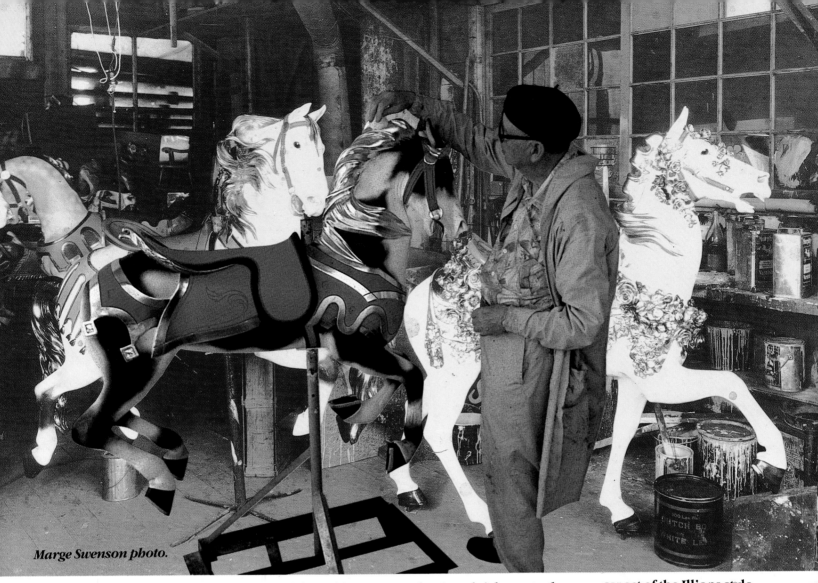

After the carver's job was finished, the painters had to prepare the figures and with their pigments and brushes give life to the natural-wood figures and add bright ornamentation. Park paint, poorly applied over the years, has obliterated almost all of the original painter's artistic work. Bernard Illions, son of the famous Coney Island carver, began sanding and applying primer to his father's carvings about 1910. M.C. Illions, the patriarch of the family and business, was an accomplished painter as well as a fine carver. Bernard learned to paint by working at the side of his father and older brothers. He became a full fledged factory painter while still a teenager and worked there until the shop closed in 1927. Though examples of original paint on Dentzel and Philadelphia Toboggan Company carousels exist, none of M.C. Illions' has been found. Barney, who recreates authentic factory painting, is one of the few

survivors of the golden age of carousels. The technique he used in the Coney Island shop more than 60 years ago was as follows: New figures were painted with a thin coat of primer consisting of white lead paint, turpentine and boiled linseed oil. Three coats were applied to the figures, which were sanded after each coat. All the colors of the bodies and trim were mixed with a Japan dryer to give the pieces a flat finish and to speed up drying time. The body was painted by hand with a stippling method that blended the colors uniformly and created a natural hair-like quality. Colors, even white, were applied wet on wet. Brushes were cleaned and dried frequently to achieve a blend as fine as that made by an airbrush, but more controlled. Dapple gray, palomino, pinto and solid-colored horses were painted in this manner. Solid body colors were sometimes built up by adding increasingly darker layers to create

depth and richness to the final coat. This meticulous approach was a far cry from that used by inexperienced maintenance workers who later covered the figures with one color straight from a can of enamel paint. The painters could enhance details in the carving or add special touches. Muscles came to life with highlights; ears, noses, mouths and eyes seemed more real with a carefully applied splash of pink, vermillion or crimson. Hoofs were finished in raw umber with a hint of white or solid black. Most importantly, no raw color was ever used. The painters, mixing and blending a limited number of colors, created bright harmonious figures. "The Old Gent," as he was called by his sons, always looked for new ways to make his carvings unique and more exciting. According to Barney, his father often laughed when he noticed that Carmel or Stein & Goldstein had adopted some

aspect of the Illions style. One special feature, created by M.C. Illions & Sons and quickly copied by other manufacturers, was coating manes with silver, gold and aluminum leaf. The process could take up to 15 hours to complete. Gold or silver leaf in thin sheets made approximately the size of the area to be covered was applied with a tipping brush. It was then lightly burnished and shaded with a thin coat of color to bring out the depth and relief of the carving. After wiping away the excess with a cotton ball, a tint of the pigment remained in the recesses. In the final stage, the horses were thoroughly cleaned and two or three coats of spar varnish were brushed on. M.C. Illions was uncompromising in the quality of the carousels that left his factory. He often ran over budget on a commission, but would rather work seven days a week than deliver a machine that was less than perfect.

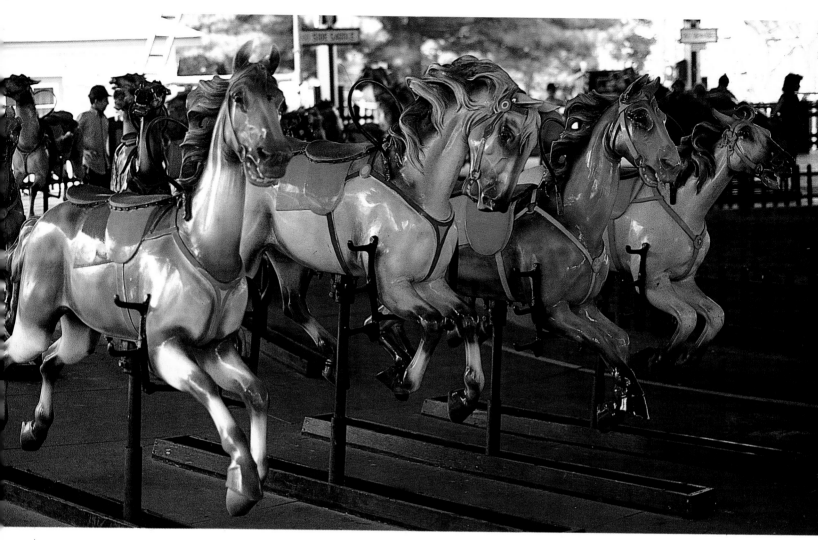

M.C. Illions & Sons produced the horses for three Pryor and Church racing derbies. A racing derby was a grand event that used almost life-size horses rotating at speeds three times faster than most carousels. The larger horses also could accommodate two riders. Illions received the contract to build these figures late in the season and had to devise a way to finish the task on schedule. His son Rudy adapted a large chisel to a pneumatic gun used to caulk the wooden joints of sailing vessels. Illion's intimate knowledge of horse anatomy and skill in handling a chisel enabled him to carve the figures in a freehand fashion. He carved large sections, taking long sweeping cuts without splintering the surfaces of these monumental steeds, circa 1926. *Playland Rye, New York.*

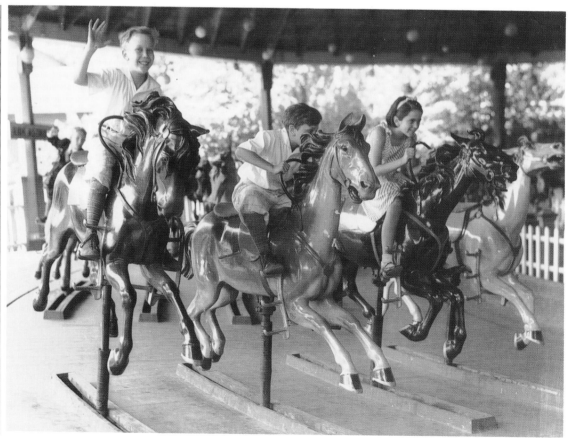

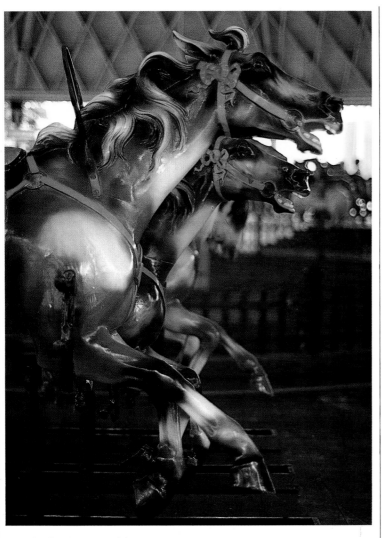

Speed was also one of Illions' traits. An accurate artist, he could carve equally well with either hand. In order to produce more carousels in a shorter time, he built a pneumatic chisel that he used to rough out the bodies of his figures. Illions had another unusual carving technique. Unlike most other carvers, he put the eyes in during the roughing-out stage of production, not as a finishing touch. He wanted to make the eyes blend with the horse's total expression and believed he was less likely to spoil the final result by implanting the eyes first in the easily cracked wood.

Unfortunately, his business acumen was not as highly developed and organized as his artistic sense. Bad real estate investments lead to the factory's end. In the Depression of 1929 Illions lost everything.

Like other carvers from the golden days of carousels, Illions made a living after his factory closed by repairing animals and decorations on existing carousels and creating religious carvings. At the age of 84, Illions died and was buried in Brooklyn.

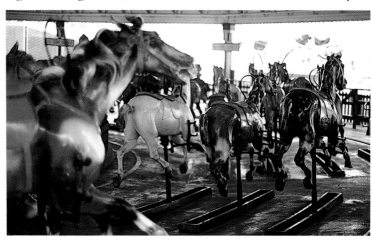

Unlike his carousel horses, Illions' derby horses had minimal ornamentation, amounting only to chest straps, saddles and a few ribbons flying from the bridles. These figures still managed to capture the spirit and thrill of a real horse race, circa 1926.

Pryor and Church produced many racing derbies other than the three carved by Illions. Their other machines had plain, unimaginative figures. It is easy to see why Illions was recognized for his carving genius when this static figure is compared to Illions' work, above, circa 1920. *Dickenson County Historical Society, Kansas.*

The last three carousels produced in the M.C. Illions and Sons factory were Supreme models. Built in the 1920s, they were the grandest and most elaborate creations of the company. This last and finest machine was carved for the lobby of Prospect Park Hotel at Coney Island, New York. Illions, like Daniel Muller, excelled in carving realistic and spirited figures. Illions also gave each figure its own unique and fanciful touch, circa 1927. *Bernard and Bette Illions photo.*

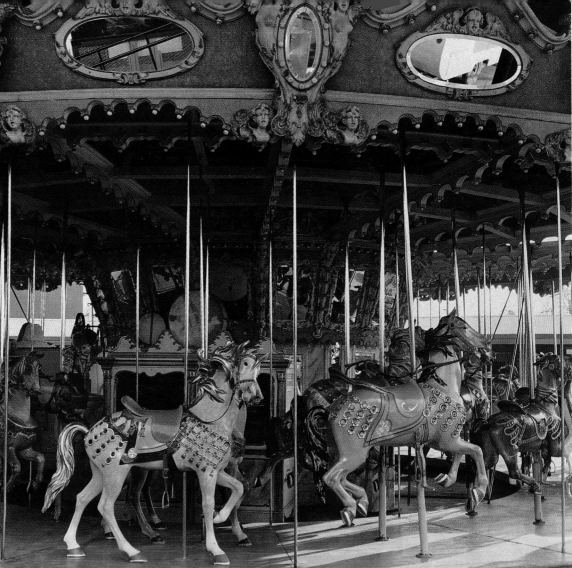

After declining orders for carousels, brought on by the stockmarket crash and Depression, forced Marcus Illions to close his shop, he continued to repair and refurbish carousels. The "Old Gent", as he was known to his sons, anticipated better times when the carousel business would again flourish, circa, 1947. *Bernard and Bette Illions photo.*

A magnificent example of Illions' extraordinary talent is represented in this figure. An early catalog called this unique horse the "Southern Belle." It was created to display the talent and creativity of the M.C. Illions and Sons factory. The remarkable carving has winged cherubs behind the saddle cantle and an elaborate wind-blown mane that hangs 8 inches from the neck on the back side of the horse. Gold-leaf manes were a special innovation of the Illions shop, but they were adopted by so many other manufacturers that they became a trademark of Coney Island carvings, circa 1911.

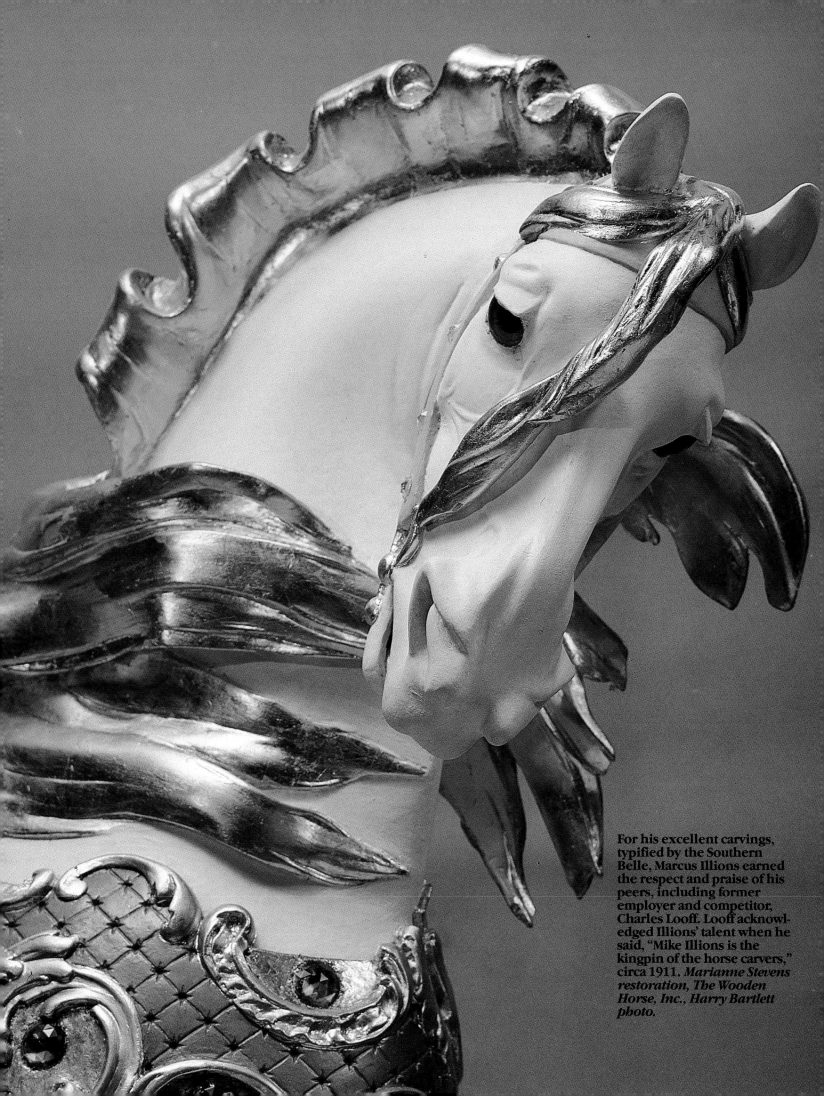

For his excellent carvings, typified by the Southern Belle, Marcus Illions earned the respect and praise of his peers, including former employer and competitor, Charles Looff. Looff acknowledged Illions' talent when he said, "Mike Illions is the kingpin of the horse carvers," circa 1911. *Marianne Stevens restoration, The Wooden Horse, Inc., Harry Bartlett photo.*

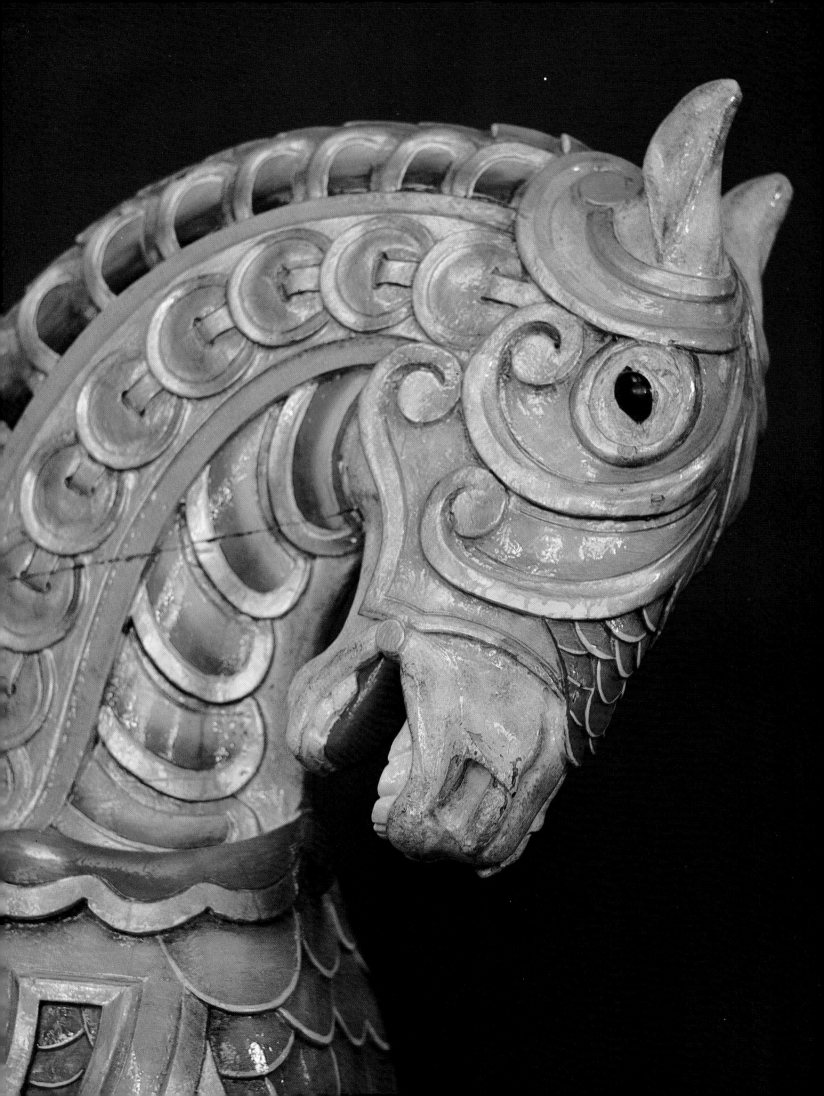

STEIN & GOLDSTEIN

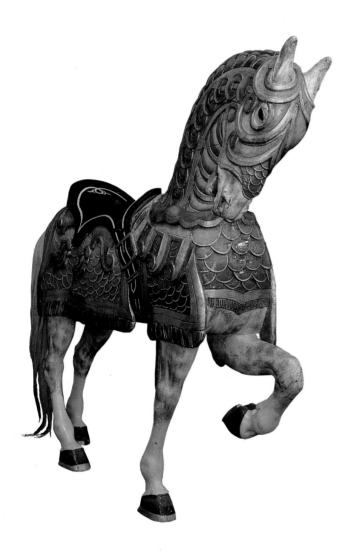

The armored lead horses by Solomon Stein and Harry Goldstein are some of their most artistic and impressive creations. Full-face cham-froms, massive buckles and intricately detailed fish-scale caparisons characterize their work. As newly arrived immigants, they carved fine, ornate ladies' combs, a paradox to this massive, beautifully restored carving from a carousel that last operated in Great Falls, Virginia, circa 1915. *Stevens collection, Harry Bartlett photo.*

Two Russian immigrants met when they were hired to carve in Mangels' carousel factory, and worked as freelance carvers under the direction of Marcus Illions. This meeting led to a partnership that endured through more than a decade of carousel production. Solomon Stein and Harry Goldstein had several things in common, although Goldstein was 15 years older than his partner.

Both men immigrated to the United States within a year of each other. Both had carved in American factories that made women's fine combs before they tried their hands at carousels. Goldstein settled in Brooklyn with his wife and son in the same neighborhood as Stein, his wife, a Russian immigrant named Annie Goldberg, and their three children.

Influences by other Coney Island carvers, namely Looff and Illions, are prevalent in the horses that the two carved. But Stein and Goldstein developed their own particular breed of animal and their own scale: large!

Stein and Goldstein carved garlands of roses, tassels and buckles on their horses like their competitors. But for them, bigger was better. This may have been a reaction to the tiny, meticulous carving that they both performed at their jobs in the comb factories.

Stein and Goldstein worked in Mangels' factory for two years before they decided in 1907 to risk their steady weekly pay on the chance of making greater profits in a business of their own. They contracted their carving services to other companies before forming the Artistic Caroussel Manufacturing Company in 1912. Working from dawn to dusk, six days a week in cramped quarters, the partners filled orders for others while they built their own carousel. Their company was small and they usually employed only family members.

Henry Dorber, a third owner, supplied the machinery for the carousels. He used castings for the jumping horses in order to get around Mangels' patent. When Dorber left the company in 1914, it was reorganized as Stein and Goldstein, Artistic Carousal Manufacturers. A few signed horses from this company are known to exist.

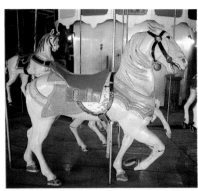

Stein & Goldstein began by carving carousel figures in their homes at night and selling the individual pieces to frame builders in their Coney Island neighborhood. These early figures have the carvers' traditional characteristics, including flat, feathered manes, giant buckles, laid-back ears, oversized saddles, bared teeth, eyes set high on the heads and aggressive expressions, circa 1908. *Lake Mishnock, Rhode Island.*

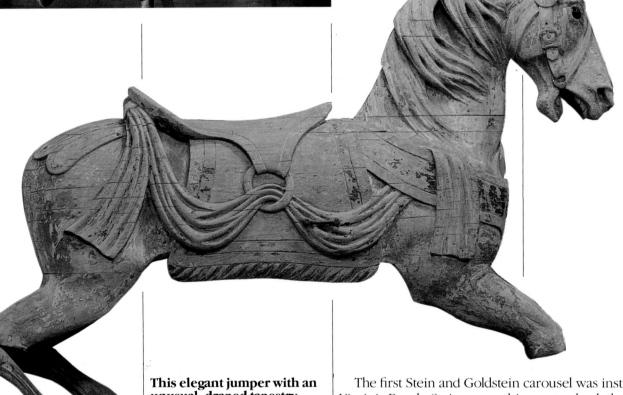

This elegant jumper with an unusual, draped tapestry decoration was rescued from the scrap pile at Disneyland in the 1960s. Carefully selected by a Disney artist from others in the pile because it would fit in the trunk of his Jaguar, this early carving was stripped of paint that had weathered and cracked in the California sun, circa 1909. *Davis collection.*

The first Stein and Goldstein carousel was installed in Virginia Beach. Stein was on his way to check the foundling creation when it caught fire and was completely burned. Stein returned from the trip with a souvenir that he called his "$20,000 plate." The loss was a financial nightmare for the new company, but their second carousel, sent to Brockton, Massachusetts, was a grand success. From then on the partners began building on a prosperous career in the carousel business and earning a place of honor among the carvers of the period.

Stein and Goldstein carved only horses. Their steeds were fierce, aggressive animals that strained to run free. Although they were massive, solid horses, they were well-proportioned and lifelike. The lead horse was often covered with armor, a favorite theme. It was the built-in strength of these horses that allowed them to carry the weight of their mail, fishscale blankets and heavy girths and harnesses with majesty.

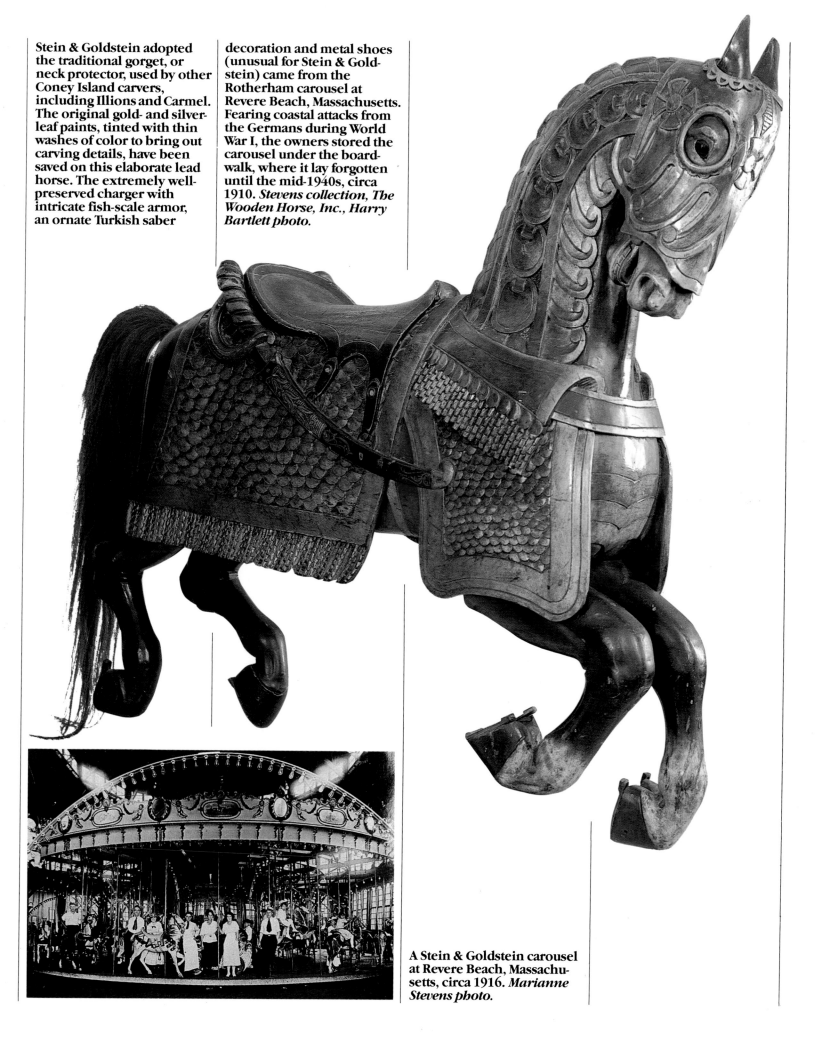

Stein & Goldstein adopted the traditional gorget, or neck protector, used by other Coney Island carvers, including Illions and Carmel. The original gold- and silver-leaf paints, tinted with thin washes of color to bring out carving details, have been saved on this elaborate lead horse. The extremely well-preserved charger with intricate fish-scale armor, an ornate Turkish saber decoration and metal shoes (unusual for Stein & Goldstein) came from the Rotherham carousel at Revere Beach, Massachusetts. Fearing coastal attacks from the Germans during World War I, the owners stored the carousel under the boardwalk, where it lay forgotten until the mid-1940s, circa 1910. *Stevens collection, The Wooden Horse, Inc., Harry Bartlett photo.*

A Stein & Goldstein carousel at Revere Beach, Massachusetts, circa 1916. *Marianne Stevens photo.*

147

Although they never carved any menagerie figures, Stein & Goldstein did use an unusual growling leopard to create a saddle for this over-sized, elongated jumper. Stein & Goldstein carved the largest of all American carousel figures, circa 1908.

During the past 100 years, New York's Central Park carousels have entertained millions of Sunday afternoon pleasure seekers.

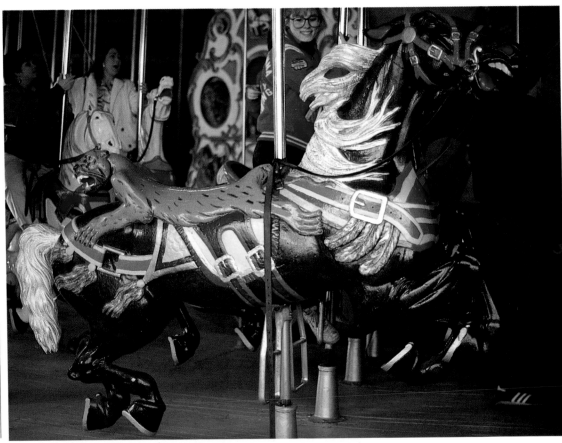

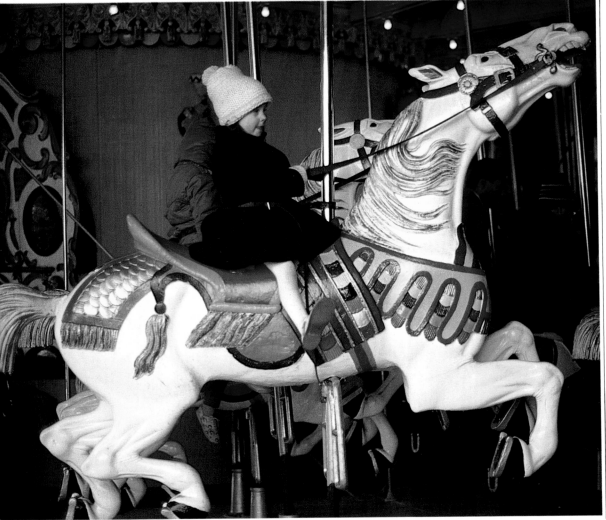

New York's Central Park has been the home of a carousel since the 1870s. The early carousel was propelled until 1912 by one mule harnessed to the center pole in the basement. This early Stein & Goldstein carousel replaced the old fire-damaged merry-go-round in 1954. The Russian immigrants' skill and style were developing when this carousel was built. The carvings are somewhat crude compared to the more dramatic and defined features in their later work, but the designs remained the same. Even so, these massive, elongated horses are over-whelming to behold, circa 1908.

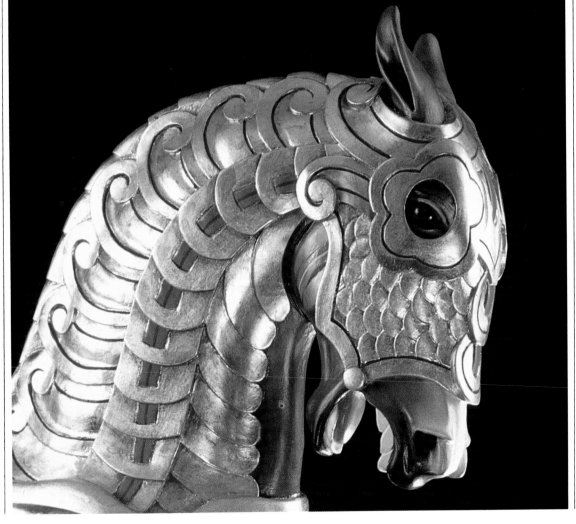

A beautifully restored outside-row stander has a growling leopard strapped down with a typically over-sized Stein & Goldstein surcingle buckle. Many carvers and manufacturers used animal skins for saddles, but none were as finely carved or more artistically created than this one, circa 1916. *Orre collection.*

Stein & Goldstein horses are highly stylized with fierce, aggressive expressions. Ornate, intricate carving in the armor of this lead horse makes it appear less severe than other examples of their work, circa 1910. *Tony Orlando restoration, Shoenbach collection.*

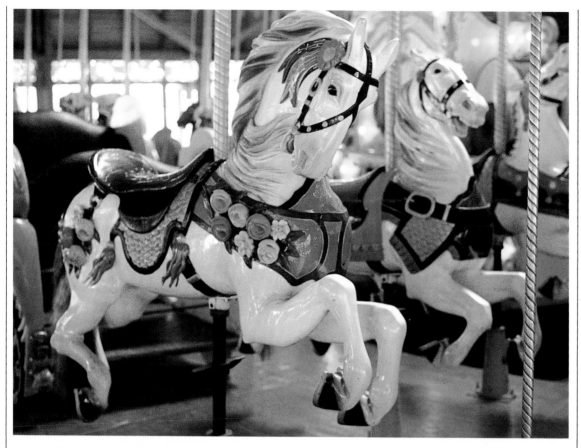

Stein & Goldstein's early carvings were greatly influenced by M.C. Illions, for whom they worked as freelance carvers from 1905 to 1907 in the W.F. Mangels shop. When they left the factory, they supposedly took copies of Illions' patterns with them. Shortly after establishing the Artistic Carousel Manufacturing Company, however, they developed their own distinctive style. Their massive, muscled steeds may have been inspired by the czar's cavalry mounts in their native Russia, circa 1912.

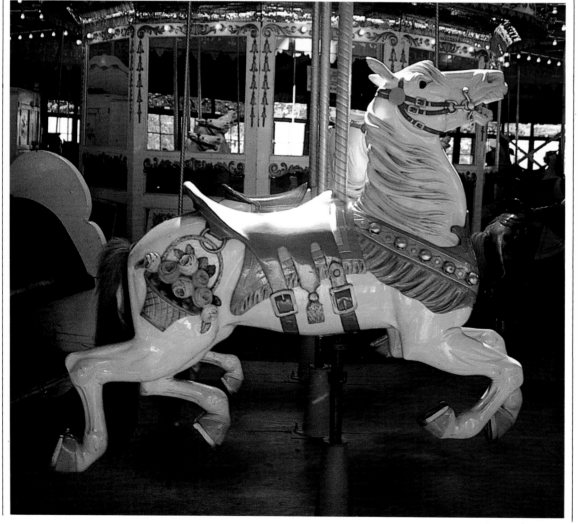

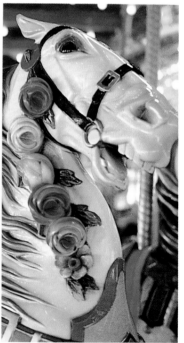

Bushnell Park in Hartford, Connecticut, is the home of the only restored carousel made by Stein & Goldstein, Artistic Carousel Manufacturing Company. They often softened the imposing nature of their powerful figures with delicate floral embellisments such as these cascades and bouquets of roses.

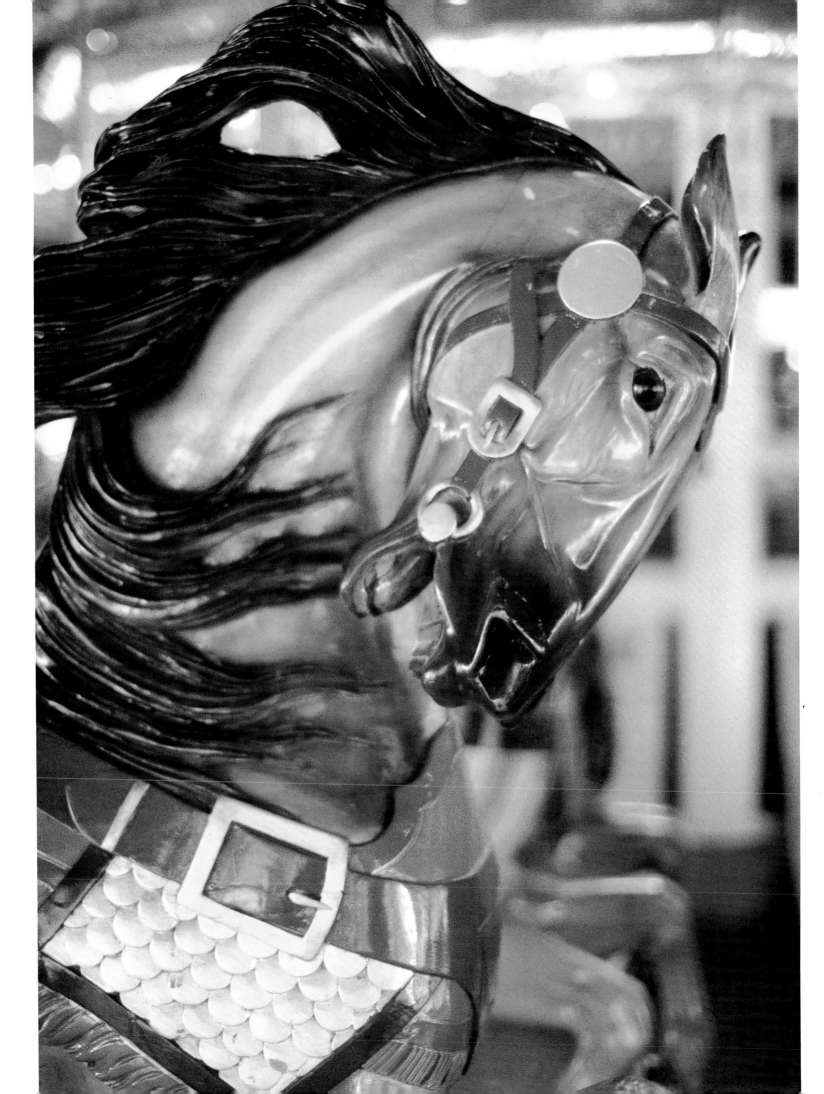

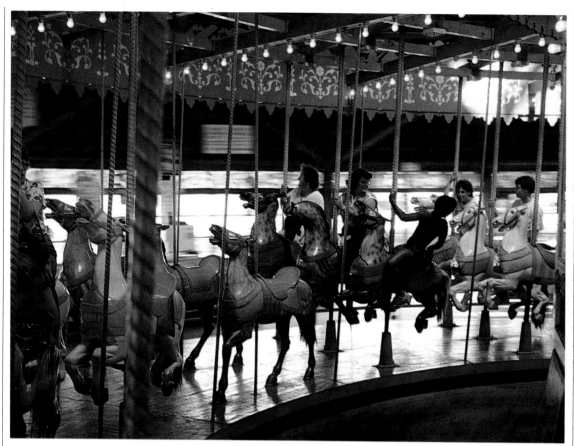

The inner side of all carousel figures is relatively plain, since this view was seldom seen by the passing throng. *Bushnell Park, Hartford, Connecticut.*

Forty-eight of Stein & Goldstein's magnificent high-spirited horses were restored by Bushnell Park Carousel Society, one of many civic organizations dedicated to preserving America's classic wooden-carousel heritage. The future survival of these valuable operating antiques depends on groups such as this one, circa 1912.

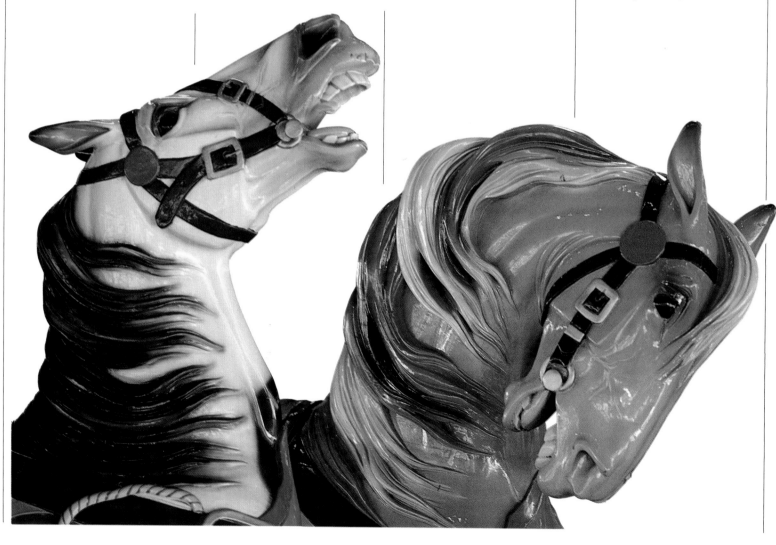

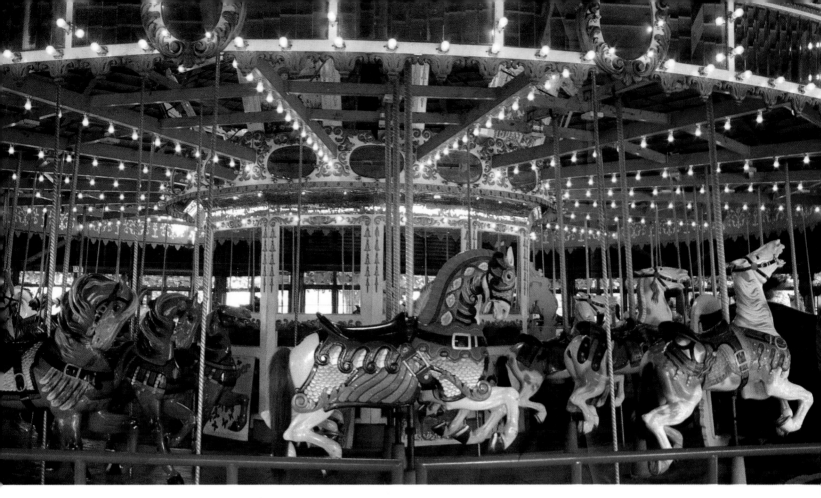

Stein & Goldstein made the largest and some of the most elaborate carousels ever built. In addition to mastering the art of carousel carving, they showed astute business sense and realized profits were to be made in the operating rather than the carving end of the carousel industry. Of the 17 carousels the two men built, they owned and operated 11 of them. Eventually they branched out into other amusement rides. Harry Goldstein, who survived his younger partner, Solomon Stein, by 18 years, continued to operate a carousel until he died in 1945.

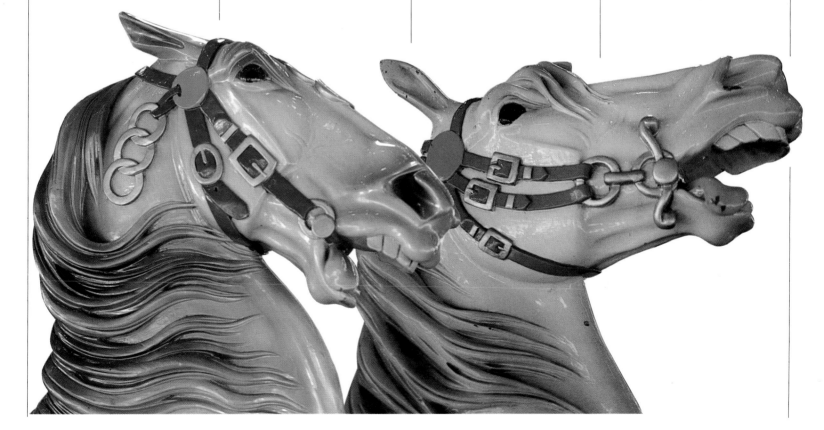

Lancing metal rings while on horseback was the inspiration for the early carousels, designed as a practice device for the tournaments. Capturing a brass ring for a free ride, an imitation of the original event, is disappearing quickly as the cost of liability insurance soars, circa 1910-12. *Nunley's carousel, Baldwin, New York.*

Stein & Goldstein's dragon chariot shows the design influence of M.C. Illions. The dragon, used by all Coney Island carvers, stemmed from the popularity of Chinese art after the turn of the century, circa 1912. *Bushnell Park, Hartford, Connecticut.*

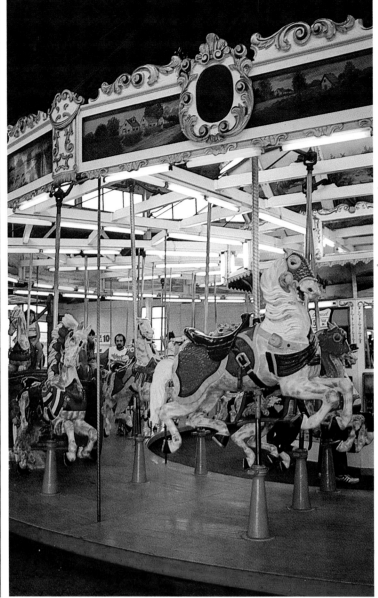

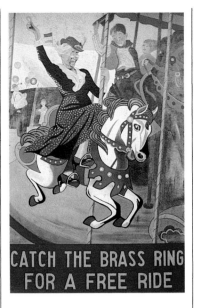

A popular modern-day expression, "Go for it," is derived from reaching for the brass ring. *Orlando collection.*

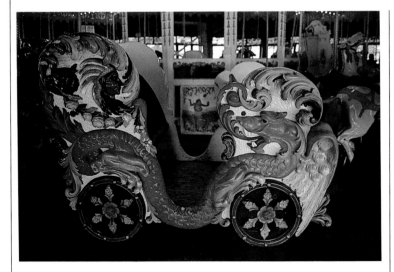

Over-sized buckles adorned typical Stein and Goldstein carvings. Rose garlands, a popular carousel decoration, were deeply carved and imposing when they graced the flanks of their great animals.

Stein and Goldstein built their carousels with machinery produced by William Mangels, Fred Dolle, Tom Murphy or M.D. Borelli. Rows of horses, five and six abreast, lunged around the platforms that were 60 feet across. One of their carousels, perhaps the only six-abreast machine ever built, was supposed to seat 100 riders. But the carvers' early training in fine carving was not lost on the large machines. Shields and ornate panels were intricately and exquisitely carved. The overall effect of their carousels was unbridled excitement.

The Russian immigrants retained ownership of approximately 11 of the 17 carousels that they had built. As they became more involved with the operation of carousels, they began carving less and branched out into other aspects of the amusement park business. Artistic Carousal Manufacturers was dissolved after World War I. Stein died of cancer in 1937 at the age of 55. Goldstein, who continued operating parks and an arcade machine business was around 80 years old when he died in 1945.

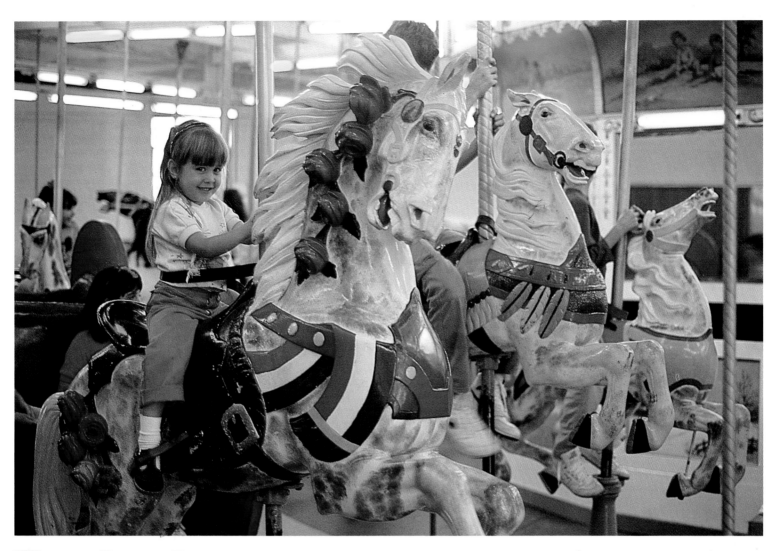

True connoisseurs of carousel magic, the children, pay no attention to carving styles and types of decoration. Just riding the colorful painted ponies releases their own fantastic imaginations and leaves them with a special memory. The enraptured expressions of little, smiling faces was the ultimate goal of the carousel makers.

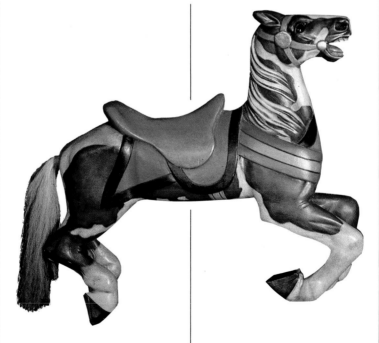

In the early 1920s, when the carousel industry began to slip away, Stein & Goldstein, among others, sought out other ways to utilize their carving talents. They carved circus wagon decorations and hundreds of horses destined for use as children's barber chairs for a Chicago firm. This one was found gathering dust in a Leadville, Colorado, warehouse.

While building their large carousels, Stein & Goldstein often placed a row of six of these petite 24-inch-high kiddie ponies on their machine in order to lay claim to a six-abreast machine, circa 1912. *Veder collection.*

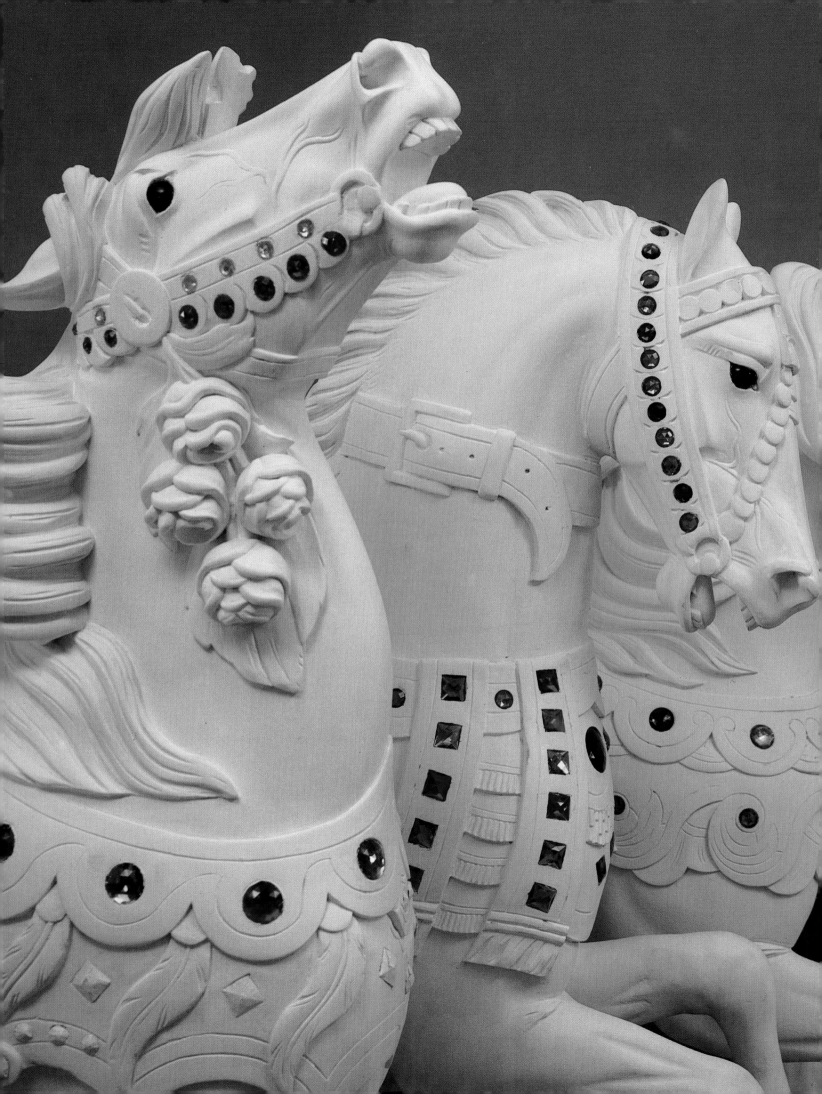

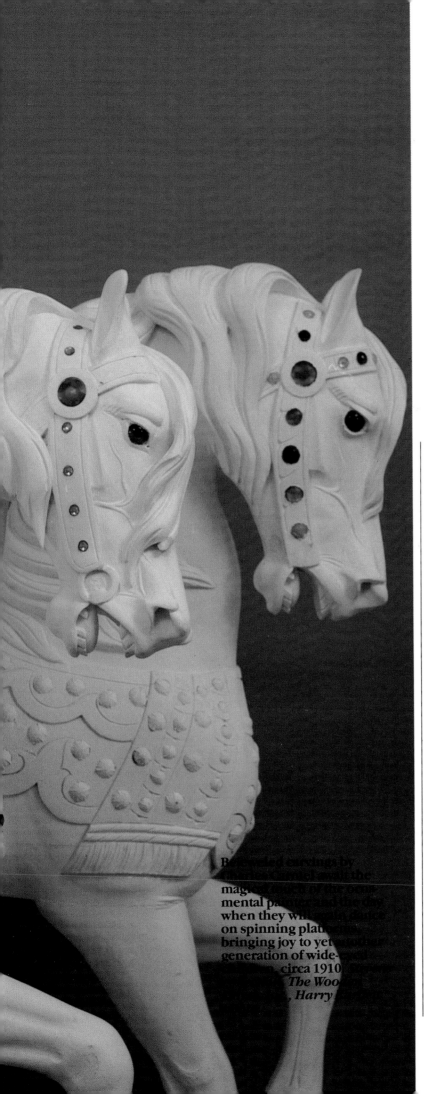

Bejeweled carvings by Charles Carmel await the magic touch of the ornamental painter and the day when they will again dance on spinning platforms, bringing joy to yet another generation of wide-eyed riders. circa 1910. (from The Wooden ... , Harry ...)

Carousel Artist
CHARLES CARMEL

Charles Carmel, an eclectic Coney Island carver, absorbed and used techniques developed by his peers working in New York and Philadelphia. He borrowed to such an extent that researchers are unable to ascertain in what areas he was a copier or an innovator.

Perhaps the Carmel horse epitomizes the carousel spirit. On his well-shaped animals any style could appear. Manes could be caught by the same strong winds that tousseled the hair of an Illions or Looff horse. His creations could carry a no-nonsense military saddle associated with Muller or an oversized buckle favored by Stein and Goldstein. Carmel was so dedicated to realism that he often gave his horses drooping tongues, bad teeth and other minor imperfections that he noticed in animals using the bridle path that went past his carving shop near Prospect Park in Brooklyn.

The mixture of styles influencing Carmel's work is easily understandable. A listing of the people for whom Carmel worked reads like a "Who's Who" book of carousel greats. The seventeen-year-old Russian probably learned to carve before he and his young bride, Hannah, immigrated to the United States in 1883. Looff hired him as a carver around the turn of the century. Carmel made animals for the carousel manufacturers Borelli, Dolle, Mangels and Murphy. He worked with Illions, Goldstein and Stein and perhaps the Muller brothers. He definitely supplied horses for the Philadelphia Toboggan Company. Payroll ledgers for the PTC show Carmel charged $35 to carve a larger jumper or standing horse, $25 for a medium horse and $20 for a small jumper or stander. Working under several employers, Carmel probably was instructed to produce certain styles. It was to his credit that he was versatile enough to meet those demands.

Many of Carmel's horses that survived the years have bridles, saddles and trappings studded with rows of colorful jewels. This peculiar treatment was apparently added by Borelli, who was fascinated with Carmel's designs. Borelli started in the carousel business as a starry-eyed ring boy in charge of the brass

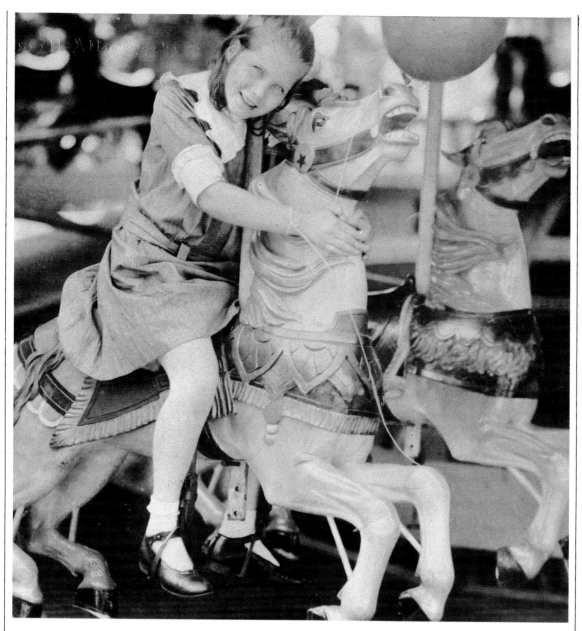

ring device. As a successful carousel manufacturer, Borelli spent hours during the off season applying glass jewels to Carmel's horses. Some figures have more than 300 gems on their trappings. Overcome with zeal for this work, Borelli sometimes studded the bodies of the animals and faces of bas-relief portraits carved into the sides of the horses.

Carousels in a good location could produce an income of $500 a day—a fortune in the early 19th century. In an attempt to tap the profits of owning and operating a carousel, Carmel built one of his own and installed it at Dreamland Park in Coney Island in 1911. The day before the park was scheduled to open, a fire destroyed the entire park. For the would-be carousel owner, the loss of his uninsured machine was financially crippling.

Carmel, who suffered ill health during the last 10 years of his life, carved from the house on Ocean Parkway in Brooklyn that he and his wife and eventually their four children occupied since the couple first arrived in America. By working a few hours a day Carmel carved figures and made repairs until diabetes and arthritis made him an invalid. He was 66 years old when he died in 1931.

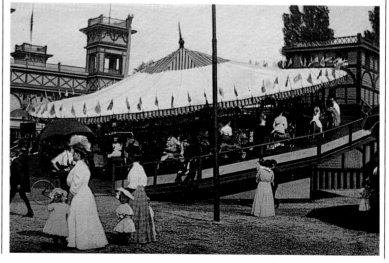

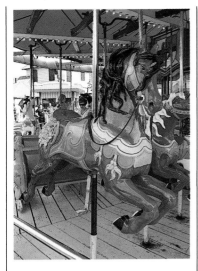

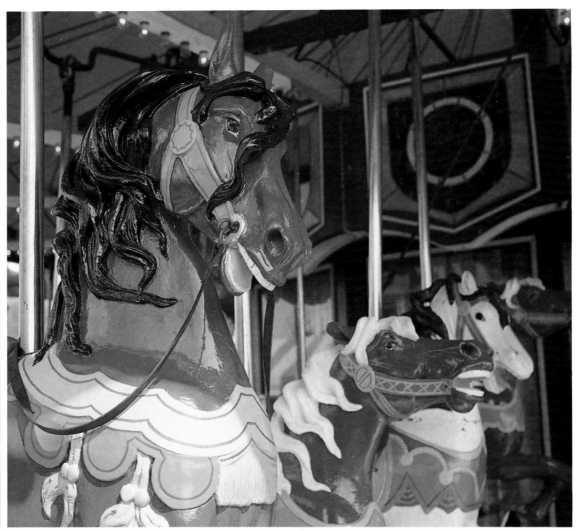

Charles Carmel's early carvings were characterized by oversized, boxy heads, circa 1905.

Wind-blown manes, usually painted in gold leaf, are a "trademark" of the Coney Island style and may have originated with Marcus Illions. Charles Carmel worked with the highly imaginative and innovative Illions at the Looff and Mangels factories. This association clearly influenced Carmel's own style, circa 1905.

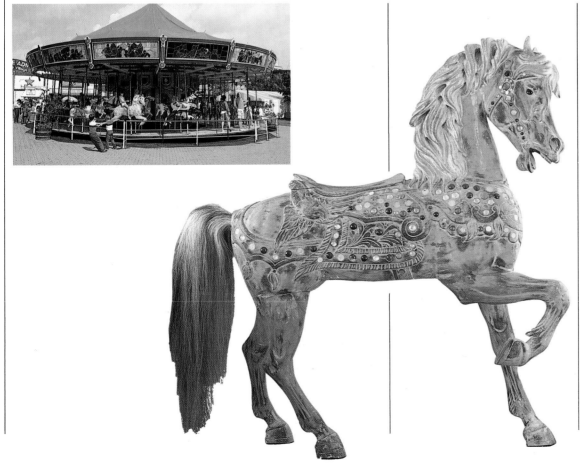

Framemaker M.D. Borelli was one of Carmel's best customers. This large, outside-row lead horse, bearing an elaborate eagle saddle decoration, was one of the first carvings Carmel produced after opening his own shop. The multitude of jewels was probably added by Borelli after he bought the horse. Borelli believed the sparkling gems lent a modern and exciting touch to the carousel. He often added as many as 300 jewels to a single figure, sometimes completely oblitering the artist's carving, circa 1905. *Farnsworth collection.*

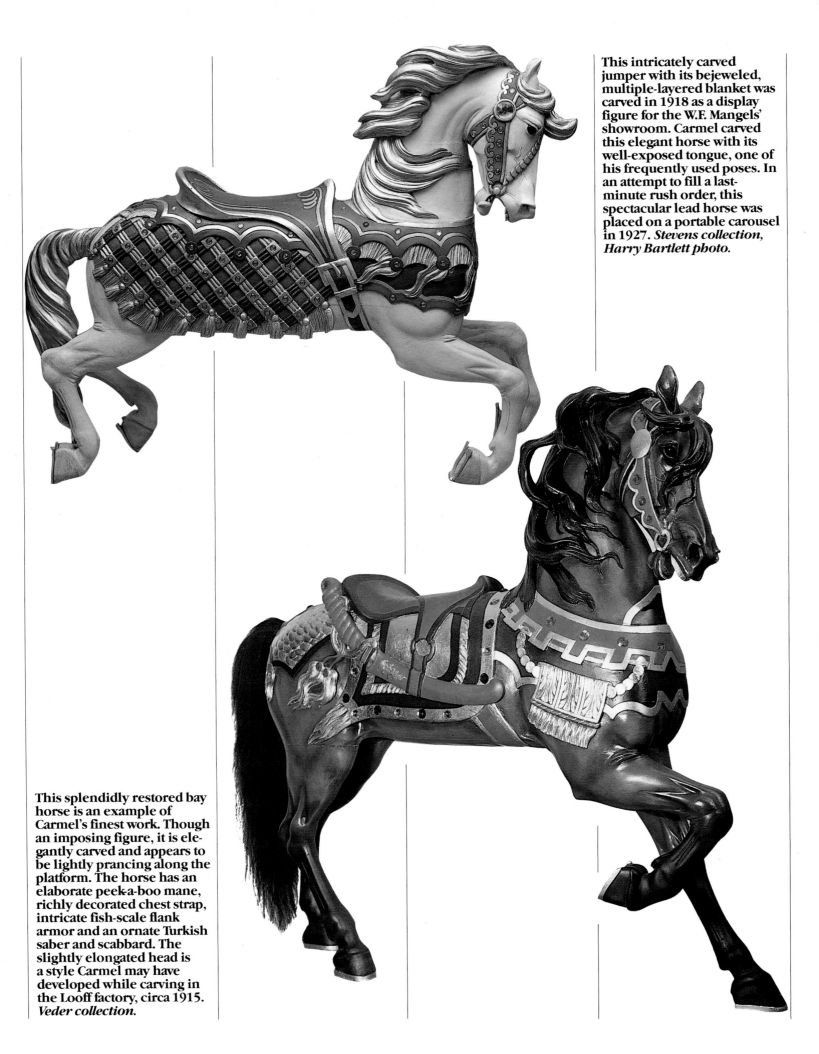

This intricately carved jumper with its bejeweled, multiple-layered blanket was carved in 1918 as a display figure for the W.F. Mangels' showroom. Carmel carved this elegant horse with its well-exposed tongue, one of his frequently used poses. In an attempt to fill a last-minute rush order, this spectacular lead horse was placed on a portable carousel in 1927. *Stevens collection, Harry Bartlett photo.*

This splendidly restored bay horse is an example of Carmel's finest work. Though an imposing figure, it is elegantly carved and appears to be lightly prancing along the platform. The horse has an elaborate peek-a-boo mane, richly decorated chest strap, intricate fish-scale flank armor and an ornate Turkish saber and scabbard. The slightly elongated head is a style Carmel may have developed while carving in the Looff factory, circa 1915. *Veder collection.*

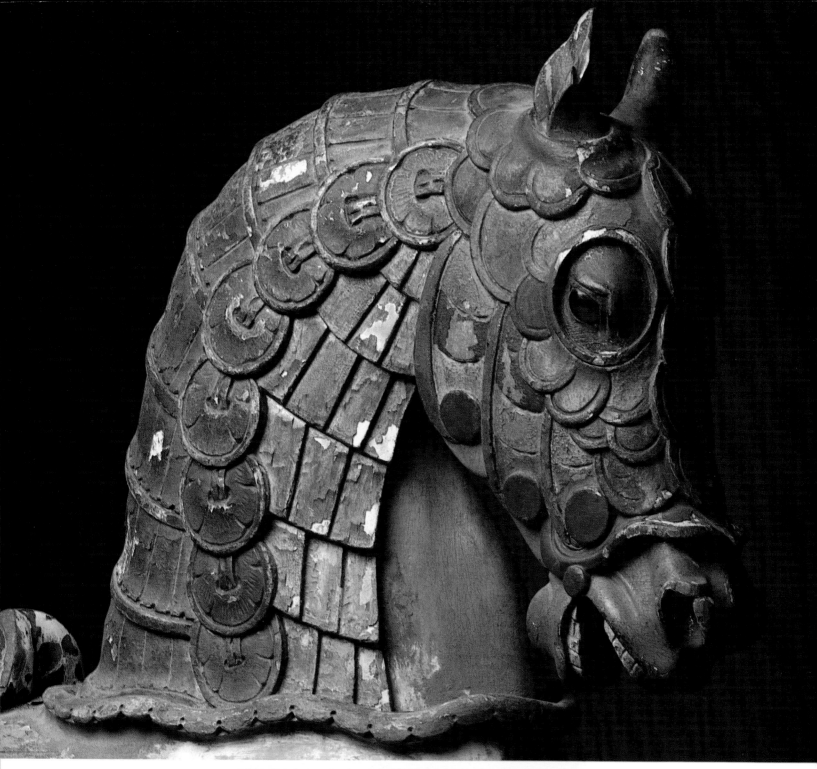

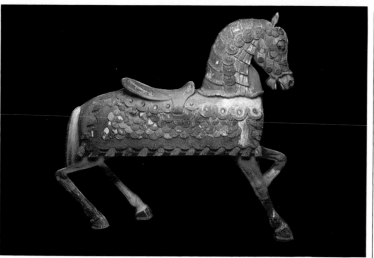

Even when shrouded in heavy armor, Carmel's horses have well-developed and gentle expressions. This king horse has a patina of many layers of muted paint and yellow varnish darkened over the years. It was taken from a carousel in Baton Rouge, Louisiana, circa 1910. *Sardina collection, Jeff Saeger photo.*

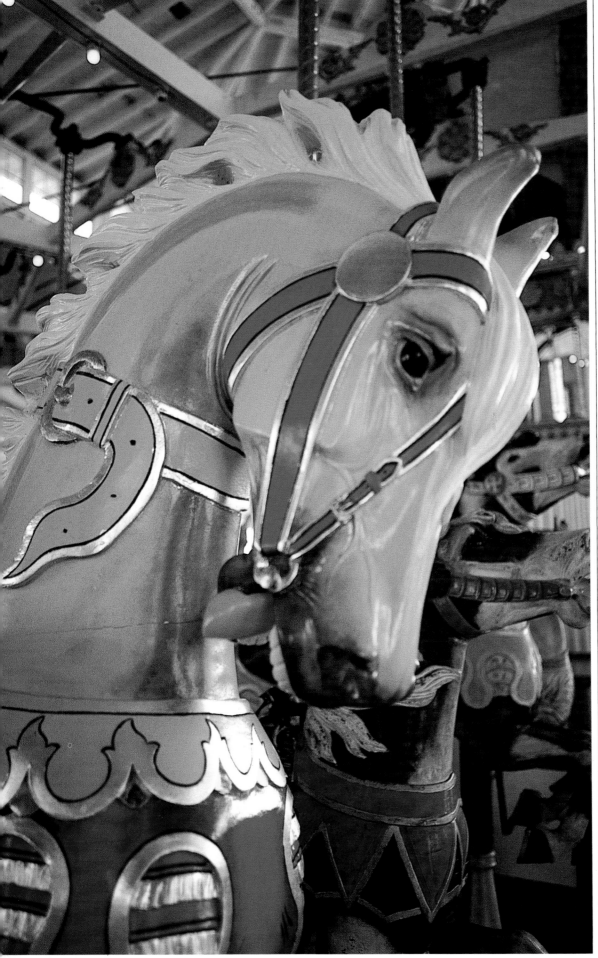

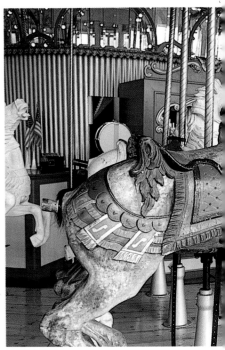

Carmel used the complete array of delicate motifs developed by individual Coney Island carvers to create the perfect blend of reality and fantasy, illustrated here in this recently restored jumper. The gold and silver leaf add the flashy touch that gave Coney Island carousels a reputation for flamboyancy, circa 1911.

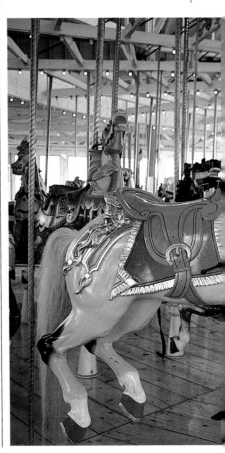

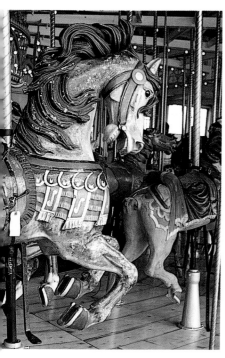

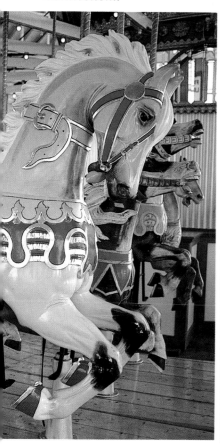

This thrilling outside-row jumper has a wonderfully carved, windswept mane that reverses direction as it nears the brass pole. Exaggerated manes characterized the Coney Island carving style. The oversized saddle buckle is usually associated with Stein & Goldstein carvings, circa 1911. *Lighthouse Point Park, New Haven, Connecticut.*

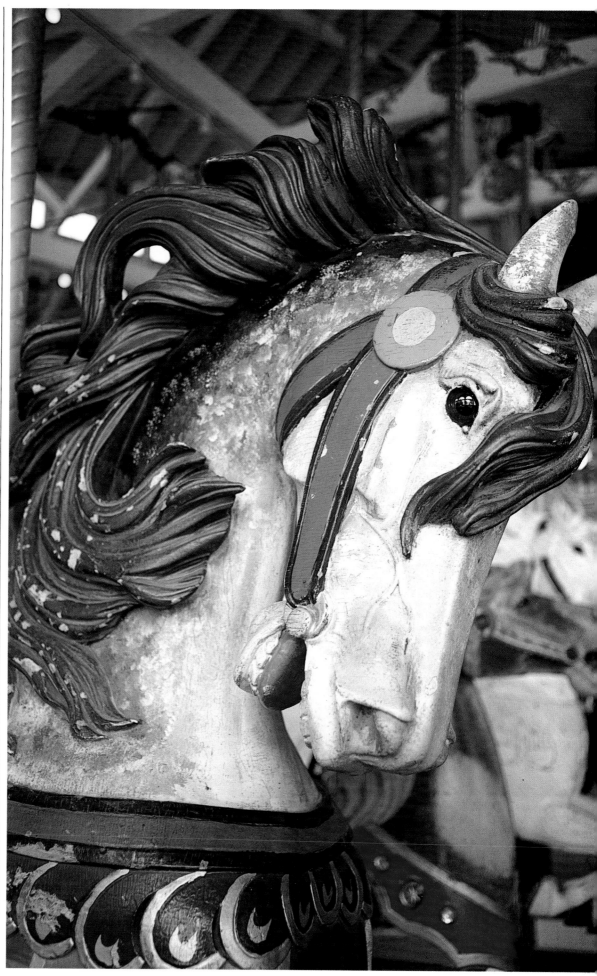

163

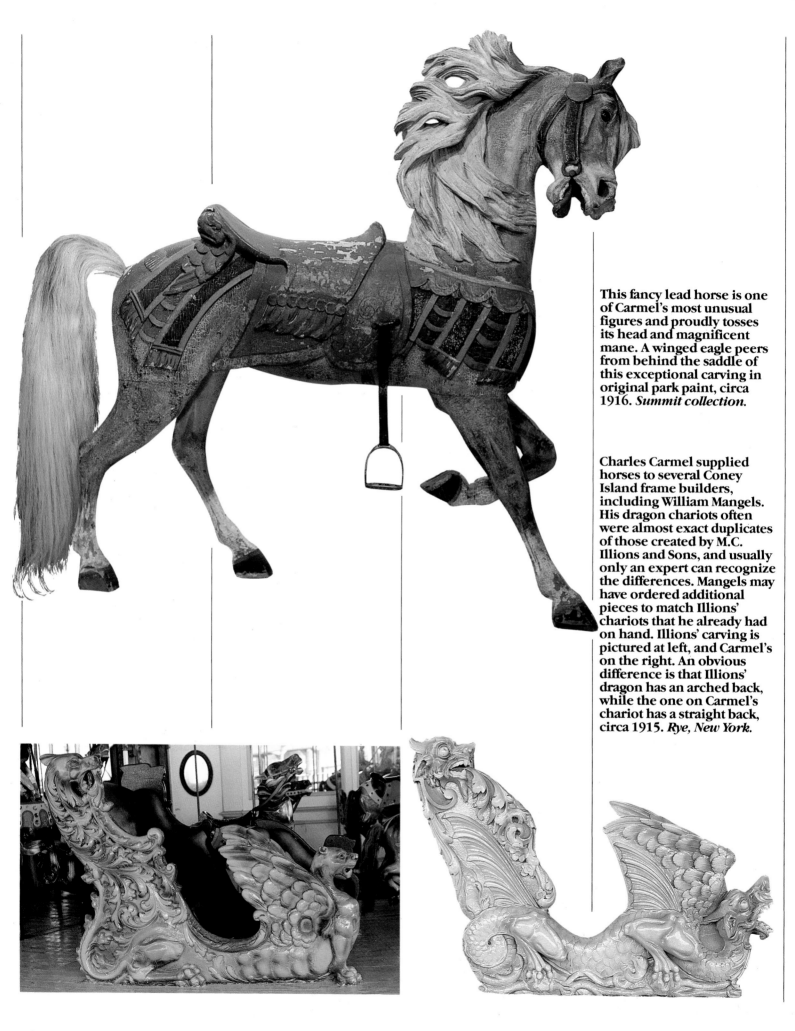

This fancy lead horse is one of Carmel's most unusual figures and proudly tosses its head and magnificent mane. A winged eagle peers from behind the saddle of this exceptional carving in original park paint, circa 1916. *Summit collection.*

Charles Carmel supplied horses to several Coney Island frame builders, including William Mangels. His dragon chariots often were almost exact duplicates of those created by M.C. Illions and Sons, and usually only an expert can recognize the differences. Mangels may have ordered additional pieces to match Illions' chariots that he already had on hand. Illions' carving is pictured at left, and Carmel's on the right. An obvious difference is that Illions' dragon has an arched back, while the one on Carmel's chariot has a straight back, circa 1915. *Rye, New York.*

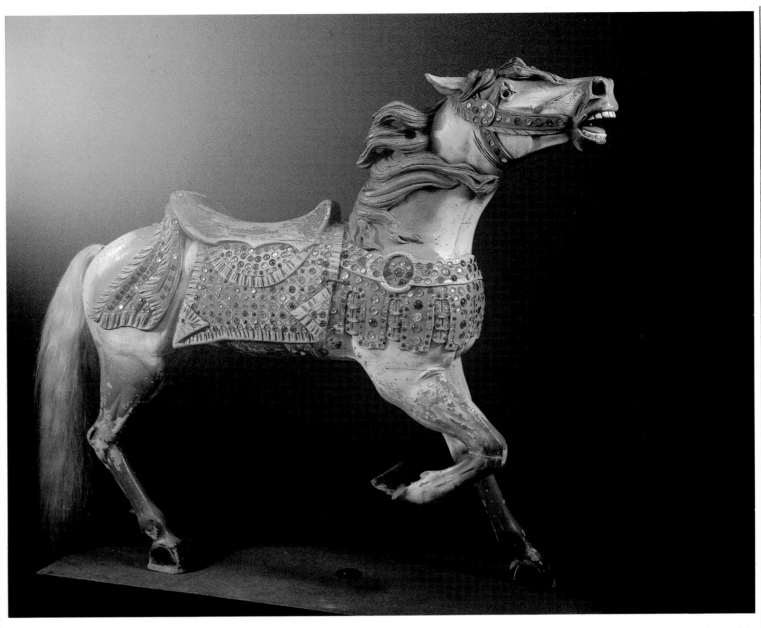

Carmel disliked jewels on his figures and used them sparingly. Ironically, his best customer, M.D. Borelli, bought hundreds of figures and studded them with enormous quantities of colored glass gems, circa 1910. *Daniel collection.*

This Robinson Caruso chariot, attributed to Carmel, is found on board a carousel at the Fun Forest in Seattle, Washington. The carving was decorated (or destroyed) by M.D. Borelli, who thought that jewels added excitement to carousel figures and that more was better. During the off-season, the frame builder applied jewels in random patterns and colors with little regard for the carving, circa 1912-1920. *Jim Hennessey photo.*

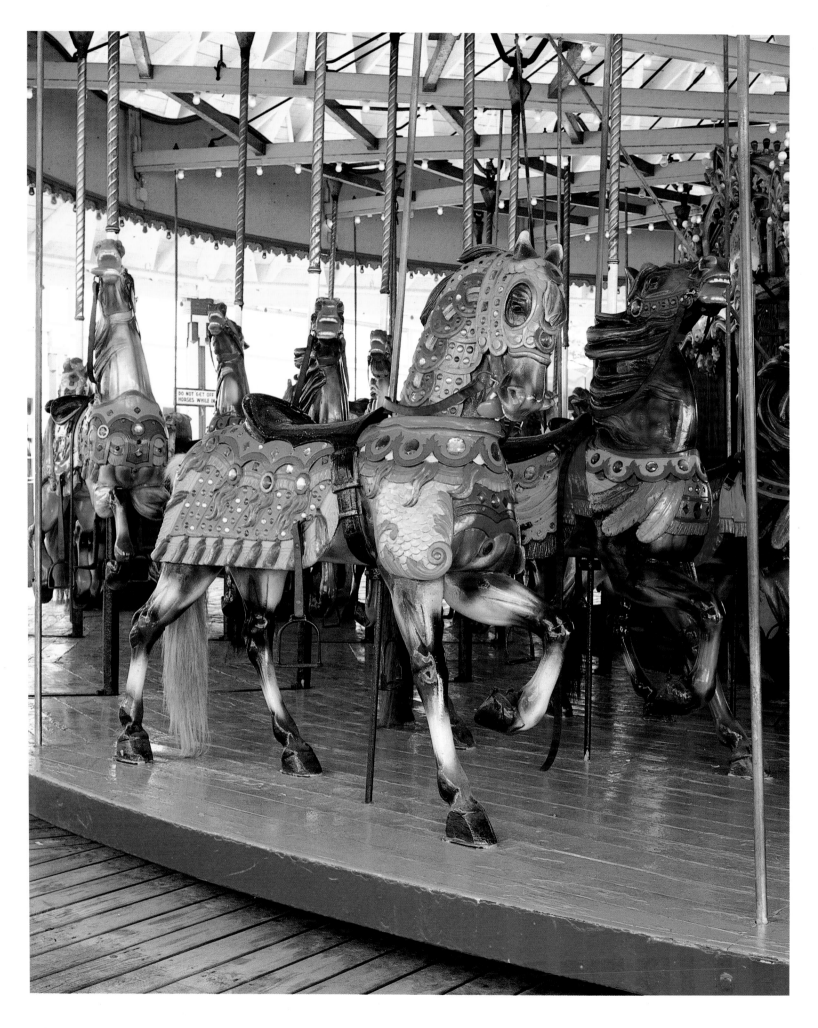

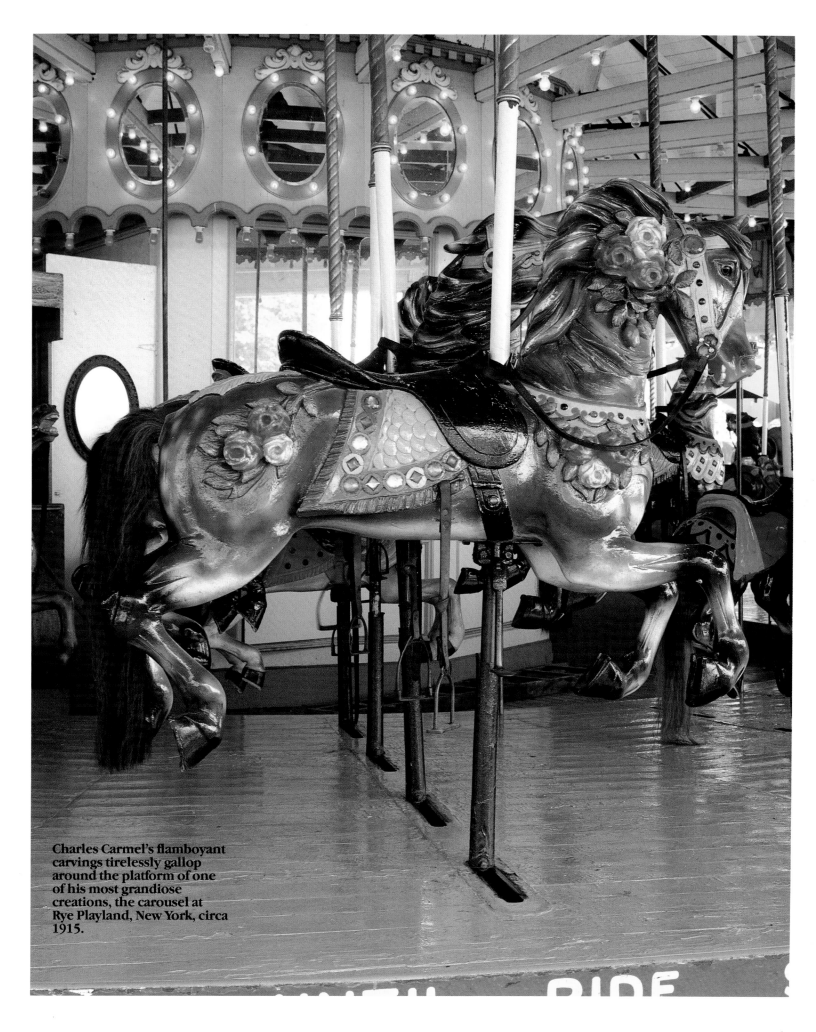

Charles Carmel's flamboyant carvings tirelessly gallop around the platform of one of his most grandiose creations, the carousel at Rye Playland, New York, circa 1915.

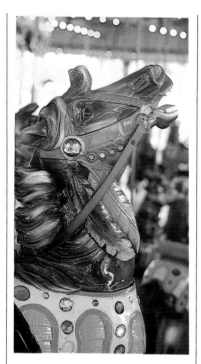

A pair of large feathers decorates the bridle of this "star-gazer," circa 1915. *Rye, New York.*

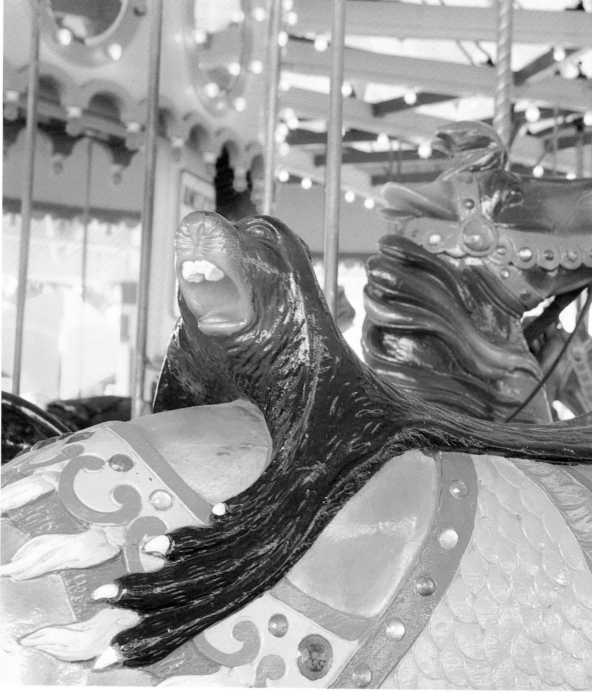

An unusual, screaming creature of fantasy creates a saddle for this proud, outside-row stander with an opulent, flowing mane and elaborate rose decorations, circa 1915. *Rye, New York.*

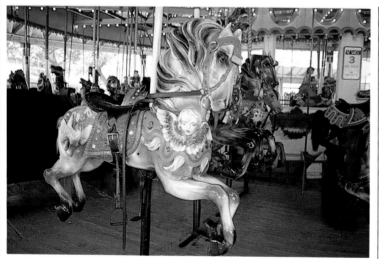

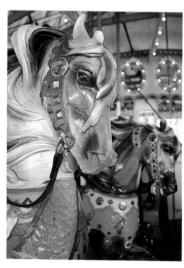

One of Carmel's finest carvings, this wonderful jumper, carries a breastplate adorned with a peaceful cherub. A pair of game birds hang over the horse's rump.

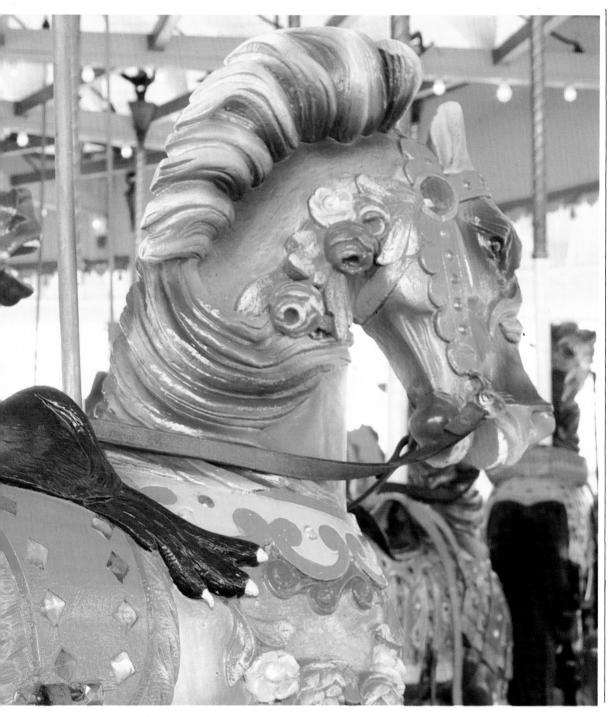

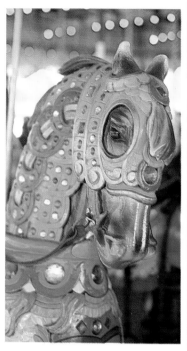

Charles Carmel, along with Looff, Illions and Stein & Goldstein, used the same armor motif to adorn their horses. This richly carved, outside-row lead horse has typical Coney Island-style armor plus expressive eyes and the drooping tongue that Carmel favored.

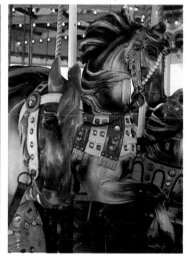

The hunter's kill, such as this pair of rabbits, was a popular decoration often used by Carmel. On this magnificent jumper, one of Carmel's finest works, a patriotic eagle clutches the chest of the horse, circa 1915. *Rye, New York.*

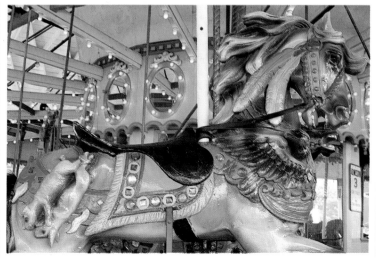

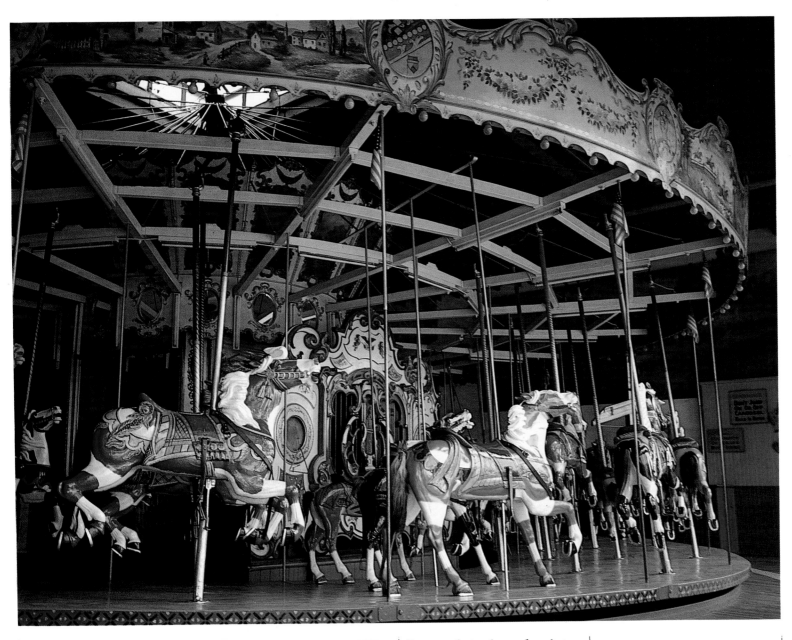

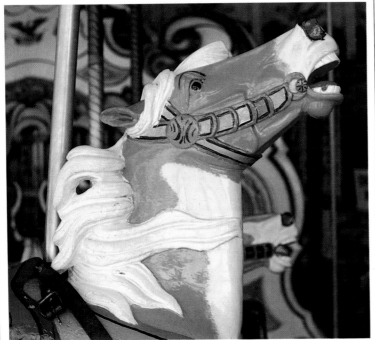

Brassy pintos in park paint populate the B. & B. carousel on Surf Avenue in New York. It is the last operating carousel in Coney Island, where nearly two dozen glittering merry-go-rounds once spinned. This may be the last machine Charles Carmel produced, circa 1920.

As seen in this horse of a different color, the quality of Carmel's carvings was always exceptional. Many authorities feel that Carmel combined the perfect balance of reality and fantasy to create the ultimate carousel horse, circa 1920.

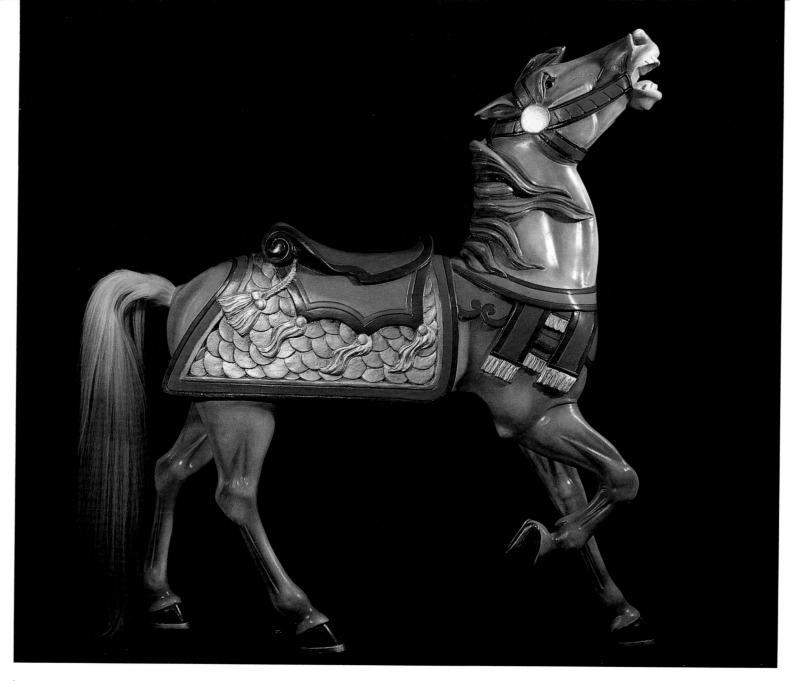

A traditional outside-row stander in the popular Carmel "star-gazer" pose wears an ornamental fish-scale saddle blanket. Carmel was not as familiar with anatomy as some of his fellow carvers, but this lack of reality may be the reason his carvings are so appealing, circa 1912. *Abbott collection, Robert Manns photo.*

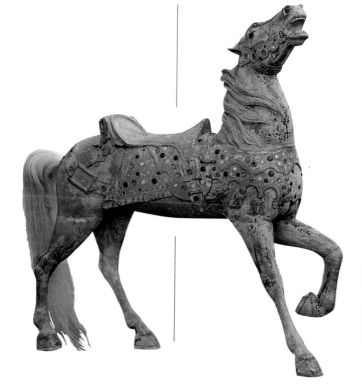

The nose-in-the-air "star-gazer" pose was popular with most Coney Island carvers. This noble Carmel horse sports a saddle attached with a massive buckle, which traditionally bedecked Stein & Goldstein figures. Carmel borrowed freely from the popular motifs used by other carvers. This outside-row stander was heavily embellished with a random assortment of jewels by M.D. Borelli, a frame maker. The figure was originally on board the carousel at Silver Beach, St. Joseph, Michigan, circa 1912. *Schoenbach collection.*

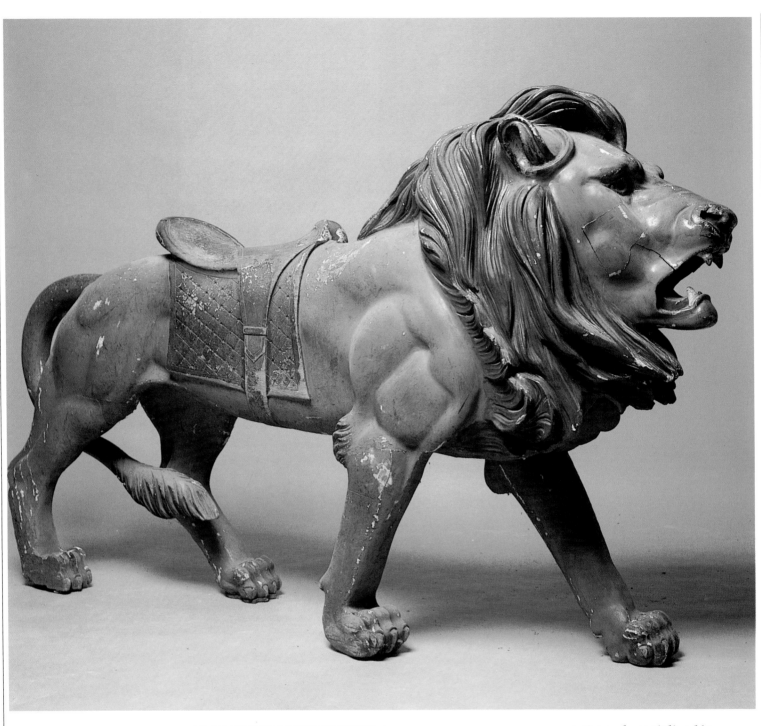

A bug-eyed Carmel lion snarls from the platform of an idle carousel in Prospect Park in Brooklyn, New York, circa 1912. The carousel factories produced figures in varying degrees of artistry, depending on the urgency of the order and prices paid.

Carmel specialized in supplying figures to frame builders, who usually required horses, and thus never developed great skill at carving menagerie figures. On special order, he produced a few animals, including camels, sea monsters, goats and lions. This rare Carmel lion in old park paint, one of his few menagerie carvings, was last used on a carousel in Baton Rouge, Louisiana, circa 1915. *Sardina collection, Jeff Saeger photo.*

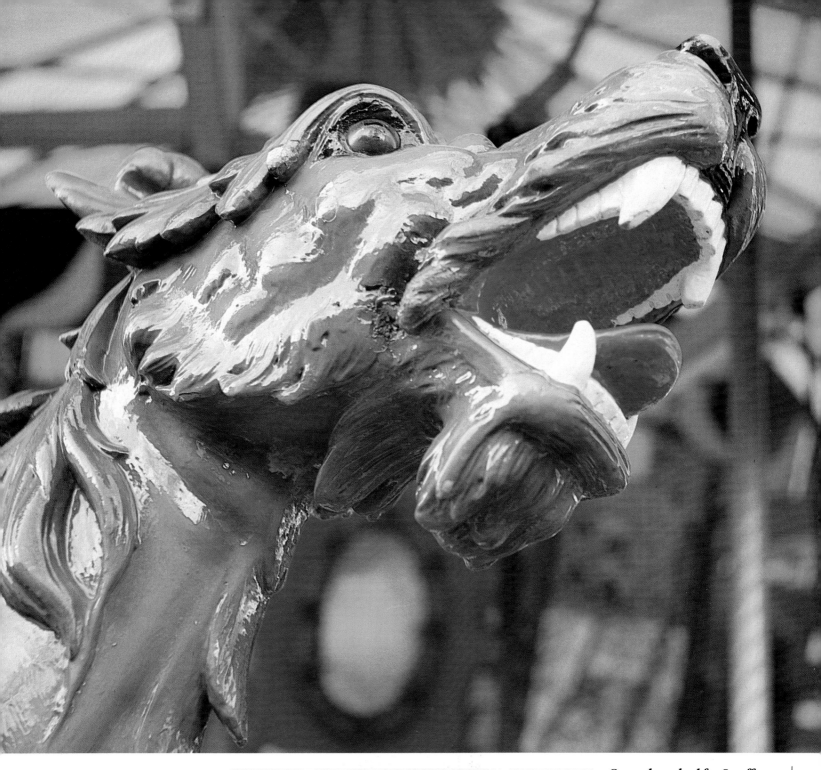

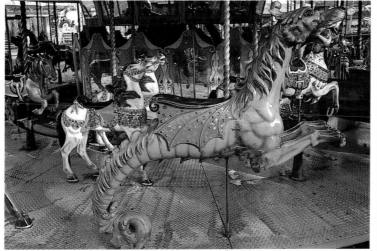

Carmel worked for Looff as a freelance carver on and off for 15 years. During this time, he developed his skills and borrowed many of Looff's characteristic details. Carmel's sea monster from Fun Forest Park in Seattle, Washington, is almost an exact copy of those produced in the Looff factory. Only an expert would notice the subtle differences. It is also possible that an unknown freelance carver produced this figure, and others like it, and sold them to shops in the Coney Island area, circa 1912. *Jim Hennessey photo.*

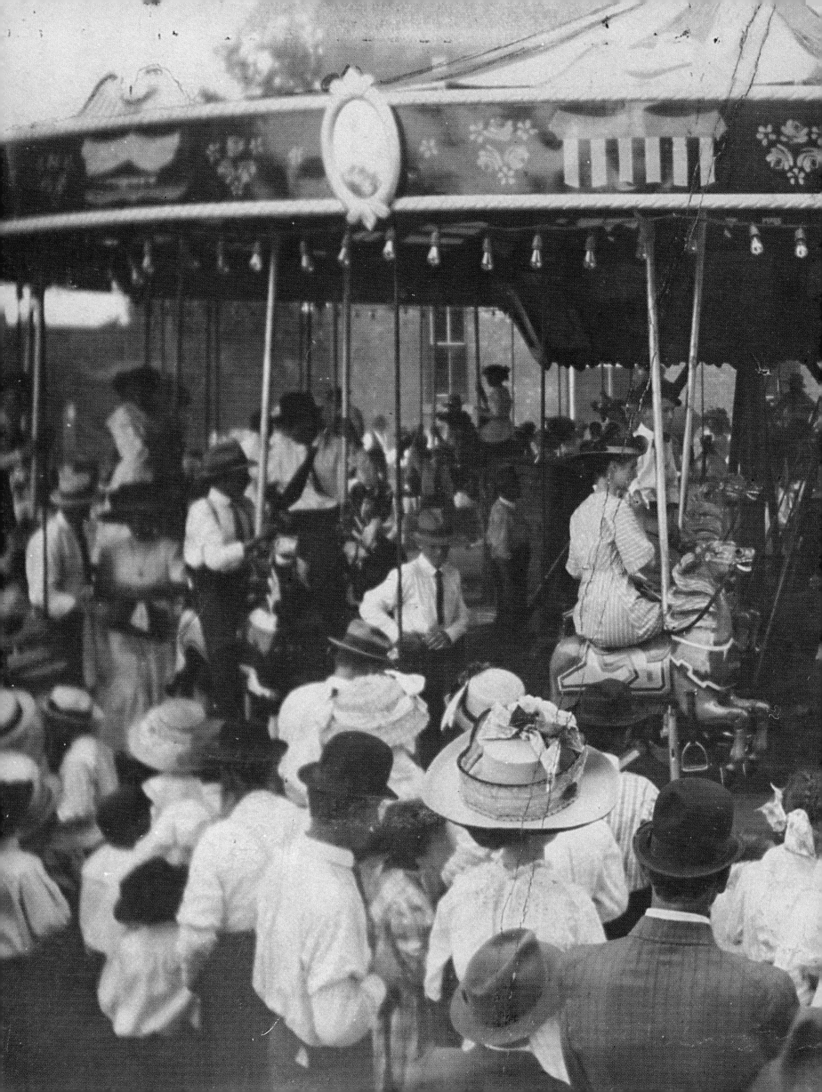

The
COUNTY FAIR
Style

In the sleeked-down style of the County Fair carousels, form and function were as closely united as the wooden horses and their built-in saddles. Carousel animals were made strong enough to carry energetic youths and more sedate, but heavier adults. But the County Fair breed was developed primarily to gallop across the countryside in a whirlwind of one-night stands.

A traveling carnival was home for these carousels. In later years these nomads received more adornment, but the forerunners of the County Fair stallions were long, lean and lightly carved.

This style and the manufacture of portable machines developed at two American sites. One flourished in the Midwest under the stewardship of Charles Wallace Parker. The other site in North Tonawanda, New York, became the carousel capital of the United States. More carousels were produced in North Tonawanda than in any other place. Although several factories in this area made carousels, the ones that produced notable machines had either or both the names Herschell and Spillman listed among the owners.

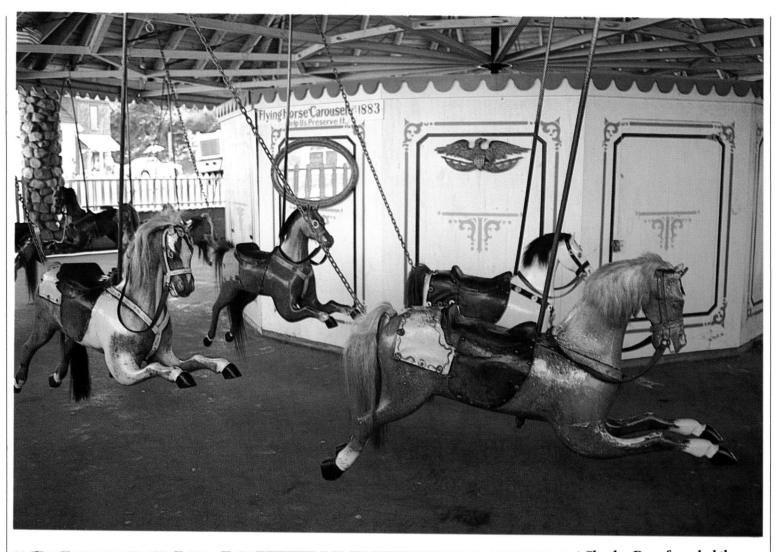

Charles Dare founded the New York Carousal Manufacturing Company in Brooklyn, New York, around 1870. Up to that time he had produced hobbyhorses, whose designs probably had been adapted for his first carousel figures. These flying horses, with their unnatural outstretched front legs, are still in use at Watch Hill, Rhode Island, circa 1884.

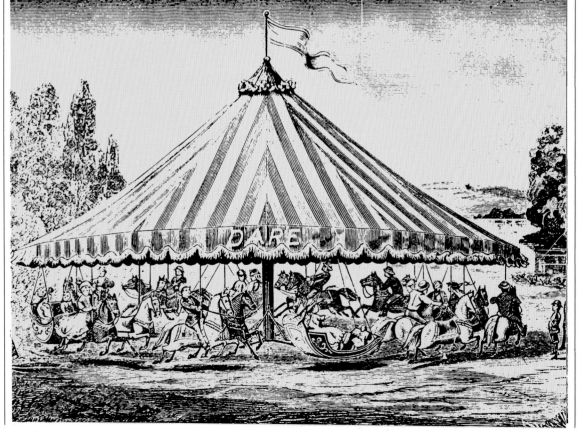

By the 1890s Dare had a prosperous business employing several dozen workers to produce platforms, tracks and flying-horse style merry-go-rounds.

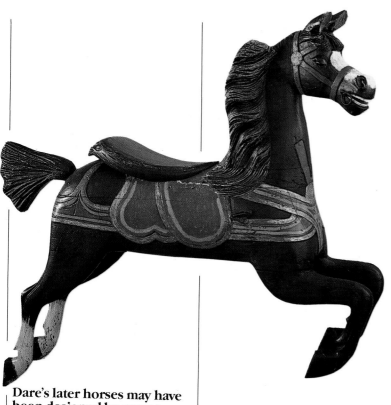

Dare's later horses may have been designed by carver Samuel Robb, well-known for his cigar-store Indians and other ornamental carvings. These simple figures have a folk-art charm. Dare's horses had real hair tails. This one had a wooden bobtail added at a later date, circa 1905. *Farnsworth collection.*

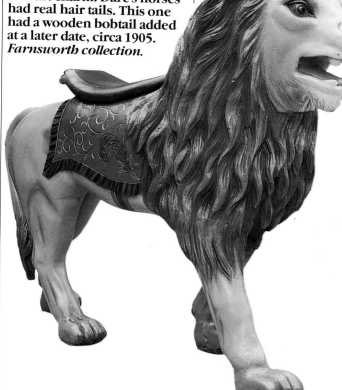

Dare produced an interesting array of menagerie figures, including camels, deer, elephants and lions. This beautifully restored carving is one of only two known surviving Dare lions. The figure is surprisingly large (67 inches long), compared to the size of the horses. The lion is well carved, yet retains the folk-art charm found in other Dare figures, circa 1880-1890. *Orre collection.*

County Fair carousels flowered with the nurturing of Herschell and Parker, but Charles W.F. Dare planted the seeds for this style. Dare was apparently a hobbyhorse manufacturer before he started building carousels. The toys were primitive reproductions and their simple design was repeated in the carousel horses he produced.

Dare's New York Carousal M'F'G' Company in New York City produced its first portable carousels in America sometime between 1867 and 1875. An 1878 catalog shows horses with fat, grinning faces squeezed into tight halters. Saddles were made from wood but were carved separately and mounted on the horses. For eyes Dare set glass marbles, some clear and some with swirls, into the innocent-looking faces of the animals he produced.

Around 1890 Dare renamed his operation the Charles W. Dare Company and moved it to Brooklyn, New York. He made a variety of amusement devices and a few portable carousels. Camels, deer, donkeys and elephants accompanied the horses on Dare's machines. Although his factory was located near the Coney Island companies famous for ornate decorations, Dare retained his simple designs. When he died in 1901, he left a legacy that was eventually fulfilled by other dedicated carousel builders.

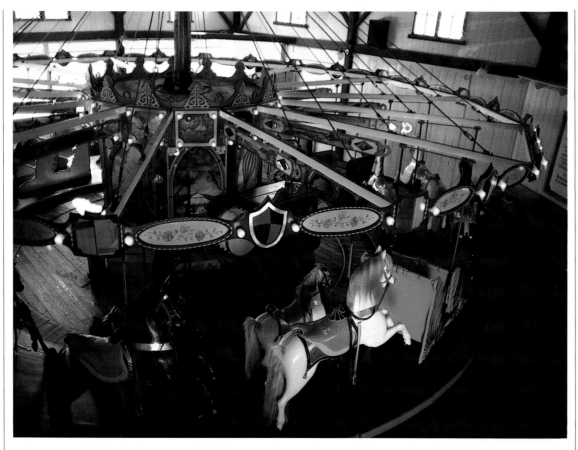

An early Dare platform machine, still carrying riders on the island of Martha's Vineyard in Massachusetts, is the oldest operating carousel in the United States. The figures had Dare's traditional hobbyhorse features with real hair manes and tails, circa 1880-1884.

This early carousel provided figures in several sizes to accommodate riders of all ages. These first machines often had more adults than children on board.

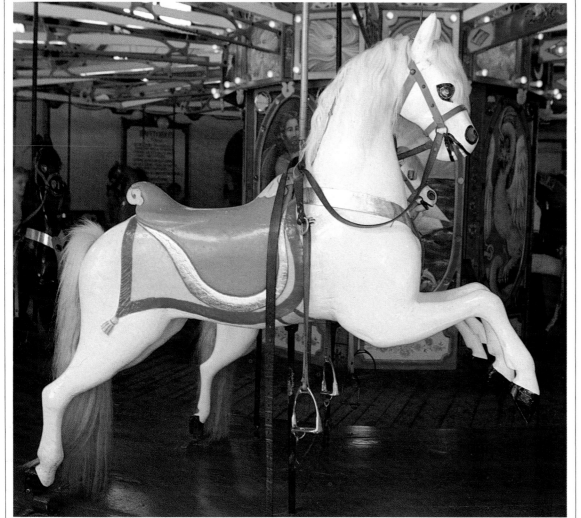

Dare sometimes used multi-colored marbles instead of the glass eyes favored by other manufacturers. He also was the only carousel maker to provide his horses with a running martingale — a leather thong that linked the bridle with the chest strap and prevented horses from throwing their heads back, circa 1895.

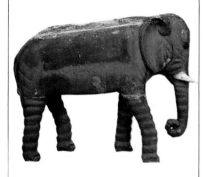

Dare's menagerie figures also had a charming naive quality. The design for this petite elephant was later adapted by the United States Merry-Go-Round Company of Cincinnatti, Ohio. Originally, the elephant wore an up-holstered seat, circa 1880. *Stevens collection, Harry Bartlett photo.*

The plain carvings Dare used set an example for portable carousels and became what is known as the County Fair style. Dare's horses were later copied by the C.W. Parker Amusement Company in Abilene, Kansas, and Armitage Herschell Company in North Tonawanda, New York, circa 1895.

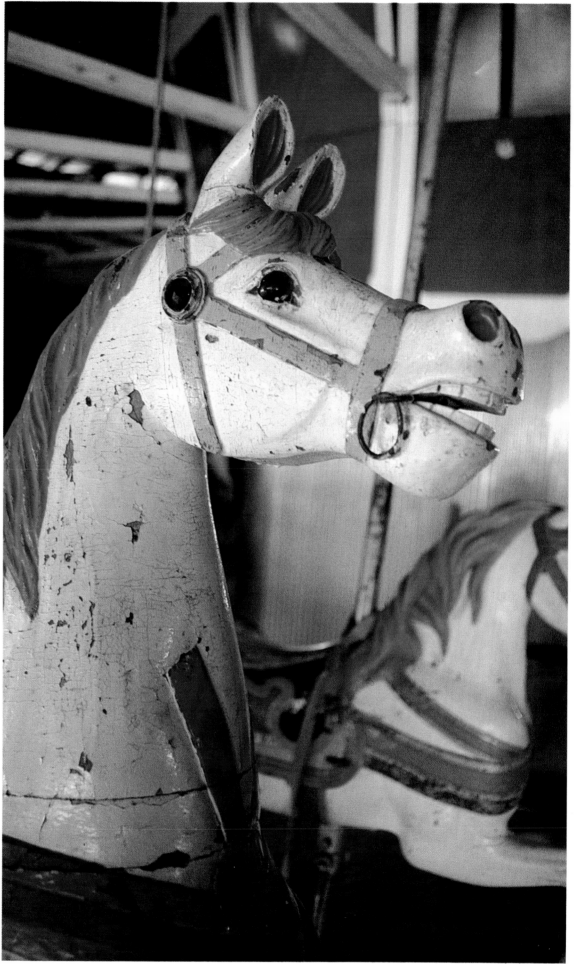

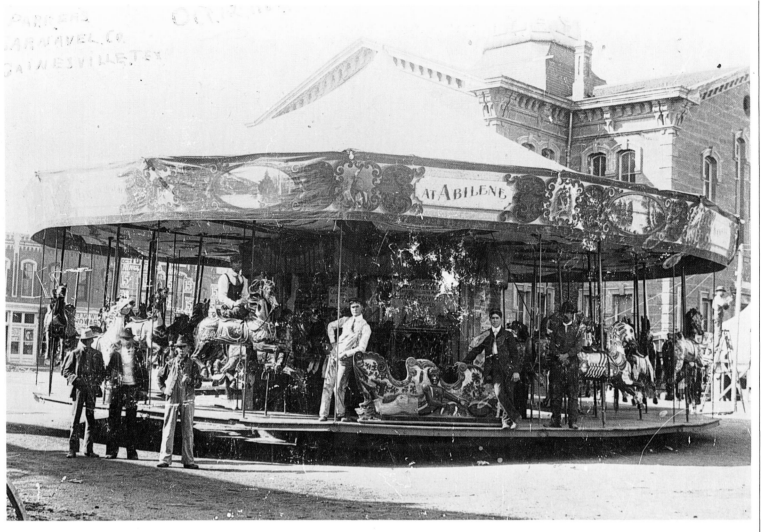

In 1892 young Charles Parker bought a second-hand carousel that he took on tour with two other partners. An inventive fellow, Parker built a bigger and better machine and established Parker Carnival Supply Company in Abilene, Kansas, circa 1900. *Dickenson County Historical Society, Kansas.*

This portable Jumping Horse "Carry-Us-All," a steam-powered track machine, was fresh out of the C.W. Parker Amusement Company factory in Abilene, Kansas, circa 1902. *Dickenson County Historical Society, Kansas.*

Parker used a popular rocking mechanism on his track machines to give his steeds a natural galloping motion, circa 1905. *Lake George, New York, Bryan Benson photo.*

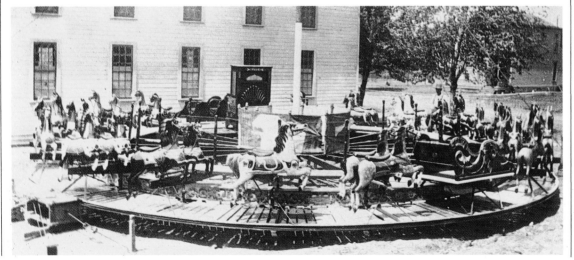

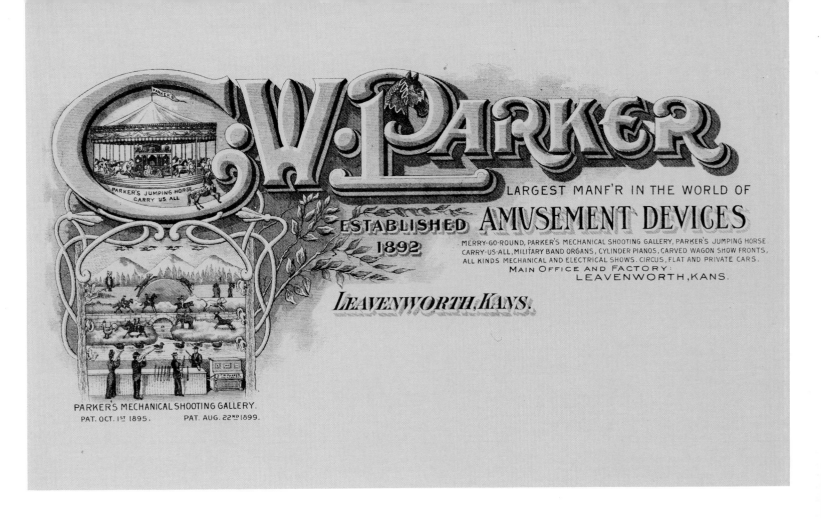

C.W. PARKER

ESTABLISHED 1892

LARGEST MANF'R IN THE WORLD OF

AMUSEMENT DEVICES

MERRY-GO-ROUND, PARKER'S MECHANICAL SHOOTING GALLERY, PARKER'S JUMPING HORSE CARRY-US-ALL, MILITARY BAND ORGANS, CYLINDER PIANOS, CARVED WAGON SHOW FRONTS, ALL KINDS MECHANICAL AND ELECTRICAL SHOWS. CIRCUS, FLAT AND PRIVATE CARS.

MAIN OFFICE AND FACTORY:
LEAVENWORTH, KANS.

LEAVENWORTH, KANS.

PARKER'S JUMPING HORSE CARRY US ALL

PARKER'S MECHANICAL SHOOTING GALLERY.
PAT. OCT. 1ST 1895. PAT. AUG. 22ND 1899.

Parker's early horses were almost exact copies of those being produced by Armitage Herschell Company in New York. These portable track machines had to be light-weight, compact and easy to store. Company advertising claimed three men could set up the complete machine in less than four hours, circa 1905.

Before "Colonel" Parker began his long career building and operating carousels and amusement parks in Kansas, all carousels were produced in the East and shipped west. But, unlike most other factory owners, Parker, who had been born in Illinois, had his roots firmly planted in the countryside. Unsuccessful in following his family's farming tradition, he devoted his life instead to bringing excitement and fun to the people who populated rural areas of young America.

The man who eventually became a self-annointed "Amusement King" set out on his career at an early age in Abilene. His first business venture, investment in a shooting gallery, soon expanded into his own galleries and a second-hand carousel. Parker and three partners took their meager carnival on the road and toured nearby towns and villages. Traveling on the small circuit invigorated Parker, the showman, who eventually bought his partners out.

Constantly tinkering with the mechanicisms of his shooting galleries and carousels while looking for improvements, Parker decided he could build a better machine. He built his first carousel sometime after 1892 and within two years the Parker Carnival Supply Co. was in production.

By 1902 Parker put his first traveling carnival on the road, and a year later he sent another out traveling by railroad. The C.W. Parker Amusement Co. in 1906 had four traveling shows and was supplying others with shooting galleries, carved wagon showfronts, concessions, banners, band organs, railroad cars and his portable Jumping Horse "Carry-Us-Alls." It was during this time that a young boy named Dwight Eisenhower, who would later become president of the United States, sanded horses in Parker's carousel factory across the tracks from Eisenhower's home in Abilene, Kansas.

A colorful and ambitious man, Parker loved the nomadic life of the traveling carnival. He immediately expanded his amusement manufacturing business with several traveling shows. At any one time he would have three or four carnivals on the road touring from the Dakotas to Texas and from Ohio to the Rockies, circa 1905. *Dickenson County Historical Society, Kansas.*

While carousel builders in the East created elaborate machines for beachfront resorts, city parks and grand expositions, Parker was busy taking his simple, portable merry-go-rounds to rural towns throughout the middle of America. An entire Carry-Us-All, including the steam engine, was piled onto railroad cars and pulled from place to place by locomotive. In areas inaccessible to the railroad, Parker used horse-drawn wagons to reach the eager riders, circa 1902. *Dickenson County Historical Society.*

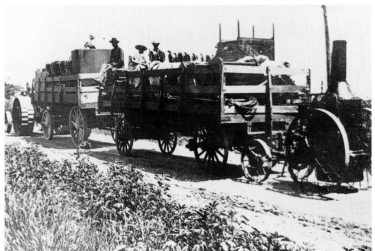

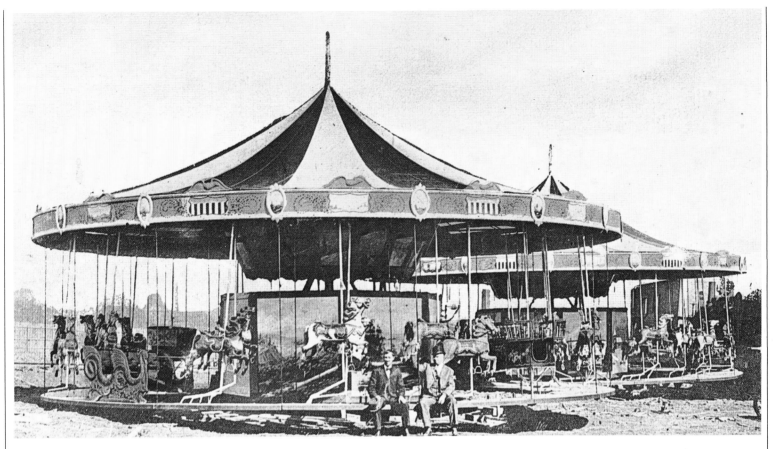

Parker, wearing a hat, sits on the platform of one of the first two machines shipped from his newly established Leavenworth, Kansas factory, February 15, 1911. *Dickenson County Historical Society.*

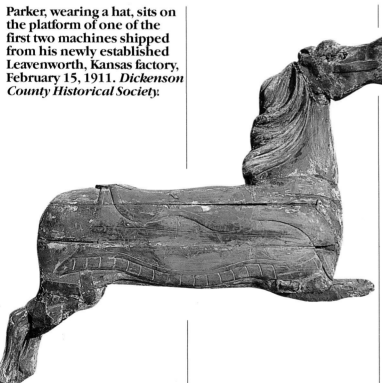

All of Parker's early horses were small and carved in standard poses with compact, portable designs and hair tails. He was more interested in providing cost-efficient entertainment to small towns than in establishing an original artistic style. His **carousels were set up and dismantled every few days as the traveling carnivals criss-crossed the country each summer. The result of constant use and hasty repairs is evident on the surviving figures, circa 1910.** *Shilvock collection.*

Primarily, Parker's steeds were required to travel far and quickly. Building every horse to conform to the same mad-dash pose had a two-fold benefit. The animated sense of speed appealed to the customers' imagination, and the identical leg position satisfied the carnivals' need to erect and dismantle rides in a hurry. These portable carousels were designed to take a minimum of space and a maximum of abuse. Carnival workers stacked the horses on wooden frames for transportation between shows. So tails were short, ears lay close to the head and embellishments had few protruding edges.

The first horses on Parker's carousels closely imitated the design of those built in North Tonawanda by the Armitage Herschell Co. Although he was not involved in the actual carving, Parker closely controlled the creations in his factory. He built carousels from 1892 until the mid-1920s and during that time his well-made machines steadily increased in artistic quality.

In the beginning, Parker's horses (for there were few menagerie animals on his carousels) pranced in an upright position and were generally gentle-looking creatures. Parker moved his factory to Leavenworth, Kansas, in 1911 and at that time his carousel horses showed substantial changes. They turned into wild creatures that hurled through the air. The forelegs curled up for a lunge; the hind legs kicked out.

An advertising poster for Charles Parker shows that the amusement czar believed flamboyant exaggeration and self-promotion were necessary in the amusement industry. Although his machines were almost identical to those being produced by the Armitage Herschell company, he boldly proclaimed the originality, uniqueness and — most important — the profitability of his creations. *Stevens collection.*

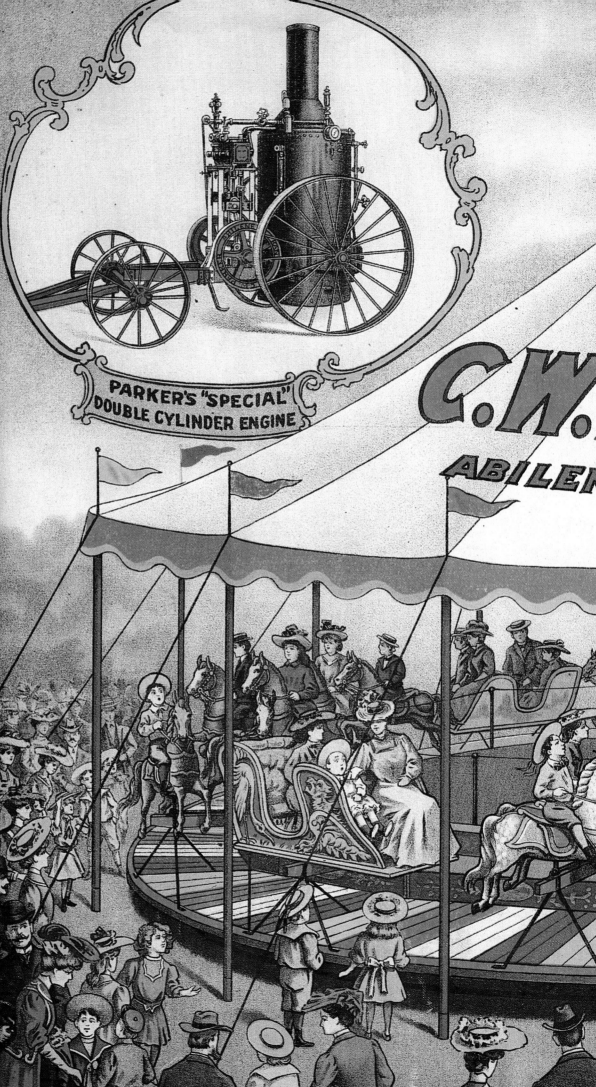

PARKER'S "SPECIAL"
DOUBLE CYLINDER ENGINE

C.W.
ABILEN

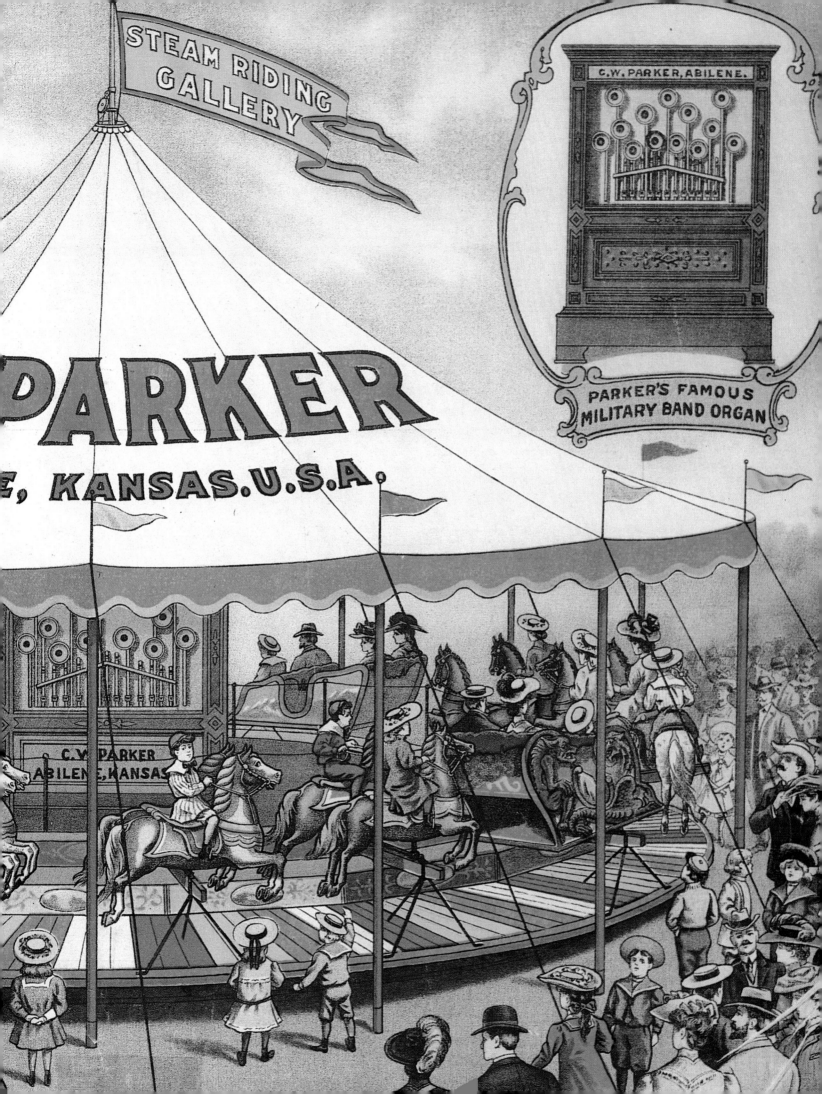

Several carousel manufacturers, including Muller, Parker and Herschell/Spillman, shod their horses with metal shoes. Parker's were cast with his address, cleverly written as "11 Worth" a play on words for Leavenworth, Kansas. These shoes were brass plated for display. *Summit collection.*

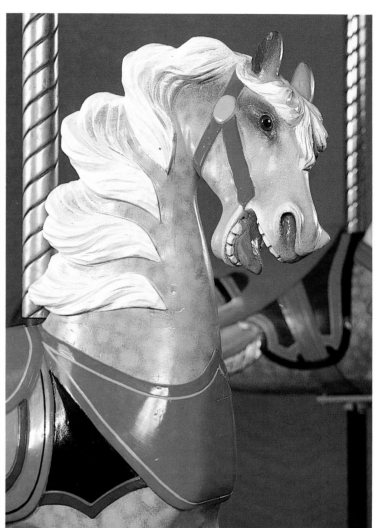

Regardless of their artistic worth, Parker's early carousels were charming creations that brought pleasure and joy to hundreds of communities throughout the Midwest, circa 1910. *Dickenson County Historical Society, Kansas.*

This inner-row jumper is from a 1911 Parker Carry-Us-All. The self-annointed "Amusement King," Parker did not produce figures of special artistic merit until he moved his factory to Leavenworth, Kansas. Most of his early horses were variations of the figures used on his track machines. *City Park Carousel, Pueblo, Colorado, Ric Helstrom photo.*

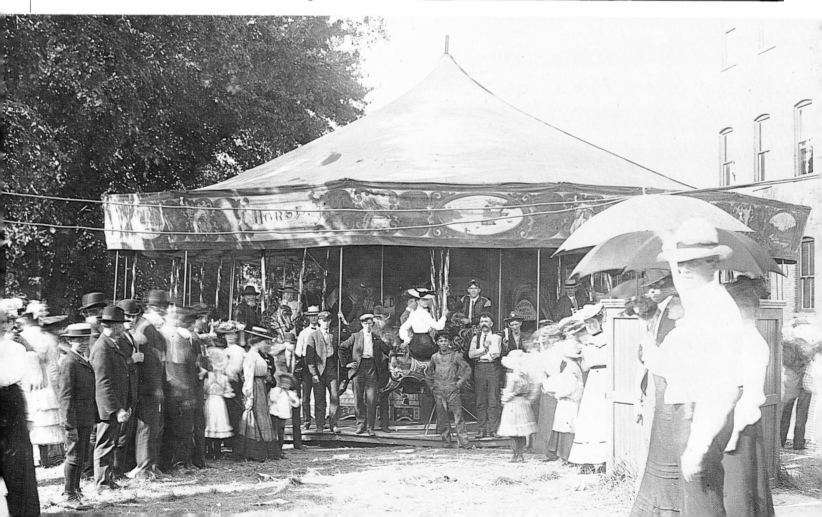

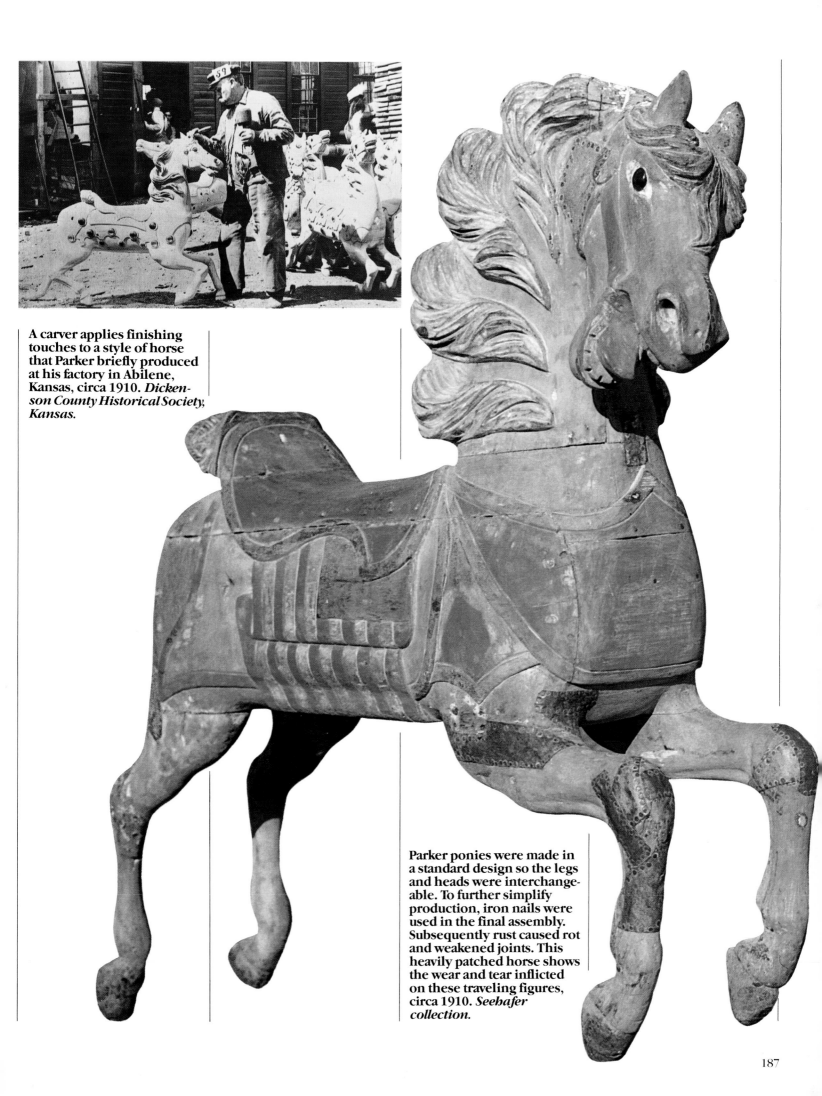

A carver applies finishing touches to a style of horse that Parker briefly produced at his factory in Abilene, Kansas, circa 1910. *Dickenson County Historical Society, Kansas.*

Parker ponies were made in a standard design so the legs and heads were interchangeable. To further simplify production, iron nails were used in the final assembly. Subsequently rust caused rot and weakened joints. This heavily patched horse shows the wear and tear inflicted on these traveling figures, circa 1910. *Seehafer collection.*

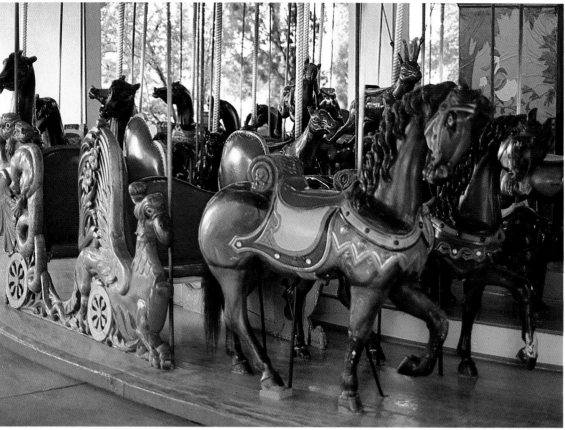

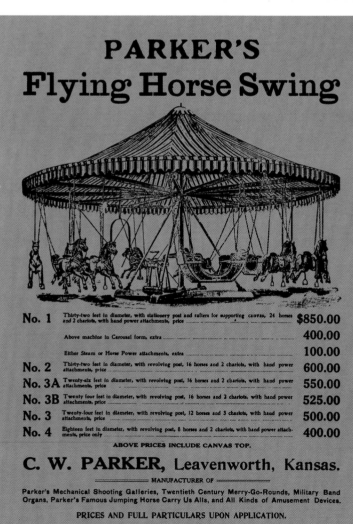

PARKER'S
Flying Horse Swing

No. 1	Thirty-two feet in diameter, with stationery post and rafters for supporting canvas, 24 horses and 2 chariots, with hand power attachments, price	**$850.00**
	Above machine in Carousel form, extra	**400.00**
	Either Steam or Horse Power attachments, extra	**100.00**
No. 2	Thirty-two feet in diameter, with revolving post, 16 horses and 2 chariots, with hand power attachments, price	**600.00**
No. 3A	Twenty-six feet in diameter, with revolving post, 16 horses and 2 chariots, with hand power attachments, price	**550.00**
No. 3B	Twenty-four feet in diameter, with revolving post, 16 horses and 2 chariots, with hand power attachments, price	**525.00**
No. 3	Twenty-four feet in diameter, with revolving post, 12 horses and 3 chariots, with hand power attachments, price	**500.00**
No. 4	Eighteen feet in diameter, with revolving post, 8 horses and 2 chariots, with hand power attachments, price only	**400.00**

ABOVE PRICES INCLUDE CANVAS TOP.

C. W. PARKER, Leavenworth, Kansas.

——— MANUFACTURER OF ———

Parker's Mechanical Shooting Galleries, Twentieth Century Merry-Go-Rounds, Military Band Organs, Parker's Famous Jumping Horse Carry Us Alls, and All Kinds of Amusement Devices.

PRICES AND FULL PARTICULARS UPON APPLICATION.

Advertisement for a "Flying Horse Swing." This style of hand-powered carousel was in use in the south up until the 1940s, circa 1912. *Smith collection.*

Lakeside Park in Denver, Colorado, is the home of an unusual Parker carousel. These strange carvings with painted wooden legs and bizarre menagerie figures, including monkeys and grotesque pigs, were probably not carved by the same company. Parker and other manufacturers commonly sold refurbished machines with figures from mixed sources, circa 1908.

Decorated trappings were carved into the smallest, fleetest carousel. The Midwest horse was often laden with bits of Americana. Ears of corn, sunflowers, flags and cowboy gear were standard designs. Many of the horses that left the new factory were shod with real metal horseshoes inscribed with "11 Worth" for Leavenworth.

Parker added spinning, round chariots or "Lover's Tubs" to the platform. In later years his horses absorbed some Coney Island characteristics, such as garlands, wilder manes and a variety of positions. But the stretched appearance of Parker's horses remained and some reached a length of 8 feet.

The "Amusement King" died in 1932 at the age of 68. Throughout his adult life, he constantly fought to improve the image of traveling carnivals above the immoral depth it had reached in some places. His advertisements carried photographs of his wife and children and stressed the wholesome nature of the entertainment. Regardless of the success of his campaign, Parker's fleet horses galloped into the heartland of America and left excitement behind in their dust.

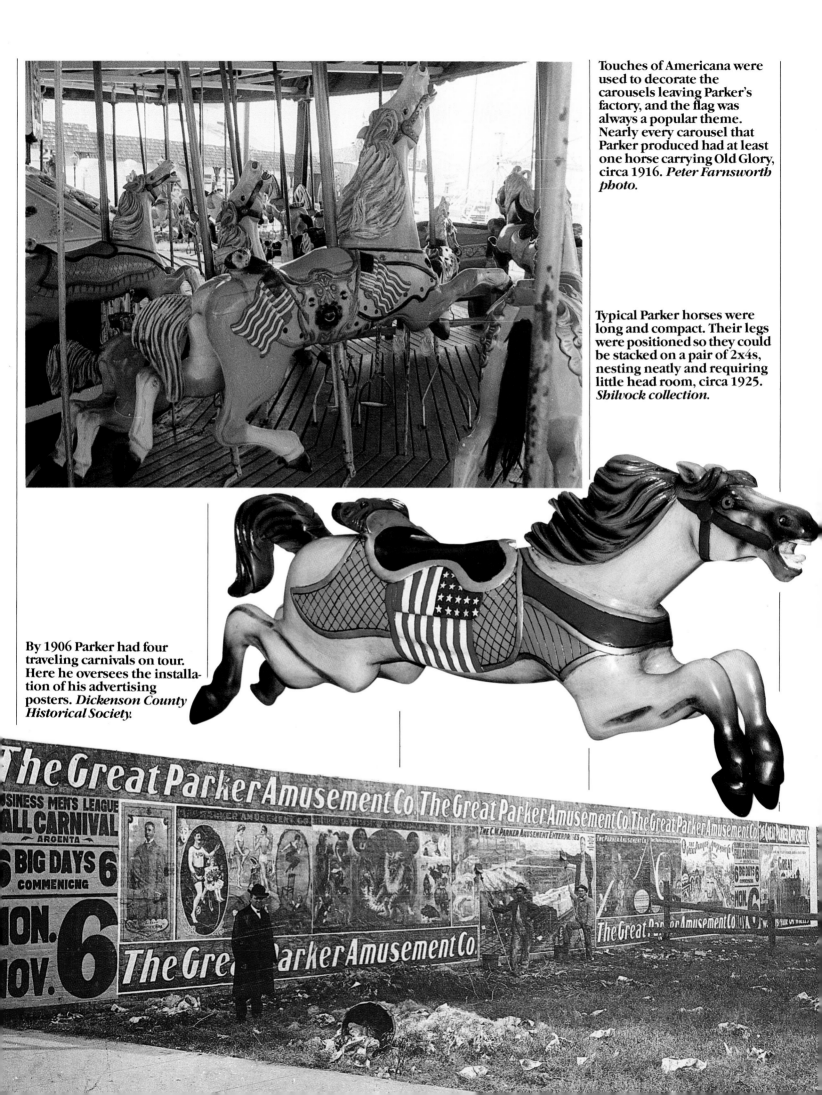

Touches of Americana were used to decorate the carousels leaving Parker's factory, and the flag was always a popular theme. Nearly every carousel that Parker produced had at least one horse carrying Old Glory, circa 1916. *Peter Farnsworth photo.*

Typical Parker horses were long and compact. Their legs were positioned so they could be stacked on a pair of 2x4s, nesting neatly and requiring little head room, circa 1925. *Shilvock collection.*

By 1906 Parker had four traveling carnivals on tour. Here he oversees the installation of his advertising posters. *Dickenson County Historical Society.*

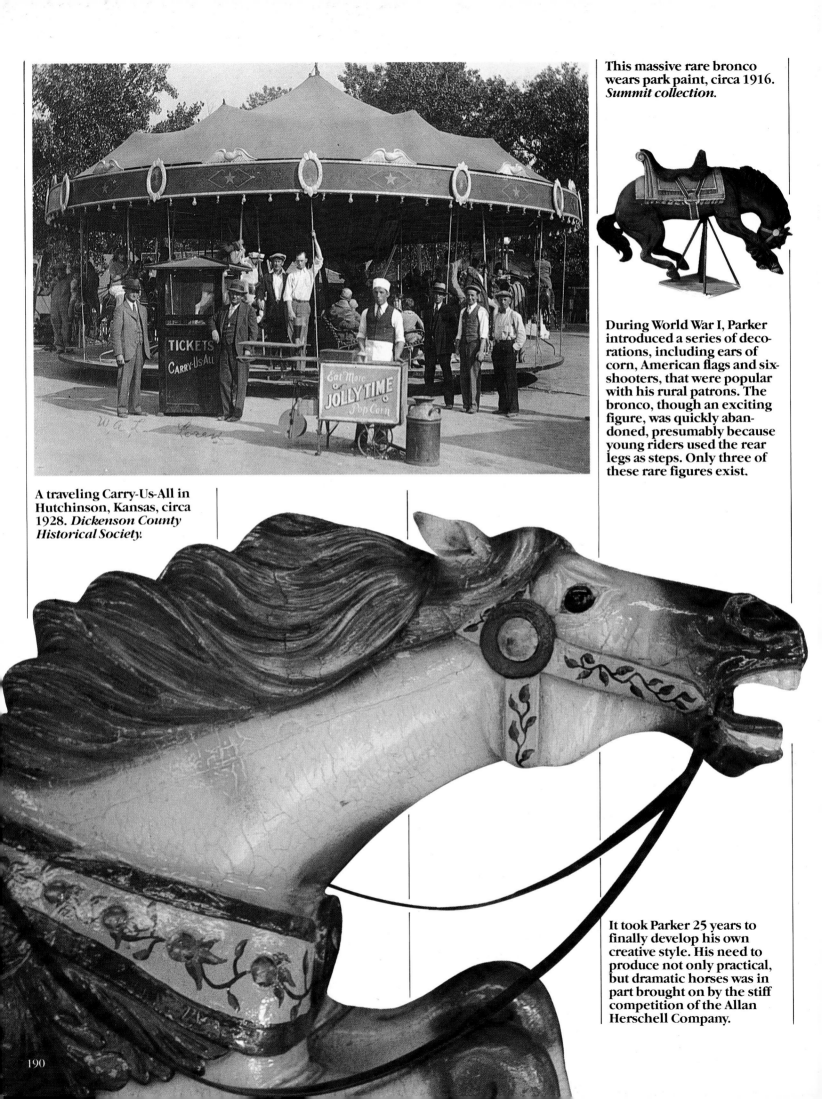

This massive rare bronco wears park paint, circa 1916. *Summit collection.*

A traveling Carry-Us-All in Hutchinson, Kansas, circa 1928. *Dickenson County Historical Society.*

During World War I, Parker introduced a series of decorations, including ears of corn, American flags and six-shooters, that were popular with his rural patrons. The bronco, though an exciting figure, was quickly abandoned, presumably because young riders used the rear legs as steps. Only three of these rare figures exist.

It took Parker 25 years to finally develop his own creative style. His need to produce not only practical, but dramatic horses was in part brought on by the stiff competition of the Allan Herschell Company.

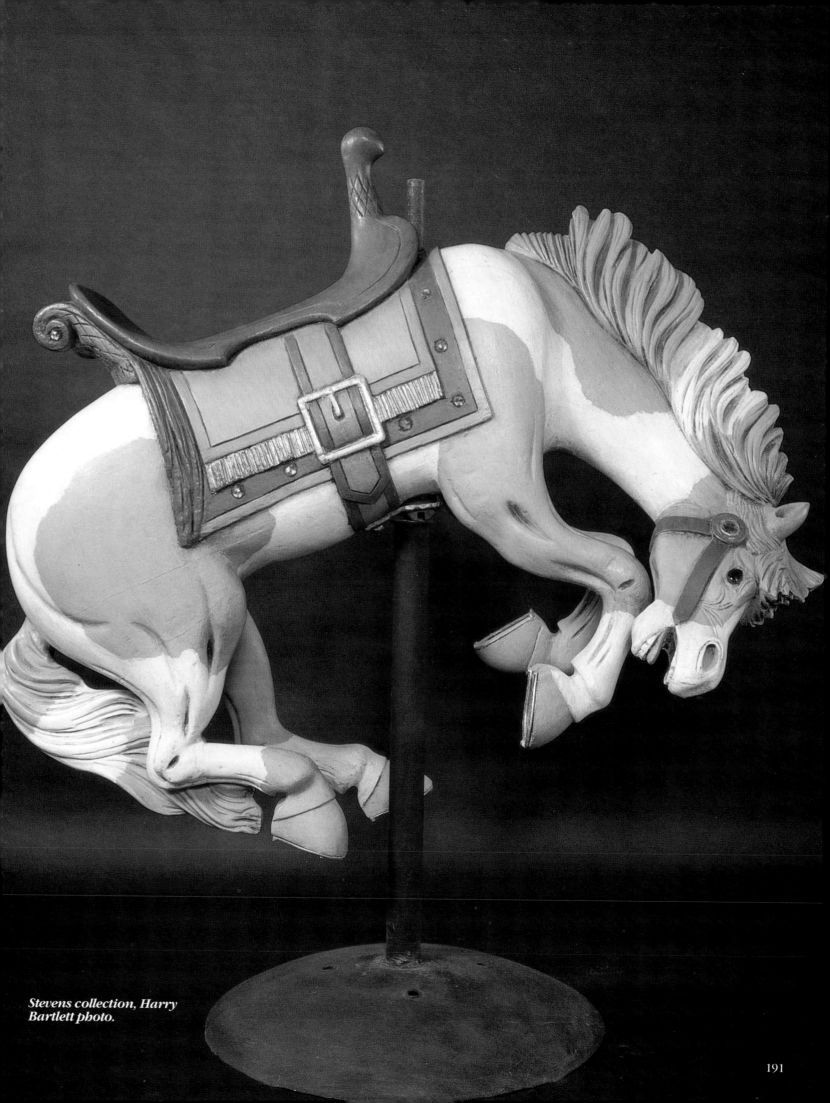

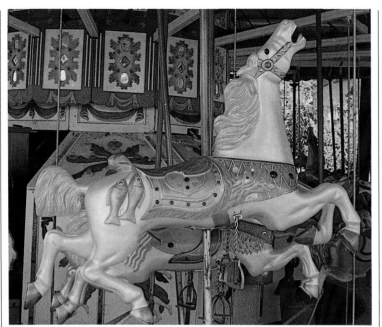

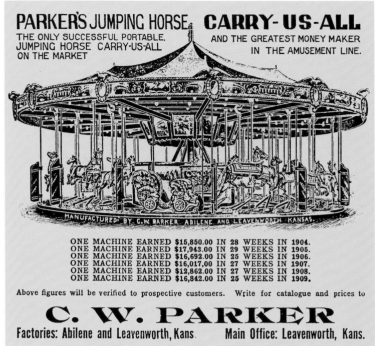

An eagle and a pair of fancy fish adorn the rumps of these high-flying jumpers. This four-abreast Parker machine operates at Bell's Amusement Park in Tulsa, Oklahoma, circa 1916. *Peter Farnsworth photo.*

An Indian pony, clad in bearskin, hurtles around the platform in seeming wild abandon. Horses with their necks stretched upward in the star-gazer pose were popular figures on Parker's carousels, circa 1916.

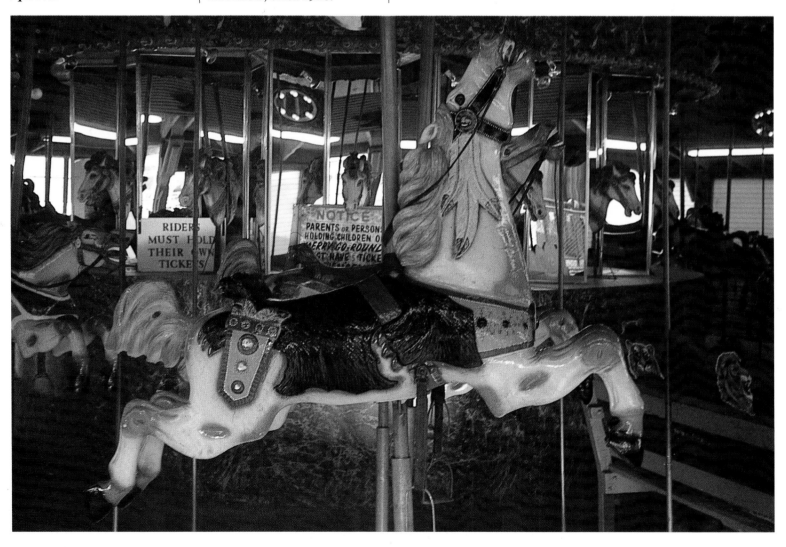

C.W. Parker, who gave himself the titles "Colonel" and "Amusement King," always praised the profitability of his wholesome entertain-ment devices. *Dickenson County Historical Society.*

"WHY IT IS CALLED CARRY-US-ALL."

When the magnificent Jumping-Horse "Carry-Us-All" was perfected C. W. PARKER decided that the plain term, "Merry-Go-Round." was too tame for such a flashy con-trivance. As it carries and pleases all ages and sizes the Genious coined the word "Carry-Us-All." French stu-dents say it should be "Carousal;" but Mr. Parker silences their objections with, "This is an all-American combina-tion." The negroes of the South, where the merry-go-round is the original half-way house to Paradise, call it hobby horses, Flying' Jinny and Spinnin' Jinny, but a few have the idea and term it "Cash-All," the nearest they can get to it. The last is nearly correct, for it surely gets "all the cash."

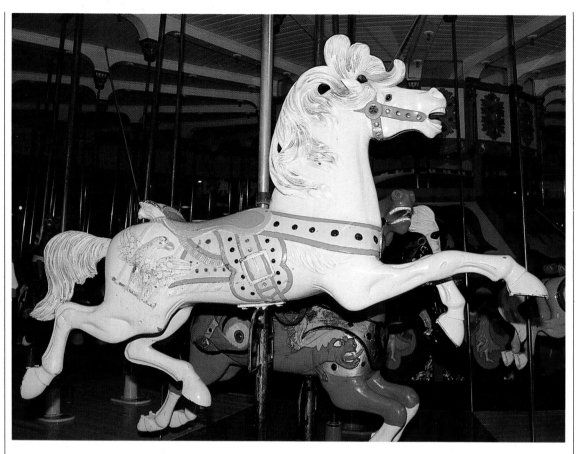

A group of German soldiers, prisoners of World War I, were allowed to work in Parker's factory in Leavenworth, Kansas. These men were talented woodworkers who gave Parker's carousel horses their first creative identity. The figures they produced were characterized by wild, wind blown manes, pompador forelocks, bobbed tails and lavishly jeweled saddle decorations, circa 1916. *Susan Foley photo.*

A pair of horses with tucked heads and jeweled armor gallop around a portable Parker machine that used the simple grasshopper mechanism to connect the brass pole to the platform. Parker claimed three men could erect his Carry-Us-All in 90 minutes, circa 1916. *Peter Farnsworth photo.*

The C.W. Parker Amusement company, which placed a numbered nameplate at the base of each carousel's center pole, made more than 800 Carry-Us-Alls. *Stevens collection.*

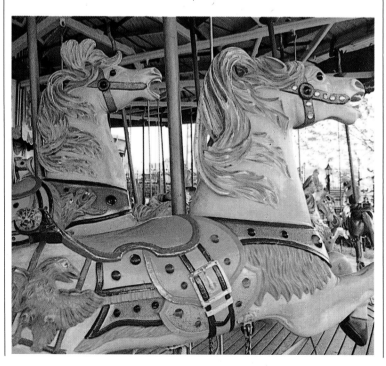

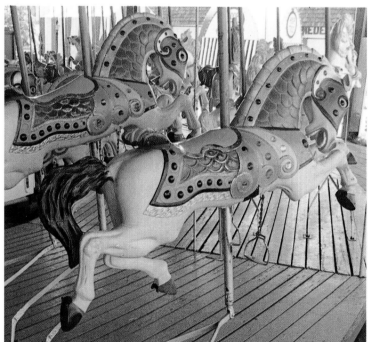

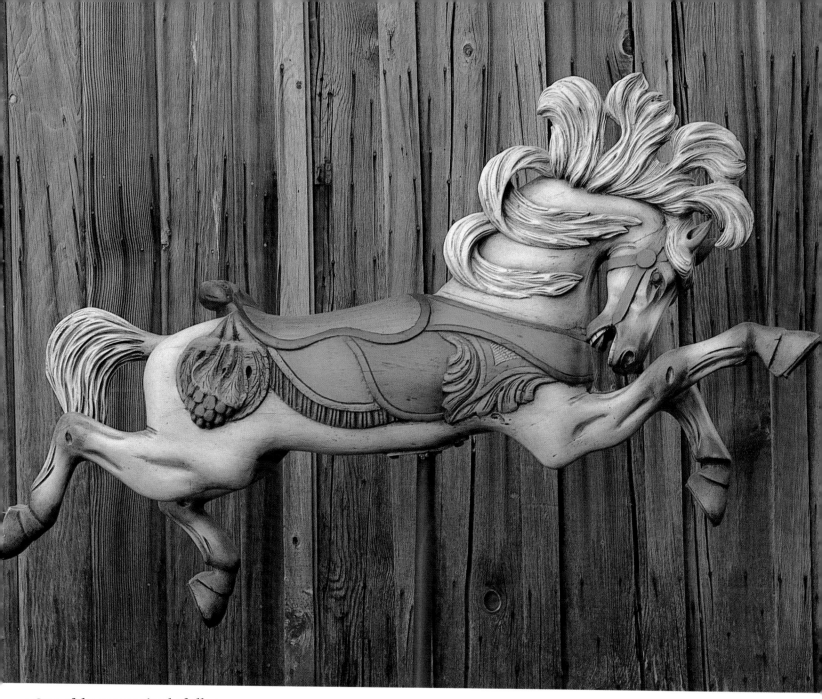

One of the most prized of all Parker carousel figures is this dramatic outstretched jumper, beautifully restored by Mary Lawrence Youree, circa 1917. *Youree collection.*

Parker's No. 316 carousel, built in 1925, was one of only four park machines that he constructed. The elaborate device, crowned with brightly colored rounding boards, cost $11,500. The carousel was shipped to Ocean Park, California, when it was first made and now operates in Canada. *Dickenson County Historical Society, Kansas.*

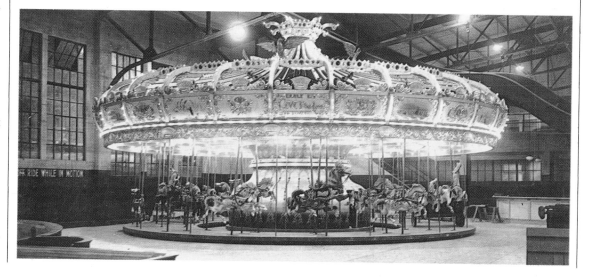

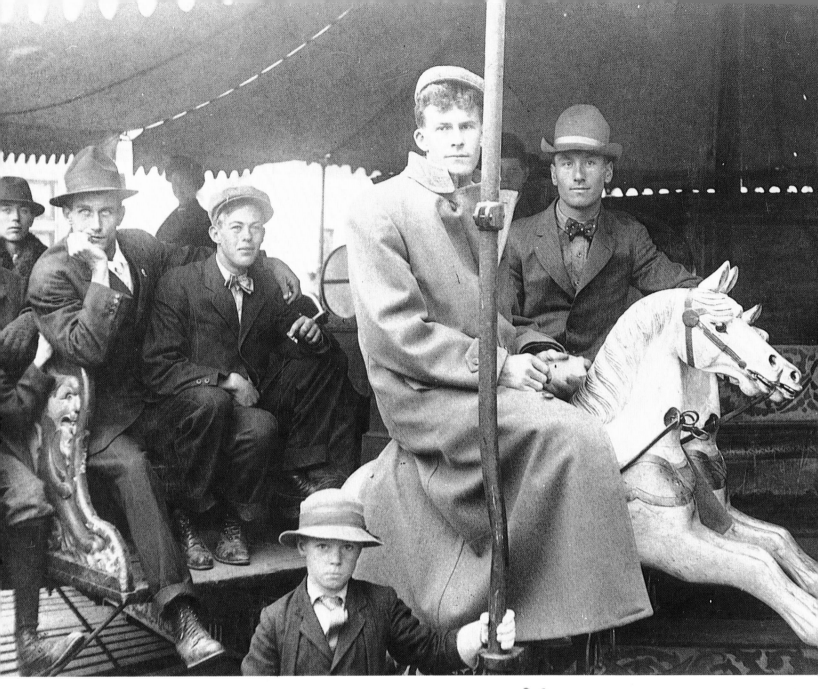

Much like Frederick Savage, Allan Herschell was an engineer and machinist. In the early 1870s he founded the Tonawanda Engine and Machine Company. They were a foundry, machinist, boilermakers and manufacturers of steam engines. Much like Savage, Herschell quickly saw how he could combine his machinery know how with this popular new toy, much to the displeasure of his partners. Several small carousel companies sprang up before the turn of the century in the Niagara area. Most simply copied the Herschell figures who had originally copied his horses from Dare, circa 1890-1900. *Gail Hall photo.*

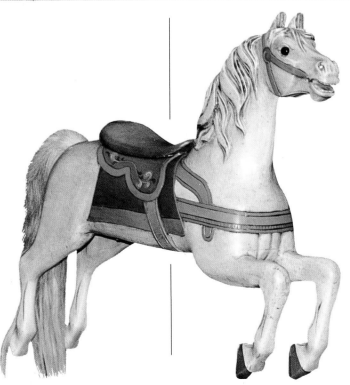

This later style Armitage Herschell horse has slightly more refined features, circa 1899. *Shilvock collection.*

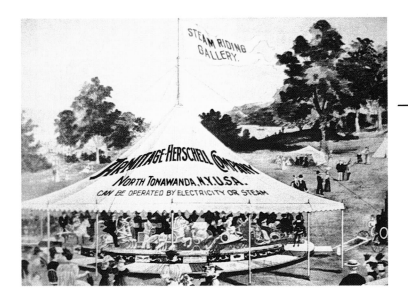

ARMITAGE HERSCHELL CO.

In another part of the country, another notable County Fair carousel builder concentrated on portable machines. One man who helped develop North Tonawanda as a carousel center originally was attracted to the machines because they offered the chance to travel in the open air.

Allan Herschell, an immigrant from Scotland, was involved in building machinery long before he built his first carousel. He was captivated by a carousel he saw on a train trip home from a doctor's appointment in New York City. A specialist there recommended that Herschell treat his lifelong case of ague with plenty of fresh air.

At that time Herschell was in the business of producing machinery and boilers. His partners in the Tonawanda Engine and Machine Company did not share Herschell's enthusiasm for carousels, but his persistence won their agreement to build a portable machine. The success of his "Steam Riding Gallery," built in 1883, led him to sell it and build another a year later.

Herschell sold half-interest in his third machine, built in 1885, to Christ Krull, and the two men took it for a three-month run at the World Exposition and Cotton Centennial in New Orleans, Louisiana. Many years later in a Spillman house publication, Bert Stickney, who helped set up and run the carousel, described the machine as a ride lighted "with gasoline torches which smoked, filling the canvas top with gasoline fumes. Then too, there was the steam engine and the boiler that burned soft coal generating about as much smoke as it did steam."

Despite the engulfing billows of smoke and fumes, people flocked to pay a nickel for a ride. The venture proved the financial merit of operating a carousel, even one that was prone to breakdowns. When Herschell wrote to his partners about his constant repairs, they encouraged him to scrap the project and return to the factory. Herschell did not write to them again for two months.

Before long, however, Herschell's associates found their carousels were a successful addition to the company's prod-

Armitage Herschell employees pose for a company photo in 1891. By this time they were producing 100 machines per year. *Smithsonian Institution.*

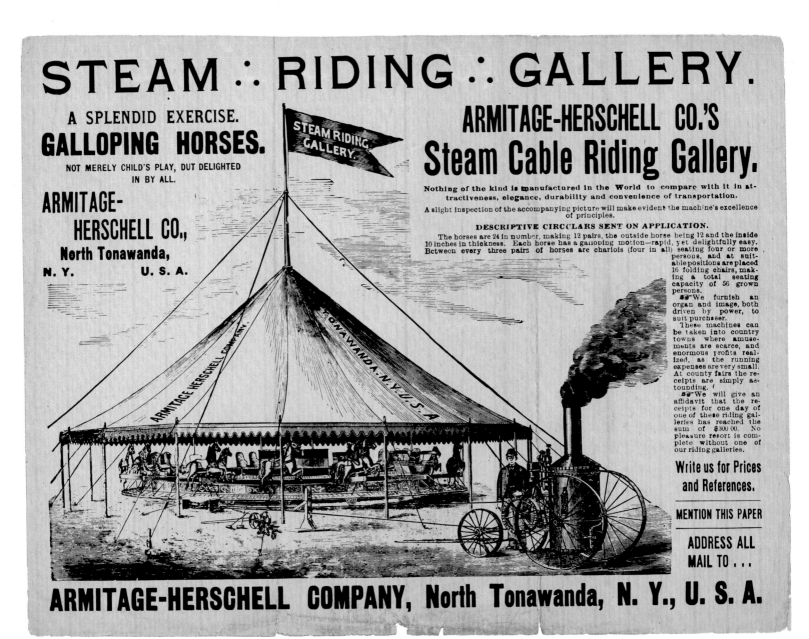
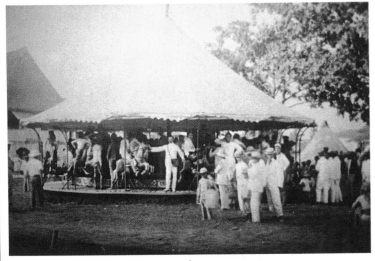

In 1894, Joseph Gwin travelled around the world operating and selling Armitage Herschell machines. His travels took him to Japan, China, Tahiti, Singapore, South Africa and India. *Smithsonian Institution.*

uct line. By 1891 the company, reorganized under the name the Armitage Herschell Company a year earlier, had manufactured and sold at least 100 carousels. Three years later, in 1894, the factory was producing 300 carousels a year.

Overall success was so great that the company branched into real-estate investments. But the market was unstable and when the economy collapsed in 1899, it dragged the Armitage Herschell Company down with it.

Herschell's carousels probably traveled farther than those from all other companies combined. J.D. Gwin even took a Herschell carousel to Tahiti. There the carousel's engine was powered by coconut shells because conventional fuels of wood or coal were in short supply. Inhabitants of the South Pacific Island paid the equivalent of $600 per day to ride the intriguing carousel. The man who bought the machine in Tahiti eventually built a four-story hotel from the profits.

Herschell took his carousels to India and received several orders from wealthy individuals amused by the foreign machines. Committed to the portable carousel, Herschell circled the globe with his wooden horses.

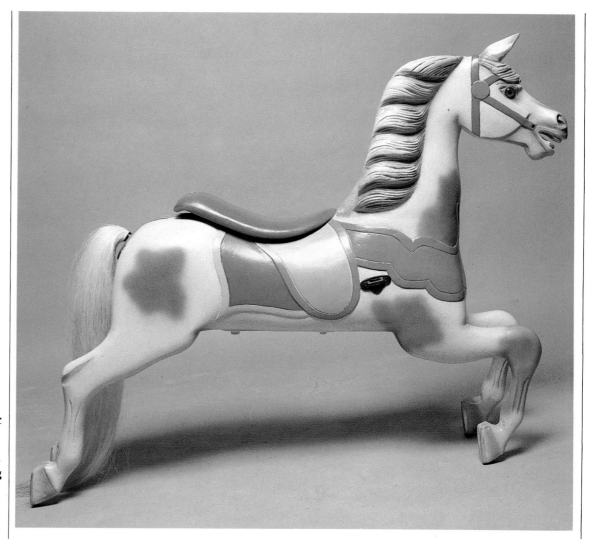

Allan Herschell constructed his first steam-powered merry-go-round in 1883. Concerned more with the mechanics than the aesthetic quality of the figures, he simply copied a Dare horse with a couple of minor modifications, including a floating saddle which is a separate piece of wood attached to the horse's back, circa 1898. *Sardina collection.*

This Armitage Herschell steam riding gallery operated at the 1904 World's Fair. The horses rocked back and forth in a galloping motion as they rotated around a wheeled track. A simple canvas tent usually covered the machine. Beautifully restored, this wonderful machine now operates at Union Station in St. Louis, circa 1898. *Judy and Carlos Sardina restoration.*

This Armitage Herschell steam engine was constructed in 1898 to power a steam riding gallery. *Sardina collection.*

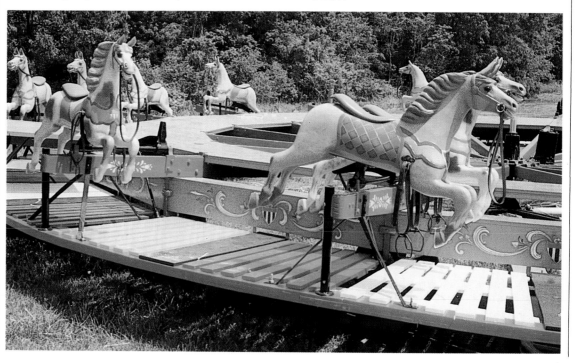

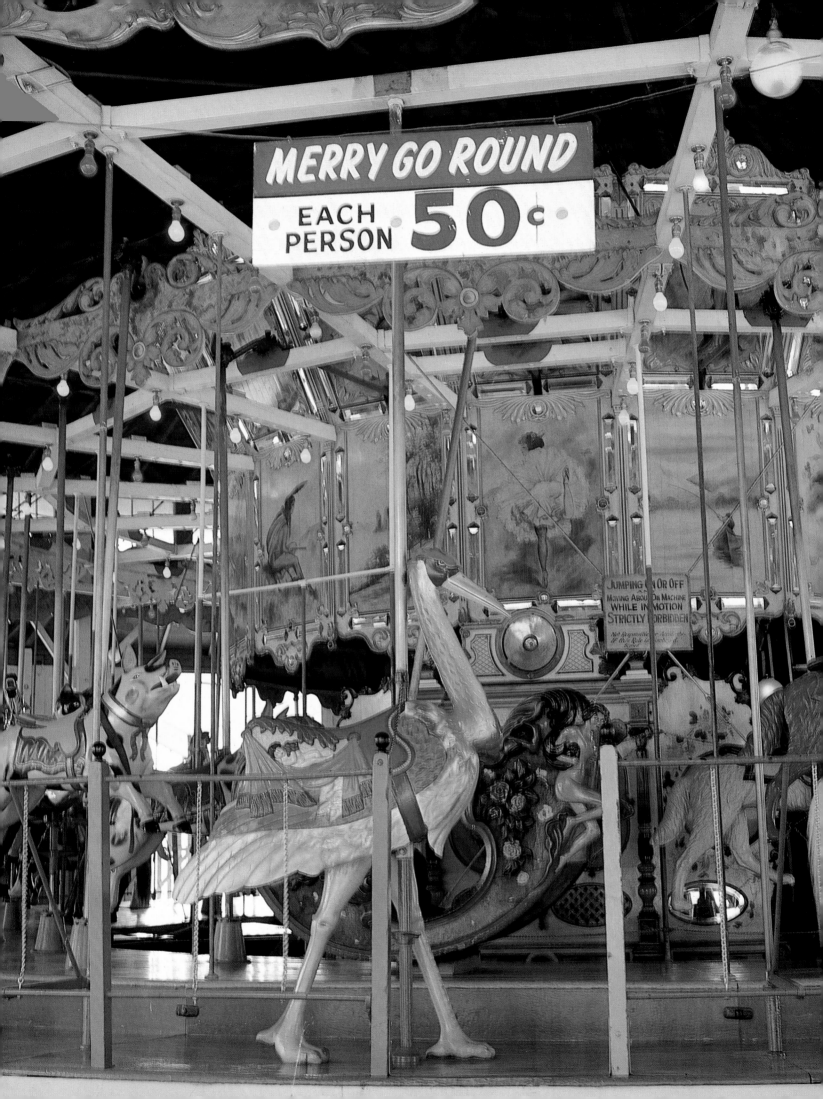

Herschell/Spillman was one of the few companies to produce a stork, circa 1910. *Balboa Park, San Diego, California.*

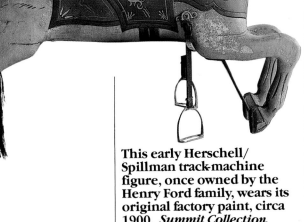

This early Herschell/Spillman track-machine figure, once owned by the Henry Ford family, wears its original factory paint, circa 1900. *Summit Collection.*

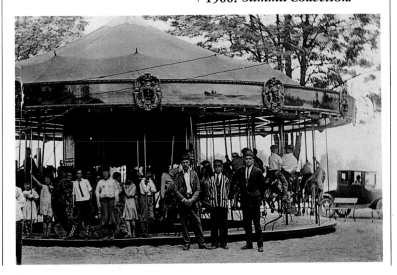

Herschell's marriage to Ida Spillman in 1882 led to an important business association with her brothers. The Herschell-Spillman Company bought out the failing Armitage Herschell Company, including carousel, engine and machinery production in 1903. Herschell-Spillman made more carousels than any other American factory before it was reorganized in 1920.

Horses that populated the company's machines were both produced on the premises and commissioned from other carvers. The company's efforts produced figures that were box-shaped and stiff, but sported manes and sweet faces resembling Looff horses. Through the years, more poses were added and the carving became more sophisticated, animated and ornate.

Around 1913 several changes took place in the Herschell-Spillman factory. Larger, permanent carousels were built. This, in turn, led to an expansion of the number of menagerie animals offered. Lions, tigers and frogs were added to the assortment of chickens, dogs, zebras and pigs already in production.

A wide range of themes also appeared on the chariots attached to the Herschell-Spillman machines. Wholesome bathing beauties, patriotic reproductions of Uncle Sam and the American flag and Mother Goose characters were carved into the stationary gondolas. Artists filled the scenery panels with nostalgic landscapes and used the ever-popular beveled mirrors and light-catching jewels to add sparkle to the rounding boards.

Catalogs in 1913 offered models powered by steam, gasoline engines or electric motors. Its carousels were smaller and not as heavily decorated as those of other companies, but they were available for less than $2,000.

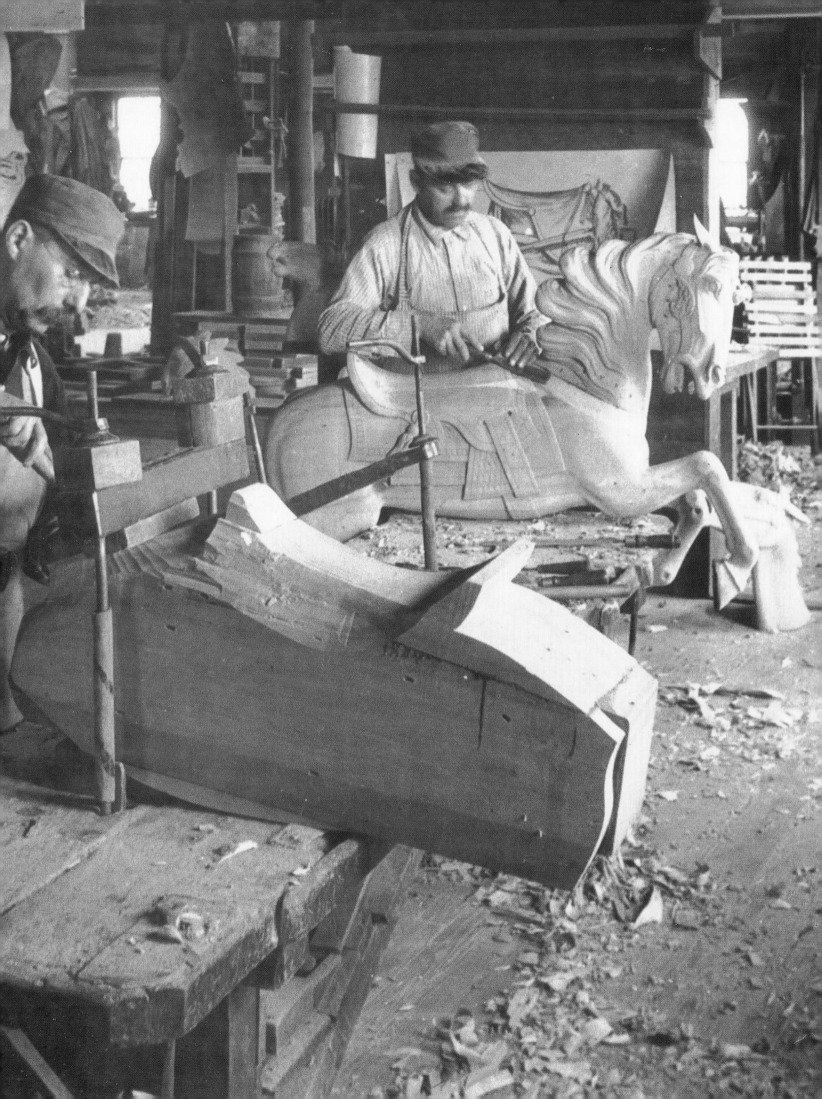

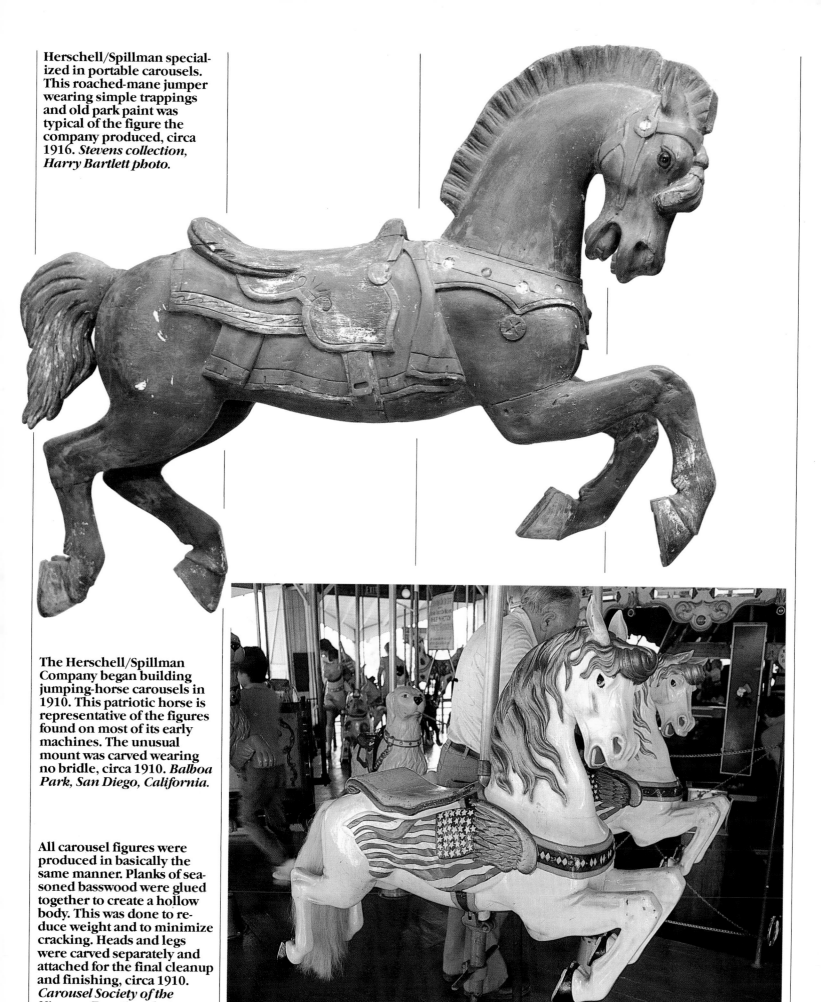

Herschell/Spillman specialized in portable carousels. This roached-mane jumper wearing simple trappings and old park paint was typical of the figure the company produced, circa 1916. *Stevens collection, Harry Bartlett photo.*

The Herschell/Spillman Company began building jumping-horse carousels in 1910. This patriotic horse is representative of the figures found on most of its early machines. The unusual mount was carved wearing no bridle, circa 1910. *Balboa Park, San Diego, California.*

All carousel figures were produced in basically the same manner. Planks of seasoned basswood were glued together to create a hollow body. This was done to reduce weight and to minimize cracking. Heads and legs were carved separately and attached for the final cleanup and finishing, circa 1910. *Carousel Society of the Niagara Frontier photo.*

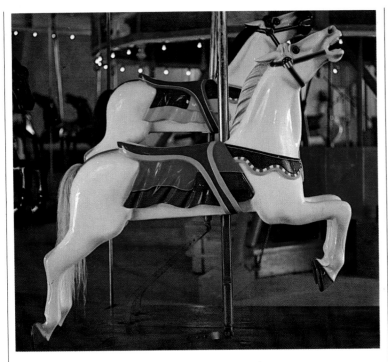

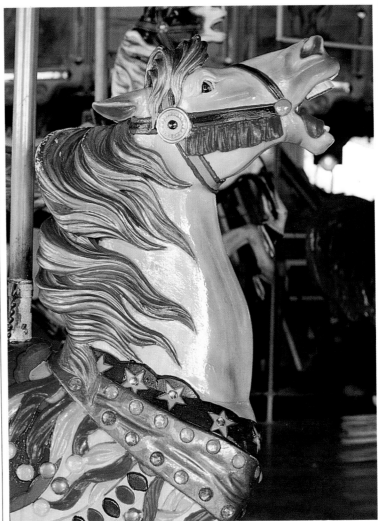

Herschell/Spillman built portable machines in various sizes and levels of ornamentation. This restored two-abreast portable carousel in Story City, Iowa, is typical of the company's simplest machines, circa 1913. *Pete Tekippe photo.*

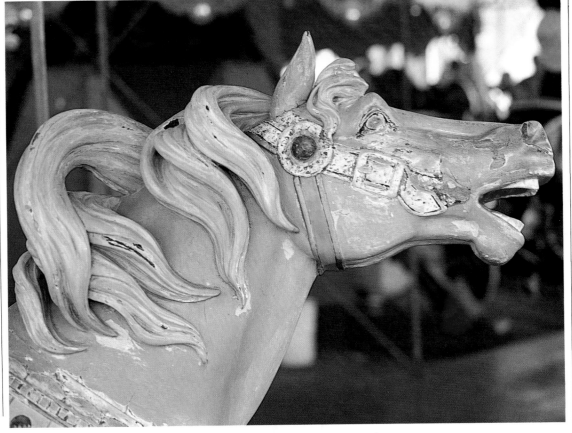

Although Herschell/Spillman specialized in portable, or road carousels, it also built large, fantastic park machines. They were usually 50 feet in diameter with three or four rows of animals. The assortment of menagerie figures included lions, tigers, storks, giraffes, ostriches, roosters, frogs, dogs, cats, deer, goats and zebras. The horses on these park machines were well carved with ornate trappings, circa 1910. *Balboa Park, San Diego, California.*

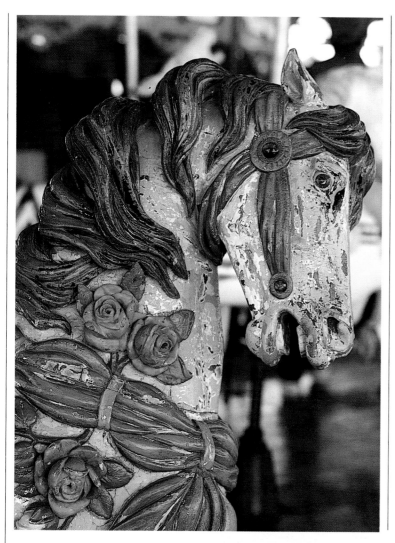

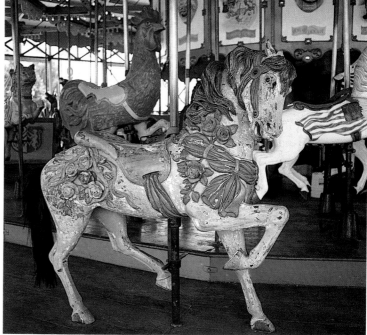

This noble outside-row stander is decorated with a beautiful assortment of well-carved roses and a large bow, circa 1915.

The ornamental outside-row horses for the park carousels were undoubtedly inspired by the Coney Island carvings of Looff, Illions and Carmel. By using Herschell/Spillman patterns, Illions supplied the company with one set of figures. He added fancy flourishes, which may have been adopted in the company's shop, circa 1915.

Horses on the Herschell/Spillman park machine were given rather pointed rumps, seen here on a dramatically posed ouside-row stander laden with meticulously carved details.

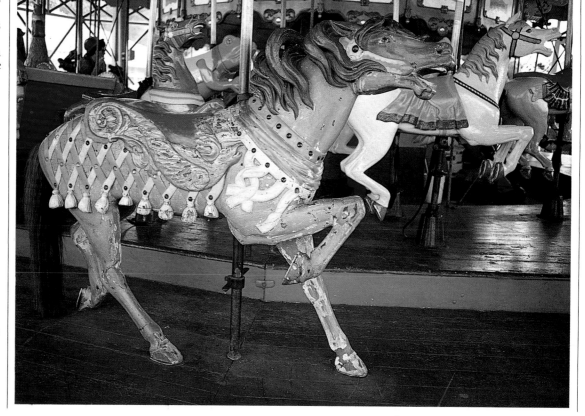

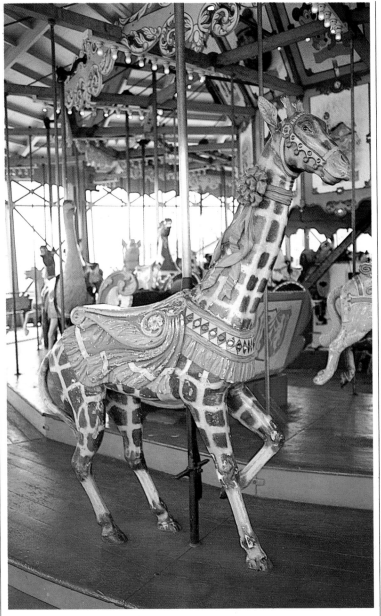

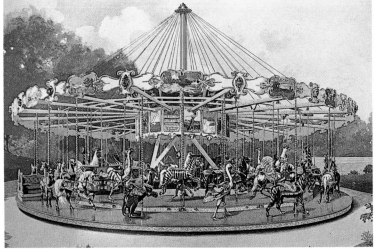

A factory illustration shows the recommended assortment of menagerie figures, including the rare kangaroo, pictured below, from Oaks Amusement Park, Portland, Oregon, circa 1921. *Susan Foley.*

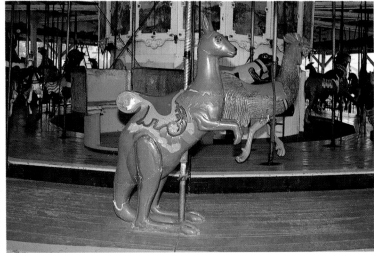

This highly detailed giraffe comes from a Herschell/Spillman park machine, circa 1915.

Herschell/Spillman produced a remarkably well-carved selection of menagerie figures for its portable machines, includ-ing these fine pairs of roosters and dogs on board the carousel in Story City, Iowa, circa 1913. *Pete Tekippe photo.*

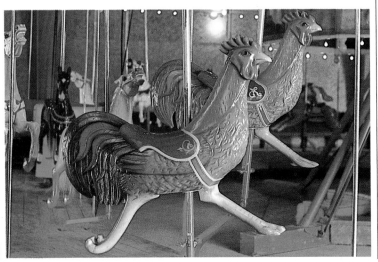

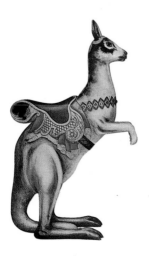

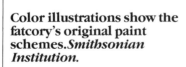

Color illustrations show the fatcory's original paint schemes. *Smithsonian Institution.*

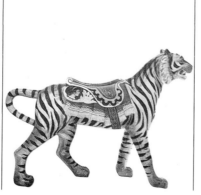

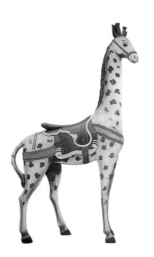

The Herschell/Spillman "hop-toad," as it was identified in the company catalog, was the only carousel figure carved wearing human-style clothing. This was a popular figure that was placed on almost every menagerie machine.

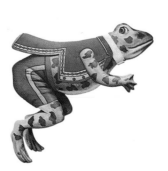

Herschell/Spillman Company produced a large number of chariots in a wide variety of styles. The Uncle Sam chariot was one of the most popular and was often a part of the portable machines, circa 1913. *Story City, Iowa, Pete Tekippe photo.*

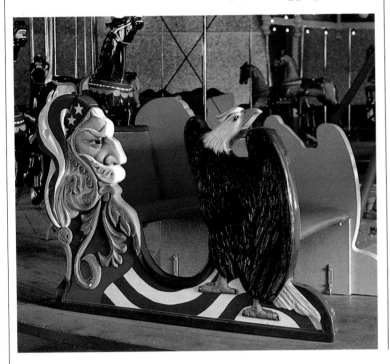

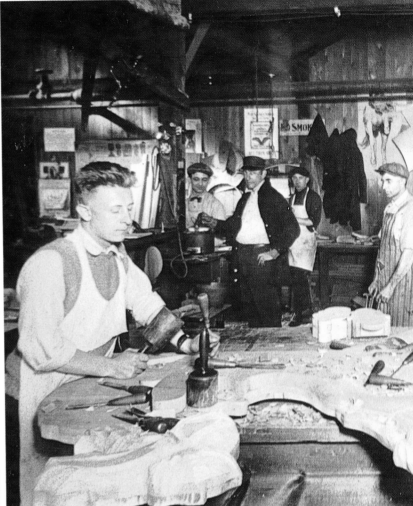

This art noveau carving was found on many portable chariots, circa 1916.

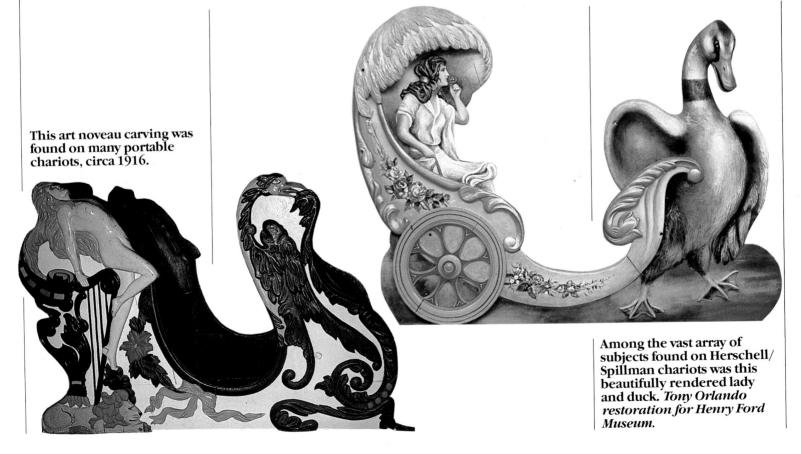

Among the vast array of subjects found on Herschell/Spillman chariots was this beautifully rendered lady and duck. *Tony Orlando restoration for Henry Ford Museum.*

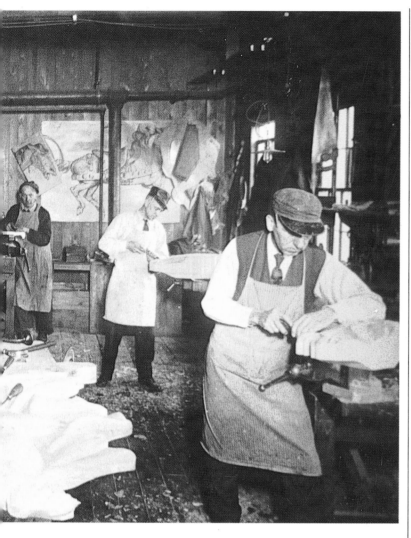

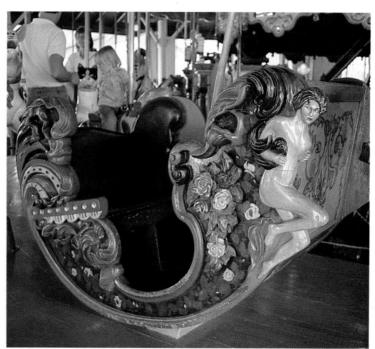

This exotic chariot was sometimes placed on a Herschell/Spillman park machine. The chariot was attached to the overhead jumping mechanism to give it a rocking motion, circa 1910. *Balboa Park, San Diego, California.*

Artists fashion chariot sides in the carving shop. *Smithsonian Institution.*

Carousel manufacturers produced specialty carvings at the customer's request. This one-of-a-kind ring-dispensing lion may have been a special order or an experiment. The rings, inserted at the end of the tail, come out through the mouth and tongue. The carousel operator controlled a switch that would illuminate the big cat's red, piercing eyes, circa 1920. *Daniel collection, Randy West photo.*

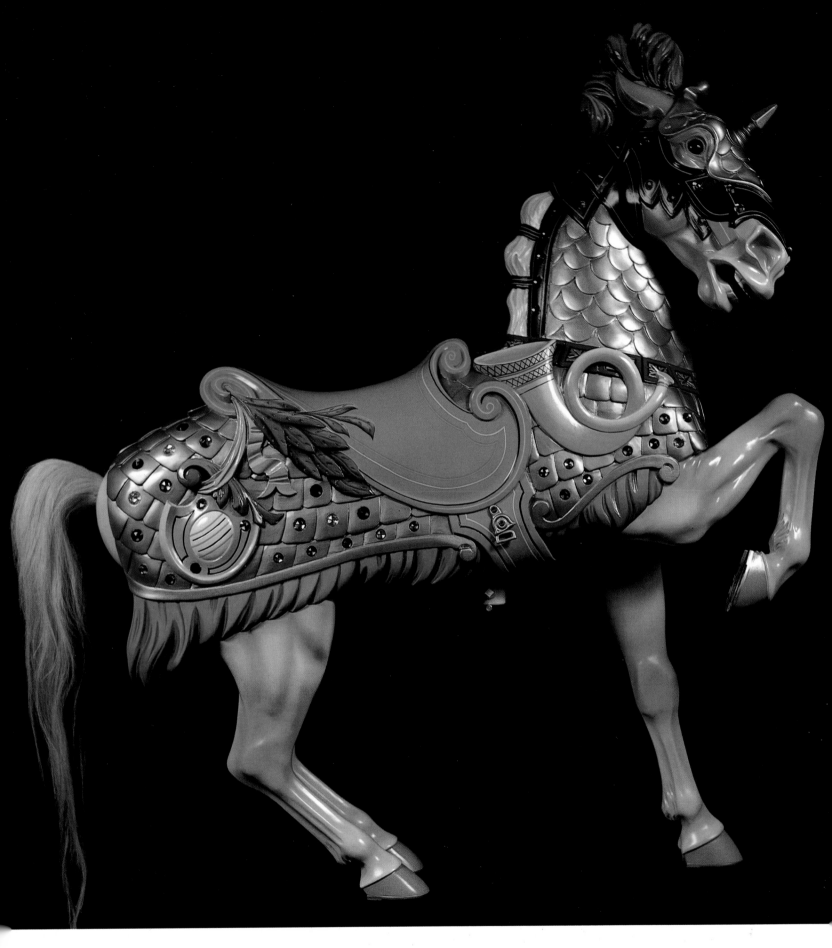

The Herschell/Spillman Company was reorganized in 1920 when Allan Herschell's name was dropped. The new firms also took over the old Armitage Herschell plant in North Tonawanda, New York. The designs for the carousel figures, including the full array of menagerie animals, were the same. The armored lead horse, above, was designed before World War I and was used by both the Herschell/Spillman and Spillman Engineering Companies, circa 1920. *Grand Rapids Public Museum, Michigan, restored to authentic colors by Tom Layton, Richard Szczepanski photo.*

Carousel Manufacturer

SPILLMAN ENGINEERING CO.

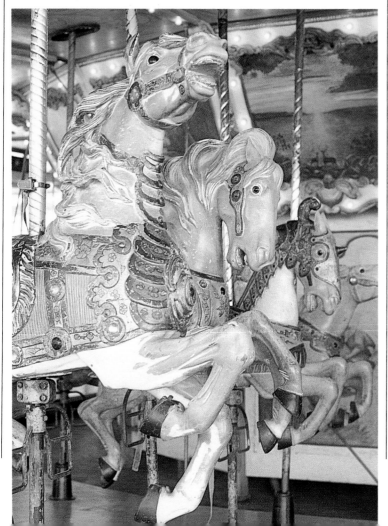

A "pure" machine is populated by figures from only one company or carver. This Looff stray is on the outside row of a Spillman carousel. Spillman bought a few dozen jumpers from the defunct Looff factory in the mid-20s. Eleven ended up on Griffith Park's carousel.

Health reasons forced Herschell into semi-retirement in 1911, but he was retained as a consultant until 1913. His absence, however, was short-lived. Two years later, in 1915, he formed the Allan Herschell Company. The reformed Spillman Engineering Corporation and the new Herschell company continued to produce carousels for several years despite the crippling conditions of the Depression.

Both companies continued using designs developed during their joint association. They offered five basic carousel styles: a two-abreast machine with simple horses, a three-abreast machine with simple horses, a three-abreast machine with more elaborate horses and some menagerie figures, a stationary park machine with a full menagerie assortment and a fancy park machine with a full menagerie.

To counter the simple designs of the horses, the chariots were richly carved, elaborate works. Folksy themes, patriotic designs and Mother Goose figures covered the sides of these stationary seats and added variety to the overall appearance.

The Spillman company began making larger stationary park carousels in the 1920s. These machines were less ornate than those built in Coney Island or Philadelphia, but they maintained the same high quality and fine form. A 1923 catalog listed a large variety of animals available on its machines. Lions, tigers, ostriches, cats, dogs, goats, roosters, storks, giraffes, deer, zebras, frogs and trotting, galloping, charging or armored horses could be selected. Spillman offered three- and four-abreast park machines up to 50 feet in diameter and two- and three-abreast portables 32 feet in diameter.

On its park machines, Spillman Engineering followed the formula of other successful manufacturers. The entire carousel was fabulously decorated with jewels, beveled mirrors and bas relief carvings. The carvers produced elaborate panels to disguise the mechanical works and create excitement for the carousel's entire theme. The center pole and rounding boards were laden with carved ornamentation and picturesque scenes. Details were not overlooked either. At one time every horse was shod with iron horseshoes.

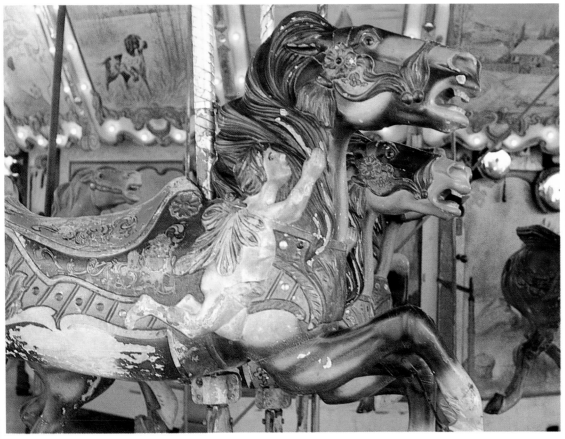

Griffith Park in Los Angeles California, is the home of one of Spillman's finest horse carousels. It has an impressive collection of magnificently decorated figures.

Horses produced by Spillman Engineering Company had wavy, flowing manes and ornate secondary carvings that distinguished them from the Herschell/Spillman figures, circa 1926. *Griffith Park, Los Angeles, California.*

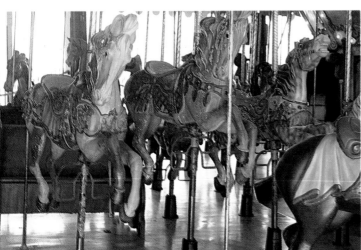

Spillman Engineering Company initially used Herschell/Spillman designs. This outside-row jumper shows the later Spillman style — a longer head and heavier, more well-proportioned body. The later figures were mostly machine-carved and had little hand carving, circa 1921.

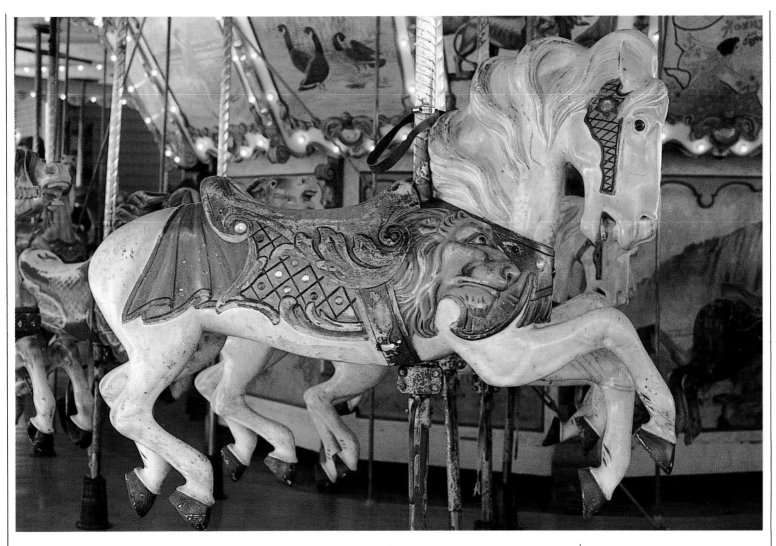

An ornate carving of a lion head adorns the elongated body of this Spillman jumper. The relationship of the head and body is misproportioned, creating an awkward appearance, circa 1926. *Griffith Park*.

A company catalog illustrates a three-abreast portable carousel, circa 1925. *Smithsonian Institution*.

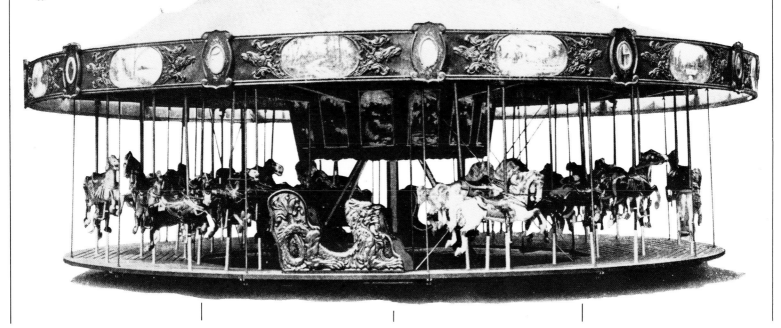

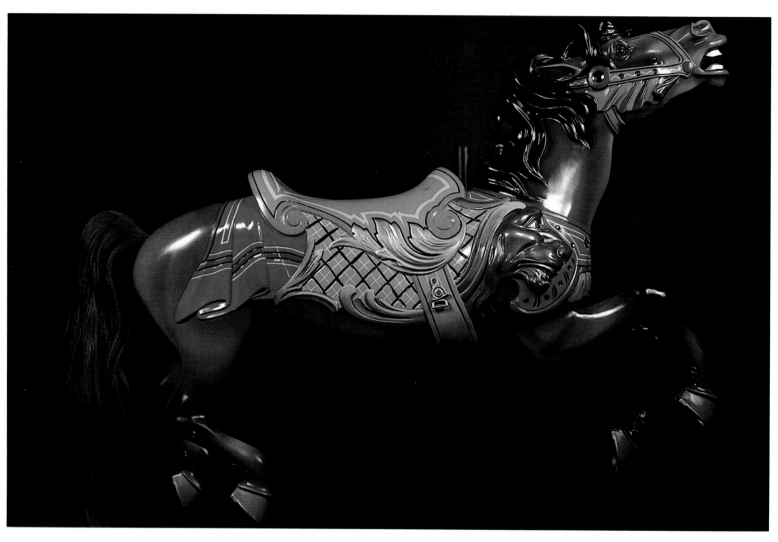

Spillman horses usually have short necks and elongated heads, as is visible on this ostentatious outside-row jumper.

Spillman Engineering produced the most elaborate and artistic of all portable carousel figures, circa 1928. *Grand Rapids Public Museum, Michigan, Richard Szczepanski photo.*

By the late 1920s, keen competition was bringing hand-carved wooden carousels to extinction. During this final stage, the carousel makers began fastening aluminum heads and legs to the wooden bodies. In an effort to survive the devastating Depression, Spillman produced an all-aluminum figure in 1930 and the era of the wooden carousel came to a close. This gorgeous armored charger, with its unusal carved plume and spiked chamfrom was beautifully restored to original factory colors for Grand Rapids Public Musuem in Michigan. It was part of one of the last wooden carousels made by Spillman Engineering, circa 1926. *Richard Szczepanski.*

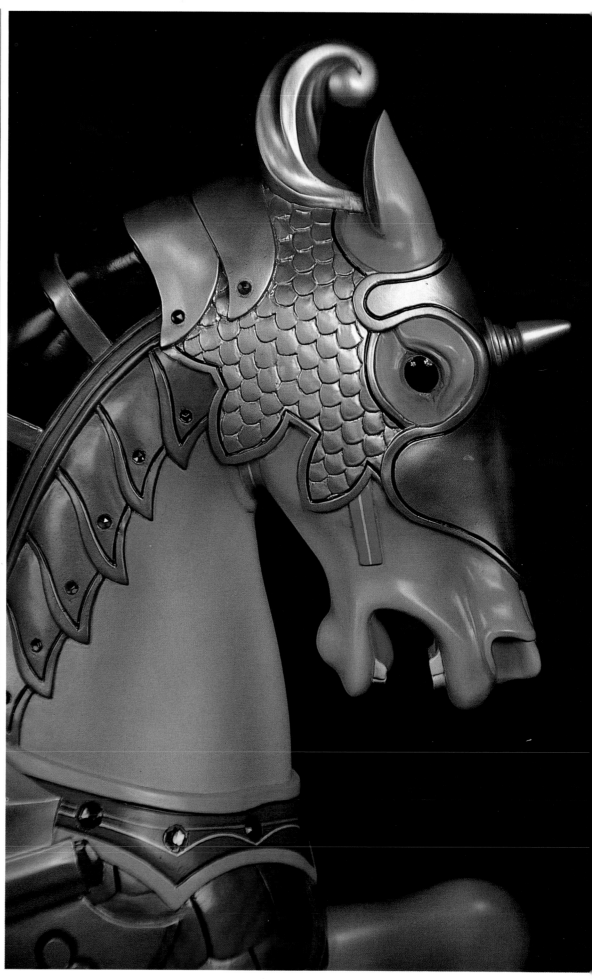

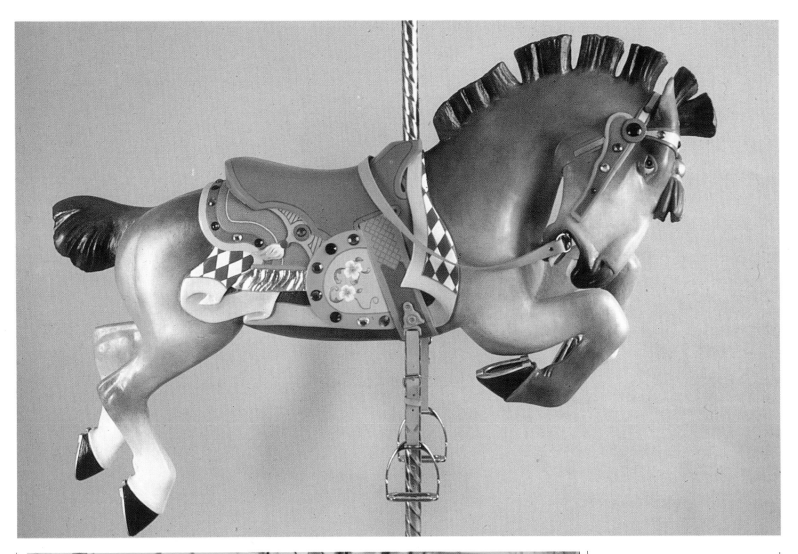

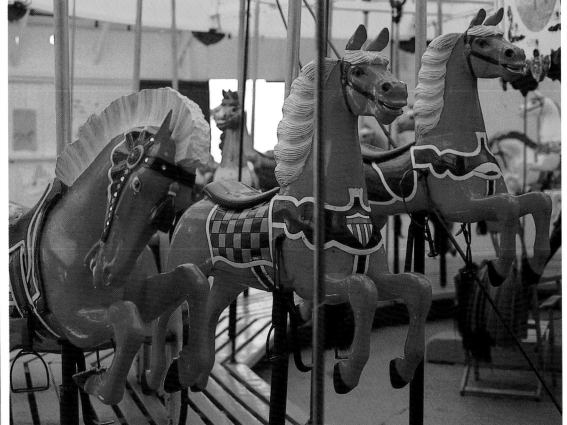

In 1913 Allan Herschell formed a new company and ceated a new portfolio of designs with large, distinct heads and small, compact bodies. These figures were made especially for traveling carnivals that stressed the need for sturdy, easily maintained, durable horses, circa 1918. *Restored to original factory finish by Tony Orlando, Tim Hunter photo.*

The first machine produced by Allan Herschell's new company in 1916 operates at the site of his original factory in North Tonawanda, New York. In an effort to expedite the completion of this first carousel, he apparently populated it with several early Armitage Herschell horse that he had on hand. *Carousel Society of the Niagara Frontier.*

Carousel Manufacturer

ALLAN HERSCHELL CO.

Allan Herschell's horses were designed to travel. The ears were folded back to minimize the chance of them breaking off. The decoration and poses were very simple styles well suited for traveling carnivals which were his main customers.

The Allan Herschell factory in North Tonawanda, New York, is now a museum dedicated to the preservation of carousel art.

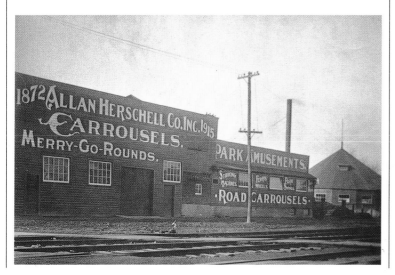

His carousels traveled extensively on the North American continent, too. Many festivals and celebrations in Mexico were incomplete without the figures of a portable Herschell carousel turning round and round to the tunes of a band organ. The inexpensive, simple design of these portable machines made them popular in America's South. In that region the merry-go-rounds were given other names, such as Flying Dutchman, Riding Galleries, Flying Horses, Hobby Horses and Flying Jennys. The operators were less imaginative; they called the carousels Tonawanda machines.

Saddles on Herschell's horses were carved from separate pieces of wood and attached with a few screws. This allowed operators to more easily replace the part of the figure that received the most wear and tear. From the beginning, Herschell's horses were carved in almost identical patterns. Variety was dependent on different colors in the animals and their trappings. This practice made switching from hand-carved figures to other methods of production a natural progression for the company.

To combat the economic blight of the Depression by cutting labor costs and increasing profit and to construct a more durable product, the Allan Herschell Company began making the heads and legs of carousel animals from cast aluminum. (Allan Herschell died in 1927 when he was 76, but the company continued uninterrupted.) Eventually the entire animal was cast in metal. These horses lasted longer and were more cost-effective to produce, but they heralded the end of America's first affair with wooden, hand-carved carousels.

Because the North Tonawanda companies produced more carousels than any of the other factories, and their portable machines traveled the farthest, the majority of Americans are familiar with this tyle. Typical memories of the carousel heritage were formed when thousands of youngsters climbed aboard carousels traveling with carnivals or county fairs amusement rides. Merry-go-rounds still went through the countryside and offer children magical rides, but the horses are made of fiberglass or aluminum now. Of the thousands of wooden horses that once thundered across the land, very few remain. And no one can say for sure where all have gone.

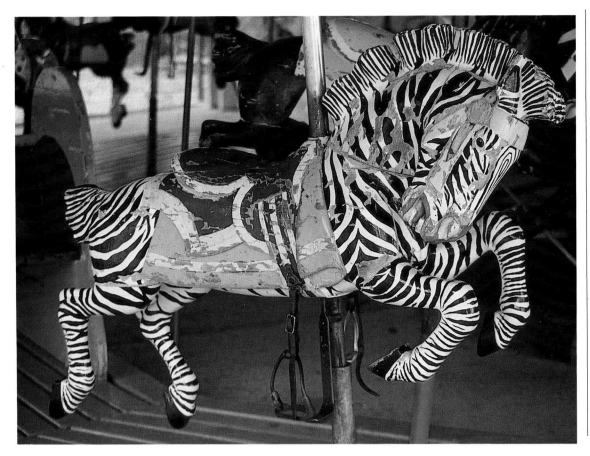

A cropped-mane Allan Herschell jumper on board the Cheyenne Mountain Zoo carousel in Colorado Springs, Colorado, has been mistakenly painted as a zebra, circa 1924. *Ric Helstrom photo.*

Allan Herschell built the most popular of all portable carousels. His machines operated throughout the United States and were exported overseas. The Allan Herschell Company produced more carousels than any other manufacturer.

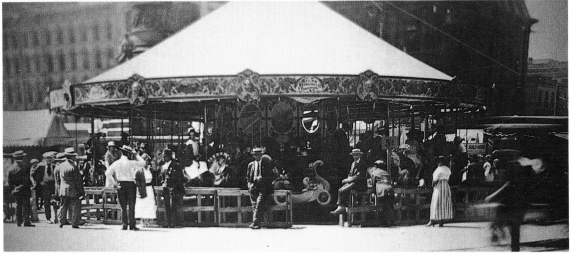

Portable machines, such as this one, operated at almost every county fair and carnival in the United States from the 1930s to the 1960s. These durable little carousels lasted despite heavy use, frequent abuse by the riders and neglect of the operators, circa 1919. *Dana Tucker photo.*

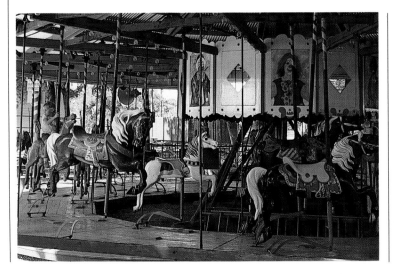

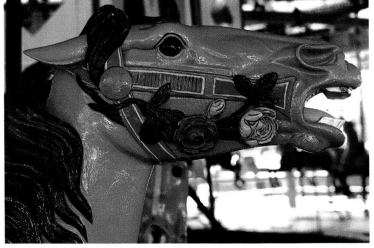

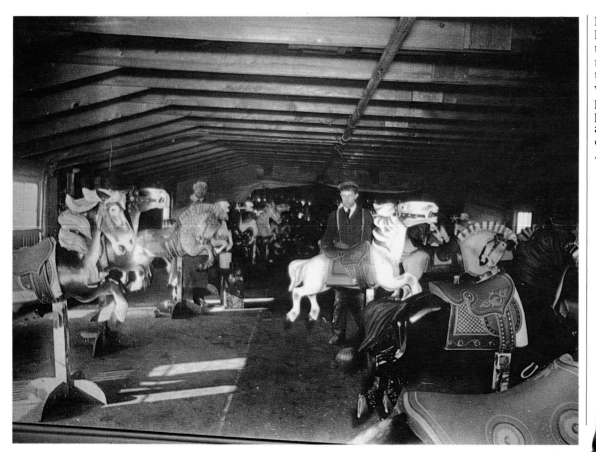

Freshly completed Allan Herschell ponies wait their turn to be packed up for shipment. Though simply carved, the horses are richly painted with decorative filigree and pinstriping. The ornamental painter added life, muscles and richness with their magical brushes, circa 1922. *Smithsonian Institution.*

The horses produced by Allan Herschell after World War I were made with the carving machine. Making the figures more durable and economical was a necessity fostered by close competition and hard times following the crash of the stock market. In the process, the heads became oversized and poorly proportioned and the ears were carved in the laid-back position to reduce damage during transit and set-up.

Trying to survive the Depression, the Allan Herschell Company, then managed by John Wendler and C. Starkweather, began producing horses cast entirely in aluminum. The figures are characterized by simple poses, thick short legs and little ornamental embellishment. The last carved wooden figures were used as patterns for the metal horses. Most traveling carnivals use carousels with figures such as these, which were produced from the mid-1930s through the 1970s. Now even these aluminum figures have been abandoned in favor of less expensive fiberglass horses.

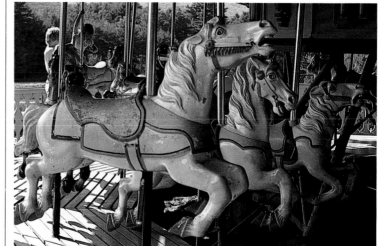

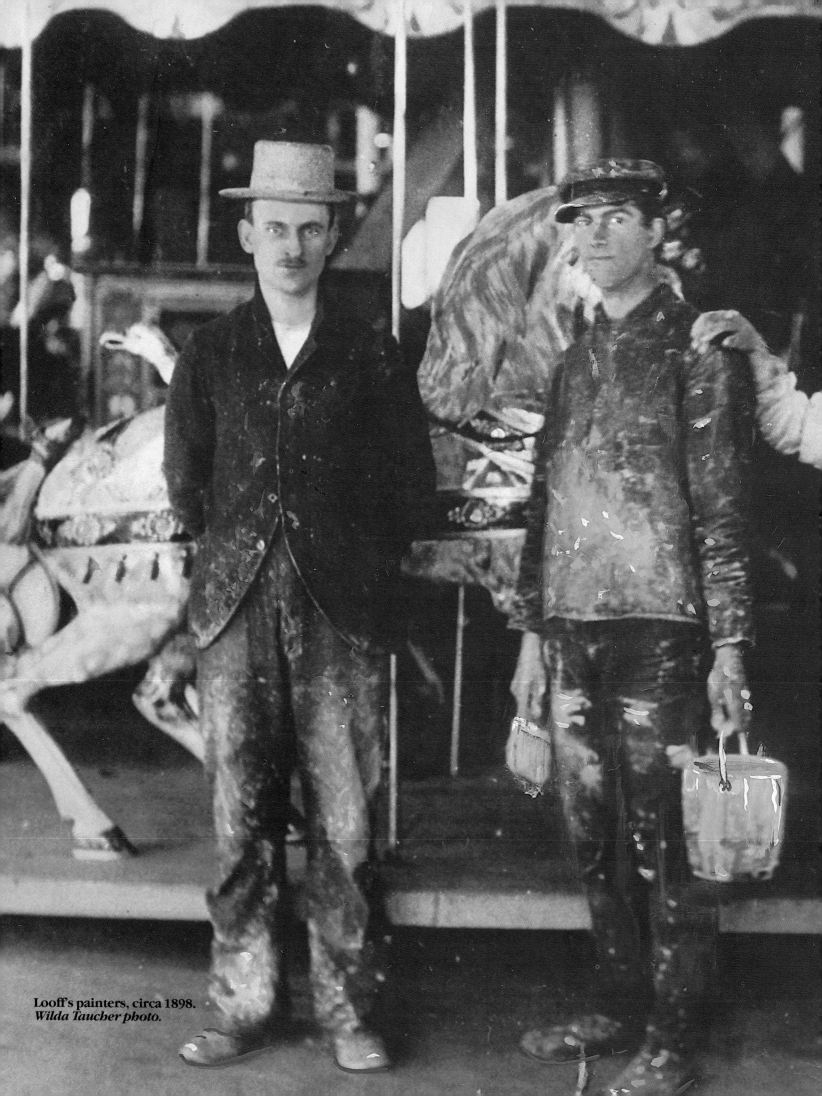

Looff's painters, circa 1898.
Wilda Taucher photo.

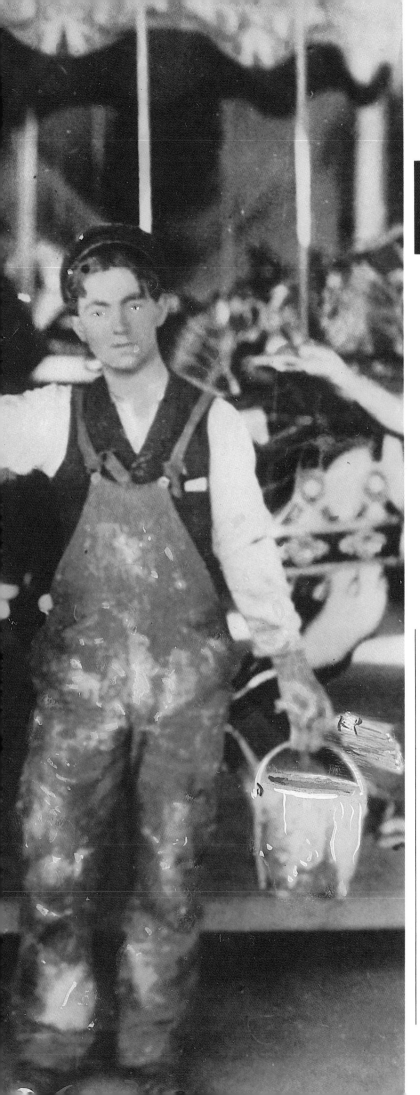

Carousel Art

PRESERVATION

A multitude of American youngsters and adults rode the spinning, rocking horses built during the golden age of carousels. But riding one now is a rare experience, except for people who live in California or New York, which together have almost one-quarter of the existing wooden carousels in operation today. Of the 7,000 to 9,000 carousels that were built in American factories, fewer than 300 are in use.

In some respects, the resurgence of interest in carousels has reduced the number of machines that perform the task for which they were created. Financially carousels usually are worth more when the figures are sold individually to collectors than when they are whole. Beyond the sobering purchase price, restoration and maintenance of an entire carousel is a monumental undertaking. But to the benefit of a generation of uninitiated carousel riders, a pocket of preservationists has emerged.

Efforts of individuals on opposite sides of the country have led to the creation of two museums dedicated to safeguarding carousels for future generations. Most of the historical items so eagerly collected by carousel manufacturer William Mangels have been scattered around the country, although they still can be found by chance among other historical exhibits. Two newly established museums have corralled some momentos of the carousel era and regularly take riders for a spin back into time on a herd of the old, but rejuvenated horses.

Allan Herschell, namesake and grandson of the prolific portable carousel manufacturer, Rae Proefrock and others organized a civic group in New York to buy the original factory complex used by the Allan Herschell Company, to set up a carousel in the roundhouse and to collect memorabilia for static displays throughout the existing buildings.

The Carousel Society of the Niagara Frontier, a non-profit group dedicated to the rejuvenation of the old factory site, is restoring the North Tonawanda factory. During the summer months volunteers operate the No. 1 Special 1916 40-foot Allan Herschell carousel installed in the wooden roundhouse used to test machines when the company was in full production. Herschell believes the carousel is the first or nearly the first one produced by the company formed in late 1915. It carries 25 of the original 26 horses. The king horse, retained by the previous owner in Canada, was duplicated by carvers in the area.

Herschell disclaims any expertise about his grandfather's business, but his interest in his carousel heritage was piqued when he took his 90-year-old father to the 1977 National Carousel Association convention in Atlantic City, New Jersey. The interest expressed in carousels surprised both men. A year later an article appeared in the local newspaper in North Tonawanda suggesting the community bring a carousel to the area. Ironically, the place that had produced so many carousels never had one for the public to ride, according to Herschell. Eventually the right combination of people met and the project began. Although displays in the wood shop, paint shop, carving shop and assembly room are still limited, anyone can ride the carousel for 25 cents from Memorial Day to October.

On the western edge of the country, Carol and Duane Perron founded the ''Portland Carousel Museum'' in 1982 with the goal of preserving America's rich carousel heritage and educating the public about the different sytles and carvers. The permanent collection displays 30 to 50 figures showing all the carvers, companies and various periods of the carousel era. Old photographs are used to illustrate the history of the carousel. A Looff carousel adjacent to the museum takes visitors on a real ride into the past, while a small gift shop sells carousel books and collectibles.

Work by the non-profit group that operates the museum includes an ongoing project to restore the six carousels that give Portland the right to call itself ''The City of Carousels.'' No other city has more. In the future the group plans to establish a national registration program to ensure authenticity of carousel figures throughout the United States and Canada.

A few civic organizations have performed minor miracles to keep particular carousels intact. In certain communities where an existing carousel has fallen into disrepair or no longer is wanted by the operator, residents have organized to preserve their link with the past. Usually one or two determined people enlist the aid of local government officials and publicize the project. Fund-raisers, donations and volunteer assistants are used to renovate the carousel. As money becomes available, sections of the carousel are repaired and they are stripped and repainted or returned to the original paint.

Carousel pioneer Allan Herschell's original factory in North Tonawanda, New York, has been purchased and converted into a museum by the Carousel Society of the Niagara Frontier. The city was once the home of several carousel and band-organ manufacturers, including the North Tonawanda Musical Instrument Works, the Artizan Company and the Wurlitzer Company, the most well-known maker of band organs.

Groups of schoolchildren visit the carousel museum regularly and line its walls with their artwork. This drawing is by Karen Zahm.

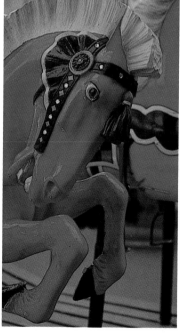

The museum's most memorable exhibit is an operating carousel built by the Allan Herschell Company in 1916. The factory, which specialized in portable machines, was the most prolific of all carousel manufacturers. It made more than 1,500 carousels.

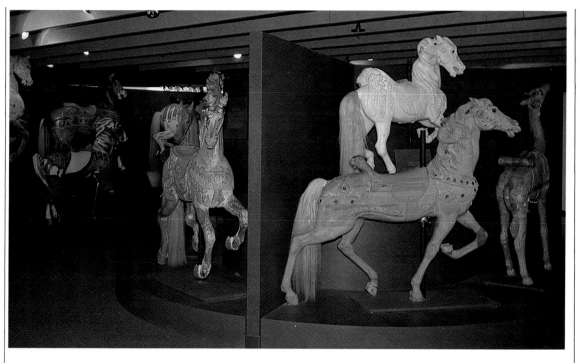

The "City of Carousels," Portland, Oregon, hosts more operating antique carousels than any other city in the United States. Portland Carousel Museum contains an extensive collection of carousel figures representing all the major carvers and factories and examples of various periods of their work. *Susan Foley photo.*

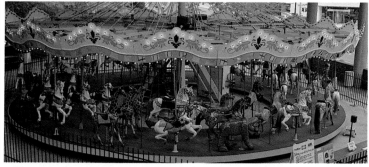

Volunteers, members and friends of the Portland Carousel Museum have restored several carousels, including Philadelphia Toboggan Company No. 15, which operated at Expo '86 in Vancouver, Canada, before it returned to its permanent home in Portland, circa 1907. *Susan Foley photo.*

A beautiful Looff menagerie carousel operates on a site adjacent to the museum. The assortment of figures, created from the 1880s to 1916, represents many stages of Looff's illustrious carving career. The carousel is on loan to the museum from Carol and Duane Perron. *Susan Foley photo.*

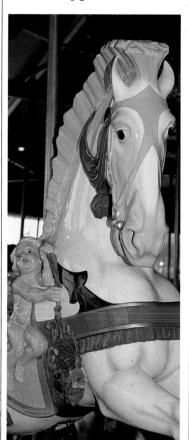

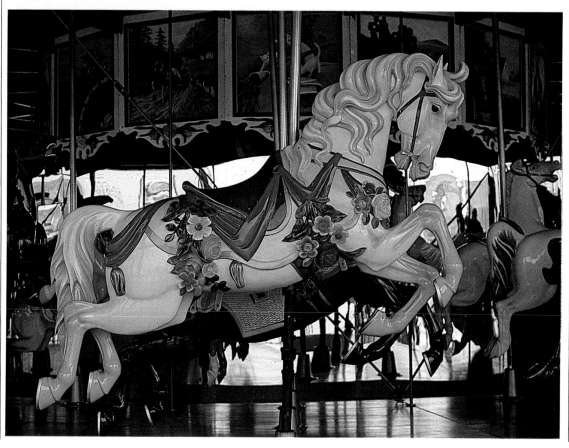

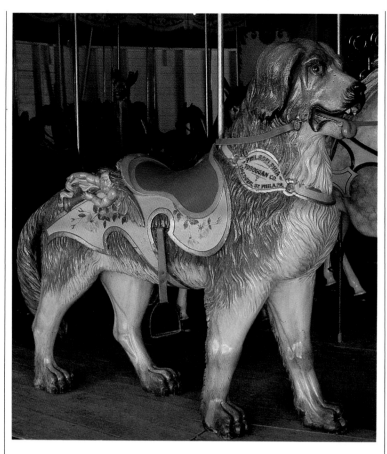

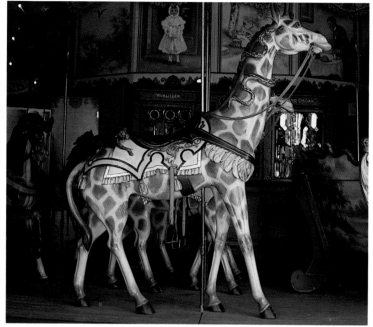

In 1928 the small town of Burlington, Colorado, installed PTC No. 6 carousel, which had been built in 1905. The beautiful menagerie machine was restored by Denver artist Will Morton, beginning in 1976. The figures on board, some of the finest examples of Philadelphia Toboggan Company menagerie carvings, are attributed to Daniel Muller.

Carousels have been protected from extinction in California at Santa Monica and Berkeley, in Colorado at Burlington and Pueblo, in Oregon at Portland and in North Carolina at Burlington. Other restoration projects have begun in St. Louis, Missouri, and Colorado Springs, Colorado.

Few operating carousels in the United States can claim the distinction of wearing original paint. Removing layers upon layers of touch-up and cover-up paint and searching for the colors applied in the carousel factories is a time-consuming and expensive task. Even so, a small group in eastern Colorado managed to save its carousel, paint and all. (Two Dentzel machines -- one in Pen Argyle, Pennsylvania, and one in Lansing, Michigan -- also wear their original paint.)

In Kit Carson County, Colorado, where the population barely numbers 7,000, residents decided to rescue their Philadelphia Toboggan Company carousel located at the fairgrounds in Burlington. First, a Wurlitzer Monster Military Band Organ was restored -- in time for bicentennial celebrations during the county fair in 1976. The glorious music resounding from the organ that had stood silent as the home of field mice and snakes for 45 years may have inspired members of Kit Carson County Carousel Association to continue their fund-raising efforts and complete the restoration project. In 1979 Will Morton was commissioned for an 18-month project to return the three-abreast machine with its 46 menagerie animals and four chariots to the original paint. John Pogzeba, a Denver art conservator, was hired to restore the 45 scenery paintings. The same year Machine No. 6 (the sixth in a series of 79 carousels) was designated a National Historic Site and nominated for National Landmark status.

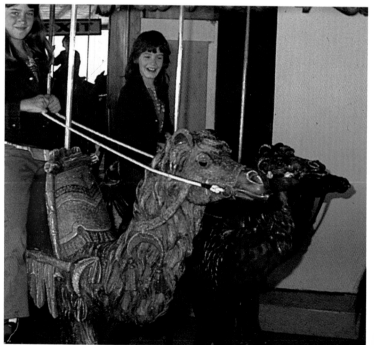

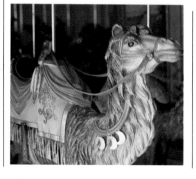

After 70 years, the darkened varnish covering the animals had practically obliterated all of the ornamental painting, as seen above. But the restoration process returned the old paint to its original finish.

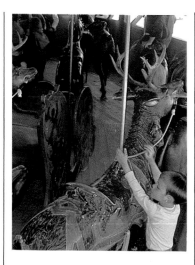

The woodpecker decorating the neck of this magnificent deer was almost invisible until the old varnish was removed. The trick to the process is to remove the varnish layer without harming the old paint. Both, unfortunately, are affected by the same solvents. The task is further complicated by uneven wear to the carousel paint. Saddles, shoulders and rump areas experienced the heaviest use. In some spots, the varnish, paint and part of the wood itself had been worn away.

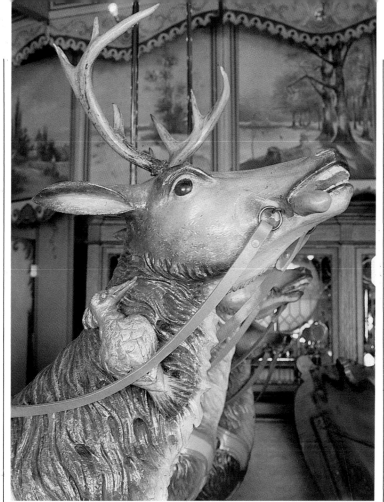

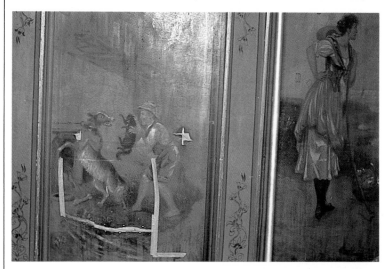

The Burlington, Colorado, restoration project was the most historically comprehensive of any American carousel. These photographs show the difference in the torn, darkened scenery panels before and after they were returned to their original glory by John Pogzeba. Scenery panels are restored in much the same manner as carousel figures.

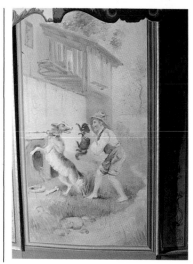

This particular carousel, built in 1905 and bought in 1928 from Elitch Gardens, an amusement center in Denver, was not always popular with local residents. In the past, the decision to spend $1,250 for the carousel, an extravagant amount in the eyes of the rural community leaders, ruined the political careers of two of the county's three commissioners. Under protest the carousel was added to the permanent displays on the county fairgrounds.

The carousel had barely settled into its new home when economic considerations closed the county fair from 1931 to 1937. During that time the buildings, including the one holding the controversial carousel, were used to store corn and hay provided to local farmers by a government-assistance program. Varmints and vermin were attracted to the stored feed and infested the immobile carousel figures. When workers cleared away the debris in preparation of the fair's reopening, they found considerable destruction. The band organ appeared to be ruined and many wanted to burn the machine and figures, which had fallen into a sorry state of disrepair.

Instead, shovels and soapy water were used liberally, a tape player was added to provide music and the horses pranced around their platform for another 40 years. In the early 1970s residents chose to fix up the carousel for America's Bicentennial and had the band organ restored. The finished carousel, restored to its original paint and turning to the tune of its own Wurlitzer was officially dedicated in 1981. Burlington's PTC, No. 6 carousel is one of America's most important carousel treasures. It is operated only during fair week and on special occasions. The limited use and Colorado's dry climate have helped preserve this wonderful example of carousel art.

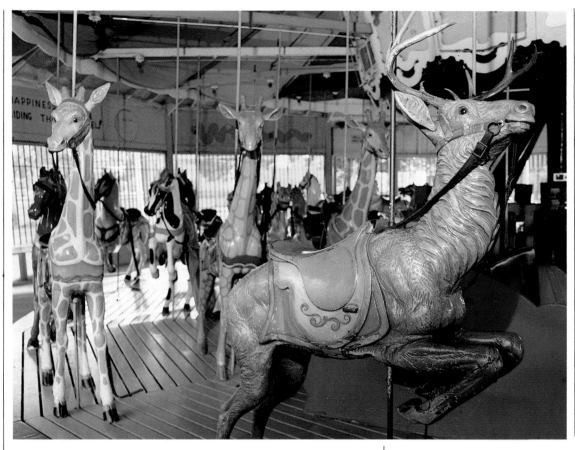

Civic groups thoughout the country have been responsible for saving many carousels. The Jaycees of Logansport, Indiana, raised funds to buy this early Dentzel stationary machine, one of only three that exist. After it was saved from the auction block, Cass County Carousel Association began restoring the figures one at a time, circa 1905.

In Logansport, Indiana, residents rallied to keep their 1902 Dentzel machine in the community of 20,000 people. The carousel, only one of three in existence with all stationary figures, was moved to the small town in 1919 from Fort Wayne, Indiana. The three-abreast machine was operated privately until 1969, when the last owner died, and the carousel was tied up in an estate until 1972.

Frank Callipo, a Jaycee, found out the carousel was going to be sold to a Chicago firm and taken from its familiar location in the city park. The Jaycees held a radiothon and raised $21,000, more than enough to cover the $15,000 purchase price. The Cass County Carousel Association, a non-profit organization run by representatives from the community, the Jaycees and the park service, formed immediately to take over the operation and repairs.

In 1983, the association began stripping the deteriorating figures, repairing them and repainting them to match the original colors when possible. The first surprise came when

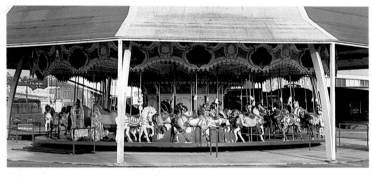

As family-owned amusement parks disappear, carousels are sold one figure at a time, as seen in this 1985 auction of PTC No. 59 carousel in Panama City, Florida. The auction attracted dealers and collectors from all over the United States. Some of the outside-row figures commanded a price of $16,000.

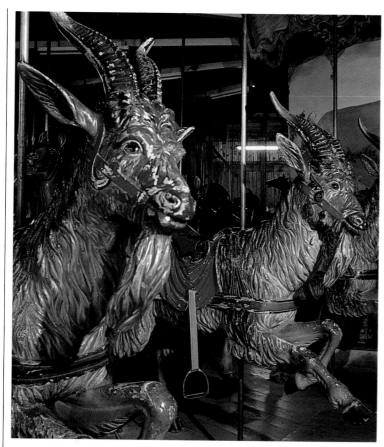

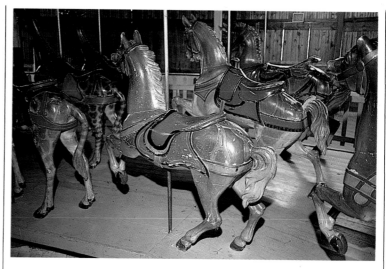

the carousel's panther turned out to be a tiger. The black cat had been created by a lazy painter who did not want to bother with the animal's stripes. Of the 44 horses and menagerie figures, four are completely redone and the remainder are scheduled for refurbishing -- two at a time so the carousel can still operate during the evenings from Memorial Day to Labor Day, for 40 cents a ride.

Small, family-owned amusement parks are becoming a rarity. But private collectors do buy entire carousels. These machines are refurbished to perfection and placed in tourist-oriented commercial centers. At most auctions after bids are taken for individual pieces, the whole machine is offered for sale for the total of the generated sum of bids plus 10 percent.

In 1984 a New York real estate developer and his wife bought the Idora Park carousel in Youngstown, Ohio, for $385,000. David and Jane Walentas told reporters after they had bought the carousel and its octagonal housing, they planned to install the Philadelphia Toboggan Company machine built in 1922 in a proposed waterfront park in New York City next to the Brooklyn Bridge. Local residents were sad to see their herd of 48 wooden horses leave the area, but took some comfort knowing the public would still have a chance to ride the beautiful steeds.

Changing social patterns have drastically altered many locations that were once home to America's great summer-time beach resorts. Condominiums and hotels have shoved aside amusement centers where the value of real estate has escalated. In other areas, deteriorating neighborhoods have all but driven the family amusement parks out of business. The once-great Coney Island in New York is an example of the latter. In its heyday Coney Island offered the happy throngs 22 glorious carousels. Now a shabby shell of the park and one operating carousel remain.

Pen Argyl, Pennsylvania, is the site of one of the few carousels that still have original factory paint. The three-abreast stationary Dentzel carousel was rebuilt in the factory in 1923. The remarkable machine could be restored, like the carousel in Burlington, Colorado, to the rich, colorful condition in which it left the factory.

The inside, or left side, of the carousel figures was not ornately decorated or painted because it was not usually visible to the passing crowd. Though muted under yellowing varnish, the original ornamental painting is clearly evident on these beautiful Dentzel carvings, circa 1907.

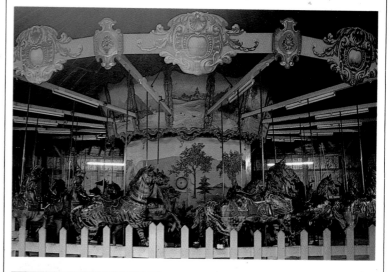

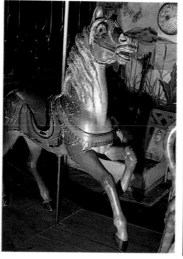

Pen Argyl's Dentzel machine looks much the same as it did in 1923, except it is now illuminated with fluorscent lighting and darkened by the aging varnish.

Carousel figures were originally painted in harmonious colors. Painstaking attention was paid to the pin-striping and decorative painting on the trappings, as seen on this Dentzel mare, circa 1907.

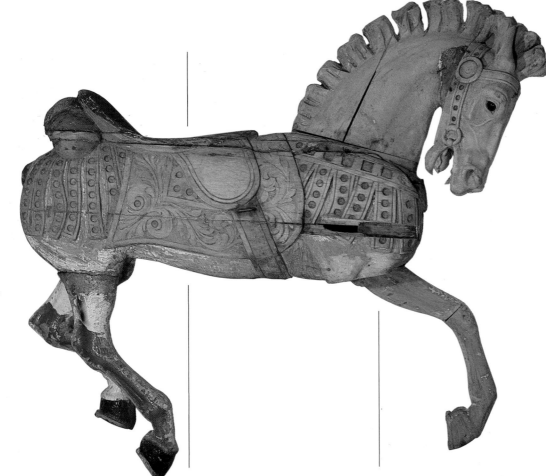

Most commercial operators lack the money or willingness to invest in extensive renovation of the carousel figures. Before the 1970s, carousel art in this condition would have been discarded. Figures with severe leg damage or extensive rot are now saved by dedicated collectors and professional restorers. Such projects require a great deal of time and money. This Looff jumper will be restored to its prime. *Smith collection.*

Many commercial parks, such as Disneyland, have reproduced some of their carousel figures in fiberglass in an effort to reduce maintenance expenses and save the originals. Owners of small amusement parks, enticed by the exorbitant prices offered by eager collectors and auctioneers, have replaced antique wooden figures with fiberglass reproductions.

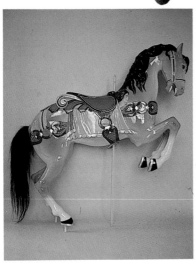

Skilled artists, such as Rosa Ragan, are adept in removing dozens of layers of park paint, exposing the original factory paint and repainting the figures. Great care is taken to preserve the original paint and conserve it under a newly repainted surface. There is one rule in restoration: Never do something that cannot be undone later. This figure is from the only two-abreast stationary Dentzel machine in existence. It operates in Meridian, Mississippi.

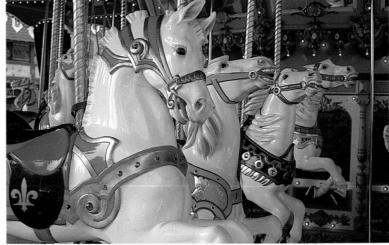

Continual use, though it is what carousels were created to provide, eventually damages even the sturdiest figure. Ears break off, gouges mar wooden flanks, jewels disappear, unskilled operators make hasty repairs and, sometimes, thieves steal entire animals. Fires, the wooden animals' most deadly enemy, and Mother Nature with her capricious floods and storms continue to obliterate carousels, too.

Disneyland and Disneyworld have made fiberglass reproductions of some wooden carousel figures in an attempt to preserve the originals and still offer the public a bona fide carousel ride. The limited introduction of these molded replacements has not greatly affected the carousel world yet -- for better or worse.

Certainly, the idea has merit. Communities and park operators, faced with the loss of a carousel, could make models, sell some of the originals to finance the project and keep the rest of the figures. And, like the cast aluminum descendants

of hand-carved carousel figures, the reproductions are more durable and less expensive to maintain. Increasing the margin of profit makes operating a carousel more attractive to private operators. In addition, once a mold is made, any number of copies can be produced again.

On the other hand, carousels would lose their special individuality, their one-of-a-kind appeal. Confronted with 100 Stein and Goldstein armored chargers or 1,000 Dentzel rabbits, the public sees just another mass-produced amusement ride.

Thus, fiberglass might pave the road to extinction that carved wooden carousels began to travel after the first aluminum castings were made in the 1920s.

Or it might be the ingredient needed to sire a hardy, new breed of carousel, to be enjoyed by another generation of laughing children who cling to the painted ponies that go round and round and up and down.

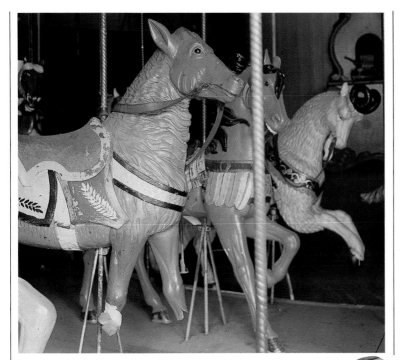

Heavily used park carousels would often receive a fresh coat of paint every season. Many figures that have been restored were wearing more than 50 coats of thick enamel paint. Usually garish and poorly applied, this finish became known as "park paint." Concessionaires, or ride operators, were usually responsible for repainting and maintenance. Their indifference and ineptness are obvious on this Carmel machine, which has set idle for many years in Prospect Park, Queens, New York.

The art and beauty of a carousel figure often disappear under layers of gaudy park paint. Dozens of coats of enamel paint can obliterate intricate ornamental carving, as seen in this Parker jumper, circa 1916. *Schoenback collection.*

Amusement park maintenance workers are usually in charge of the upkeep of the carousel, too. These untrained individuals, some of whom may have been well-meaning, usually applied heavy coats of enamel straight from the can. Most of the detailed flourishes in the carvings are then hidden by bright, though often tasteless, park paint finishes, circa 1938. *Playland, Rye, New York.*

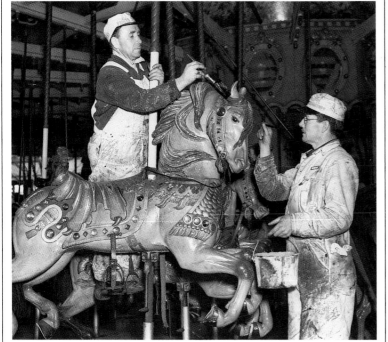

The carousel carver's art is almost unrecognizable under indifferent paint jobs, such as the slapdash method used on this Looff lion on board an Illions machine at Corona Park, Queens, New York, circa 1909. Henry Stubbman won the lion for his carousel while playing pinochle with M.C. Illions. The carousel, a merger between the Feltman and Stubbman carousels, was created for the 1965 New York World's Fair.

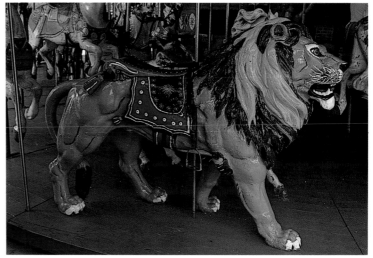

Collecting and Restoring
CAROUSEL ART

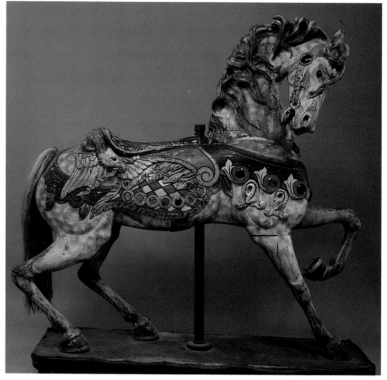

Everything on the carousel is fair game for hunters of collectibles: tickets, rounding boards, poles, shields, band organ figures and, of course, the animals. A search for the now-rare beasts that once populated every respectable amusement center can lead across the country. Great herds of wooden horses, popular items among collectors, have been thinned by abuse, neglect and natural disasters.

Menagerie animals are highly prized because fewer were carved. Dentzel pigs, rabbits and cats are favorites, but hunters who have tracked down lions, giraffes, ostriches and even domestic dogs made by less well-known carvers have found rewarding treasures. It is not unusual for collectors to remove layers of park paint from a horse and discover -- to their surprise -- a camouflaged zebra underneath.

The decorated right side of the chariots appeal to carousel collectors and are becoming increasingly popular. Themes on these intricately carved bas-relief sculptures range from fierce dragons to sly cupids. Two to four chariots usually were included on the platforms of the large, park machines, so they are not extremely rare. The silhouette or inside panel is valuable if it still has its original paint. Some were painted in minute detail to look as though they were carved exactly like the decorated side.

Shields that covered joints, scenery panels enclosing the center pole and equipment and rounding boards attached to the outside rim of the carousel's crown are sought by collectors, too. Under layers of park paint, the colors applied while the carousels were in operation, lurk nostalgic landscapes, scenes from America's past and portraits of the famous or beautiful. Some rounding boards may have been painted only, not carved, so their value depends upon the condition of the original paint. Shields and center panels, however, were often heavily carved with scrolling before they were painted. Finding the carousel manufacturer's name panel under many layers of garish pink and green park paint is a special bonus. Beveled mirrors with ornate frames were used as panels, especially around the center pole where riders could catch a glimpse of themselves riding by.

Band organs that supplied the jolly music for carousel riders can be restored to their former glory like the rest of the carousel pieces. Most of the musical parts were imported from Germany and other European countries. They sometimes had animated figures such as drummers with moving arms, tamborines that shook and faces with mouths that opened and closed in time to the music. The carved and painted facades of these music machines usually were fashioned in Europe, but some were carved in the United States to complement a certain carousel.

Most collectors of carousel art value the outside-row figures because they were the largest and were most heavily carved. Another factor that increases the desirability of a figure is the condition of the paint. Old paint applied with care, like this coating on a beautiful Loof stander, is highly regarded. Figures produced by the classic carousel artists (Muller, Illions, Looff, Dentzel and Carmel) are among the most prized. *Stevens collection, Harry Bartlett photo.*

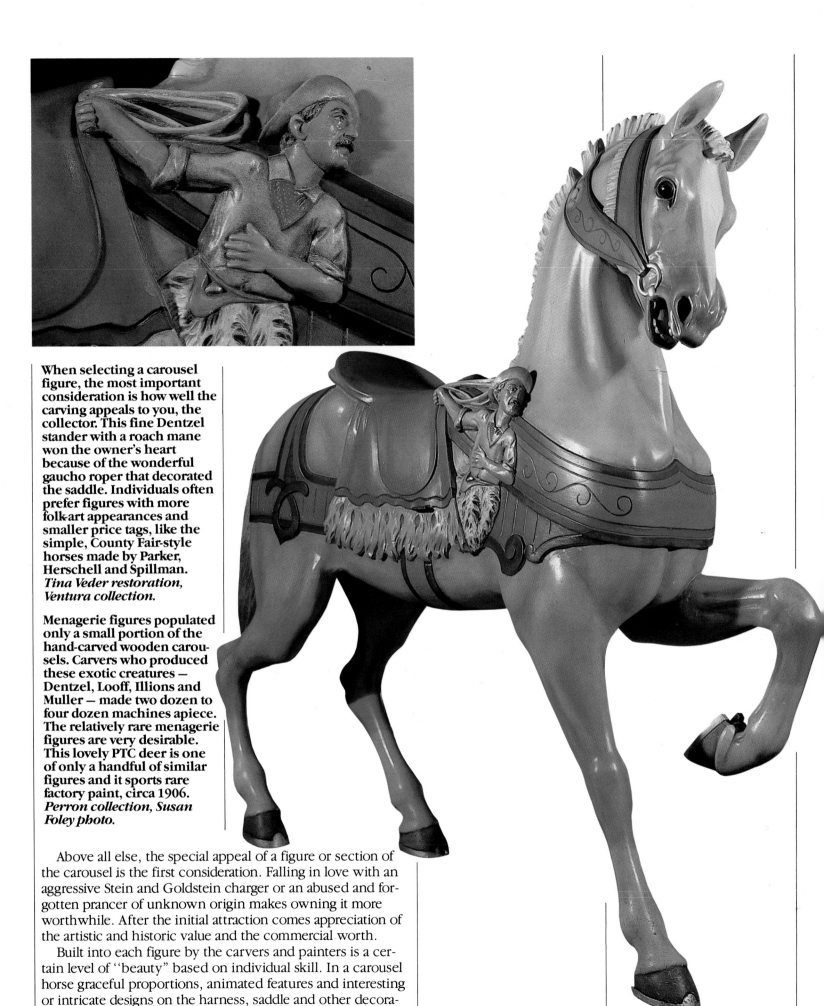

When selecting a carousel figure, the most important consideration is how well the carving appeals to you, the collector. This fine Dentzel stander with a roach mane won the owner's heart because of the wonderful gaucho roper that decorated the saddle. Individuals often prefer figures with more folk-art appearances and smaller price tags, like the simple, County Fair-style horses made by Parker, Herschell and Spillman. *Tina Veder restoration, Ventura collection.*

Menagerie figures populated only a small portion of the hand-carved wooden carousels. Carvers who produced these exotic creatures — Dentzel, Looff, Illions and Muller — made two dozen to four dozen machines apiece. The relatively rare menagerie figures are very desirable. This lovely PTC deer is one of only a handful of similar figures and it sports rare factory paint, circa 1906. *Perron collection, Susan Foley photo.*

Above all else, the special appeal of a figure or section of the carousel is the first consideration. Falling in love with an aggressive Stein and Goldstein charger or an abused and forgotten prancer of unknown origin makes owning it more worthwhile. After the initial attraction comes appreciation of the artistic and historic value and the commercial worth.

Built into each figure by the carvers and painters is a certain level of "beauty" based on individual skill. In a carousel horse graceful proportions, animated features and interesting or intricate designs on the harness, saddle and other decorations contribute to the total artistic value.

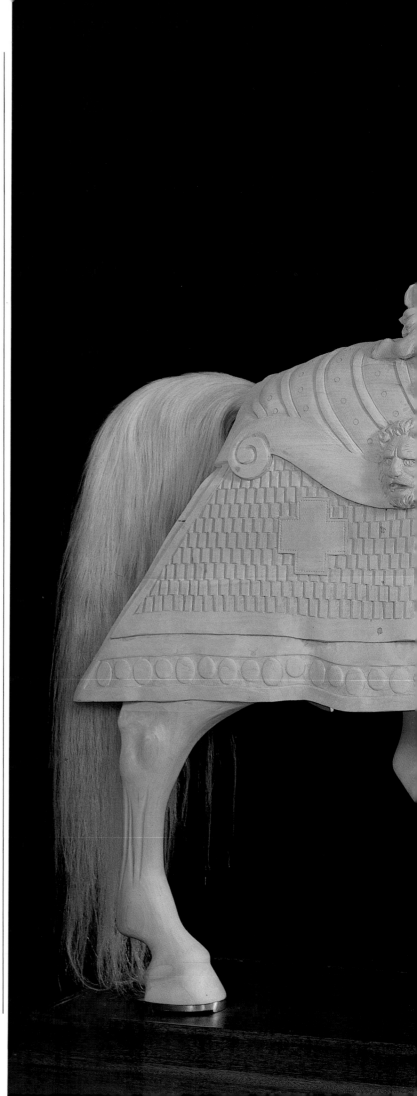

The scarcity of exceptional figures and resulting high prices have created a demand for reproduction carvings of the old carousel animals. Artists such as Jim Smock reproduce extraordinary carvings such as this Muller armored horse. Muller is known to have produced only five armored horses. This copy was reproduced from a factory photograph. The original apparently no longer exists. To ensure the re-creation is not confused with an original in years to come, Smock carved this figure 10 percent larger than Muller's standard horses.

Collectors will go to great lengths to preserve carousel art. Artist Jim Smock restored this Dentzel thoroughbred, which had almost one-third of the figure missing — the back, one side, two legs, chest and head. This unusual cut-away view shows the hollow construction clearly. The restored figure is shown below. *Stout collection.*

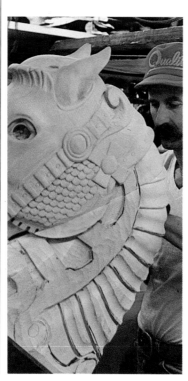

Collectors of Americana find a wealth of interesting material from which to choose among carousel items. The majority of the carousel carvers and painters were immigrants, but they wore the adopted label, "American," with pride. To show their gratitude and happiness in the new country, they often used patriotic symbols -- flags, eagles and portraits of statesmen -- in their decorations. American themes depicting characters of the Wild West or the cavalry were popular among carvers, too.

More than 100 years have elapsed since the first hand-carved carousels were produced by the major carvers in America and more than 50 years since the last all-hand-carved wooden ones were made. With the passage of time, antique collectors have also taken an interest in carousels. These machines suffered from constant use and hasty repairs, but they were built solid. When their popularity waned in the 1950s, some carousels were stored in relatively safe places. Initial construction and undisturbed storage has made some fine specimens available to collectors today.

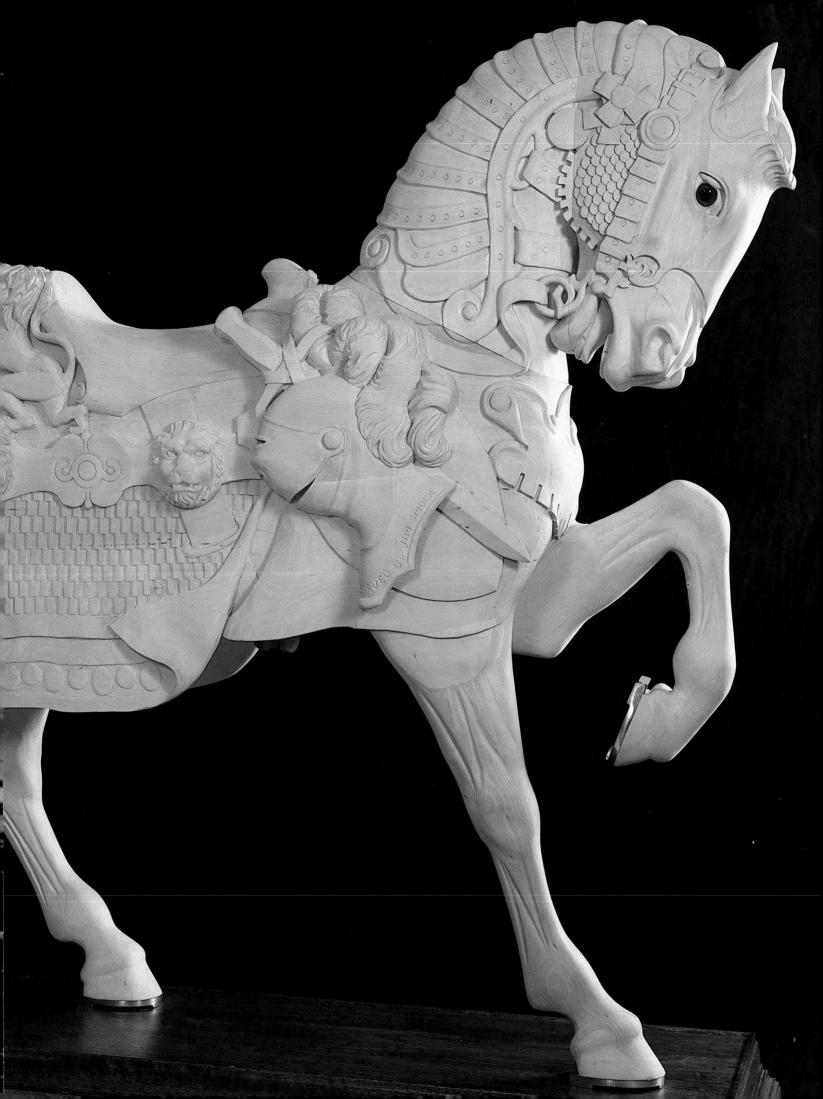

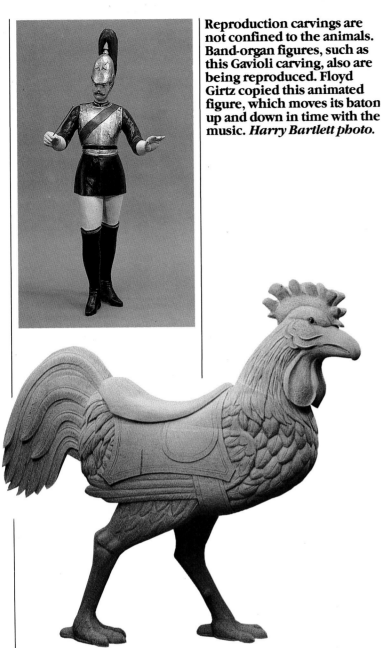

Reproduction carvings are not confined to the animals. Band-organ figures, such as this Gavioli carving, also are being reproduced. Floyd Girtz copied this animated figure, which moves its baton up and down in time with the music. *Harry Bartlett photo.*

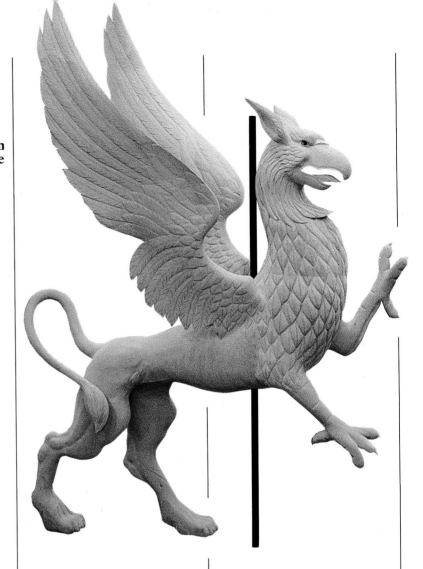

The Dentzel rooster is a rare carousel figure; only five are known to exist. Artist Joe Leonard carved this exquisite and exacting reproduction.

Contemporary carousel figures are becoming popular. Joe Leonard carved this exceptional griffin for a San Francisco, California, client.

Age alone can instill historical value into a carousel piece, but other considerations can have greater effect on the degree of worth. Often museums house items of historical value, the patterns or tools used in the construction process, that hold no interest for private collectors. But a figure that signals the turning point in a particular artist's career, for example, would be valued by historians and collectors alike. Pieces that represent events having a major impact on the society (the erection of the Statue of Liberty would be one) would carry a significant historical value, but may not influence the value to collectors.

In addition to special-interest collectors are the people who are solely interested in the financial or investment aspects of collecting carousel items. Some figures are extremely rare and command high prices when they are sold. Since the resurgence of interest in carousels, the figures and memorabilia have been increasing in value. So far, that trend has continued.

The average price for a new factory-carved horse in the 1920s was $35. By 1950 these used horses were worth around $50, but in the early 1970s, the early days of the car-

ousel revival, the price jumped to $500. Today these carvings are commanding a much higher price. Horses commonly sell for $5,000 to $15,000 and menagerie figures for $15,000 to $40,000, the higher figure reflecting the rarity of these animals. Selling prices depend on the carver, quality, size and condition with Muller, Dentzel, Illions, Carmel and Looff figures leading the list. The more simple Herschell, Spillman and Parker figures bring much less.

Renewed interest in carousels in the 1970s uncovered many pieces that had been stored and forgotten in basements and barns. But out of the 7,000 to 9,000 produced, fewer than 300 remain. Following the trail of a carousel figure requires patience and imagination.

During the search for a carousel figure, it is important to research and read as much about carousels as possible. Visiting carousels still in existence around the United States is a delightful, yet important, way to gather valuable knowledge about the subject. The more collectors know about carousels, their carvers and the period of construction, the better decisions they can make when buying a horse or other figure.

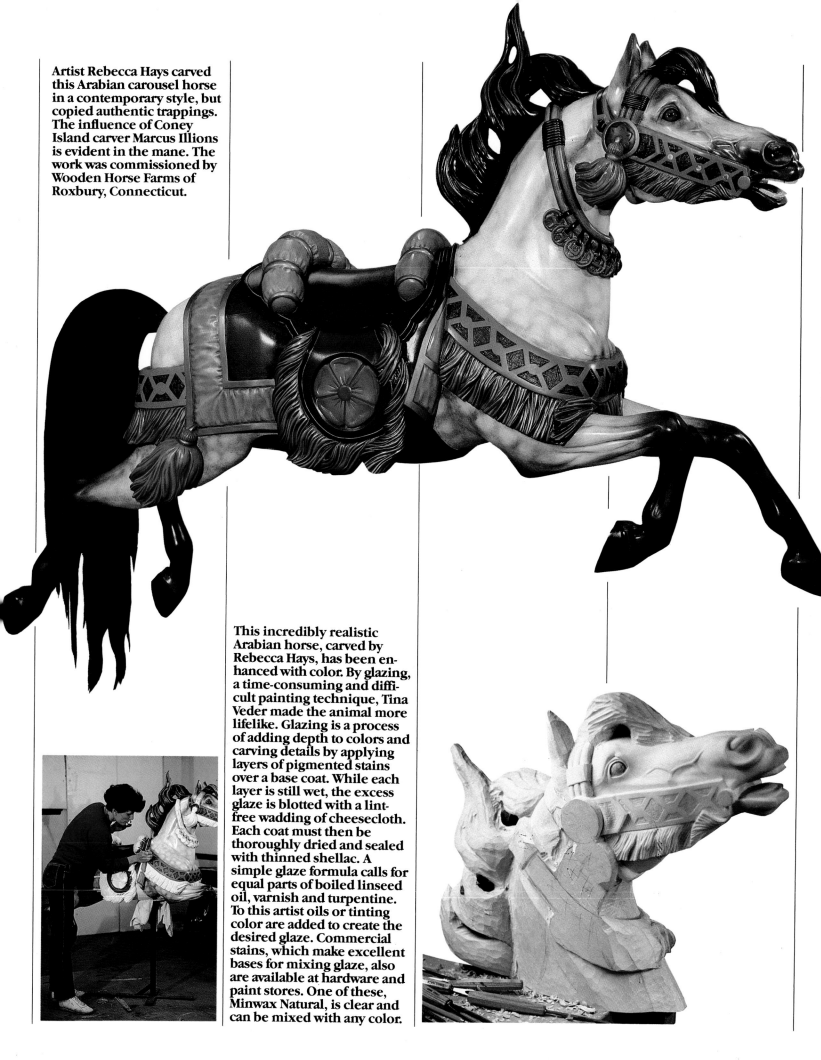

Artist Rebecca Hays carved this Arabian carousel horse in a contemporary style, but copied authentic trappings. The influence of Coney Island carver Marcus Illions is evident in the mane. The work was commissioned by Wooden Horse Farms of Roxbury, Connecticut.

This incredibly realistic Arabian horse, carved by Rebecca Hays, has been enhanced with color. By glazing, a time-consuming and difficult painting technique, Tina Veder made the animal more lifelike. Glazing is a process of adding depth to colors and carving details by applying layers of pigmented stains over a base coat. While each layer is still wet, the excess glaze is blotted with a lint-free wadding of cheesecloth. Each coat must then be thoroughly dried and sealed with thinned shellac. A simple glaze formula calls for equal parts of boiled linseed oil, varnish and turpentine. To this artist oils or tinting color are added to create the desired glaze. Commercial stains, which make excellent bases for mixing glaze, also are available at hardware and paint stores. One of these, Minwax Natural, is clear and can be mixed with any color.

Antique dealers, though they seldom display a large carousel figure, may have heard of one for sale. Store owners are in constant contact with other people involved in antiques through catalogs, at shows and by talking to customers and suppliers. Enlisting the help of local antique dealers, inquiring at shows and traveling to other cities can lead to a carousel figure.

Two national organizations, the National Carousel Association and the American Carousel Society, hold yearly conventions and print regular newsletters. Since members of these groups are interested in collecting carousel artifacts, they can offer clues and swap information from their own searches.

Auctions and gallery sales sometimes have carousel figures among the antiques offered for sale. A telephone call to the director to find out if such an item will be offered can be a time-saver.

Letting as many people as possible know about your search increases the chance for success. Friends, relatives and acquaintances can widen the range of available information, as can ads in the classified section of newspapers or specialized magazines.

The second stage in the hunt is knowing what to look for -- and what to avoid -- in a prospective collectible. A thick covering of chipped or worn paint is actually an asset. Layers of paint can be removed to reveal the original paint or at least the fine carving underneath. Uncovering the secrets of a carousel figure is an adventure. To assure that the surprises are pleasant ones, some things should be watched for and avoided.

Carousels were built to turn a profit. A broken animal had to be repaired and put back into use as quickly and cheaply as possible. Legs, especially, took a beating from the hordes of riders that swarmed over the carousels each day. They were reattached with nails and screws, reinforced with strips of metal and painted over. These hasty repairs were often made by an unskilled operator who misplaced or threw away the original broken piece. Rejuvenating a figure with minor repairs is relatively easy. Major jobs, such as replacing missing pieces or correcting large structural damage, can be expensive.

Storage for the most part did not protect the wooden horses and animals from two destroyers -- rot and infestation. Damage by dry rot invades the wood like a cancer until steps are taken to stop the growth. Probing a deteriorated area with an awl or sharp knife will reveal the extent of damage. If the instrument slides into the wood easily, or if the area feels crumbly and soft, dry rot has been at work. Chemicals on the market can halt the growth of dry rot and restore weak areas to a more wood-like consistency, but usually the affected area must be dug out. Small patches can be remade without great expense, but extensive damage is a costly challenge. A collector should consider the value of a particular piece before buying one with major problems.

Value of a carousel animal depends, like any other collectible, on the rarity of the breed. That force makes a menagerie character worth more than one of the inside-row horses, or the name panel more prized than the landscapes and portraits painted on the rounding boards. Being one of a kind makes any figure more precious.

Horses signed by either carvers or manufacturers are relatively rare. However, Marcus Illions, who worked as a carver for many years before establishing his own company, took enormous pride in his creations and boldly signed several lead or king horses. The signed figures are the most coveted by collectors, circa 1910. *Sardina collection, Jeff Saeger photo.*

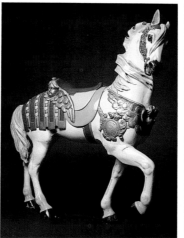

Collectors usually seek the more elaborate outside-row figures produced by Dentzel, Looff, Muller, Carmel and Illions. But some prefer the simple county-fair charm found in the carvings of the

Herschell/Spillman or Parker figures, pictured below. These are frequently less expensive and a good place to start for the novice collector. *Tony Orlando restoration, Tim Hunter*

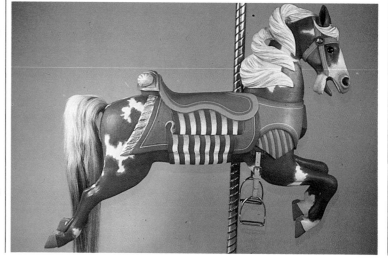

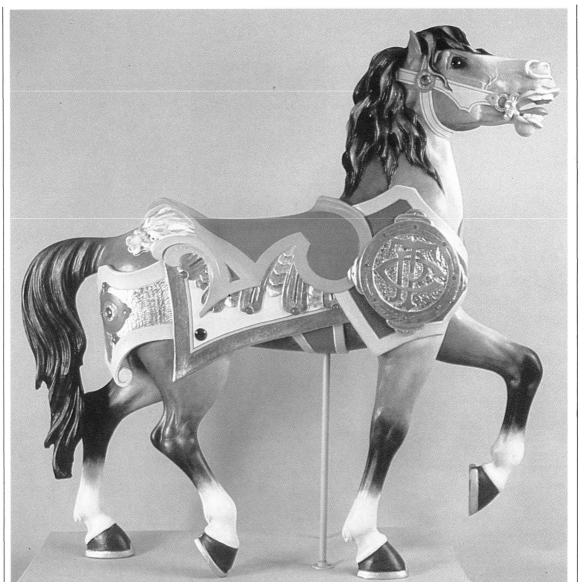

As with most works of art, authenticity and identification are major considerations with collectors. Carousel figures were produced for entertainment and little attention was given to the artist's identity. Philadelphia Toboggan Company did not allow the carvers to sign any of their creations, but usually included at least one horse bearing the company's monogram on each carousel. Definite confirmation of the identity of the artist or manufacturer greatly enhances the value of a figure, circa 1915. *Tony Orlando restoration, Tim Hunter photo.*

Lead or king horses received the most elaborate decorations of the entire carousel and they top the list of valuable finds. Occasionally these horses carry the factory's name or carver's signature. These horses are sought after both because only one was placed on each carousel, and because the carvers loaded them with extraordinary decorations. Both of these characteristics elevate lead and king horses above other carousel figures.

Most collectors prefer large, outside-row standing horses which were reserved for the head carver's attention. The rarer menagerie figures are also very popular. Collectors seek out the best examples of the carver's art, making Illions, Muller, Zalar and Carmel figures among the most prized.

The condition of each figure is another consideration. A well-preserved animal, especially one with original or very old park paint, will be appreciated no matter what the style or year of production. All of these factors play a part in deciding the worth of a carousel animal. Collectors should try to find the best ones that they can afford.

Arguments have been made on both sides of the issue about whether carousels should be considered fine art. Some say the carving and painting began as primitive art forms, but that artists, such as Muller, Zalar and Illions, who dedicated their lives to the perfection of their work, eventually crossed the line and elevated the craft into a fine art. With or without formal training, talented carvers understood the concepts of form, style and movement and raised the carousel above its common roots. Even the panels of the rounding boards, adorned with landscapes and portraits, have been called the "poor man's art gallery."

Others maintain that carousels are folk art, pure and simple. The people who developed and designed carousels have earned a respected place among folk artists. And because the creations were meant to be used, not merely observed from afar, they further fit the description of folk art.

Despite the controversy, carousel figures and other pieces are collected by those who appreciate both artistic carving and simple folk art. Like the thousands of ordinary children and adults who have ridden carousels, they are attracted to this special magic.

One of the first steps in restoring carousel art is to remove dozens of layers of thick paint. Experts recommend cold-tank dipping by experienced professionals. Figures should never be stripped by the hot-dip technique (through the use of heated solvents), which can cause warping and delamination. Artist Betty Carlson removes paint with a heat gun, which melts thick enamel. The process gives the artist complete control without the possibility of harsh chemicals attacking the wood. *Gary Jameson photo.*

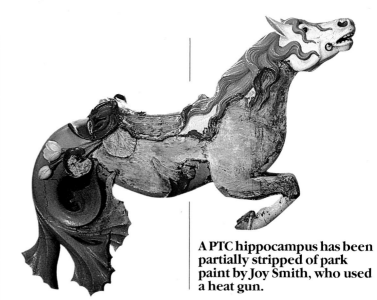

A PTC hippocampus has been partially stripped of park paint by Joy Smith, who used a heat gun.

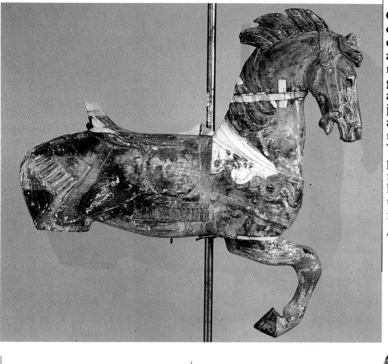

Carousel collectors are often criticized for hastening the disappearance of operating antiques. But many have been responsible for saving gorgeous examples of carousel art from oblivion. This Illions jumper had been decapitated and had extensive rot in the rear legs. Restoration artist Tony Orlando carefully replaced the rotten areas with new wood, added the missing legs and re-attached the head to restore the figure to its former elegance. *Tim Hunter photo.*

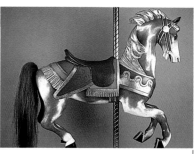

Some figures are found with brittle paint that can be chipped away with a small knife blade. Old paint will flake off in chips exposing the original factory-painted surface. The tedious process can take hundreds of hours. The Schoenbacks spent an entire Michigan winter uncovering this PTC zebra's factory paint. Once the original surface is exposed, oil paint can be carefully blended to fill in the worn and faded areas. This technique is particularly satisfying when the figures are solid and require no structural repairs. The restorer not only preserves the carver's art, but also can experience the ornamental painter's creative touch. *S. Herrmann photo.*

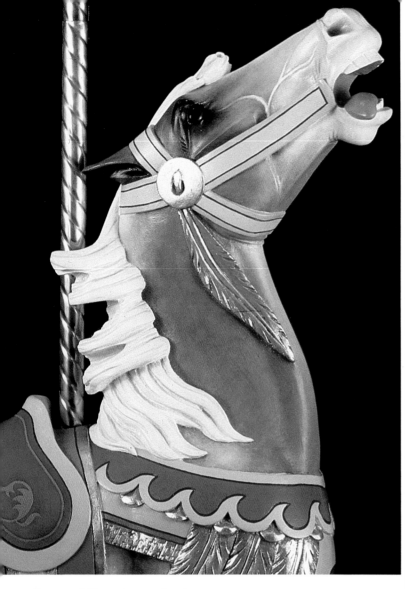

Collectors were once content to paint their figures to match the decor of their living or dining rooms. They now attempt to restore figures to authentic or original paint. In recent years, artists such as Tony Orlando have spent countless hours researching the original factory colors and painting techniques used by the artists more than half a century ago. They have discovered that the original painters took great care to harmonize the colors of the horse, saddle and trappings and added ornamental decorations, such as pinstriping, with great care. Gold- and silver-leaf paint were generously applied, as on this Carmel star-gazer. *Tim Hunter photo.*

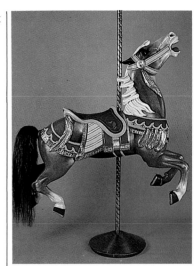

Though Marcus Illions carved all of the heads himself, the bodies were often made by apprentice carvers with the results sometimes less than perfect. Artist Peggy Sue Seehafer carefully restored this Illions horse, paying particular attention to the trappings and saddle, in an effort to de-emphasize the disproportioned body. Using acrylic paint as a base, she airbrushed shading to accent muscles and details. Acrylic was used because it flexes with the movement of the wooden joints and minimizes cracking. The mane was finished with gold leaf for an authentic restoration.

Carousel figures can also be presented without paint. Some stripped animals have virtually no cracks or imperfections, as seen in this fantastic Muller/Dentzel prancer. The exposed wood should be treated with a clear sealant to prevent cracking. This technique underscores the woodcarver's art by showing every chisel mark and construction detail, circa 1904

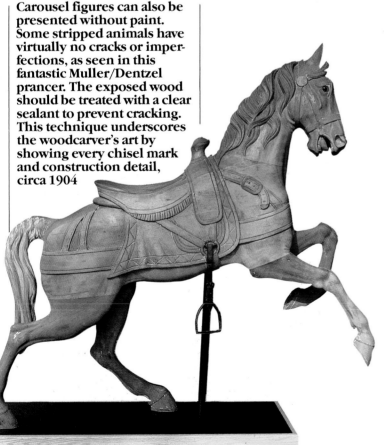

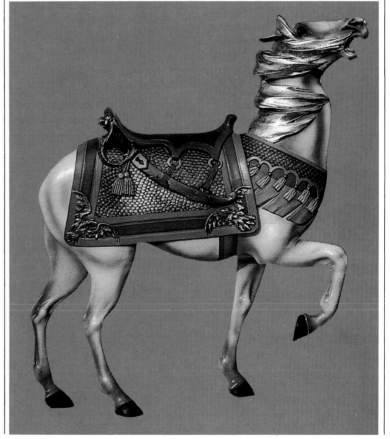

GUIDE TO MENAGERIE FIGURES

● More Than Five Exist

■ Rare, Five or Less Exist

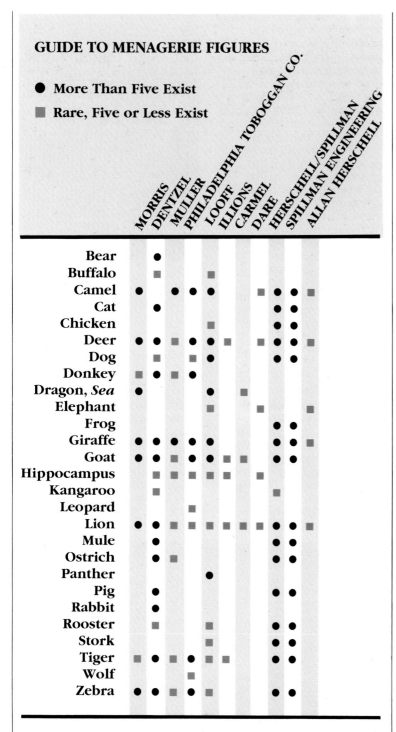

	MORRIS	DENTZEL	MULLER	PHILADELPHIA TOBOGGAN CO.	LOOFF	ILLIONS	CARMEL	DARE	HERSCHELL/SPILLMAN	SPILLMAN ENGINEERING	ALLAN HERSCHELL
Bear		●									
Buffalo		■			■						
Camel	●		●	●	●				●	●	■
Cat		●							●	●	
Chicken						■			●	●	
Deer	●	●	■	●	■	■		■	●	●	■
Dog		■		■	●				●	●	
Donkey	■	●	■	●							
Dragon, *Sea*	●				●		■				
Elephant		■					■		■		
Frog									●	●	
Giraffe	●	●	●	●	●				●	●	■
Goat	●	●	■	●	●	■	■		●	●	
Hippocampus		■	■	■			■				
Kangaroo		■									
Leopard				■							
Lion	●	●	■	■	■	■	■		●	●	■
Mule		●							●	●	
Ostrich		●	■						●	●	
Panther					●						
Pig		●							●	●	
Rabbit		●									
Rooster		■			■				●	●	
Stork					■				●	●	
Tiger	■	●	●	■	●	■			●	●	
Wolf				■							
Zebra	●	●	■	●	■				●	●	

All menagerie figures are relatively rare, since carousel platforms were populated primarily with horses. Parker and Stein & Goldstein never produced any menagerie figures, although Parker did supply at least one carousel with an assortment of animals of unknown origin. Another factor affecting the enhanced value of menagerie figures is that companies and carvers, such as Looff, Dentzel, Muller, Illions and Carmel, produced two dozen to five dozen carousels each, and PTC stopped carving menagerie figures in 1907. The only companies to produce menagerie figures in significant numbers were the Herschell/Spillman Company and its successor, Spillman Engineering.

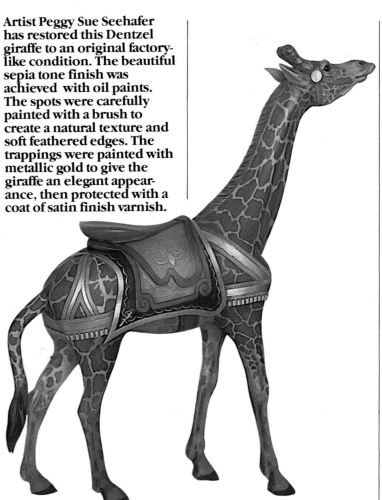

Artist Peggy Sue Seehafer has restored this Dentzel giraffe to an original factory-like condition. The beautiful sepia tone finish was achieved with oil paints. The spots were carefully painted with a brush to create a natural texture and soft feathered edges. The trappings were painted with metallic gold to give the giraffe an elegant appearance, then protected with a coat of satin finish varnish.

Age plays a secondary role in predicting the value of a certain piece. Collectors of primitive folk art prefer the earliest specimens, but generally an ornate, later model wins out over an older and simpler figure. Even the later animals which had their bodies roughed out with carving machines are highly valued. Because the heads, manes and finish work on the trappings were finished by hand, these half-breeds bring top prices.

Imitations of the old carousel figures have cropped up with increased regularity. Crude reproductions from Mexico are sometimes sold to unsuspecting collectors. These wooden horses are buried in earth or beaten with chains to make them look like old, authentic American carousel figures. Such pieces costing $300 in Juarez, Mexico, have been sold in the United States for $2,500; a giraffe sold for $8,000. A glance in the pole hole at the inside walls of the body cavity, however, will reveal whether the figure has been recently carved.

European figures also are sold as genuine American products. These figures are not as undesirable as the modern Mexican imitations because they can be as old and as cleverly carved as those produced in America. Some European pieces, such as the French kiddie figures, are one-third the size of the native variety, though. Again, the best protection against buying a fake is to buy nothing sight unseen and to learn as much as possible about carousel carving before making a purchase.

First and foremost, however, a collector should choose a figure that has a special attraction. Pick one that makes you smile and fits your personal needs, the same way you would select a pet. Choose something you like.

This Dentzel deer with its patriotic eagle saddle decoration is attributed to the carving skill of Daniel Muller. Deer were often carved with a thick ruff, which made them look more like elks. These figures almost always had real deer antlers since thin wooden horns were extremely difficult to carve and easily broken. Restoration artist Tobin Fraley has subtly blended oil pigments to create a realistic fur-like appearance, circa 1920. *Daniel collection, Richard Blair photo.*

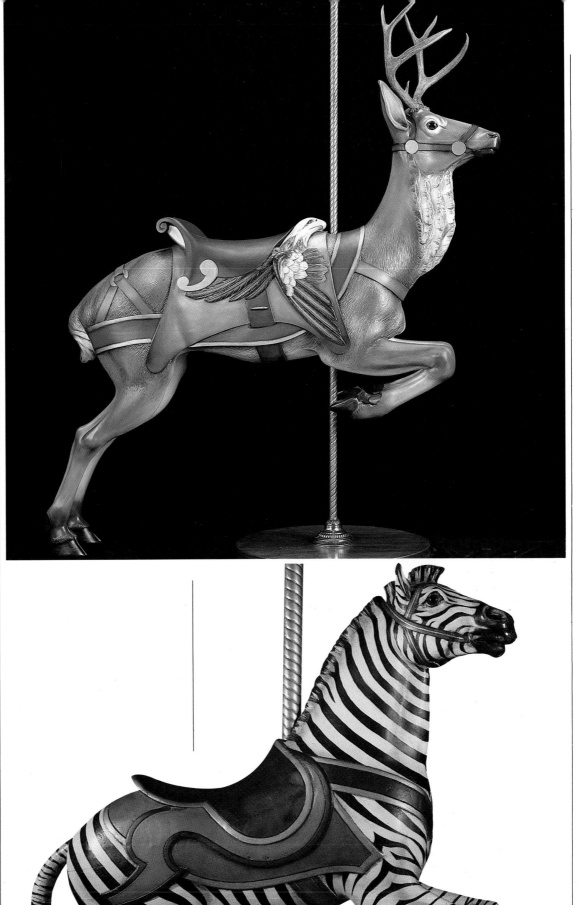

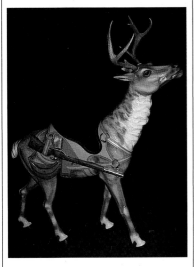

Gray and Judy Tuttle used an airbrush to restore this PTC deer. This familiar painting style is commonly used on operating carousels.

This rare Philadelphia Toboggan Company zebra jumper has been beautifully restored. There are two schools of thought among collectors concerning carousel restoration. One is to refinish the figure and keep all imperfections, joint marks and wood-grain areas, as shown in this figure. Retaining the faults gives the figure more of an antique appearance and makes the construction much more obvious. The other restoration practice is to remove all imperfections, as seen in the deer above. This makes the figure look the way it did on the day it left the factory, circa 1906. *Ventura collection.*

DENTZEL

Mullers immigrate to U.S. ●

● America's centennial
celebration.

LOOFF

● Charles Looff emigrates to New York.

● Carves and installs first
carousel in Coney Island, N.Y.

● Opens carousel factory

DARE

● Charles Dare founds the New York
Carousel Manufacturing Co.
in Brooklyn.

● Armitage/Herschell Co. founded
as machine shop and foundry.

STYLE EVOLUTION OF
AMERICAN CAROUSEL CARVERS
AND MANUFACTURERS

PRODUCING CAROUSELS

REFURBISHING OR OPERATING CAROUSELS

CARVING CAROUSEL FIGURES

PRODUCING AMUSEMENT EQUIPMENT OTHER THAN CAROUSELS

PRODUCING METAL CAROUSEL FIGURES

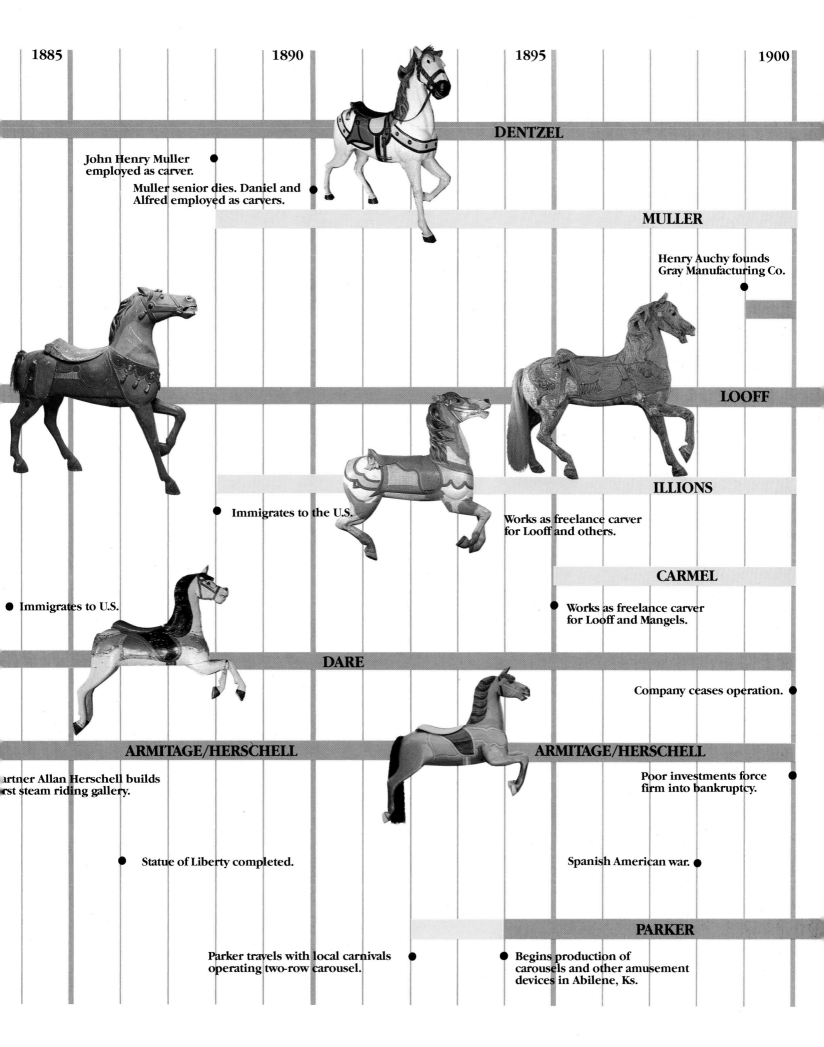

1885 1890 1895 1900

DENTZEL

John Henry Muller employed as carver. ●

Muller senior dies. Daniel and Alfred employed as carvers. ●

MULLER

Henry Auchy founds Gray Manufacturing Co. ●

LOOFF

● Immigrates to the U.S.

Works as freelance carver for Looff and others.

ILLIONS

CARMEL

● Immigrates to U.S.

● Works as freelance carver for Looff and Mangels.

DARE

Company ceases operation. ●

ARMITAGE/HERSCHELL **ARMITAGE/HERSCHELL**

artner Allan Herschell builds rst steam riding gallery.

Poor investments force firm into bankruptcy. ●

● Statue of Liberty completed.

Spanish American war. ●

PARKER

Parker travels with local carnivals operating two-row carousel. ●

● Begins production of carousels and other amusement devices in Abilene, Ks.

243

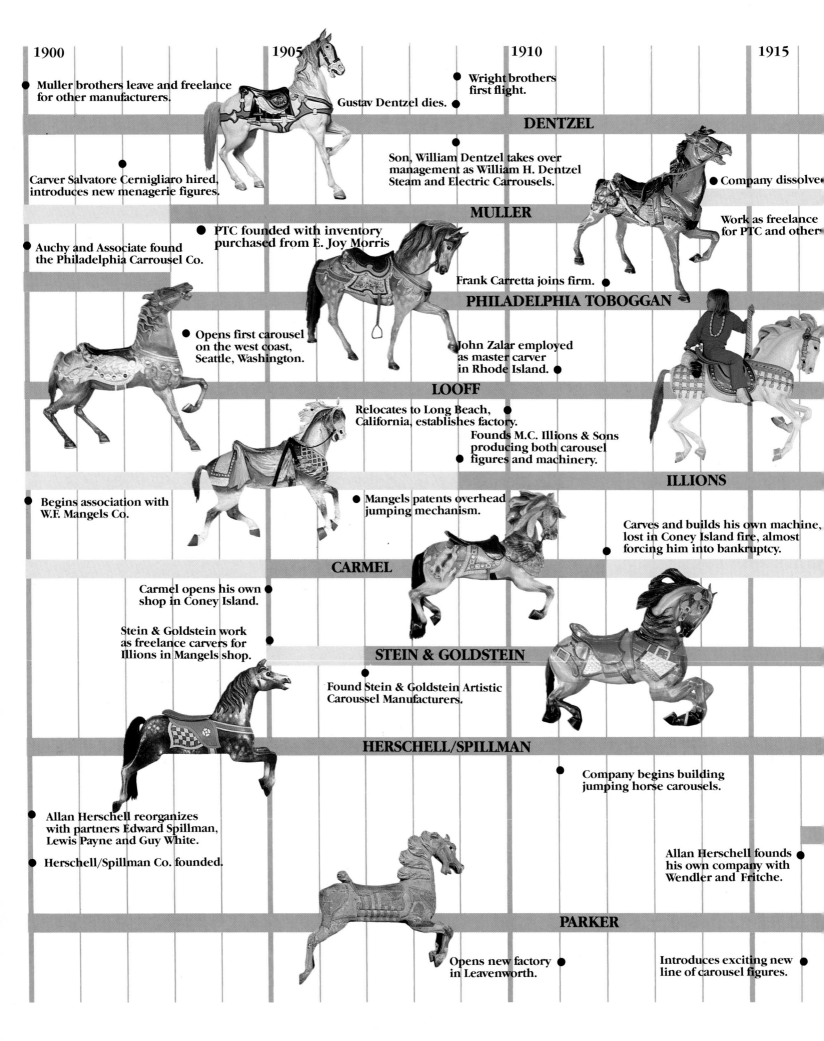

1900 **1905** **1910** **1915**

Muller brothers leave and freelance for other manufacturers.

Gustav Dentzel dies.

Wright brothers first flight.

DENTZEL

Son, William Dentzel takes over management as William H. Dentzel Steam and Electric Carrousels.

Company dissolved

Carver Salvatore Cernigliaro hired, introduces new menagerie figures.

MULLER

Work as freelance for PTC and others

PTC founded with inventory purchased from E. Joy Morris

Auchy and Associate found the Philadelphia Carrousel Co.

Frank Carretta joins firm.

PHILADELPHIA TOBOGGAN

Opens first carousel on the west coast, Seattle, Washington.

John Zalar employed as master carver in Rhode Island.

LOOFF

Relocates to Long Beach, California, establishes factory.

Founds M.C. Illions & Sons producing both carousel figures and machinery.

ILLIONS

Begins association with W.F. Mangels Co.

Mangels patents overhead jumping mechanism.

Carves and builds his own machine, lost in Coney Island fire, almost forcing him into bankruptcy.

CARMEL

Carmel opens his own shop in Coney Island.

Stein & Goldstein work as freelance carvers for Illions in Mangels shop.

STEIN & GOLDSTEIN

Found Stein & Goldstein Artistic Caroussel Manufacturers.

HERSCHELL/SPILLMAN

Company begins building jumping horse carousels.

Allan Herschell reorganizes with partners Edward Spillman, Lewis Payne and Guy White.

Herschell/Spillman Co. founded.

Allan Herschell founds his own company with Wendler and Fritche.

PARKER

Opens new factory in Leavenworth.

Introduces exciting new line of carousel figures.

244

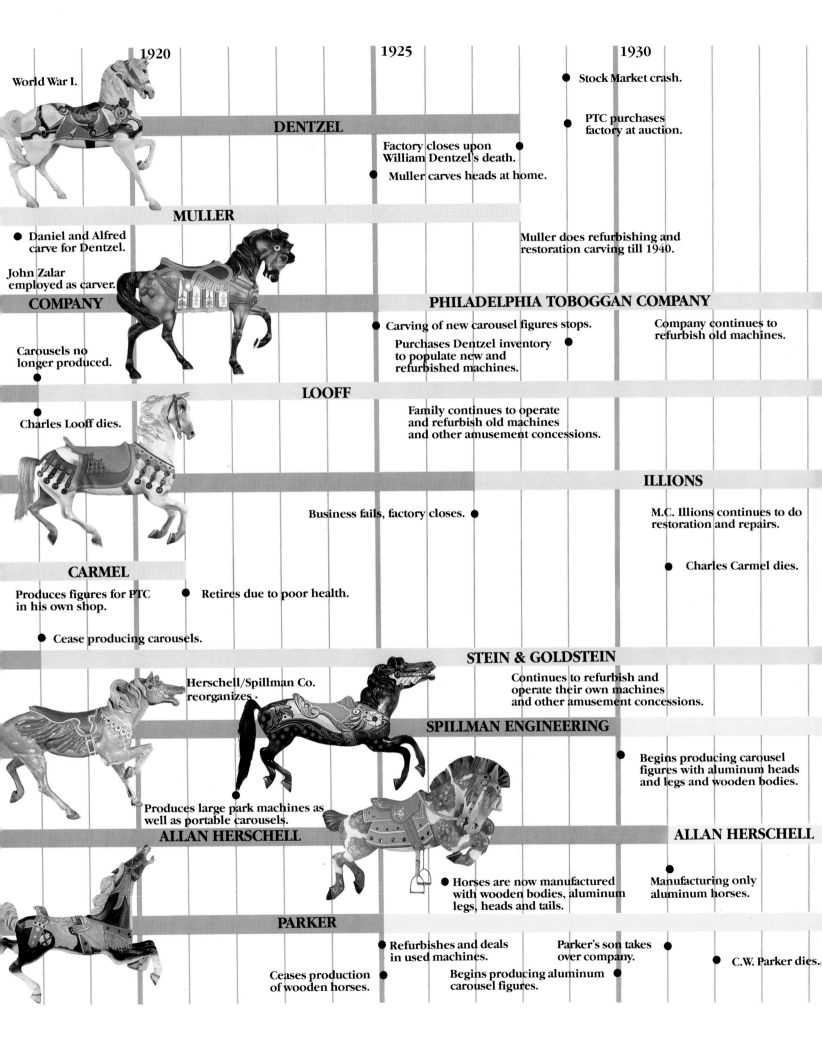

1920 1925 1930

World War I.

DENTZEL

Factory closes upon William Dentzel's death.

Muller carves heads at home.

Stock Market crash.

PTC purchases factory at auction.

MULLER

Daniel and Alfred carve for Dentzel.

John Zalar employed as carver.

Muller does refurbishing and restoration carving till 1940.

COMPANY **PHILADELPHIA TOBOGGAN COMPANY**

Carousels no longer produced.

Carving of new carousel figures stops.

Purchases Dentzel inventory to populate new and refurbished machines.

Company continues to refurbish old machines.

LOOFF

Charles Looff dies.

Family continues to operate and refurbish old machines and other amusement concessions.

ILLIONS

Business fails, factory closes.

M.C. Illions continues to do restoration and repairs.

Charles Carmel dies.

CARMEL

Produces figures for PTC in his own shop.

Retires due to poor health.

Cease producing carousels.

STEIN & GOLDSTEIN

Herschell/Spillman Co. reorganizes.

Continues to refurbish and operate their own machines and other amusement concessions.

SPILLMAN ENGINEERING

Begins producing carousel figures with aluminum heads and legs and wooden bodies.

ALLAN HERSCHELL **ALLAN HERSCHELL**

Produces large park machines as well as portable carousels.

Horses are now manufactured with wooden bodies, aluminum legs, heads and tails.

Manufacturing only aluminum horses.

PARKER

Refurbishes and deals in used machines.

Parker's son takes over company.

C.W. Parker dies.

Ceases production of wooden horses.

Begins producing aluminum carousel figures.

Carousel
DIRECTORY

OPERATING CAROUSELS

The following is a list of the hand-carved wooden carousels currently operating in the U.S. and Canada. The finest examples are noted with a horse symbol. Carousels are occasionally sold or relocated. It's recommended to call ahead before visiting for hours of operation.

CALIFORNIA

DISNEYLAND
Anaheim
Dentzel with Looff/S&G/Carmel, 4 rows, inner row added, some altered and fiberglass horses. ▼

TILDEN PARK
Berkeley
Herschell/Spillman, c. 1912, 4 rows, menagerie, inner row AH metal horses.

KNOTT'S BERRY FARM
Buena Park
Dentzel, c. 1902, 3 rows, menagerie, Wurlitzer band organ #165.

SHORELINE VILLAGE
Long Beach
Looff, c. 1906, 4 rows, only operating Looff menagerie with classic rams, camels and giraffes, restored 1982. ▼

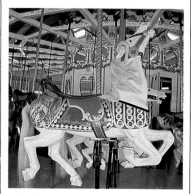

GRIFFITH PARK
Los Angeles
Spillman, c. 1926, 4 rows, delivered new from factory with a dozen Looff jumpers, Wurlitzer band organ #165. ▼

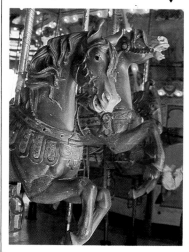

CASTLE PARK
Riverside
Dentzel, mixed with a few PTC, c. 1907, 3 rows, menagerie.

BALBOA PARK
San Diego
Herschell/Spillman, c. 1910, 3 rows, menagerie, 2 level platform, brass ring.

SEAPORT VILLAGE
San Diego
Mangels-Looff, c. 1885, 3 rows, menagerie, Gebruder Bruder band organ #107, c. 1914.

GOLDEN GATE PARK
San Francisco
Herschell/Spillman, c. 1912, 3 rows, menagerie, fanciful restoration 1984.

SAN FRANCISCO FLEISCHAKER ZOO ▲
San Francisco
Dentzel, c. 1921, 3 rows, menagerie with several nice Illions horses on-board.

MARRIOTT'S GREAT AMERICA
Santa Clara
PTC #45, c. 1918, 3 rows, great carving by John Zalar

SANTA CRUZ BEACH BOARDWALK ✦
Santa Cruz
Looff, c. 1911-12, 4 rows, all horses, brass ring, Ruth band organ, c. 1894.

SANTA MONICA PIER ✦ ▲
Santa Monica
PTC #62, c. 1922, 3 rows, restored 1981, Wurlitzer band organ #153, c. 1924.

SIX FLAGS MAGIC MOUNTAIN
Valencia
PTC #21, c. 1912, 4 rows, some figures fiberglass reproductions.

COLORADO

KIT CARSON COUNTY FAIRGROUNDS ✦
Burlington
PTC #6, c. 1905, 3 rows, menagerie, America's finest carousel with original paint.

CHEYENNE MOUNTAIN ZOO
Colorado Springs
Allan Herschell, c. 1924, 3 rows, aluminum legs, original scenery paint.

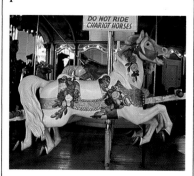

ELITCH GARDENS ▲
Denver
PTC #51, c. 1920-28, 4 rows, extraordinary chariots, original location, Wurlitzer band organ.

LAKESIDE PARK
Denver
Parker, c. 1908, 4 rows, menagerie, very odd figures, possibly Mexican, may have been a trade-in.

CITY PARK
Pueblo
Parker, c. 1911, 3 rows, outside S&G, restored 1984.

CONNECTICUT

LAKE COMPOUNCE PARK
Bristol
Mix-Carmel/Looff/S&G/ Murphy, 3 rows, Wurlitzer band organ #153.

BUSHNELL PARK
Hartford
Stein & Goldstein, c. 1914, 3 rows, restored 1980, finest example of a S&G operating carousel. ▼

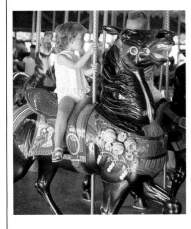

LIGHTHOUSE POINT PARK
New Haven
Mix-Carmel/Looff/Murphy c. 1911, 4 rows, recent restoration.

DISTRICT OF COLUMBIA ▲

NATIONAL CATHEDRAL
U.S. Merry-Go-Round Co., c. 1913, 2 rows, menagerie, operates first Friday and Saturday in May, wonderful primitive carousel.

FLORIDA

WALT DISNEY WORLD MAGIC KINGDOM
Lake Buena Vista
PTC #46, badly altered, c. 1917, 5 rows.

OLD TOWN
Kissimmee
Looff/Carmel mixture, c. 1895-1915, menagerie, 3 rows. ▼

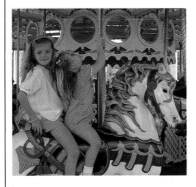

GEORGIA

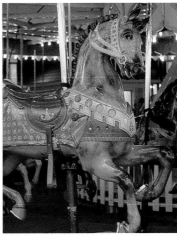 SIX FLAGS OVER GEORGIA
Atlanta
PTC #17, c. 1908, 5 rows, formerly at Riverview park, Chicago, one of the great classic carousels. ▼

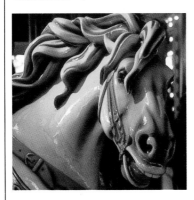

LAKE WINNEPESAUKAH/ FUNTOWN USA
Rossville
PTC #36, c. 1916, 4 rows.

ILLINOIS

MARRIOTT'S GREAT AMERICA
Gurnee
Dentzel, c. 1920, 3 rows, menagerie.

KIDDIELAND
Melrose Park
PTC #72, c. 1925, 3 rows, has 16 signature horses.

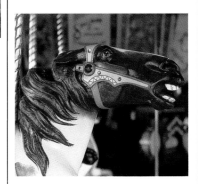

INDIANA

THE CHILDREN'S MUSEUM
Indianapolis
Dentzel, c. 1900, 3 rows, menagerie, Mangels mechanism, outer row converted to jumpers, Wurlitzer band organ #146B, c. 1919.

RIVERSIDE PARK
Logansport
Dentzel, c. 1902, 3 rows, menagerie, all stationary figures.

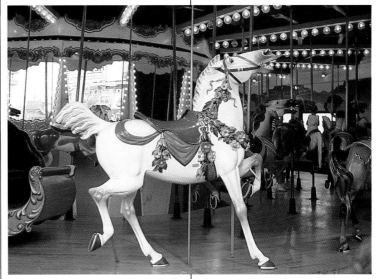

IOWA

OLD THRASHERS FAIRGROUNDS
Mt. Pleasant
Herschell/Spillman, 2 rows, track, steam engine, operates at fair time.

STORY CITY PARK
Story City
Herschell/Spillman, c. 1913, 2 rows, menagerie, portable, nicely restored.

KANSAS

DICKENSON COUNTY HISTORICAL SOCIETY
Abilene
Parker, c. 1901, early and rare, 2 rows, track, steam-powered.

GAGE PARK
Topeka
Spillman circa 1920, restored 1989, 3 rows, Wurlitzer band organ. ▼

LOUISIANA

CITY PARK
New Orleans
Carmel/Mix, c. 1905, 3 rows.

MAINE

PALACE PLAYLAND ▲
Old Orchard
PTC #19, c. 1910, 4 rows.

WILLOW BROOK MUSEUM
Newfield
Armitage Herschell, track machine.

AGASSIZ VILLAGE
West Poland
Spillman, c. 1927, 3 rows, portable.

MARYLAND

HARBOR PLACE
Baltimore
Herschell/Spillman, c. 1912,
2 rows, menagerie, portable.

BETHESDA SQUARE SHOPPING CENTER
Bethesda
Herschell/Spillman, c. 1915,
2 rows, some fiberglass.

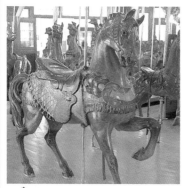

 GLEN ECHO PARK
Glen Echo
Dentzel, c. 1921, 3 rows, me-
nagerie, Wurlitzer band organ
#165 Military, original location.

TRIMPERS RIDES/WINDSOR RESORT
Ocean City
Herschell/Spillman, c. 1907,
3 rows, menagerie, beautiful art
nouveau ticket booth.

WATKINS REGIONAL PARK
Largo
Dentzel/Muller, c. 1905, 3 rows,
unique menagerie, Muller
carvings.

MASSACHUSETTS

RIVERSIDE PARK
Agawam
Mengels-Illions, c. 1909, 4 rows,
menagerie, unusual American
Beauty stallion.

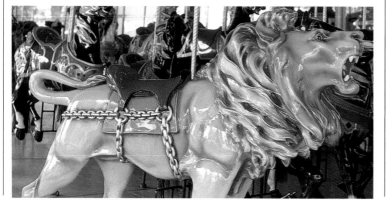

WHALOM PARK
Fitchburg
Looff/Mix, c. 1909-10, 3 rows,
menagerie.

MOUNTAIN PARK
Holyoke
PTC #80, c. 1929, 3 rows, origi-
nal location, Artizan and North
Tonawanda band organs.

LINCOLN PARK
North Dartmouth
PTC #54, c. 1920, 3 rows.

FLYING HORSES OF MARTHA'S VINEYARD
Oaks Bluff
Dare, c. 1884, 2 rows, brass ring,
oldest operating carousel.

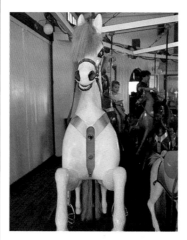

HERITAGE PLANTATION
Sandwich
Looff, 3 rows.

EDAVILLE R.R.
South Carver
Dutch, c. 1912, 2 rows.

MICHIGAN

HENRY FORD MUSEUM
Dearborn
Herschell/Spillman, c. 1913,
3 rows, menagerie, original
scenery panels.

AUTOWORLD
Herschell/Spillman, c. 1916,
3 rows, menagerie.

HISTORICAL CROSSROADS VILLAGE
Flint
Parker, c. 1912, 3 rows, Artizan
band organ.

THUMPER'S VALLEY
Flushing
Parker/Mix, c. 1916, 2 rows.

DUTCH VILLAGE
Holland
Allan Herschell, c. 1920, 3 rows.

WINDMILL ISLAND PARK
Holland
Dutch, kiddie carousel.

MINNESOTA

VALLEYFAIR AMUSEMENT PARK
Shakopee
PTC #76, c. 1925, 3 rows,
Wurlitzer band organ #153.

ST. PAUL FAIRGROUNDS
St. Paul
PTC #33, c. 1914, 4 rows,
nice old paint.

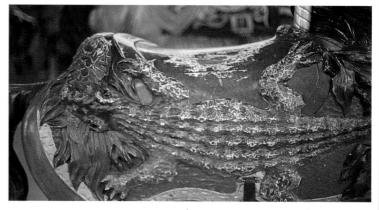

MISSISSIPPI

FAIRYLAND PARK
Greenville
Tonawanda track, c. 1908,
2 rows.

HIGHLAND PARK
Meridan
Dentzel, c. 1909, only 2 row
stationary Dentzel menagerie in
existence, original scenery.

MISSOURI

FAUST PARK
Chesterfield
Dentzel, c. 1927, 4 rows,
restored 1982.

SIX FLAGS OVER MID-AMERICA
Eureka
PTC #35, c. 1915, 4 rows.

NEBRASKA

HAROLD WARP PIONEER VILLAGE
Minden
Armitage Herschell, 2 rows,
track, mixed figures, steam
calliope.

NEW HAMPSHIRE

STORY LAND
Glen
German, c. 1900, 3 rows.

FANTASY FARM
Lincoln
Allan Herschell, c. 1920's,
3 rows.

CANOBIE LAKE PARK
Salem
Mix – Looff/S&G/Dentzel,
c. 1903, 3 rows, menagerie,
look for the signed lion.

NEW JERSEY

CLEMENTON LAKE AMUSEMENT PARK
Clementon
PTC #49, c. 1919, 3 rows, original location.

SIX FLAGS GREAT ADVENTURE
Jackson
English, Savage Gallopers, c. 1881-1890, 3 rows.

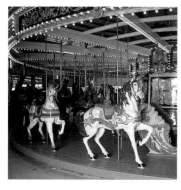

CASINO PIER
Seaside Heights
Mix – Dentzel/Looff/S&G, c. 1910, 4 rows, menagerie, Wurlitzer band organ #146A.

WONDERLAND PIER
Ocean City
PTC #75, c. 1926, 3 rows, brass ring.

SOUPY ISLAND
West Stepford
German, Frederick Heyn.

NEW MEXICO

SPRING RIVER PARK
Roswell
An international assortment of hand carved figures; 3-row menagerie, one of the most unusual carousels.

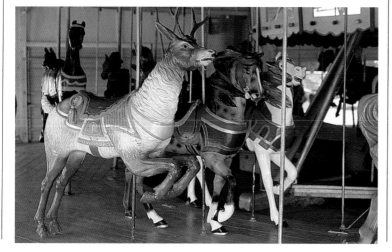

NEW YORK

NUNLEY'S CAROUSEL
Baldwin
Murphy/Stein & Goldstein, c. 1910, 3 rows, brass rings, Wurlitzer band organ #153.

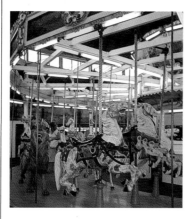

B & B CAROUSEL
Coney Island
Carmel, one Illions armored horse on board, 3 rows, brass rings, Gebrueder band organ, only wooden carousel operating in Coney Island.

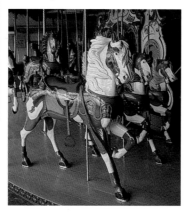

ONTARIO BEACH PARK
Charlotte
Dentzel, c. 1905, 3 rows, menagerie.

GEORGE F. JOHNSON RECREATION PARK
Binghamton
Allan Herschell, c. 1919, 4 rows, Wurlitzer band organ #146-B.

ROSS PARK ZOO
Binghamton
Allan Herschell, c. 1919, 4 rows, Wurlitzer band organ #146-A.

G. W. JOHNSON PARK
Endicott
Allen Herschell, 3 rows.

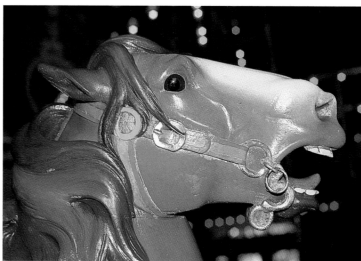

CENTRAL PARK
New York City
Stein & Goldstein, c. 1908, 4 rows, Gebrueder band organ, the largest American carousel figures.

CAROUSEL SOCIETY OF THE NIAGARA FRONTIER
North Tonawanda
Allan Herschell, c. 1916, 3 rows, Wurlitzer band organ #153.

NEW RIALTO PARK
Olcott
Herschell/Spillman, c. 1915, 3 rows, menagerie.

ADVENTURE MOUNTAIN AMUSEMENT PARK
Owego
Spillman, 3 rows.

SANDS POINT PRESERVE
Port Washington
1. Herschell/Spillman, c. 1916, 3 rows. menagerie, display only
2. Primitive, 2 rows, c. 1860, display only, oldest carousel in America

FLUSHING MEADOWS/ CORONA PARK
Queens
Mangels-Illions, c. 1903-1908, 4 rows, mixture of Stubbman and Feltman's carousels.

FOREST PARK
Queens
Muller Dentzel, c. 1910, 3 rows, A. Ruth & Sohn band organ, great military carvings.

GASLIGHT VILLAGE
Lake George
Parker, 2 rows, track

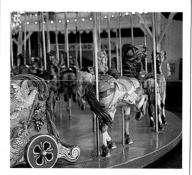

SEABREEZE PARK
Rochester
PTC #36, c. 1915, 3 rows, Wurlitzer band organ #165.

RYE PLAYLAND PARK
Rye
1. Mangels-Carmel, c. 1928-29, 4 rows, Carmel's best carving.
2. Prior & Church/Illions Racing Derby, c. 1926, 4 rows.

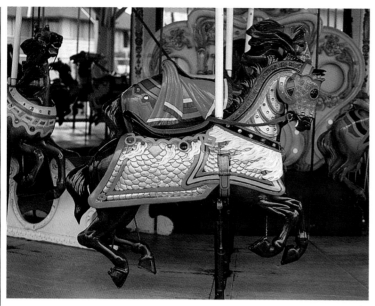

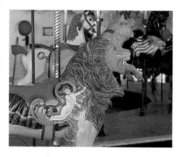

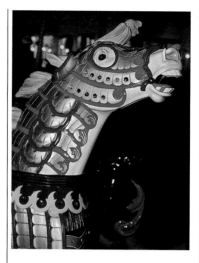

KAYDEROSS PARK
Saratoga
Illions, c. 1917, 2 rows, portable.

HIGHLAND PARK
Union
Allan Herschell, 3 rows.

PAGE AVENUE PARK
Union
Allan Herschell, 3 rows.

JOEL'S STEAK HOUSE
Verona
Allan Herschell, 2 rows.

NORTH CAROLINA

BURLINGTON CITY PARK
Burlington
Dentzel, c. 1917, 3 rows, menagerie, restored 1981-1983.

 CAROWINDS
Charlotte
PTC #67, c. 1923, 4 rows.

PULLEN PARK
Raleigh
Dentzel, c. 1922, 3 rows, menagerie, Wurlitzer band organ #125.

OHIO

GEAUGA LAKE
Aurora
Illions, c. 1918, 3 rows.

KINGS ISLAND
Kings Mills
PTC #79, c. 1926, 3 rows.

TUSCORA PARK
New Philadelphia
Herschell/Spillman, c. 1928, 3 rows, Wurlitzer band organ #150, c. 1928.

 ZOO AMUSEMENT PARK ▲
Powell
Mangels-Illions, c. 1914, 3 rows, portable, Wurlitzer band organ #153.

CEDAR POINT
Sandusky
 1. KIDDIELAND
Dentzel, c. 1905-15, 3 rows, menagerie, home of one of Muller's famed armored horses.
2. MIDWAY
Prior & Church Racing Derby, c. 1925, 4 rows.
3. MIDWAY
Daniel Muller, c. 1912, 4 rows (missing outer row), Wurlitzer band organ #153.
4. FRONTIER TOWN
Dentzel, c. 1921, 4 rows, menagerie with, Muller carvings Wurlitzer band organ #153. ▼

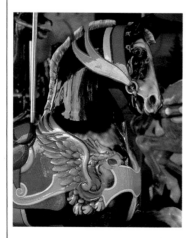

SHADY LAKE PARK
Streetsboro
Kiddie Illions, 2 rows.

OREGON

BURGER KING RESTAURANT
Portland
Spooner of Burton-on-Trent, 3 rows, English roundabout, c. 1900.

JANTZEN BEACH CENTER
Portland
Parker, c. 1921, 4 rows

OAKS AMUSEMENT PARK ▲
Portland
Spillman, c. 1921, 3 rows, menagerie, two level platform.

CAROL'S CAROUSEL WESTERN FORESTRY CENTER
Portland
Illions/Carmel, 3 rows, Mangels mechanism, c. 1914.

WILLAMETTE CENTER
Portland
Looff, c. 1880-1911, 3 rows, menagerie, "museum in the round" displaying all phases of Looff's carvings, Wurlitzer band organ #153.

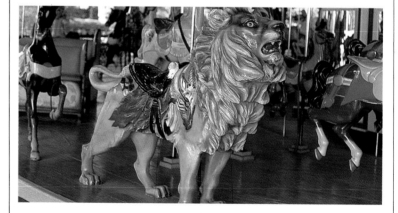

PENNSYLVANIA

ALBION BORO PARK
Albion
US Merry-Go-Round Co.

DORNEY PARK
Allentown
Dentzel, c. 1901, 3 rows, stationary menagerie.

KNOEBEL'S GROVES AMUSEMENT PARK
Elysburg
1. Kramers Karousel Works Carmel, c. 1913, 4 rows.
2. Stein & Goldstein, 2 rows.

CONNEAUT LAKE PARK
Conneaut Lake
T.M. Harton/Muller, c. 1905, 3 rows menagerie. Most outside row figures sold in 1988 and replaced with reproductions.

BUSHKILL PARK
Easton
Mix-Muller/Dentzel/Carmel, 3 rows, menagerie, brass rings.

LAKEVIEW AMUSEMENT PARK
Royersford
Allan Herschell

KENNYWOOD PARK ▲
West Mifflin
Dentzel, c. 1927, 4 rows, menagerie, Wurlitzer band organ #153, c. 1914.

BLAND PARK
Tipton
Herschell/Spillman, 3 rows, Wurlitzer band organ #146B.

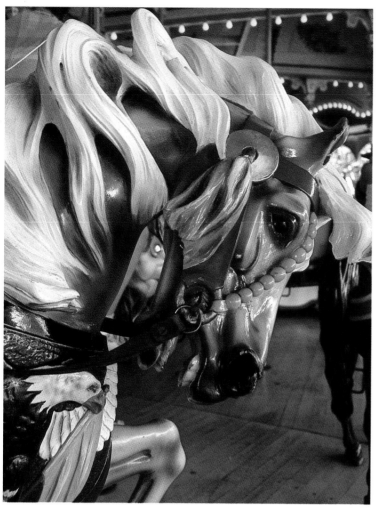

HERSHEYPARK ▲
Hershey
PTC #47, c. 1919, 4 rows,
Wurlitzer band organ #153,
wonderful Zalar carvings.

IDLEWILD PARK
Ligonier
PTC #83, c. 1931, 3 rows,
Wurlitzer band organ #105.

WEONA PARK ▲
Pen Argyl
Dentzel, c. 1917, 3 rows,
original paint, stationary me-
nagerie, brass rings, a rare gem.

RHODE ISLAND

CRESCENT PARK
East Providence
Looff, c. 1895-1905, 4 rows,
menagerie, Ruth & Sohn band
organ.

ATLANTIC BEACH PARK
Misquamicut
Mangels-Illions, 3 rows,
Wurlitzer band organ #146-150.

SLATER MEMORIAL PARK
Pawtucket
Looff, c. 1895-1900, 3 rows,
menagerie, stationary. ▼

WATCH HILL FLYING HORSES
Watch Hill
Dare, c. 1884, 2 rows, flying
horses, brass ring. ▼

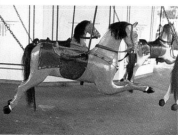

SOUTH CAROLINA

**MYRTLE BEACH
PAVILION & PARK**
Myrtle Beach
Herschell/Spillman, c. 1915,
3 rows, menagerie, two level
platform, restored 1982.

SOUTH DAKOTA

PRAIRIE VILLAGE
Madison
Armitage Herschell, c. 1893,
2 rows, track, steam operated.

**JOYLAND CHILDREN'S
AMUSEMENT PARK**
Sioux Falls
Parker, c. 1917.

TENNESSEE

DOLLYWOOD
Pidgeon Forge
Dentzel, c. 1920, 3 rows, me-
nagerie, brass ring, several rare
figures including 2 dogs and a
rooster, Gavioli band organ. ▼

LIBERTYLAND
Mid-South Fairgrounds
Memphis
Dentzel, c. 1909, 3 rows.

TEXAS

ZOO WORLD
Abilene
Parker, 3 rows.

SIX FLAGS OVER TEXAS
Arlington
Dentzel, c. 1926, 4 rows.

FIREMEN'S PARK
Brenham
Herschell/Spillman, c. 1910,
2 rows.

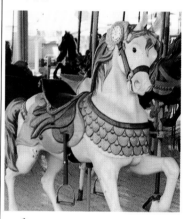

STATE FAIR PARK ▲
Dallas
Dentzel, c. 1920, 4 rows, all
horses, some Muller carvings.

FOREST PARK
Fort Worth
Carmel/Parker, c. 1911, 4 rows.

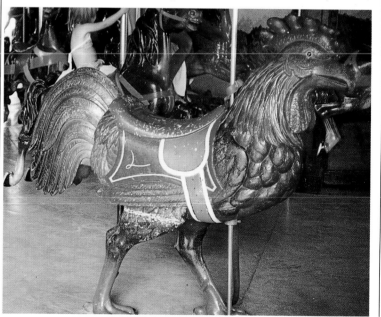

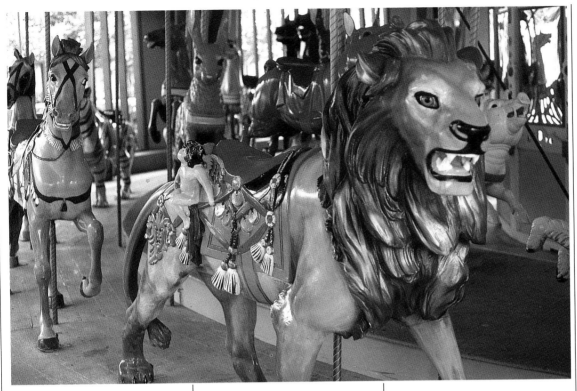

🐎 ASTROWORLD ▲
Houston
Dentzel, 3 rows, outside row by Muller, great menagerie carvings.

NEFF'S AMUSEMENT PARK
San Angelo
Herschell/Spillman, 2 rows.

UTAH

LAGOON AMUSEMENT PARK
Farmington
Herschell-Spillman, c. 1900, 3 rows, menagerie.

LORIN FARR PARK KIDDIELAND
Ogden
Parker/Allan Herschell, 3 rows.

VIRGINIA

🐎 KINGS DOMINION
Doswell
PTC #44, c. 1917, 4 rows.

BUCKROE BEACH AMUSEMENT PARK
Hampton
PTC #50, c. 1920, 3 rows, original location.

WASHINGTON

ENCHANTED VILLAGE
Federal Way
Parker, c. 1906, 3 rows.

WESTERN WASHINGTON FAIR
Puyallup
PTC, 3 rows, portable. ▼

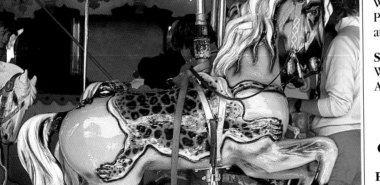

DOUBLE R AMUSEMENT
Long Beach
Herschell/Spillman, c. 1928, 3 rows.

🐎 RIVERFRONT PARK
Spokane
Looff, c. 1909, 3 rows, menagerie, rare sneaky tiger & early giraffe, brass rings, Artizan band organ.

WEST VIRGINIA

CAMDEN PARK
Huntington
Spillman, 3 rows.

WISCONSIN

ELLA'S DELI
Madison
Mix on Parker frame, c. 1927.

FIREMAN'S PARK
Waterloo
Parker, c. 1911, 2 rows, operates for special events.

STORYBOOK GARDENS
Wisconsin Dells
Allan Herschell, c. 1922, 3 rows.

CANADA

PLAYLAND AMUSEMENT PARK
Vancourver, British Columbia
Parker, c. 1905, 3 rows.

RIVERSIDE PARK
Guelph, Ontario
Allan Herschell, 3 rows, menagerie.

CANADA'S WONDERLAND
Maple, Ontario
PTC #84, c. 1928, 4 rows.

LAKESIDE PARK
St. Catherines, Ontario
Looff includes many Illions, c. 1903, 4 rows, menagerie.

CENTREVILLE
Toronto, Ontario
Dentzel, c. 1920's, 3 rows, menagerie.

PARC SAFARI
Hemmingford, Quebec
2 rows.

LA RONDE/ TERRE DES HOMMES
Montreal, Quebec
Belgian, c. 1885, 3 rows.

FAIRGROUNDS PARK
Roseneath, Ontario
Parker, Mexican, c. 1900, 3 rows.

MUSEUMS

THE SMITHSONIAN INSTITUTION NATIONAL MUSEUM OF AMERICAN HISTORY
Washington, DC
Dentzel figures on display.

THE INDIANAPOLIS CHILDREN'S MUSEUM
3010 North Meridian
Indianapolis, Indiana
Working carousel: Dentzel Menagerie 3-abreast, outer row converted to jumpers.

HERITAGE PLANTATION
Grove Street
Sandwich, Massachusetts
Working carousel: Looff 3 abreast mixture, permanent exhibit.

GRAND RAPIDS PUBLIC MUSEUM
54 Jefferson Street
Grand Rapids, Michigan
Spillman Engineering carousel, c. 1928, supplied from factory with 11 Looff jumpers, beautiful original restoration.

GREENFIELD VILLAGE & HENRY FORD MUSEUM

Dearborn, Michigan
Working carousel, Herschell/Spillman menagerie, c. 1913.

THE CAROUSEL SOCIETY OF THE NIAGARA FRONTIER

180 Thompson Street
N. Tonawanda, New York
Allan Herschell carousel, c. 1916, original Allan Herschell factory site.

INTERNATIONAL CAROUSEL MUSEUM

N.E. Holiday
Portland, Oregon
Permanent exhibit, working carousel, early Looff menagerie on loan from Duane and Carol Perron.

PHILADELPHIA MUSEUM OF ART

2600 Benjamin Franklin Parkway
Philadelphia, Pennsylvania
Permanent exhibit.

DICKINSON COUNTY HISTORICAL SOCIETY

412 S. Campbell
Abilene, Kansas
Working carousel, Parker track machine, c. 1901.

SHELBURNE MUSEUM

Shelburne, Vermont
permanent exhibit, Dentzel Menagerie in original factory paint, c. 1895.

CIRCUS WORLD MUSEUM

Baraboo, Wisconsin
Working carousel, Herschell portable, c. 1929.

NEW ENGLAND CAROUSEL MUSEUM

Bristol, Connecticut
Extensive display of carousel figures with restoration shop.

PUBLICATIONS

THE CAROUSEL TRADER

87 Park Avenue West, Suite 206
Mansfield, OH 44902
(419) 529-4999
Monthly color magazine with essential information on carousel events including auction news, tips for collectors and much more. Highly recommended.

DEALERS OF CAROUSEL ART

Many provide restoration services and appraisals.

Jim & Gayle Aten
Carousel Antiques
7626 S.W. Hood
Portland, Oregon 97219
(503) 452-2383

Daniel's Den
720 Mission Street
So. Pasadena, CA 91030
(213) 682-3557

Jon & Barbara Abbott's
"Carousel Corner"
Box 420
Clarkston, MI 48016
(313) 625-1233

Merry-Go-Art
2606 Jefferson
Joplin, MO 64801
(417) 624-7281

Musical Mounts & Arts Inc.
Box 83
Phillipsburg, OH 45354
(513) 884-7051

Pegi O. Sanders
5802 E. Shea Blvd.
Scottsdale, AZ 85254
(602) 948-3268

Dave Boyle
36 Andrews Trace
New Castle, PA 16102
(412) 656-8181

The Wooden Horse, Inc.
920 West Mescalero Road
Roswell, NM 88201
(505) 622-7397

Class Menagerie
55 Windsor Terrace
Yonkers, NY 10703
(914) 423-8477

Old Parr's Carousel Animals
7235 1/2 North Sheridan Road
Chicago, IL 60626
(312) 588-8474

Walt Youree
14941 Henrici Rd. South
Oregon City, OR 97045
(503) 656-0193

Americana Antiques
203 South Morris
Oxford, MD 21654
(301) 226-5677

ORGANIZATIONS

AMERICAN CAROUSEL SOCIETY

470 Pleasant Ave.
Ridgewood, NJ 07450
Promotes conservation of antique carousel art and operating carousels. Publishes newsletter and holds conventions.

NATIONAL CAROUSEL ASSOCIATION

P.O. Box 8115
Zanesville, OH 43702
Promotes conservation and preservations of hand-carved carousels. Publishes newsletter with an annual conference.

COLORADO CAROUSEL SOCIETY

Box 66
Stratton, CO 80836
Encourages the preservation, restoration, and maintenance of Colorado's operating carousels.

RESTORATION SERVICES

Faircloth Restoration Studios
2170A Commerce Avenue
Concord, CA 94520

The Carousel Works
44 W. Fourth Street
Mansfield, OH 44902

Lise Liepman
1108 Neilson Street
Albany, Ca 94706

Will Morton VIII
499 S. Moor Street
Lakewood, CO 80226

Tony Orlando
6661 Norborne
Dearborne Heights, MI 48127

R & F Designs
95 Riverside Avenue
Bristol, CT 06010

Layton's Studios
Route 4 Box 163
New Castle, PA 16101

Rosa P. Ragan
905 W. Johnson
Raleigh, NC 27605

Gladys Hopkins
44 Morse Street
Natick, MA 01760

Tina Veder
55 Winsor Terrace
Yonkers, NY 10701

CARVERS

Bill Hamlet
614 Polk Street
Raleigh, NC 27604

Rebecca Hays
RFD #1 Box 399
Keene, NH 03431

Joe Leonard
Custom Woodcarving
P.O. Box 510
14595 Baird Street
Burton, OH 44021

W.P. Wilcox
2122 West Midwood Lane
Anaheim, CA 92804

Carousel Connection
Woody Homan
9101 Northridge Drive
Oklahoma City, OK 73132

SUPPLIES

Sally Craig
336 W. High Street
Elizabethtown, PA 17022
Hair tails & stirrups

Dave Boyle
36 Andrews Trace
New Castle, PA 16102
Custom display stands

Flying Tails
1209 Indiana Avenue
So. Pasadena CA 91030
Hair tails & stands

Mayer Import Company, Inc.
25 West 37th Street
New York, NY 10018
Jewels in quantity

Woodcarvers Supply
P.O. Box 8928
Norfolk, Va 23503

Van Dykes
Woonsocket, SD 57385
Carousel glass eyes

CAROUSEL MUSIC

Vestal Press
P.O. Box 97
Vestal, NY 13851

Carrousel Music
Box 231
Chambersburg, PA 17201

Artacus
P.O. Box 284
State College, PA 16804

BIBLIOGRAPHY

American Heritage
June 1958
American Heritage
Publishing

Bishop, Robert
American Folk Sculpture
E.P. Dutton & Co., Inc., 1974

Carousel Art Magazine
Issue #1-26
Marge Swenson,
Garden Grove, California

Christensen, Erwin D.
*Early American
Wood Carving*
World Publishing Co.,
Cleveland, 1952

Dinger, Charlotte
Art of the Carousel
Carousel Art Inc.,
Green Village, N.J., 1983

Fraley, Tobin
The Carousel Animal
Zephyr Press, Berkeley, Ca.,
1983

Fried, Frederick
*A Pictorial History
of the Carousel*
Vestel Press, Ltd.,
Vestal, N.Y., 1964

Fried, Fredrick
"Daniel Carl Muller",
The Merry-Go-Roundup
National Carousel
Association, Inc.
Vol. 5, Number 3, July 1978

Hornung, Clarence P.
*Treasury of American Design
& Antiques*
Harry N. Abrams, Inc.,
publisher, New York 1950

Mangels, William F.
*The Outdoor Amusement
Industry*
Vantage Press, Inc.,
New York, 1952

McCullough, Edo
Good Old Coney Island
Charles Scribner's Sons,
New York, 1957

Summit, Roland
Flying Horses Catalogue #1,
The Carousels of
Coney Island
Rolling Hills, California,
1970

Weedon, Geoff &
Ward, Richard
Fairground Art
Abbeville Press, Inc.
New York 1983

Williams, Barbara
"John Zalar,
The Master Carver"
The Merry-Go-Roundup,
National Carousel
Association, Inc., 1979

Veder, Tina Cristiani
*Carvers and Their
Merry-Go-Rounds*
Second Annual Conference
Committee, National
Carousel Roundtable, 1974

INDEX